SAINT LOUIS ILLUSTRATED

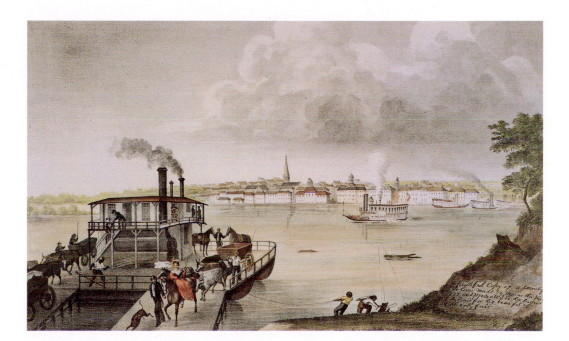

JOHN W. REPS

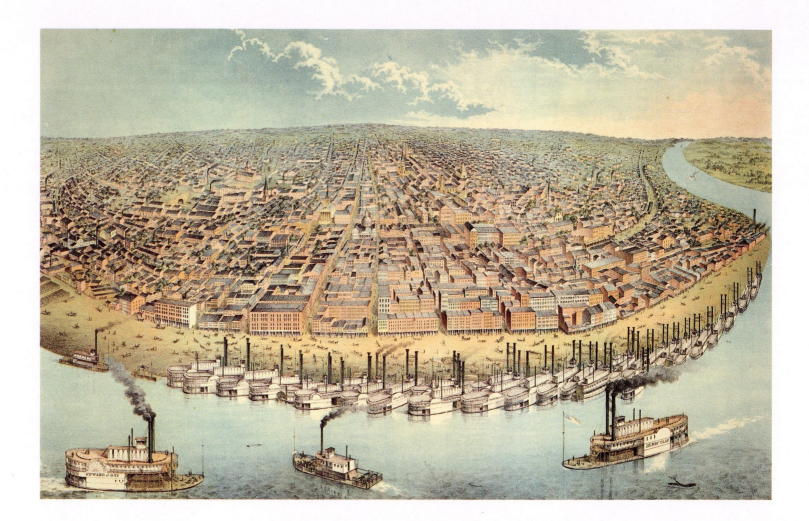

UNIVERSITY OF MISSOURI PRESS
Columbia, 1989

SAINT LOUIS ILLUSTRATED

NINETEENTH-CENTURY ENGRAVINGS AND LITHOGRAPHS OF A MISSISSIPPI RIVER METROPOLIS

Library of Congress Cataloging-in-Publication Data

Reps, John William.
Saint Louis illustrated.

Bibliography: p.
Includes index.
1. Saint Louis (Mo.) in art. 2. Prints, American.
3. Prints—19th century—United States. I. Title.
NE954.2.R47 1989 769'.44 88-20914
ISBN 0-8262-0698-0 (alk. paper)

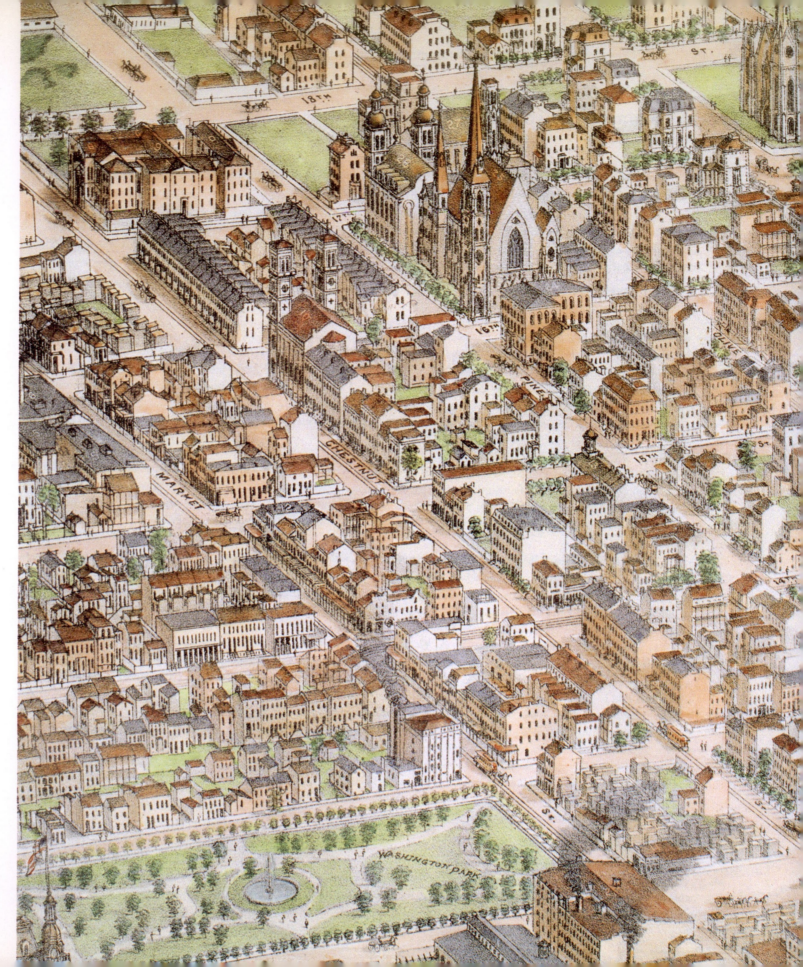

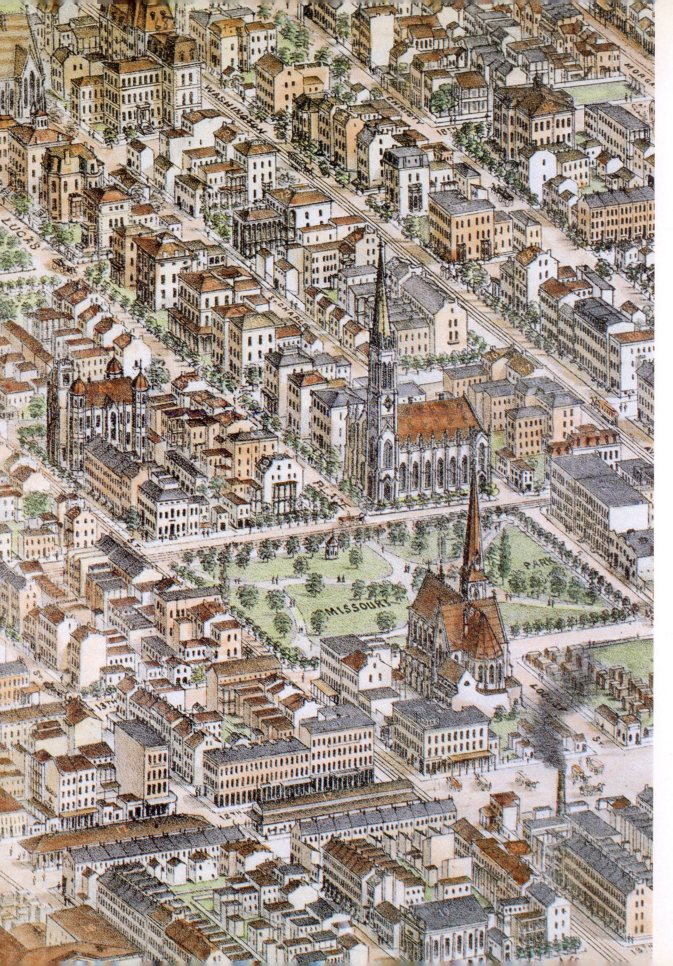

This Book is Dedicated
To the Memory
of my
Mother and Father,
Grandparents,
and
Great Grandparents,
all once
Citizens of the
City of St. Louis:

Whose German, Swiss, Italian,
Irish, and English Ancestry
Symbolize the Remarkable Diversity
of Their City in the Nineteenth Century

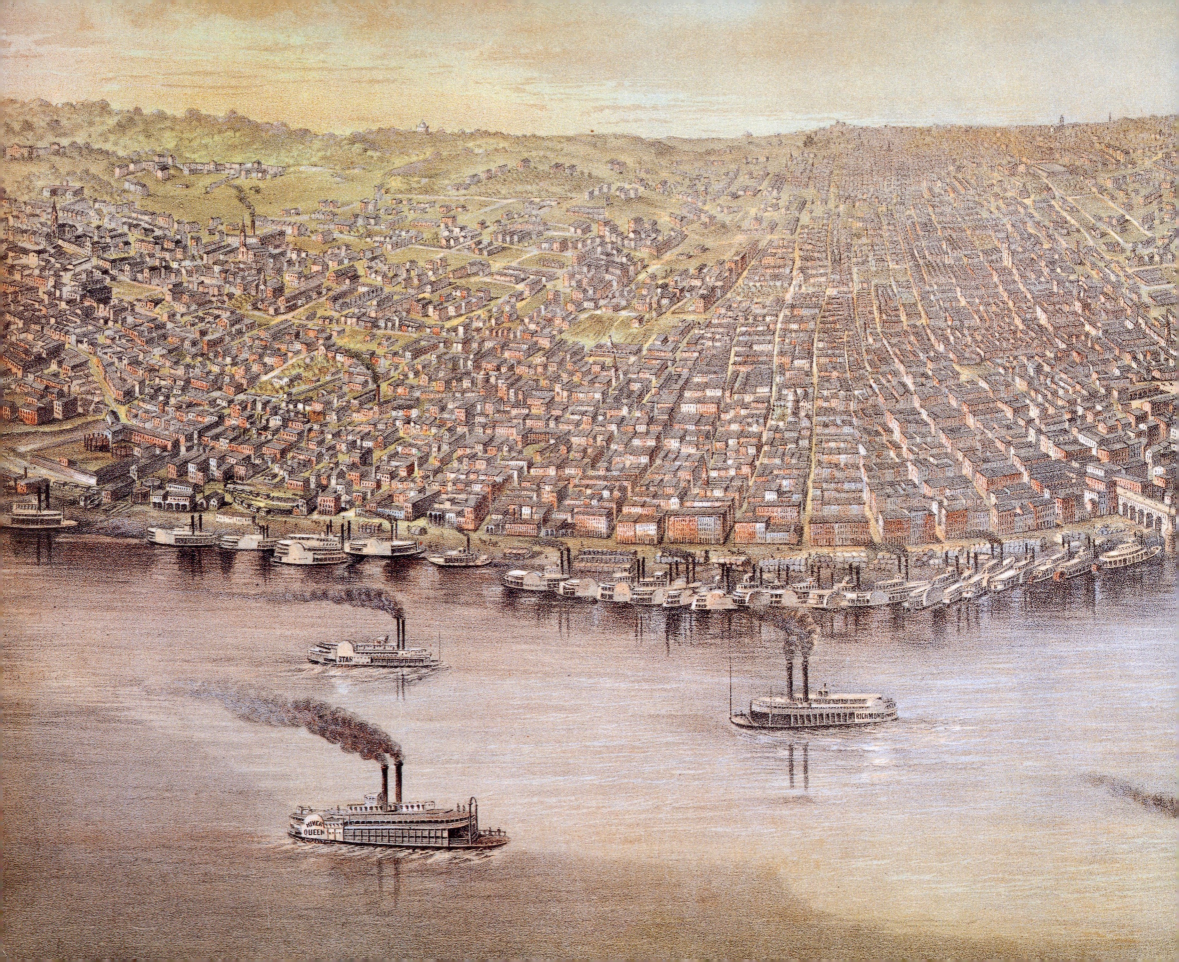

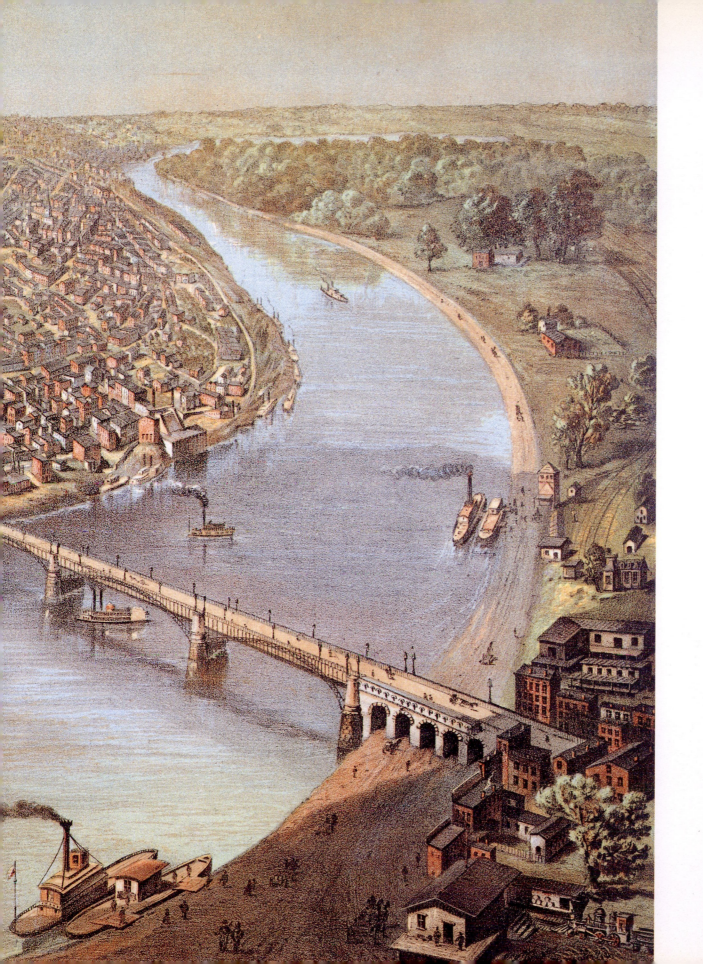

CONTENTS

Introduction, *ix*

I. Origins of the St. Louis Tradition, *1*

II. Early St. Louis and the First Printed Views of the City, *14*

III. John Caspar Wild and St. Louis in the Early 1840s, *29*

IV. St. Louis Viewmakers in the Years before the Civil War, *52*

V. The City from Above, *80*

VI. Views of St. Louis in the Era of War and Reconstruction, *101*

VII. The St. Louis of Camille N. Dry, *126*

VIII. Viewmaking in St. Louis: The End of an Era, *154*

Acknowledgments, *180*

Notes on the Illustrations, *182*

Bibliography, *189*

Index, *195*

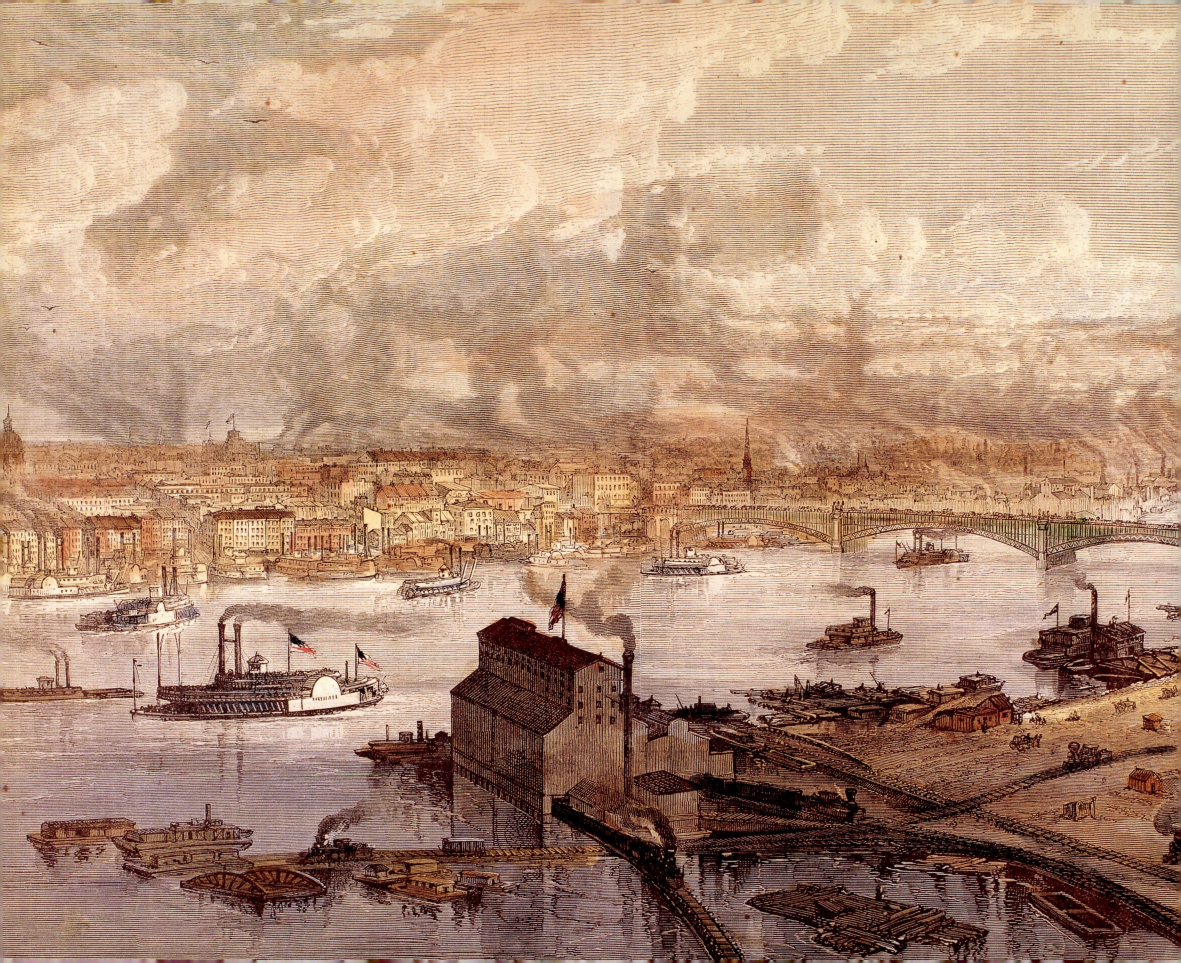

INTRODUCTION

This work examines how one kind of artistic endeavor popular throughout America in the nineteenth century was used to illustrate the city of St. Louis and how the results can increase our understanding of what the city was like as it grew from village to metropolis. It introduces the artists, printers, and publishers who created these pictorial records, explores how they went about their work, reproduces most of the images they composed, and explains how these views reveal elements of urban change and growth. Contemporary descriptions by residents and visitors supplement this information and help in interpreting what the artists recorded.

Although some views took the form of individual drawings or paintings, a far larger number of images became available to wider audiences through the medium of print. Thus, dozens of lithographs or engravings in wood or steel record the appearance of the city at various stages of its existence. Many of these views reached the market as single sheets designed for use as wall decorations. Others appeared as illustrations in books, magazines, newspapers, and reports. Some views of the city decorated bank notes, bonds, or certificates. A few can be found in souvenir view booklets, on the covers of sheet music, or on lettersheets, billheads, broadsides, or posters.

Urban views that displayed all or most of the city provide the pictorial focus of the book; with few exceptions, partial views showing only street scenes, groups of buildings, or individual structures are not considered. Before the middle of century almost all the views that we will be concerned with depicted St. Louis as the artist looked at the city from the Illinois shore of the Mississippi. Thus, the early images of the city take the form of skyline panoramas with St. Louis seen stretching along the river from south to north and sloping upward to the higher ground on the west.

Although several artists continued to use this style of urban portraiture in later years, many of the views of St. Louis after 1850 showed it from vantage points high in the air—places artists could not have occupied except in their imaginations. To create such images, artists needed techniques that went beyond sketching the city from a fixed spot in the distance. Such high-level, bird's-eye views allowed residents or those living elsewhere to understand the basic pattern of St. Louis, to grasp the nature of its site, and to appreciate the city's extent and variety in a manner impossible to convey by any other means until the advent of modern aerial photography.

These printed urban portraits begin very early in the nineteenth century and thus allow us to follow St. Louis's evolution from a frontier village to a major metropolis. Few cities in the country can boast of an equally rich heritage recording their development. However, many of these prints are extremely rare, the earliest and several others being known only by single impressions. Other prints exist in very limited numbers, a few of which are not represented in St. Louis collections. This volume contains illustrations of several views that have not previously been reproduced.

Although trained and experienced artists created many views of St. Louis that provide splendid examples of topographic art, a number of others came from less talented hands, and some are almost totally devoid of artistic merit. Yet all provide insights into how the city looked in the past, how artists perceived and recorded their impressions of the place, how printmakers used the various methods of creating multiple images that flourished in the nineteenth century, and how publishers sought to sell their products.

The urban viewmakers responsible for these images followed practices that began centuries before. The reader needs to understand something of that tradi-

tion in order to appreciate more fully the contributions of St. Louis townscape artists. The first chapter thus summarizes European precedents in drawing and printing city views and examines the development of American viewmaking up to the publication of the first separate views of St. Louis. It also introduces the various techniques of printmaking used to produce multiple images.

Chapter II considers pioneer artists who provided the first printed images of the city, one as early as 1817 and several that reveal how St. Louis appeared in the 1830s. In this early era of viewmaking nearly all the images of the city were created by itinerant artists. The third chapter introduces John Caspar Wild, one of these itinerants who made St. Louis his home for several years and who during that time drew many handsome lithographs capturing the appearance of the city from several locations. His work included a 360-degree panorama, a rare form of city view; the only other one in America at that time was of Philadelphia, also drawn by Wild.

Two chapters trace the evolution of St. Louis viewmaking from the mid-1840s to the beginning of the Civil War. The first considers a number of low-level townscape panoramas, including an extraordinary creation by newly arrived German craftsmen who drew and printed a highly detailed, water-level view of the city nearly four and one-half feet long. The second introduces the earliest bird's-eye views of St. Louis. One of these, known only from a unique impression in the Missouri Historical Society, provides a superb guide to the pattern and appearance of the city on the eve of war.

Chapter VI examines the views of St. Louis during the periods of war and reconstruction through the end of the 1870s. At this time local publishers began to use views of St. Louis as book illustrations, and editors of national illustrated journals sent their artists to draw the city for wood engravings that helped readers grasp how St. Louis had developed as a river metropolis. Other publishers issued views of the city to mark the opening of the great Mississippi bridge that James Eads of St. Louis designed.

The next chapter explores in considerable detail the most extraordinary city view ever published in America and one of the world's noteworthy achievements in urban cartography. Camille N. Dry produced this monumental, 110-sheet depiction of the city in 1875. In prodigious detail, Dry—doubtless assisted by a team of helpers—recorded every building, street, park, and landscape element of St. Louis in such a manner that sections of the city far distant from his assumed viewpoint are as legible as those in the immediate foreground.

A final chapter follows the creation of additional views of St. Louis through the end of the century and up to the St. Louis World's Fair in 1904. The several large-size views produced by St. Louis artists and publishers during this period bring the tradition of printed viewmaking in the city to an end, for by that time this method of depicting cities had run its course everywhere, and photography had largely replaced the hand-drawn view as a method of representing cities.

Notes on the illustrations used in this book and others that have been found but not reproduced will be found at the end of the book. These notes provide complete citations to each view, supplying the full title, date of publication, size, and—where known—the artist, printmaker, printer, and publisher. They also identify St. Louis institutions, museums, and libraries and sources elsewhere that hold original impressions of the prints in their collections.

Footnotes to the text identify sources of information and in many cases also include additional material related to topics under discussion. A bibliography of books and articles gives the full publication information for the works cited in the notes. Whatever biographical information exists on each viewmaker has been incorporated in the text and notes. A section of acknowledgments recognizes the many persons who have contributed to this work.

This book appears at a time when—as throughout most of the last century—St. Louis once again faces a promising future that will bring changes and improvements. Photographs, video tapes, and remotely sensed images from satellites in space now record its appearance and structure. Although these depictions of St. Louis provide all the accuracy that anyone could ask, they lack the spirit and character of the prints issued in the last century that are the focus of this book.

In many ways the nineteenth century was the Golden Age for St. Louis. Its business and commercial life flourished, it provided homes and neighborhoods for a diverse population, and its educational, religious, and cultural institutions vigorously expanded their services to enrich the entire community. Certainly that was true as well in the field of printed urban views when the city turned its face toward so many artists and basked in the warmth of their attention. This presentation of what they produced celebrates their achievements in capturing the look and feel of a small river town as it grew to become one of the nation's greatest cities.

ORIGINS OF THE ST. LOUIS TRADITION

No American city seemed more assured of a bright future than St. Louis in the middle of the nineteenth century. Its merchants controlled the Missouri River trade and dominated the commercial life of the mid-Mississippi valley. No serious rival threatened its mastery of the region, and only Cincinnati and New Orleans enjoyed like positions elsewhere. Rows of warehouses and wholesale establishments lined the streets near the busy levee; hotels and shops filled the adjoining retail business district; factory chimneys in several concentrations of industry proudly belched the smoke that signaled employment and prosperity; and to the north, south, and west beyond the business district stretched solidly built neighborhoods housing the city's increasingly diverse population.

St. Louis could boast of more than mercantile supremacy. The city served as the cultural and educational capital for its large region. Founded in 1763 as a fur-trading post, it had already passed through its pioneering years as a frontier settlement while younger communities in the midwest like Chicago still struggled to survive. Major civic buildings like the Courthouse and such quasi-public institutions as the Mercantile Library added touches of elegance to the urban scene. Compared to newer towns, St. Louis with its concert halls, schools and colleges, and numerous clubs, societies, and organizations seemed refined and sophisticated.

Moreover, because St. Louis attracted persons of varied ethnic backgrounds, religions, and customs, it possessed a cosmopolitan character unsurpassed by any other inland city. When it was learned that the site selected for the town lay within the huge Louisiana Territory secretly ceded to Spain by France, the original French residents soon found themselves joined by a few Spanish colonials. English-speaking settlers also established themselves in St. Louis in its early days and came in increasing numbers after the United States acquired the Territory in 1803. Other Europeans soon followed: first the Irish and Germans and then, toward the end of the century, Italians, as well as smaller numbers from other countries.

Each of these groups built churches, and St. Louis thus acquired a far more varied and attractive skyline than would have been the case with a less heterogeneous population. Public buildings and important commercial structures added further architectural variety and interest. It is small wonder, then, that artists came to St. Louis to portray its impressive appearance and capture in their images some of its energy and prosperity. They found St. Louis an ideal subject, its distinctive character serving as an inspiration to their art and its residents providing a ready market for the results of their efforts.

Whether they knew it or not, the urban viewmakers responsible for these images practiced a form of art having a long history. In the balance of this chapter we will examine how viewmaking began in Renaissance Europe, how artists accompanying early explorers and settlers applied this tradition in depicting colonial American communities, and the ways in which viewmakers in the new republic of the United States recorded the appearance of its towns and cities. The views of St. Louis will thus be more easily understood as a part of an artistic legacy handed down over many generations.

A landmark of urban topographic art was created over five hundred years ago by an Italian artist named Jacopo de' Barbari, when he produced a marvelous woodcut view of Venice. His high-level perspective helped to change forever the way people in the West looked at and perceived urban communities. Figure 1–1 reproduces a small portion of one of the six large sheets that make up this celebrated print. This detail shows the Piazza San Marco and its immediate surroundings and is typical of the meticulous care de' Barbari took

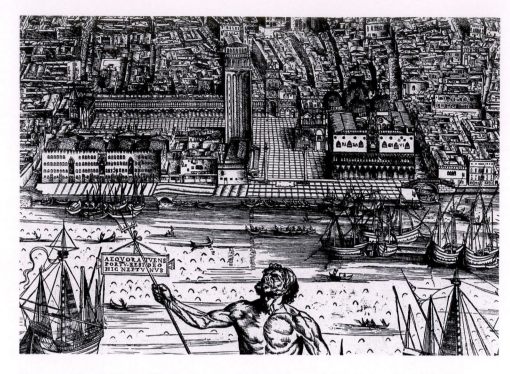

Figure 1–1. Detail. View of Venice, in 1500, drawn by Jacopo de' Barbari and published in Venice by Anton Kolb. (The Newberry Library.)

Figure 1–2. Plate 43 from Compton and Dry, *Pictorial St. Louis,* showing a portion of St. Louis northwest of Washington Avenue and Tenth Street in 1875. (Collection of A. G. Edwards and Sons, Inc., St. Louis, Missouri.)

to render every aspect of the city with almost photographic exactitude.[1]

This woodcut marked a spectacular leap forward in recording the spatial dimensions of urban life, for it combined a number of characteristics, any one of which would merit consideration and which taken together constitute an artistic and conceptual milestone. First, this is the earliest known, separately issued city view to have survived, all earlier printed city views having appeared as book illustrations.[2] Second, it is enormous in size, measuring about four and one-half by nine feet. Third, de' Barbari depicted the entire city, and the generous scale of his view allowed him to introduce a wealth of architectural detail.

1. For the definitive study of this view see Juergen Schulz, "Jacopo de' Barbari's View of Venice: Map Making, City Views, and Moralized Geography Before the year 1500." Fig. 1 in this work is a reproduction of the entire view. The view has been most recently reproduced in James Elliot, *The City in Maps: Urban Mapping to 1900,* fig. 11.

2. Francesco Rosselli apparently engraved and sold four multisheet city views before 1500. Only one sheet of one of them survived to the modern era, and that was destroyed in World War II. It showed a portion of Florence. A later one-sheet woodcut version of this exists in a single impression. The single-sheet version is reproduced in Schulz, "Barbari's View of Venice," fig. 5.

Fourth, he selected a viewpoint lofty enough to show the alignment of every street and the appearance of each building. Further, although this record of Renaissance Venice lacks exact engineering precision, it depicts the city with unusual fidelity and provides a reliable guide to the pattern and appearance of whole quarters as well as individual structures. Finally, de' Barbari created a print of extraordinary beauty and appeal, using decorative features with imagination and taste. He thus combined art and utility in a way that enhanced both and allowed neither to interfere with the other.

Three hundred and seventy-five years later an otherwise obscure artist named Camille N. Dry produced an equally detailed and even larger lithographic view of St. Louis. Figure 1–2 reproduces one of the 110 sheets composing Dry's view. A later chapter describes this multisheet print in detail and presents many other examples of its remarkable character and striking appearance. Dry's print represents an achievement that for its time and in its own way approaches that of de' Barbari's masterpiece. His accomplishment marked the culmination of many years of American urban viewmaking that grew out of the

flourishing European tradition of separately issued city views that de' Barbari began so spectacularly.

To understand the place of St. Louis city views and their artists in history we must look back even before the time of de' Barbari's view to begin a survey that will take us from Renaissance Europe to St. Louis on the eve of its remarkable change from a frontier village to a Mississippi River metropolis. Along the way we will examine the several methods of printmaking that artists from the Renaissance to the present day have used to create multiple images on paper. We will also identify many of the practices and techniques of rendering cities originated by European artists that St. Louis viewmakers carried on throughout the nineteenth century.

The first printed depictions of cities took the form of tiny and highly stylized illustrations in a world history published in Cologne in 1474.[3] Soon other artists, printers, and publishers surpassed this modest effort and created more realistic illustrations of cities. Erhard Reuwich of Utrecht took a gigantic stride forward in 1486 when he printed a book containing views he had drawn on the way to and in the Holy Land while accompanying Bernhard von Breydenbach, Dean of Mainz, on a pilgrimage in 1483–1484.

Reuwich's best known woodcut is his superb view of Venice, a portion of which Figure 1–3 reproduces. This first itinerant urban viewmaker also produced several other handsome and reasonably accurate woodcuts showing such places as Jerusalem, Rhodes, and Candia, on the island of Crete. Most of these were so long that Reuwich had to use several woodblocks for each image. He then pasted the sheets together and folded them to fit inside the book. Almost four hundred years later a very long view of the St. Louis skyline had to be constructed in an almost identical fashion.[4]

The publication of Breydenbach's *Peregrinationes* with Reuwich's woodcuts demonstrated the appeal of books with large, clear, and detailed illustrations. It also reflected the hunger for knowledge about the appearance of distant places in a world whose boundaries were swiftly receding during an era of exploration and increased knowledge. A similar attitude prevailed in America during the nineteenth century as explorers rolled back the Western frontier. Many travel books and articles included images of the towns and cities springing up along

Figure 1–3. Detail. View of Venice in 1486, drawn, cut, and published in Mainz by Erhard Reuwich. Facsimile. (Olin Library, Cornell University.)

and beyond the Mississippi, foremost among them being St. Louis.

People of the Renaissance wanted to know about the past as well as about distant places in the present. These needs led to the publication in 1493 of the *Nuremberg Chronicle,* compiled and edited by the learned Hartmann Schedel. This enormous volume contained some 1,800 woodcut portraits, maps, views, illustrations of animals, and depictions of mythical races of mankind, all accompanied by a text that combined biblical lore, classical mythology, ancient and modern history and geography, and almost anything else that persons of the early Renaissance knew or thought.[5]

Of the many city views, only those occupying two pages—like that of Rome reproduced in Figure 1–4—contain recognizable features. Schedel and the chief artist, Michel Wolgemut, used any sources they could find for their images. For example, they borrowed Reuwich's view of Venice without acknowledgment (and doubtless without permission) and reduced and simplified it. Dozens of subsequent artists and publishers followed this practice of graphic

3. Werner Rolevinck, *Fasiculus Temporum.*

4. Reuwich's work appeared in Bernhard von Breydenbach, *Peregrinationes in Terram Sanctam.* The many editions of this book are listed in Hugh William Davies, *Bernhard von Breydenbach and His Journey to the Holy Land, 1483–4: A Bibliography,* in which portions of many of Reuwich's woodcuts are reproduced. See also the facsimile edition: Breydenbach, *Die Reise ims Heilige Land: ein Reisebericht aus dem Jahre 1483.*

5. Hartmann Schedel, *Liber Cronicarum.*

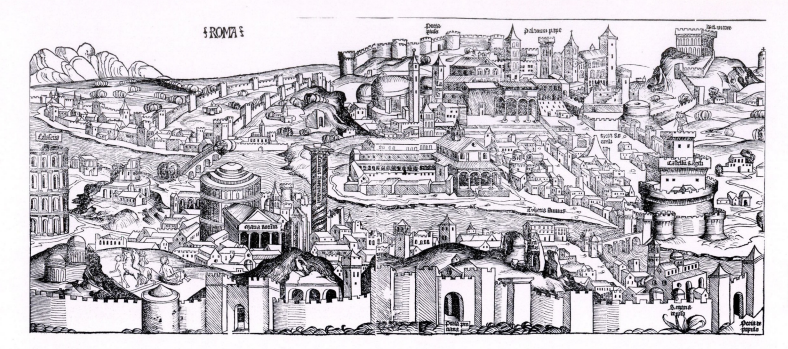

Figure 1-4. View of Rome ca. 1493, printed and published in Nuremberg by Anton Koberger in 1493. (John W. Reps.)

plagiarism, including—as later chapters will demonstrate—several who produced views of St. Louis.[6]

The immediate success of the *Nuremberg Chronicle* led to the production of many similar books combining history, geography, and travel. None exerted greater influence than Sebastian Münster's *Cosmographei,* first published in 1544, reissued three times, and then thoroughly revised and vastly expanded in 1550. For that edition Münster added thirty-one double-folio woodcut city views. Among them was the view reproduced in Figure 1-5, showing the buildings of Florence as if seen by an observer looking downward at an angle steep enough to provide glimpses of all the principal structures, the city walls, the Arno River and its bridges, and the surrounding countryside.[7]

6. For the substantial body of literature about the *Nuremberg Chronicle* see the bibliography in Adrian Wilson, *The Making of the Nuremberg Chronicle,* which includes a color facsimile of the Nuremberg view, following p. 136. See also Wilson, *Making of Nuremberg Chronicle,* chap. 7, pp. 193–205, for a discussion of Albrecht Dürer's role in the project. For Nuremberg in the period when the *Chronicle* appeared, see Gerald Strauss, *Nuremberg in the Sixteenth Century,* esp. pp. 238, 254–61. Elisabeth Rücker, *Die Schedelsche Weltchronik,* includes small but legible reproductions of the city views that contain recognizable features, along with full-size color facsimiles of those of Cologne and Venice.

7. Ruthardt Oehme, "Introduction" to *Cosmographei,* v-xxvii, lists the various editions of Sebastian Münster, *Cosmographei.* Münster probably based his image of Florence on the view of the city by Rosselli; see n. 2 above.

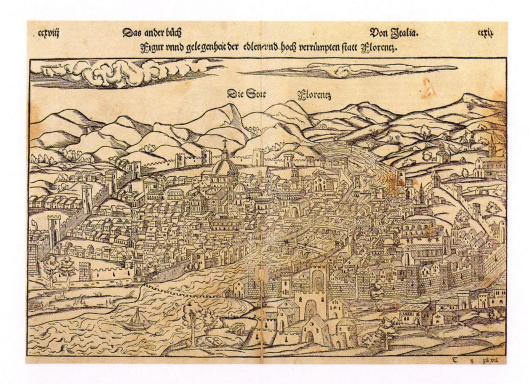

Figure 1-5. View of Florence ca. 1490, published in Basel by H. Petri in 1550. (John W. Reps.)

After Münster's death in 1552 his publishers continued to revise and re-issue the *Cosmographei*. By 1600 they had produced no fewer than twenty-four posthumous editions in German, Latin, French, Italian, and Czech. Clearly, this enormously popular work would have been familiar to nearly all educated persons throughout Europe. The *Cosmographei* introduced its readers to the bird's-eye perspective, and this novel manner of representing cities quickly gained acceptance alongside the more traditional ground-level, skyline view or the slightly elevated townscape panorama.[8]

Münster's maps and views and almost all others printed before the middle of the sixteenth century consisted of simple line drawings executed as woodcuts, either by the artist himself or by an experienced woodcut craftsman. Woodcuts offer limited opportunities for achieving tonal variation through fine hatching or cross-hatching because such fine lines tend to weaken the woodblock and cause it to be damaged by the press. Because of this, the artist needed to restrict himself to only the boldest and most obvious of details.[9]

In addition to these atlas pages and book illustrations, artists created many multisheet views of cities similar to de' Barbari's 1500 view of Venice.[10] However, only members of the nobility and wealthy commoners could have afforded them. For example, before publishing his view of Venice, de' Barbari stated that its price would be three ducats, a month's salary for a skilled artisan in that prosperous city.[11]

The price of the multisheet views partly explains the popularity and the far greater numbers of single-sheet city views. These were issued in substantial numbers by Italian, Flemish, Dutch, and German artists, cartographers, and publishers beginning in the 1540s with the work in Rome of Antonio Lafreri. Scores of these attractive prints depict towns and cities in one of two styles: either high-level, oblique bird's-eye perspective or plan-views, consisting of a

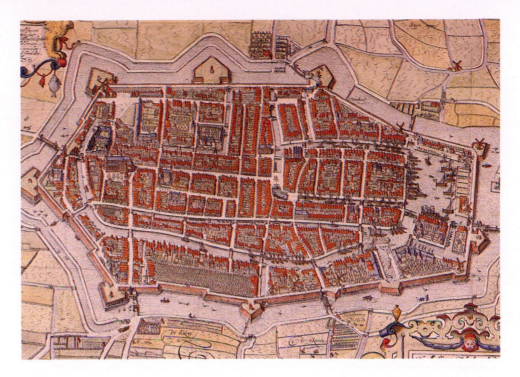

Figure 1–6. Plan-view of Alkmaar ca. 1597, drawn by Cornelis Drebbel in 1597. (John W. Reps.)

city map on which the artist has superimposed perspectives of all the buildings.[12]

Figure 1–6 reproduces an example of a plan-view, an engraving of the Dutch city of Alkmaar drawn by Cornelis Drebbel and used as a folded illustration for a book published in 1597. Probably the publisher also sold individual copies, for with the aid of skilled colorists—then a respected trade—this highly

8. A specialized atlas of islands of the world containing city views, Benedetto Bordone's *Libro di Benedetto Bordone Nel qual si Ragiona de Tutte l'Isole del Mondo . . .*, preceded Münster. For a brief note on this work see Baltimore Museum of Art, *The World Encompassed*, exhibit item 183. A direct competitor of Münster was Johannes Stumpf, *Die Gemeiner Loblicher Eydgnoschafft Stetten Landen und Völckeren Chronik Wirdiger Thaaten Beschreybung . . . (Schweizer Chronik)* with many fine woodcut views. It was this volume that stimulated Münster to issue his much-revised edition of 1550 with its many new city views.

9. Woodcuts are created by carving away that portion of a wood plank that is not to be printed, leaving in relief relatively thin lines or wider masses of the design that can be coated with ink. Paper is then laid on top of the inked block, and enough pressure is applied by a press to transfer the ink to the paper. The best modern summary of the process is David Woodward, "The Woodcut Technique," in Woodward, ed., *Five Centuries of Map Printing*, 25–50. See also Arthur M. Hind, *An Introduction to a History of Woodcut, with a Detailed Survey of Work Done in the Fifteenth Century*.

10. Publishers in many other places issued equivalent prints of enormous size and meticulous detail. The following were among those drawn and printed before 1600: Augsburg (1521), Cologne (1531), Amsterdam (1544), Cairo (1549), Nuremberg (1551), Genoa (1553), Rome (1555), London (ca. 1560), Bruges (1562), Antwerp (1565), Florence (1584), Oxford (1588), Freiburg (1589), and Cambridge (1592). Most of these are mentioned in Schulz, "Barbari's View of Venice." Many of the German, Austrian, and Swiss multisheet views and plan-views of the sixteenth and seventeenth centuries are reproduced in Friedrich Bachmann, *Die Alte Deutsche Stadt*.

11. Schulz, "Barbari's View of Venice," 441, n. 44. Quite aside from the cost, the heroic size of these views made them impractical for persons owning a residence or place of business with less than palatial dimensions.

12. The most detailed analysis of Lafreri's output is R. V. Tooley, "Maps in Italian Atlases of the Sixteenth Century." For an analysis of a so-called Lafreri atlas, see Tooley, "'Lafreri' Atlases." Lafreri's business was in Rome, but Venetian mapmakers were also very active in this period. See a note by Woodward to catalog entry 27 in "La Geografia Moderna."

detailed engraving surely would have appealed to persons with a broad range of tastes and incomes as a possible wall decoration. In similar fashion many of the St. Louis views illustrated in this volume have been colored to make them more attractive.

By the end of the sixteenth century line engraving on copper plates had almost totally superseded the use of woodcuts as a means of reproducing city views. Engraving promised far sharper and cleaner impressions, a greater precision and authority of lines, opportunities to achieve tonal character through fine hatching and cross-hatching, and the ability to create much more elaborate decorative features and lettering.[13] Several of the views of St. Louis are engraved, and an understanding of the process will help us better appreciate the results.

The engraver duplicates the lines of the artist's drawing by incising the surface of a smooth metal plate with any of several special tools, chiefly the graver or burin.[14] The engraver uses other tools to create tiny indentations in the surface where the resulting print is to show stippling, and he employs punches for repetitive elements like symbols for towns, images of trees, or small letters. Other mechanical devices produce multiple parallel rules, dotted lines, and similar special effects. In the nineteenth century all of these methods of copper engraving were carried over into steel engraving, a method of reproducing prints that became widely used and was employed in printing a number of St. Louis views, chiefly those used as plates in books.[15]

In 1572 Georg Braun and Franz Hogenberg of Cologne issued the initial volume of the first atlas devoted entirely to cities, their *Civitates Orbis Terrarum*. Each of the five volumes contained a hundred or so engraved city views with descriptive and historical text on the reverse. Most of the views also included a numbered legend identifying important places, a feature found on many of the views of St. Louis.[16]

Although the Braun and Hogenberg atlas provides an unrivaled survey of the sixteenth-century urban world, the compilers used older printed sources for many of their images. For example, quarter-century-old Münster woodcuts—themselves often derived from even earlier prototypes—provided models for the engravings of Besançon and Constantinople. Braun and Hogenberg copied other views, like the plan-view of Amsterdam reproduced in Figure 1–7, from multisheet prints.[17] Braun forthrightly acknowledged this borrowing in his foreword to the atlas when he stated that "some cities have been delineated" by artists commissioned for the task while "other views" have been "obtained by diligent inquiry from those who have depicted certain individual cities."[18] Several viewmakers of St. Louis were not this candid and simply appropriated as their own earlier images of the city created by other artists.

Some of the Braun and Hogenberg views showed their subjects as they might have been seen at ground level by a traveler approaching by road.[19] Braun, however, favored high-level perspectives or the plan-view type of representation of cities. He put it in these words: "Towns should be drawn in such a manner that the viewer can look into all the roads and streets and see also all the buildings and open spaces." Nearly three hundred years later artists who almost certainly knew nothing of Braun created the first such bird's-eye images of St. Louis for exactly the same reason, views that are treasured today because of the wealth of detail such elevated perspectives made possible.

In the seventeenth century a new generation of urban viewmakers in the Netherlands helped to meet the demand for city plans and views by publishing hundreds of single-sheet engravings and many outstanding atlases. Joan Blaeu published an important two-volume city atlas of Holland and Belgium in 1649. He issued most of his city views with fine hand coloring that added to the beauty of his skillfully engraved plates.[20]

Blaeu's rival, Jan Jansson, published his own city atlas in six parts, begin-

13. It was also possible to revise an engraving or to correct errors by burnishing the portion of the surface to be changed, then hammering on the reverse side to create a smooth and true surface.

14. This is a v-shaped instrument that is pushed forward along the surface at angles and with pressures that displace varying amounts of copper. Lines need not be uniform but can vary in width, usually tapering to a sharp point where the engraver has gradually reduced the pressure on the burin before lifting it altogether to end the line.

15. For a compact summary of the engraving process, see Coolie Verner, "Copperplate Printing." See also Arthur M. Hind, *A History of Engraving and Etching from the 15th Century to the Year 1914.* Unlike a woodcut where the design is in relief and ink on the printing surface can be transferred to paper with only moderate pressure, ink on an engraved plate fills the incised lines below the surface and can be transferred only by pressure sufficient to force the paper into the engraved lines.

16. For information about the *Civitates,* I have relied on the following: R. A. Skelton, "Introduction," vii-xlvii, and R. V. Tooley's "Preface," v-vi, both to the facsimile edition; A. E. Popham, "Georg Hoefnagle and the *Civitates Orbis Terrarum*"; Johannes Keuning, "The 'Civitates' of Braun and Hogenberg"; Arthur Hibbert, "The Historical Background," and Ruthardt Oehme, "Medieval Pictorial Maps," in Hibbert and Oehme, *Old European Cities.*

17. In this case, Cornelis Anthoniszoon's great view of Amsterdam in 1544 was available for them to reproduce in a smaller and somewhat simplified form. For a reduced but still legible color reproduction of Anthoniszoon's work, see Elliot, *City in Maps,* pl. 2.

18. Quoted in Skelton, "Introduction."

19. Among others, the Oxford and Stockholm views in the *Civitates* are traditional skyline townscapes. For a color reproduction of the Stockholm engraving see the facsimile edition of Braun and Hogenberg, *Civitates Orbis Terrarum.* A color reproduction of the Oxford view (to-

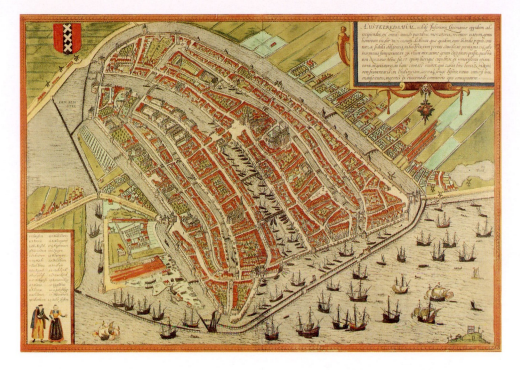

Figure 1–7. Plan-view of Amsterdam in 1544 after a woodcut by Cornelis Anthoniszoon, published in Antwerp and Cologne by Georgius Bruin, Simon Novellanus, and Franciscus Hogenbergius in 1572. (John W. Reps.)

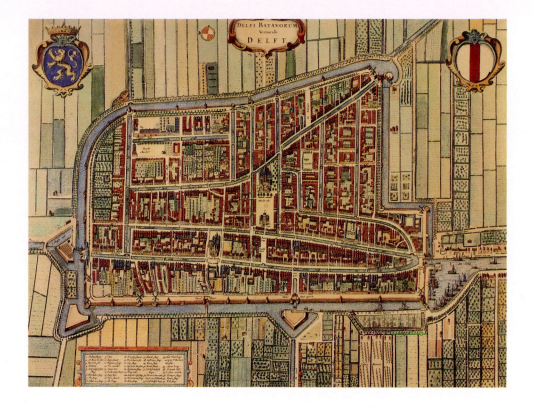

Figure 1–8. Plan-view of Delft in 1649 or before, published in Amsterdam by Frederik de Wit in 1698. (John W. Reps.)

ning in 1657. He used some Braun and Hogenberg plates he had acquired, copied others from Blaeu, and contributed some of his own work. Eventually Jansson's and Blaeu's plates came into the hands of Frederik de Wit, who about 1695 produced his own large city atlas that included the view reproduced in Figure 1–8.

Although this plan-view of Delft is undeniably attractive, by the time de Wit published the engraving it was badly out-of-date. It originally appeared in Blaeu's atlas, and after de Wit acquired the plate he merely substituted his name for that of the first publisher without making any other changes. This

image thus records conditions in Delft as they existed long before de Wit published his atlas. Among the many St. Louis views that we will examine are several similar examples of badly out-of-date images that lazy or unscrupulous publishers issued during the nineteenth century.

Matthew Merian ably carried on the tradition of viewmaking in Germany. In 1642 Merian issued the first of eighteen volumes of city views that covered most of Europe. He also produced engravings for other publications, like the long skyline panorama of Constantinople shown in Figure 1–9, from Pierre d'Avity's atlas, *Neuve Archontologia Cosmica,* published at Frankfurt about 1649. The earliest views of St. Louis followed this style, depicting the city as the artists saw it at ground level from across the Mississippi.[21]

gether with that of Windsor Castle) is in Ralph Hyde, *Gilded Scenes and Shining Prospects: Panoramic Views of British Towns 1575–1900,* 8.

20. Blaeu was a master craftsman and one of the greatest printers of his era. He was also a master plagiarist, shamelessly using existing urban images from a wide variety of sources without acknowledgment. For example, the plan-view reproduction of Alckmaar in Joan Blaeu, *Tooneel der Steden van de Bereenighde Nederlanden, met Hare Beschrijvingen,* is a line-for-line duplicate of Cornelis Drebbel's depiction published nearly half a century earlier. See Figure 1–6.

21. Merian moved from Basel to Frankfurt to manage the engraving, publishing, and bookselling business begun by his father-in-law, Theodore de Bry. For de Bry see M. S. Giuseppi, "The Work of Theodore de Bry and his Sons, Engravers." For a summary description of Merian's output, see Alois Fauser, *Repertorium Alterer Topographie,* I, liii–lx, and for a catalog of all of his prints see Lucas Heinrich Wuthrich, *Das Druckgraphische Werk von Matthaeus Merian d. Ae.*

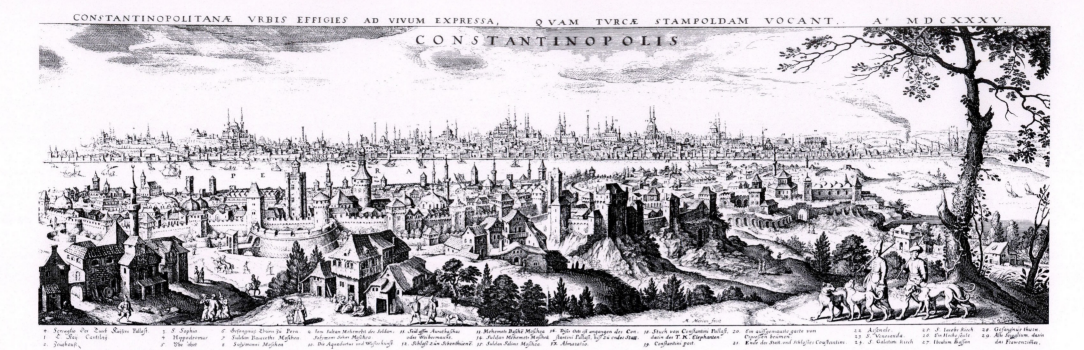

Figure 1–9. View of Constantinople (now Istanbul) in 1635, engraved by Matthew Merian and published in Frankfurt by M. Merian ca. 1649. (Division of Geography and Maps, Library of Congress.)

Thus, well before the founding of the majority of colonial towns in North America there existed in Europe a firmly established tradition of urban view-making. With the great interest shown in Europe for all things in the New World, it was little wonder that printed images of its towns proved popular. These woodcuts and engravings satisfied the curiosity of those unable to travel themselves, informed Europeans about the nature of communities in America where friends or relatives might be living, or reminded their owners about places they might have visited as merchants, colonial officials, or while in military service. In the nineteenth century similar feelings helped to stimulate interest among Easterners in the appearance of new or growing cities in the Midwest, notably St. Louis.

The first images of urban America appeared in a variety of contexts, the earliest being illustrations in books of travel and exploration, later to be the source of many views of St. Louis in the nineteenth century.[22] Figure 1–10 is one of several such bookplates engraved and published by Theodore de Bry, this one dating from 1591. It shows the short-lived Huguenot settlement of Fort Caroline established in 1564 in northeastern Florida.[23]

22. The initial image to appear was a woodcut illustration in a letter by Columbus published in Basel in 1493. It purported to show La Navidad, a town planned by Columbus on the north coast of Hispaniola shortly after he reached the Western Hemisphere. Another example from this period of discovery is a plan-view of Mexico City, possibly drawn by Cortez, recording the layout of the Aztec capital on its island site early in the sixteenth century. A reproduction of the La Navidad view can be found in Cecil Jane, trans., *The Journal of Christopher Columbus*. This is also illustrated, along with the plan-view of Mexico City in 1524, in Lynn Glaser, *Engraved America: Iconography of America Through 1800*, pls. 1-D, 5-A.

23. De Bry used for his model a watercolor painted by Jacques Le Moyne, one of the French

Figure 1-10. View of Fort Caroline, Florida, in 1564, published in Frankfurt by Theodore de Bry in 1591. (John W. Reps.)

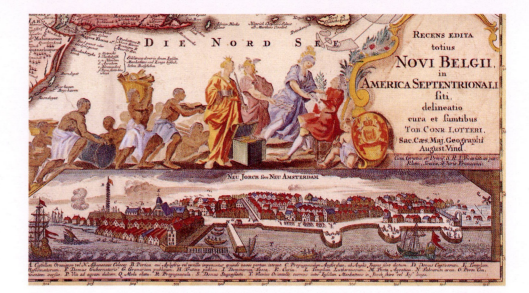

Figure 1-11. View of New Amsterdam (New York City) in 1673, drawn by Hugo Allard, from a version published after 1757 in Augsburg by Tobias Conrad Lotter. (John W. Reps.)

Other American city views could be found as insets on maps. Hugo Allard, a Dutch cartographer, provided one long-lived image of New Amsterdam (New York City) when he included an inset view of the city on his map of the Northeast in 1673. Other mapmakers appropriated this view as their own. Figure 1-11 is one example among many—a version that a German cartographer published about 1757 and reissued without revision as late as 1788, more than a century after the first appearance of what had once been an accurate urban

portrait.[24] Several nineteenth-century St. Louis views also can be found as insets like this on maps of the city or the region.

Early in the eighteenth century William Burgis, an English artist, produced the first separately issued American town view. Engraved in England in 1720 on four folio-size plates, this huge print captured the likeness of New York as seen from Brooklyn across the East River. Three similar multisheet panoramas followed: Boston in 1723, also by Burgis; Charleston in 1739; and Philadelphia in 1754. All these views went to England to be engraved and published, for no colonial craftsmen or presses could produce work of this size and quality.[25]

24. Tobias Conrad Lotter published the issues of ca. 1757 and 1788. Lotter inherited this plate from his father-in-law, Mathew Seutter, who had copied Allard's image of the city for a map he published in 1730. Following Seutter's death in 1757, Lotter simply substituted his own name on the plate and issued the map with the view unchanged. The Allard map (and a predecessor by Nicholas Visscher) and their derivatives that also featured inset views of New York are discussed and illustrated in Tony Campbell, *New Light on the Jansson-Visscher Maps of New England*.

25. For Burgis and his views, see Richard B. Holman, "William Burgis," 57–81; for his Boston view see John W. Reps, "Boston by Bostonians: The Printed Plans and Views of the Colonial City by Its Artists, Cartographers, Engravers, and Publishers," 3–56; both in Walter Whitehill and Sinclair Hitchings, eds., *Boston Prints and Printmakers, 1670–1775*. There is a note on the Philadelphia view and a bibliography of writing about it by B. G., "An East Prospect of the City of Philadelphia." The Charleston view is reproduced and described in Anna Wells Rut-

colonists. In 1599 de Bry also illustrated one of his volumes of travels with a view of St. Augustine, the oldest town in the United States, as well as the other Spanish ports of Cartagena and Santo Domingo. The British Library, *Sir Francis Drake: An Exhibition to Commemorate Francis Drake's Voyage around the World, 1577–1580*, reproduces earlier engravings of the three towns that de Bry used as his sources.

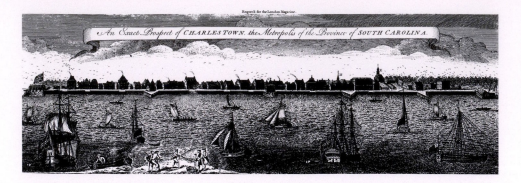

Figure 1–12. View of Charleston, South Carolina, in 1739 drawn by Bishop Roberts, published in London by the *London Magazine* in 1762. (The Old Print Gallery, Washington, D.C.)

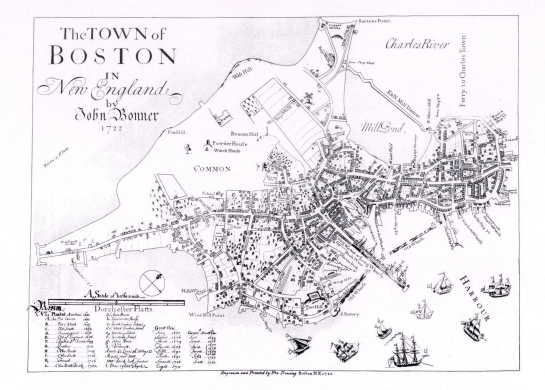

Figure 1–13. Plan-view of Boston in 1722, drawn by John Bonner and engraved and printed in Boston by Francis Dewing. (I. N. Phelps Stokes Collection, Miriam & Ira D. Wallach Division of Art, Prints & Photographs, The New York Public Library, Astor, Lenox and Tilden Foundations.)

Later publishers, needing images of these cities for illustrations or as smaller separate prints, reduced and simplified these large, multisheet engravings just as several St. Louis viewmakers would do in the next century. Figure 1–12 reproduces the reduced-size, single-sheet version of the Charleston view that the *London Magazine* used in one of its issues in 1762.[26]

Artists and publishers of other colonial city views used the single-sheet format that had proved so popular in Europe. The first single-sheet view to be drawn by an American artist and printed in the colonies showed Boston as it appeared in 1722 to John Bonner, a ship's captain and an unskilled draftsman. Figure 1–13 reproduces a portion of Bonner's version of a plan-view as engraved for publication in Boston. Evidently unable to handle perspective drawing, he simply portrayed each building as if it had toppled backward exposing its facade to the sky.[27]

Usually, however, colonial viewmakers chose a more conventional approach in depicting cities. They drew their subject as it could be seen from ground level or from some convenient hill or ship's mast. This style characterized the superb set of engraved American city views published in 1768 by a consortium of leading London printsellers under the title *Scenographia Americana*. Like the example of Montreal reproduced in Figure 1–14, each print had titles in English and French and a brief legend identifying the most important buildings.[28]

Only a few of these colonial city artists used the bird's-eye viewpoint. One notable example is the engraved depiction of Savannah, Georgia, drawn by Peter Gordon and published in London in 1734. In this print (illustrated in Figure 1–15) and in one of Bethlehem, Pennsylvania, drawn by Nicholas Garrison and issued in 1757 the artists display each town's street system, open spaces, buildings, and surroundings in such a way that the basic urban pattern of both places becomes understandable to the viewer.[29]

ledge, "Charleston's First Artistic Couple." For the New York view, see John H. Edmonds, "The Burgis Views of New York and Boston."

26. The large view of Charleston published in 1739 also served as the source for an engraving of the city issued in London in 1768.

27. For more on the Bonner plan of Boston and its metamorphosis through many states to its final publication in 1769, see Reps, "Boston by Bostonians."

28. These prints continued to be sold for many years after their first issue. In 1775 the catalog of the London firm of Sayer and Bennett listed the *Scenographia* engravings as "A collection of *Views* in *North America* and the *West Indies.*" See *Sayer and Bennett's Enlarged Catalogue of New and Valuable Prints, in Sets, or Single . . . for 1775.*

29. A color reproduction of Garrison's view of Bethlehem printed in 1757 for Robert Sayer, a London printseller, is in Gloria-Gilda Déak, *American Views: Prospects and Vistas,* 25.

Figure 1-14. View of Montreal ca. 1768, drawn by Thomas Patten and published in London by John Bowles, Robert Sayer, Thomas Jefferys, Carrington Bowles, and Henry Parker in 1768. (Division of Rare Books, Library of Congress.)

Engraved views and those executed in the newer method of aquatint etching that made it easier to record tonal gradations dominated the Federal Period.[30] Publishers issued some of these in groups, such as the engravings of Philadelphia drawn, engraved, and published in 1800 by William Birch, an English artist who had come to America six years earlier.[31] Other artists from Britain, like the Irishman William Guy Wall, painted watercolor views of cities

30. There are no separately issued aquatint views of St. Louis, although portions of some steel engravings used for book illustrations appear to have been printed in this manner. The process involves using finely powdered rosin to coat a plate (usually copper) on which a design has been lightly etched, heating the plate to fix the rosin in place in a reticulated pattern. Acid is then used to "bite" to give it the design texture. Those portions of the plate that are to be darker are exposed to acid one or more times while other parts of the plate are "stopped out" by a protective coating. Successive etching by the acid produces deeper indentations that will hold more ink and print in darker tones. The characteristic reticulated texture can also be obtained by coating the plate with rosin dissolved in alcohol or even by using sugar in place of rosin.

31. For the work of Birch, see three articles by Martin P. Snyder, all in the *Pennsylvania Magazine of History and Biography:* "William Birch: His Philadelphia Views," "William Birch: His 'Country Seats of the United States,'" and "Birch's Philadelphia Views: New Discoveries." See also Snyder, *City of Independence: Views of Philadelphia Before 1800,* 224–48; and *Birch's Views of Phila-*

Figure 1-15. View of Savannah in 1733, drawn by Peter Gordon, engraved by Pierre Fourdrinier, and published in London in 1734 by the Trustees for Establishing the Colony of Georgia. (Division of Prints and Photographs, Library of Congress.)

that an Englishman, John Hill, turned into handsome aquatints.[32] The nineteen aquatint city views executed by William James Bennett were even more attractive.[33]

By the time Bennett's last aquatints reached the market in the early 1840s,

delphia: A Reduced Facsimile of the City of Philadelphia . . . as it Appeared in the Year 1800; With Photographs of the Sites in 1960 & 1982 by S. Robert Teitelman. Three of the Birch views are reproduced in color together with a brief note in Deak, *American Views,* 38–41.

32. See Donald A. Shelley, "William Guy Wall and His Watercolors for the Historic *Hudson River Portfolio.*" The text of the prospectus announcing the series can be found in I. N. Phelps Stokes and Daniel C. Haskell, *American Historical Prints: Early Views of American Cities,* 106. For Hill, see Frank Weitenkampf, "John Hill and American Landscapes in Aquatint"; Richard J. Koke, "John Hill (1770–1850), Master of Aquatint"; Koke, *A Checklist of the American Engravings of John Hill (1770–1850);* and the note on his work in Philadelphia Museum of Art, *Philadelphia: Three Centuries of American Art,* 249.

33. Bennett studied in London at the Royal Academy and enjoyed considerable success in England before coming to America in 1826 at the age of forty. Some of his aquatints came from his own drawings, but he based others on paintings by John Hill or—like those of Washington and Richmond—on townscapes by George Cooke.

a new method of printmaking had captured the attention of the public and artists alike. Invented in the late eighteenth century by Alois Senefelder in Bavaria, lithography proved cheaper, faster, and easier than engraving, and it soon spread to France and England. When lithography made its first commercial appearance in the United States, city views were among the earliest illustrations done in this medium. Nearly every artist and publisher of large and detailed St. Louis views used this medium of reproduction.[34]

The inked surface used for printing a lithograph is neither raised, as it is in a woodcut, nor lowered, as is the case in engraving and etching. Instead, the surface is a perfectly flat slab of very fine grained calcareous stone. The artist draws the image to be printed on the surface with a fatty ink or crayon. He then washes the surface with gum arabic and a weak solution of acid to fix the design and to make the balance of the stone (which is not to print) more receptive to water.

When the lithographer is ready to print, he moistens the stone. The water—being repelled by the fatty ink—penetrates only those portions of the stone on which there is no drawing. The lithographer then inks the stone, using a fatty printing ink applied with a roller. The printing ink adheres to the lines of the drawing that, like the ink itself, are oily; it is repelled by the parts of the stone that are moist with water. The printer then applies a sheet of paper to the stone, covers it with a thin leather blanket, and cranks the stone and its covering under a scraper bar that exerts a pressure strong enough to transfer the printing ink from the stone to the paper. After the paper is removed and hung to dry the printer can remoisten the stone, reink it, and obtain another impression in the same manner.[35]

34. I have summarized the development of lithographic technology in *Views and Viewmakers of Urban America*, chaps. 3–4, pp. 24–38. The best single source is Michael Twyman, *Lithography 1800–1850, the Techniques of Drawing on Stone in England and France and Their Application in Works of Topography*. See also Walter W. Ristow, "Lithography and Maps," in Woodward, *Five Centuries*, 77–112. Facsimile editions of two early treatises on lithography explain a printing process that has not changed fundamentally since its invention. See Alois Senefelder, *A Complete Course of Lithography: Containing Clear and Explicit Instructions in all the Different Branches and Manners of that Art . . . to which is Prefixed a History of Lithography, from Its Origin to the Present Time*, and C[harles] Hullmandel, *The Art of Drawing on Stone, Giving a Full Explanation of the Various Styles. . . .*

35. Variations of this basic technique could also be followed. The development of the transfer process made it possible for the artist to draw on specially prepared transfer paper with lithographic ink or crayon and transfer the design to a lithographic stone by passing it through the press on top of a prepared stone surface. A major advantage of this device was that the lithographer did not need to reverse the artist's image when he put it on stone so that the resulting print would appear like the drawing.

Figure 1–16. View of New York City in 1817, drawn and lithographed by Edouard de Montulé and published in Paris in 1821. (John W. Reps.)

So-called stone engravings could be created by using an instrument with a steel or diamond point to cut through a thin and dried coating of oxalic salt or gum arabic and nitric acid applied to the stone's surface. Printing ink adheres to the stone only where the microscopic crust had been penetrated by the fine point of the stylus. A St. Louis artist and printer used this uncommon form of lithographic printmaking to produce a wonderfully detailed skyline view of the city in 1855, a panorama that will be examined in a later chapter.

Two very early American city views illustrate the immature and unconvincing images produced by the first lithographic presses. Figure 1–16 reproduces what apparently is the earliest lithographic depiction of an American city, the work of a French artist who drew New York in 1817 and had this little view published in Paris four year later in an atlas illustrating his travels. It is also a pioneer example of the use of two stones for one print, the second one being used to produce the buff-colored background.[36]

36. In a color lithograph, each color requires a separate stone inked with the proper color. In some lithographs a derivative color can be created by printing one color over another. Printed

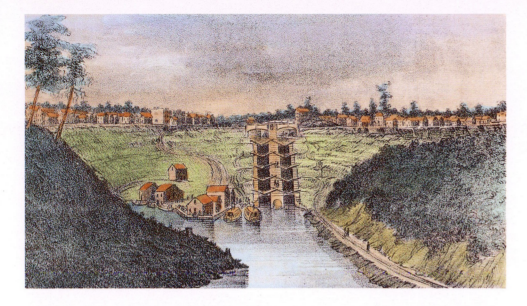

Figure 1–17. View of Lockport, New York, ca. 1825, drawn by George Catlin and printed in New York by Anthony Imbert in 1826. (John W. Reps.)

Shortly thereafter the first views of American cities printed by lithography in America made their appearance. They depicted Buffalo and Lockport, New York, and were bound in an elaborate book published in 1826 to commemorate the opening of the Erie Canal. Figure 1–17 shows one of two views of Lockport with later hand coloring. This, like the others in the volume, came from the hand of a very young and obviously still unsure George Catlin, whose later image of St. Louis is reproduced in the next chapter.[37]

A decade after these fumbling efforts at lithographic viewmaking every major city and many smaller ones as well could boast of at least one lithographic press, and lithography rapidly became the prevailing medium used for city views. Before the century ended, thousands of such images flooded the market, along with other images executed in older methods of printmaking and the even newer technique of wood engraving. In St. Louis and dozens of other places fine examples of lithographic craftsmanship replaced the crudely executed prints of an earlier day.

color is often combined with additional hand coloring, or all the color may be applied by hand. In the reproductions of views of St. Louis in this book all of these methods are represented.

37. Catlin's two views of Lockport and two of Buffalo appeared in Cadwallader Colden, *Memoir Prepared at the Request of the Committee of the Common council of the City of New York, and Presented to the Mayor of the City, at the Celebration of the Completion of the New York Canal.* Despite the date of 1825 on the title page, this work was published in 1826. The lithographs were done at the New York City press of Anthony Imbert.

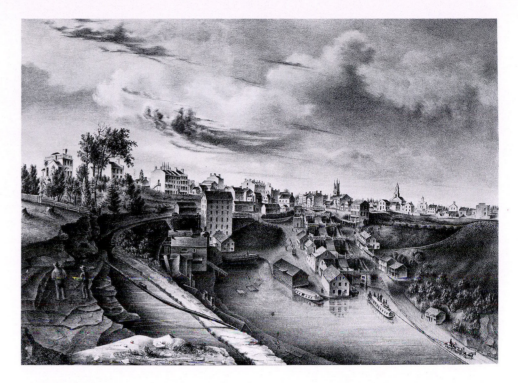

Figure 1–18. View of Lockport, New York, in 1836, drawn by William Wilson and printed by John Henry Bufford in New York City. (Division of Prints and Photographs, Library of Congress.)

Figure 1–18 shows Lockport again, this time in 1836 after the tiny town that Catlin visited had become a busy canal port. This print illustrates the great technical and artistic strides quickly made by American artists and printers as they gained greater mastery of lithography. The artist of this print captured many of the details of canal life, and the anonymous lithographer at the shop of John Henry Bufford in New York rendered on stone dozens of convincing details of this flourishing community.[38]

This chapter has identified many features of printed city views that became common as this form of art developed in Western civilization from its first appearance in the Renaissance to the early years of the nineteenth century, the period that saw the beginning of such images of St. Louis. We will now examine those rare graphic records of the young city, following a brief examination of how St. Louis was established and how it developed during the half-century that elapsed from its birth to the time when it sat for its first portrait.

38. For Bufford, see David Tatham, "John Henry Bufford, American Lithographer."

EARLY ST. LOUIS AND THE FIRST PRINTED VIEWS OF THE CITY

St. Louis began its existence in 1764, a year after Pierre Laclede Liguest selected the site as the center of his furtrading enterprise. It was there he planned to exercise the exclusive rights he had obtained from the French governor in New Orleans to trade with the Indians west of the Mississippi. From Fort Chartres, an established French settlement downriver on the Illinois side of the Mississippi, he sent a party of men to clear the land.

Laclede appointed his common-law stepson, Auguste Chouteau, then not quite fourteen, to supervise this work.[1] Many years later Chouteau, who became a revered leader of St. Louis society, recalled Laclede's instructions: "You will proceed and land at the place where we marked the trees; you will commence to have the place cleared, and build a large shed to contain the provisions and the tools, and some small cabins to lodge the men." Chouteau set out early in February and began to prepare the land as ordered. Then, as he remembered,

> In the early part of April, Laclede arrived among us. He occupied himself with his settlement, fixed the place where he wished to build his house, laid a plan of the village which he wished to found . . . and ordered me to follow the plan exactly, because he could not remain there any longer with us.[2]

1. Laclede never married Marie Chouteau, Auguste's mother by her lawful husband, René. That Laclede was the father of her other children now seems established, and the two lived together as man and wife in St. Louis. See William E. Foley, "The Laclede-Chouteau Puzzle: John Francis McDermott Supplies Some Missing Pieces."
2. "Fragment of Col. Auguste Chouteau's Narrative of the Settlement of St. Louis. Journal." Chouteau's youngest son gave his father's journal to the Mercantile Library in 1857. The date of

Figure 2–1 shows the streets of St. Louis as they existed in 1780. By this time a four-block-long extension had apparently been added at either end of what was probably the original grid of streets stretching eleven blocks north and south along the river but extending only three blocks deep. Laclede provided a public square located at the river end of the short tier of blocks in the town's center.[3]

Although Laclede planned straight streets with right-angle intersections, he did not make the streets very wide. The three streets running north and south were about thirty-eight feet in width; the more numerous cross streets were only thirty-two feet wide. For several decades only two of these streets, the modern Market and Delmar, provided access to the waterfront; the others ended at the bluff above Front Street.[4]

This linear grid resembled those of three other important and earlier French colonial towns in America: Montreal, New Orleans, and Mobile. In each place, as in St. Louis, the importance of water transportation dictated

composition remains unknown, except that it was sometime before the elder Chouteau's death in 1829. For a history of the city's oldest family, see William E. Foley and C. David Rice, *The First Chouteaus: River Barons of Early St. Louis.*

3. See Charles E. Peterson, "Colonial Saint Louis."
4. For this information about the streets and for much else as well I am indebted to Lawrence Lowic, *The Architectural Heritage of St. Louis, 1803–1891.* Lowic's study of architectural styles and the social conditions that produced them has been of great help to me. Readers looking for greater emphasis on the design of individual buildings should consult Lowic's book, especially his Bibliographical Notes.

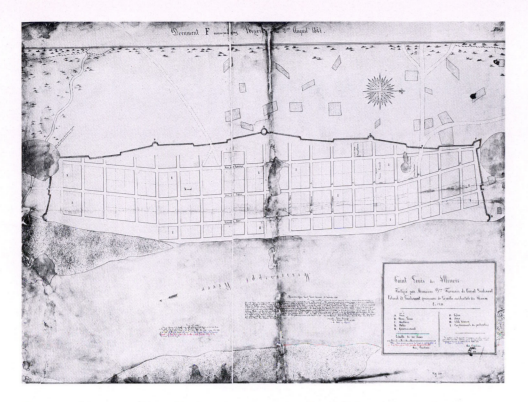

Figure 2–1. Manuscript Plan of St. Louis in 1780, as copied in 1846 from a drawing by Auguste Chouteau. (Missouri Historical Society.)

town plans that provided easy access to landing places for boats. The relatively level site of St. Louis atop a small rise or bluff provided an ideal location for such a plan while also assuring residents protection from all but the worst floods.[5]

St. Louis grew slowly during its early years. Forty persons composed the community at the end of 1764. By 1800 their numbers barely exceeded a thousand, and in 1810 the population had reached only fourteen hundred. Fur trading dominated the local economy as St. Louis traders and merchants established the city's position as the most important center for this activity.[6] No views exist showing the appearance of the city at this time, and we must rely on written descriptions for impressions of what St. Louis was like.[7]

5. For reproductions of early plans of Montreal, New Orleans, and Mobile, see my *The Making of Urban America: A History of City Planning in the United States*, figs. 40, 46, 47, and 49.

6. See Peter Michel, "The St. Louis Fur Trade: Fur Company Ledgers and Account Books in the Archives of the Missouri Historical Society."

7. Many descriptions of St. Louis written by travelers are cited or summarized in William

Some visitors came away unimpressed by what they saw. Philip Pitman stopped briefly in St. Louis in 1767 when it was only three years old. He reported that Laclede's company had "built a large house and stores" and that some forty private houses could be found there but that "no fort or barracks are yet built." He added, "The French garrison consists of a captain-commandant, two lieutenants, a fort-major, one serjeant, one corporal, and twenty men."[8]

Three decades later Gen. Victor Collot stopped in St. Louis while on his confidential reconnaissance of the Ohio and lower Mississippi valleys for the French government. Although he did not describe the town itself other than to estimate its population at 600 persons, he noted that St. Louis occupied a site "high enough to be at all times out of the reach of inundations." Further, Collot judged its location, "considered in a military point of view," to be "one of the best on the river Mississippi." He also predicted a bright economic future for the settlement:

> If we consider St. Louis in a commercial point of view, we shall find its position still more fortunate. This place will stand in the same relation to New Orleans as Albany to New York; it is there that will be collected all the produce transported by the great rivers which meet near this point, after traversing such fine and fertile countries. It is there that the traders will bring all the fine furs of the Missouri and other adjacent rivers; a source of inexhaustible riches for more than a century.[9]

Collot came to St. Louis in 1796. Accompanying him for the purpose of preparing maps of the rivers and the principal settlements was George de Bois St. Lys. His map of St. Louis appears in Figure 2–2, a depiction of the nascent city not printed until thirty years after the two men visited there. This important record of conditions at the end of the eighteenth century shows that many portions of St. Louis remained undeveloped and that after thirty years of existence the place could best be described as a straggling village.[10]

E. Lass, "Tourists' Impressions of St. Louis, 1766–1859." See also Glen E. Holt, "St. Louis Observed 'from Two Different Worlds': An Exploration of the City through French and English Travelers' Accounts, 1874–1889."

8. Philip Pittman, *The Present State of the European Settlements on the Mississippi*, 94.

9. George H. Victor Collot, *Voyages dans l'Amérique Septentrionale; ou, Description des Pays Arrosés par le Mississippi, l'Ohio, le Missouri, et autres Rivières Affluentes. . . .*

10. The manuscript drawing of this map of St. Louis, in the collection of the Missouri Historical Society, is reproduced in my *Making of Urban America*, p. 77, fig. 45. This reproduction includes an arrow correctly showing the direction of flow in the river, while in the printed version accompanying Collot's report one can note that the arrow points upstream; see Figure 2–2. The manuscript also differs from the printed version in showing a large plaza or *place* in the center of the settlement in a configuration that appears in no other source. This may have represented a proposed improvement that was never carried out.

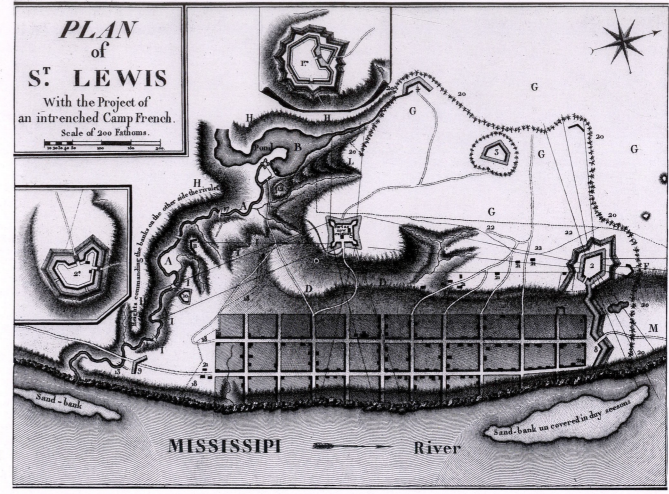

Figure 2–2. Plan of St. Louis in 1796 drawn by George de Bois St. Lys for George Henri Victor Collot and published in Paris by A. Bertrand in 1826. (Division of Geography and Maps, Library of Congress.)

When Christian Schultz visited St. Louis in 1807 he admired from a distance the prospect of its two hundred whitewashed houses, stating that they "appear to great advantage as you approach the town." However, a closer look proved disillusioning, for as Schultz remarked,

> I observed two or three big houses in the town, which are said to have cost from twenty to sixty thousand dollars, but they have nothing either of beauty or taste in their appearance to recommend them, being simply big, heavy, and unsightly structures.[11]

Capt. Amos Stoddard found the buildings of St. Louis more to his liking

11. Christian Schultz, *Travels on an Inland Voyage, Performed in the Years 1807 and 1808, Including a Tour of Nearly 6,000 miles,* as quoted in Walter B. Stevens, *The Building of St. Louis,* 11–12.

when in March 1804 he came to accept the transfer from France to the United States of Upper Louisiana. On 16 June he wrote his mother that the town consisted of "about one hundred and eighty houses, and the best of them are built of stone. Some of them, including the large gardens, and even squares, attached to them, are enclosed in high stone walls."[12]

12. Quoted in John Francis McDermott, "Captain Stoddard Discovers St. Louis," 333. Using Stoddard documents and other sources, McDermott in this article skillfully creates a word picture of the city as it appeared at this time. One paragraph suggests McDermott's ability to make us see images through words, a characteristic of all of his many valuable studies: "The town as Stoddard first saw it on February 24, 1804, lay on a bank of rock twenty feet or more above the water. Behind its two long streets of houses and a third street of barns, all parallel to the river, rose another slope to the garrison on the hill top, and, beyond that, prairie stretched

In 1811 Judge Henry M. Brackenridge praised the city's location and predicted a prosperous future for St. Louis. Nevertheless, he pointed out,

> No space has been left between the town and the river; for the sake of the pleasure of the promenade, as well as for business and health, there should have been no encroachment on the margin of the noble stream. The principal place of business ought to have been on the bank. From the opposite side [of the Mississippi] nothing is visible of the busy bustle of a populous town; it appears closed up.[13]

Brackenridge saw signs of growth and change. He noted that St. Louis "was at no time so agricultural" as the other French settlements in the vicinity and that while "it remained nearly stationary for two or three years after" the Louisiana Purchase, "it is now beginning to take a start, and its reputation is growing abroad." He reported that while only "six or seven houses" had been built in the last year, "probably twice the number will be built the next." St. Louis more than fulfilled Brackenridge's expectations, for between 1810 and 1820 the town's population more than tripled to reach the impressive figure of 4,598 at the end of the decade.

Shortly before that time the first printed image of St. Louis appeared. This small engraving is reproduced in Figure 2–3. It shows only a small portion of the town as it then existed. In the modern city the part represented lies within a six-block area bounded by Walnut, Second, Pine, and Levee or Front streets. The image decorated a ten-dollar bank note issued in 1817 by the Bank of St. Louis and bears the title "Partial View of St. Louis."

The artist remains unknown, and only the names of Leney and Rollison appear. William L. Leney and William Rollison carried on their trade in New York City, and it is highly unlikely that either one of them had seen St. Louis. They doubtless worked from a drawing provided by bank officials. Modern scholars have been able to identify all the principal structures that are repre-

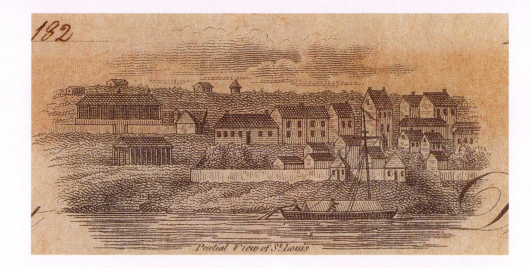

Figure 2–3. View of a portion of St. Louis in 1817, engraved by William L. Leney and William Rollison in New York, published by the Bank of St. Louis on a $10.00 bank note. (Eric and Evelyn Newman Collection.)

Figure 2–4. Key to bank note view of 1817. 1. Market House; 2. Laclede-Chouteau Building; 3. Pratte House; 4. Smith House; 5. Berthold House; 6. Lisa House; 7. Labbadie Store; 8. Labbadie Mansion; 9. Honey Building; 10. Labbadie Barn; 11. Clark Buildings; 12. Gratiot House; 13. McKnight & Brady Store; 14. Fort San Carlos Tower; 15. Fur Storage Sheds. (Missouri Historical Society.)

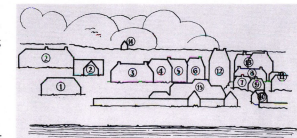

sented. Figure 2–4 shows the results of their work. The buildings represented in the view belonged to the most prominent and wealthy families of St. Louis, so obviously the engraving illustrates the largest and most impressive buildings the artist could find in the little city. In addition, six of the buildings shown in the view belonged to persons who joined in incorporating the Bank of St. Louis in 1813, and perhaps they determined both the focus and the limits of the engraving.[14]

Descriptions of the city in the years just before and after the bank issued this engraved note provide additional information about the appearance of St.

14. See Stella M. Drumm and Isaac H. Lionberger, "Earliest Picture of St. Louis."

away to the west, the north, the south. From the Illinois shore it appeared a bold and rocky eminence with ascent to the town steep and difficult. Scattered for more than a mile along the slope, the white-walled houses gave the impression of a large and elegant town. On closer approach, one break in the bluff at the foot of Bonhomme [Market] Street could be seen, and the clusters of houses with their stone walls and their fruit trees made a pleasant and romantic impression" (p. 329).

13. Brackenridge concluded this passage by noting, "The site of St. Louis is not unlike that of Cincinnati. How different would have been its appearance, if built in the same elegant manner: its bosom opened to the breezes of the river, the stream gladdened by the enlivening scene of business and pleasure, compact rows of elegant and tasteful dwellings, looking with pride on the broad wave that passes!" Henry M. Brackenridge, *Views of Louisiana Together with a Journal of a Voyage up the Missouri River, in 1811*, 120–21.

Figure 2–5. Plan of St. Louis in 1822, drawn by or for Lewis Caleb Beck, and published in Albany, New York, by Charles R. and George Webster in 1823. (Eric and Evelyn Newman Collection.)

Louis in this period. The Reverend Timothy Flint recalled his impressions of the city when he first saw it in 1816:

> St. Louis, as you approach it, shows, like all the other French towns in this region, to much the greatest advantage at a distance. The French mode of building, and the white coat of lime applied to the mud or rough stone walls, give them a beauty at a distance, which gives place to their native meanness, when you inspect them from a nearer point of view.

Nevertheless, Flint admitted that St. Louis "contains many handsome, and a few splendid buildings." Probably the houses, stores, and offices pictured on the bank note fell into that category.[15]

A lad of fourteen who arrived in St. Louis by boat in May 1819 remembered conditions along the waterfront:

> The appearance of St. Louis was not calculated to make a favorable impression upon the first visit, with its long dirty and quick-sand beach, numbers of long empty keel boats tied to stakes driven in the sand, squads of idle boatmen passing to and fro, here and there numbers pitching quoits; others running foot races; rough and tumble fights; and shooting at a target.[16]

15. Timothy Flint, *Recollections of the Last Ten Years*.
16. James Haley White, "Early Days in St. Louis," 6. White was at work on his recollections when he died in 1882.

Artists produced no other views of St. Louis until the 1830s, but a map of the city published in 1822 and several detailed descriptions provide useful information on urban growth and change. Figure 2–5 reveals how the original design, slightly augmented by 1780, had been substantially extended by the beginning of the 1820s. The original grid of the older blocks nearer the Mississippi was continued by wider streets to the west.

One new addition ran from Fourth to Seventh streets and from St. Charles to Cerré on the north and south. Auguste Chouteau and Judge J. B. C. Lucas created this subdivision of around thirty blocks on the hill forty feet above the colonial settlement. It occupied a site that Lucas called "mostly level and commanding" and offering "a full view of the Mississippi River."[17] This addition to St. Louis was only the first in what would be scores of similar real estate ventures throughout the nineteenth century.

The city directory of 1821 provided readers with the details of the expanded street system:

> Eight streets run parallel with the river, and are intersected by twenty-three others at right angles; three of the preceding are in the *lower* part of the town, and the five others in

17. Lucas advertisement, as quoted from an unidentified source in James Neal Primm, *Lion of the Valley: St. Louis, Missouri*, 107–8.

the *upper* part. The streets . . . on "the Hill," or upper part, are much wider. "The Hill" is much the most pleasant and salubrious, and will no doubt, become the most improved. . . . On the Hill in the centre of the town is a public square 240 by 300 feet [bounded by Fourth, Fifth, Market, and Chestnut streets] on which it is intended to build an elegant Court-House.[18]

The editor of the directory provided a long list of important buildings. They included ten schools, "a brick Baptist Church, 40 feet by 60, built in 1818," and the wooden Episcopal Church. He explained that the Methodists held services in the old Courthouse and that the Presbyterian congregation used the circuit court room. He also informed his readers about the construction of the brick Roman Catholic cathedral, begun in 1818 and in 1821 beginning to assume its ultimate form on the north side of Walnut Street ("Rue de la Tour" on Figure 2–5) between Second and Third.

Although lengthy, the list of business, professional, and industrial activities and occupations in the directory merits attention because it demonstrates the diversity of this little city that stood at the frontier of white settlement. Here is how the directory records the elements of St. Louis economic life:

> In St. Louis are the following Mercantile, Professional, Mechanical, &c establishments, viz: 46 Mercantile establishments . . . ; 3 Auctioneers . . . ; 3 weekly newspapers . . . ; 1 Book store; 2 Binderies; 3 large Inns, together with a number of smaller Taverns and boarding-houses; 6 Livery Stables; 57 Grocers and Bottlers; 27 Attorneys and Counsellors at Law; 13 Physicians; 3 Druggists and Apothecaries; 3 Midwives; 1 Portrait Painter, who would do credit to any country; 5 Clock and Watch makers, Silversmiths and Jewellers; 1 Silver Plater; 1 Engraver; 1 Brewery . . . ; 1 Tannery; 3 Soap and Candle Factories; 2 Brick Yards; 3 Stone Cutters; 14 Bricklayers and Plasterers; 28 Carpenters; 9 Blacksmiths; 3 Gunsmiths; 2 Copper and Tin Ware manufacturers; 6 Cabinet makers; 4 Coach makers and Wheelwrights; 7 Turners and Chair makers; 3 Saddle and Harness manufacturers; 3 Hatters; 12 Tailors; 13 Boot and Shoe manufacturers; 10 Ornamental Sign and House Painters and Glaziers; 1 Nail Factory; 4 Hair dressers and perfumers; 2 Confectioners and Cordial distillers; 4 Coopers, Block, Pump and Mast makers; 4 Bakers; 1 Comb Factory; 1 Bell man; 5 Billard-Tables . . . ; several Hacks or pleasure Carriages, and a considerable number of 57 Drays and Carts; several professional Musicians . . . ; 2 Potteries are within a few miles, and there are several promising gardens in and near to the town.[19]

A distinguished royal visitor in the early 1820s provides us with information about another aspect of St. Louis. Friedrich Paul Wilhelm, duke of Würt-

temberg, noted the presence of large earthen mounds that stood on several locations in and near the city. The map reproduced in Figure 2–5 shows the location of one of the largest and most impressive of these prehistoric Indian constructions immediately to the north of the last tier of platted city blocks. Eventually, as the city expanded, developers eliminated all traces of these interesting artificial hills.[20]

Duke Paul Wilhelm also had this to say about conditions in the modern community when he first saw it in 1823:

> St. Louis, principal town in the state of Missouri, has risen to a very respectable city. Broad streets, some already partly paved, and quite pretty houses, also a new Catholic church built in good style, give the town a pleasing appearance. In addition, the town is enlivened and supplied with many warehouses and stores furnishing all sorts of goods. The houses recently erected and the church are built of brick. The interior of the church is decorated with a few paintings which Mr. Du Bourg brought along from France, and in the bishop's dwelling a library, quite large for St. Louis, has been collected.[21]

in different business," 106; Attorneys and Counsellors at Law, 23; Practicing Physicians, 15; "Foreigners," 317. *Missouri Historical Society, Collections* 5 (February 1928): 166.

20. Many visitors to St. Louis noted the presence of the mounds in their accounts of the city. For an idea of the impression they made on one visitor in March 1834, see [Charles F. Hoffman], *A Winter in the West*, 2:74–75, in which Hoffman devoted a long passage to their description: "St. Louis can boast one class of objects among its sources of attraction, which are alone sufficient to render it one of the most interesting places in the Union. It is a collection of those singular ancient mounds, which . . . have so entirely set at naught the ingenuity of the antiquary. The mounds of the north suburb of St. Louis occupy a commanding position on the Mississippi, and cover ground enough, together, for a large body of men to camp upon. They stand distinct from each other, generally in the form of truncated pyramids, with a perfect rectangular base. At one point four or five tumuli are so grouped together as to form nearly two sides of a square, while at another several hundred yards off, two or more detached mounds rise singly from the plain. The summit of one of these is occupied by a public reservoir, for furnishing the town with drinking water; the supply being forced up to the tank by a steam engine on the banks of the river, and subsequently distributed by pipes throughout the city." Hoffman lamented the destruction of these interesting relics of a vanished civilization: "This mound, with the exception of one or two enclosed within the handsome grounds of General Ashley, is the only one fenced from the destruction that always sooner or later overtakes such non-productive property, when in the suburbs of a rapidly growing city; and it is a subject of surprise to a stranger, that, considering the want of public squares in the town, individual taste and public spirit do not unite to preserve the beautiful eminences in their exact form, and connect them by an enclosure, with shrubbery and walks, thus forming a park which might be the pride of St. Louis."

21. Paul Wilhelm, Duke of Württemberg, *Travels in North America 1822–1824*, 200. "Mr. Du Bourg" was Bishop Louis Guillaume Valentin Duborg, who came to St. Louis in 1816 from New Orleans.

18. John A. Paxton, *The St. Louis Directory and Register Containing the Names, Professions, and Residence of all the Heads of Families and Persons in Business . . .* , 262.

19. Ibid., 261. A briefer but less detailed analysis of occupations in St. Louis at this time appeared in the *Missouri Gazette & Illinois Advertiser* for 6 December 1820: Laborers, 685; Mechanics, 470; Persons engaged in commerce, 92; Grocers and Tavern keepers, 49; "Clerks and agents

The decade of the 1820s saw little of the expansion and population growth that St. Louis enjoyed in the previous ten-year interval. In that earlier period the speculation in Western lands and the prosperity that followed the War of 1812 favored the city. Following the national business and banking collapse in 1819, a recession in 1825–1826 hindered development of St. Louis, and the census of 1830 revealed that in the previous decade the city had grown by only 1,254 persons to reach 5,852.[22]

The expanded grid of subdivided land easily accommodated this population. Most residents occupied sites in the lower town where Laclede and Chouteau laid out the first streets. Few houses existed amid the hundreds of new town lots west of Fifth Street. Indeed, while these street lines existed on paper, they were less apparent on the ground. When the duke of Saxe-Weimar visited St. Louis in 1825, he commented on this aspect of the community: "The city . . . consists of one long, main street, running parallel with the river, from which several side streets run to the heights behind the city. Here single houses point out the space where another street parallel with the main street, can one day be built."[23]

Some of these buildings suggested that before long St. Louis might take on a look of solid permanency. Saxe-Weimar recorded that most of the houses were "new, built of brick, two stories high; some are of rough stone, and others of wood and clay." Most of the brick houses could be found north of Market Street, the thoroughfare that bisected the town and extended beyond Eighth Street into the countryside.[24]

One other traveler set down his impressions of St. Louis following his visit to the city in 1827. Karl Postl, writing under the name of Charles Sealsfield, provided this meager inventory of the major buildings that caught his eye:

> A Catholic and two Protestant churches, a branch bank of the United States, and the bank of St. Louis, the courthouse, the government-house, an academy and a theatre; besides these there are a number of wholesale and retail stores, two printing offices, and an abundance of billiard tables and dancing rooms.[25]

Given conditions in the city as described by these visitors, perhaps it was just as well that no artists came to St. Louis to draw its portrait for distribution in printed form. They would have found little to attract their talents, for the town then presented a crude and incomplete countenance to the outside world.

This was to change in the decade ahead when St. Louis underwent a transformation in its appearance and the first townscape artists came to record its burgeoning skyline. During the 1830s the population of the city nearly tripled to reach 16,649 by 1840 as St. Louis escaped the worst effects of the nationwide Panic of 1837. These were the years when the city emerged from its frontier garb and began to take its place in urban society.

Two views exist showing St. Louis in 1832, although in both cases the printed versions did not appear until four decades later, and the painting used to create one of the lithographic images may have been executed after the date of depiction. These prints are introduced here, rather than in order of their publication, to help in documenting the appearance of the city during the decade of the 1830s.

The first is the attractive view reproduced in Figure 2–6. The title identifies it as based on an oil painting by George Catlin then in the collection of the Mercantile Library Association. The exact date of issue of the lithograph has not been determined, but it was sometime between 1865, when the Mercantile Library acquired the painting, and 1869, when it was transferred to the Histor-

22. In *A Gazetteer of the States of Illinois and Missouri,* 326, Lewis Caleb Beck reviewed the growth and economic conditions in St. Louis after the War of 1812: "Very little improvement was made in the town until about 1812, when several new houses were erected in the American style.—After this, the number of houses increased rapidly. Mechanics of all descriptions received high wages—trade was brisk, and money plenty, and St. Louis had all the appearance of a great commercial town. But . . . this state of things did not continue long. . . . Speculators had purchased large quantities of land on a credit at very high prices—merchants had purchased in the same way immense stocks of goods in the eastern cities; and almost the whole business was transacted upon a fictitious capital. . . . Consequently, when the credits for lands and goods had expired . . . a sad reverse was experienced. Not having any considerable articles of export, every dollar of specie was remitted to the east. In the midst of this, the banks failed, creditors suffered, confidence was destroyed, and for a time, business was almost completely stopped."

23. Karl Bernhard, duke of Saxe-Weimar-Eisenach, *Travels Through North America During the Years 1825 and 1826,* 2:97.

24. See Paxton, *Directory,* 261: "By an enumeration taken by the Editor of this work, in May, 1821, it appears that the town contains the following number of dwelling houses, viz:—154 of Brick and Stone, and 196 of Wood, in the North part of the town, and 78 of Brick and Stone,

and 223 of Wood, in the South part." Never one to miss an opportunity to boast about his new place of residence, Paxton added: "There are besides the dwelling houses, a number of Brick, Stone, and wooden Warehouses, Stables, Shops and out houses."

25. Charles Sealsfield, *The Americans as They Are; Described in a Tour Through the Valley of the Mississippi,* 92–93. Sealsfield also observed, "St. Louis is a sort of New Orleans on a smaller scale. In both places are to be found a number of coffee houses and dancing rooms. The French are seen engaged in the same amusements and fashions that formerly characterized the Creoles of Louisiana. For the last five years men of property and respectability, attracted by the superior advantages of the situation, have settled at St. Louis, and their example and influence have been conducive of some good to public morals."

Figure 2–6. View of St. Louis in 1832 by George Catlin as reproduced by lithography in 1865–1869. (Collection of A. G. Edwards & Sons, Inc., St. Louis, Missouri.)

ical Society. Nor is it known who published the view, where it was printed, or who put the design on stone.[26]

George Catlin was thirty-two when he painted St. Louis not long after he made his first trip to the West in 1830 from Richmond, Virginia. Born in Pennsylvania in 1796, Catlin studied law, but abandoned that profession to work in Philadelphia painting miniatures. He spent the years 1825–1829 in New York State, where, among other work, he produced the early lithographic city view mentioned in Chapter I and reproduced as Figure 1–17. His western paintings, particularly of Indians, are far more famous than his townscapes, but in 1832 he found time to paint two depictions of St. Louis.[27]

Old residents of St. Louis with memories of how the city appeared at the time Catlin visited there must have found particularly appealing this print showing St. Louis from the point of view of someone looking northwest from the opposite side of the Mississippi. Nevertheless, the few impressions existing in public collections suggest that this print may have been issued in only a limited number of copies. In this respect it is like several other printed images of the city that are known by only one or a very small number of impressions.[28]

Catlin's St. Louis captures the look of the place before the building boom of the 1830s changed its appearance in so many ways. His view does not show, for example, the spire of the Roman Catholic Cathedral, then still under construction. Nor does the later gothic tower of Christ Church yet punctuate the skyline. Strangely, Catlin seems to omit also the new building on the waterfront housing the City Market and City Hall. This structure had been completed well before he painted the city, and it figures prominently in another print of this time from a similar viewpoint.

The artist and the publisher of a far more elaborate city view—indeed, the largest ever to be done of any American city and one to which appropriate attention will be devoted later—used a lithograpic version of another painting as a way of recalling the St. Louis of a past era while celebrating the thoroughly modern city of their own day. This image, created by Leon D. Pomarede, is reproduced in Figure 2–7. Like Catlin's, this view also shows St. Louis in 1832, but it looks west and focuses only on the central portion of the city.

Pomarede had come to America from France in 1830, settling first in New Orleans before moving to St. Louis temporarily in 1832. In addition to his painting of the city and other work, he decorated the interior of the Cathedral before returning to New Orleans five years later. In 1843 he resumed his residence in St. Louis and produced a moving panorama of the Mississippi River that he exhibited in St. Louis, New Orleans, and eastern cities.[29] When fire

26. The acquisition of the painting by the Mercantile Library is recorded in the *Annual Report of the Saint Louis Mercantile Library* for 1865, 22. The manuscript minutes of the Historical Society for 4 November 1869 note that the painting had been transferred to the Society from the Library. The painting measures ca. 10 x 20 inches. A similar oil painting by Catlin is in the National Museum of American Art, Washington, D.C.

27. Nearly every book on American art of the nineteenth century discusses Catlin and his work. See also Loyd Haberly, *Pursuit of the Horizon, a Life of George Catlin, Painter & Recorder of the American Indian;* and Joseph R. Millichap, *George Catlin.*

28. The Missouri Historical Society has a box full of these lithographs, suggesting that the Society may have published them for limited distribution to members or others. A further search of the minutes of the Society may yet reveal the circumstances of publication of this view.

29. Pomarede began the panorama in collaboration with Henry Lewis, whose similar work will be discussed in a later chapter, but the two men fell out, and Pomarede finished it with the assistance of T. E. Courtenay. See John Francis McDermott, "Portrait of the Father of Waters: Leon Pomarede's Panorama of the Mississippi." According to Peggy Samuels and Harold Samuels, *The Illustrated Biographical Encyclopedia of Artists of the American West,* 376, Pomarede received assistance on his panorama from Charles Wimar, then eighteen or nineteen.

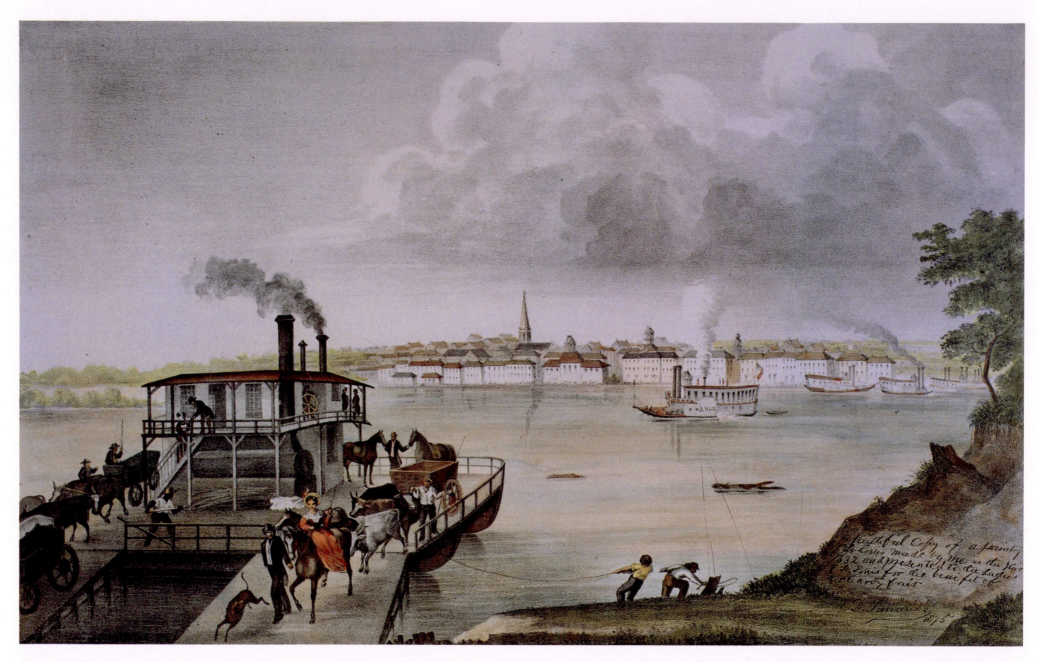

Figure 2–7. View of St. Louis in 1832 by Leon D. Pomarede as reproduced by lithography in 1875 by Camille N. Dry and Richard J. Compton. (Collection of A. G. Edwards & Sons, Inc., St. Louis, Missouri.)

Figure 2–9. View of St. Louis and the Steamboat *Peoria,* printed ca. 1832–1834. (Missouri Historical Society.)

Figure 2–8. View of St. Louis in 1835, printed in Philadelphia
by Lehman & Duval. (Geography and Map Division,
Library of Congress.)

destroyed his panorama in 1850 he came back to St. Louis permanently and
devoted his life to painting religious pictures and executing murals for such
important structures as the exhibition hall of St. Louis University and the Mer-
cantile Library.[30]

Pomarede probably painted his view of St. Louis some time after the date
of depiction given in the lithograph, and that may explain why in his print the
spire of the Cathedral appears while it is omitted in Catlin's. The editor of the
text accompanying the lithographic version of the Pomarede painting provided
a guide to his readers of 1876 that is equally valuable to us well over a century
later:

> The steam ferry-boat . . . has made its landing at the eastern bank. . . . Across the river,
> the eye takes in a goodly town, with market house standing on the spot where . . . Laclede
> landed sixty-eight years before. . . . The spire of the Cathedral, on Walnut Street, was then
> the only one of which the city could boast. . . . The low, round domes of the Baptist
> Church, on the corner of Third and Chestnut, and Dr. Bullard's, on the corner of Fourth
> and Washington, are landmarks that a few old citizens will recognize.[31]

30. For additional material on Pomarede, see John Francis McDermott, "Leon Pomarede,
'Our Parisian Knight of the Easel.'" The *St. Louis Missouri Republican* for 10 September 1854 de-
scribes Pomarede's painted decoration of the hall of the Mercantile Library. The New-York
Historical Society owns a lithograph by Pomarede published in 1835 and titled *Front View of the
Cathedral of St. Louis State of Missouri.* It measures approximately 14 x 17 inches and was printed by
"Stroobant lith."

A delineation of the city from a viewpoint similar to that used by Poma-
rede can be found above the title of a large map of St. Louis published in 1835
and is reproduced as Figure 2–8. It is more of a symbolic representation than
an effort to portray individual buildings with any fidelity. What is evidently in-
tended to be the spire of the Cathedral appears grotesquely exaggerated in
height, although the Market and City Hall directly in front of it on the water-
front seem to be drawn in more realistic fashion. The view itself is unsigned,
but it may be the work of R. Paul, the city surveyor and commissioner who
prepared the map.

A fourth view exists showing St. Louis in the early years of the 1830s. This
is reproduced in Figure 2–9 from a unique impression of an advertising card
for the steamer *Peoria,* which served the city from 1832 until a snag destroyed it
two years later. Although the image of the boat in the center foreground obliter-
ates a portion of the city's buildings, the lithograph appears to present a fairly
realistic picture of about an eight-block stretch of St. Louis north from Walnut
Street at the far left.

These views concentrate on the old portion of the city sloping down to the

31. Unsigned "Historical Sketch of the City of Saint Louis," in Camille N. Dry and Richard
J. Compton, *Pictorial St. Louis: The Great Metropolis of the Mississippi Valley,* 10. Construction of the
Cathedral was completed in 1834.

river from Third Street. As Charles Joseph Latrobe noted following his visit to St. Louis in 1833,

> the inhabitants, of French extraction, are . . . still numerous . . . in their part of the town. . . . It is amusing to an European to step aside from the hurry and bustle of the upper streets . . . to the quiet quarters of the lower division, where many a characteristic sight and sound may be observed. Who can peep into the odd little coffee-houses . . . without thinking of scenes in the provinces of the mother country.[32]

Other observers of the time commented about the dual nature of St. Louis. Charles F. Hoffman in 1834 observed, "The town partakes of the characteristics of all of its original possessors." He noted that the older sections of town consisted of "broad, steep-roofed stone edifices of the French" and an occasional "Spaniard's tall stuccoed dwelling" resembling "a once showy but half-defaced galleon in a fleet of battered frigates." By contrast, in the newer, upper town he saw only "the clipper-built brick houses of the American residents,—light as a Baltimore schooner, and pert-looking as a Connecticut smack."

While Hoffman admired the site as "one of the finest that could be found" and predicted that because of its new "broad rectangular streets" it would always "be an airy, cheerful-looking place," he maintained,

> Its streets command no interesting prospects, and indeed the town has nothing of scenic beauty in its position, unless viewed from beneath the boughs of the immense trees on the alluvial bottom opposite, when the white-washed walls and gray stone parapets of the old French houses present rather a romantic appearance.[33]

Although taken from the spot recommended by Hoffman, little of that romantic appearance permeates the crude and awkward lithograph illustrated in Figure 2–10, which came from one of the pioneer St. Louis lithographers, E. Dupré. Dupré may have drawn this himself, and almost certainly he put it on stone for inclusion in an atlas of St. Louis he printed and published in 1838.

Eugene Charles Dupré came to St. Louis from Paris, opened the Ladies Parisian Cloak Store, and advertised himself as a teacher of French before announcing in 1837

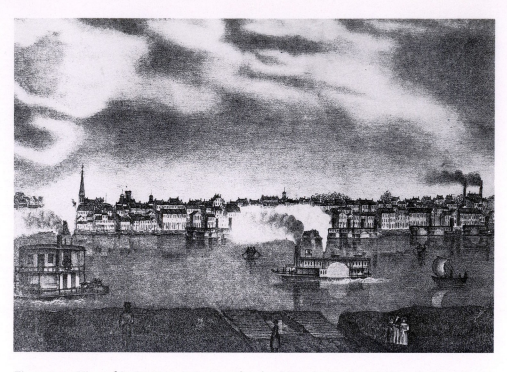

Figure 2–10. View of St. Louis in 1838, printed and published in St. Louis by Eugene Dupré. (Special Collections, Olin Library, Washington University.)

that having procured the necessary apparatus, he is now ready to furnish at the shortest notice and in the neatest manner, Lithographic drawings of towns, public and private buildings, maps, charts, views of natural scenery, and drawings of machinery of every description. . . . A good writer on stone can find employment in the above establishment.[34]

Dupré badly needed what he called "a good writer on stone," for his print is crowded, stiff, and murky. Perhaps he intended the latter quality, since he evidently delighted in picturing smoke and steam, whether pouring from the smokestacks and whistles of the steamers in the river or billowing from the factory chimneys at the far right. Although smoke had already become a prob-

32. Charles Joseph Latrobe, *The Rambler in North America,* 2:173. In his description of the city, Latrobe noted, "St. Louis, overrun by the speculative New Englanders, has begun to spread over a large extent of ground on the bank of the river, and promises to become one of the most flourishing cities of the west. A new town has in fact sprung up by the side of the old one, with long, well-built streets and handsome rows of warehouses, constructed of excellent gray limestone, quarried on the spot."

33. [Hoffman], *A Winter in the West,* 2:72–74.

34. *St. Louis Missouri Republican,* 22 August 1837, as quoted in "The Cover: E. Dupré, Lithographs," 5. According to this source, Dupré claimed to be a Bachelor of Arts of the University of Paris. Records of the Old Cathedral record his marriage on 3 July 1837 to Louise Anne Papin. The 9 August issue of the *Missouri Republican* announced his partnership with Henry G. Fette, but either this arrangement was terminated almost immediately or Dupré carried on his printing business independently while engaged in some other enterprise with Fette. His first address as a lithographer was 19 Market Street. The St. Louis Directory for 1838–1839 gives 64 ½ North First Street as his address. According to David Kaser, *A Directory of the St. Louis Book and Printing Trade to 1850,* city directories list him as lithographer with no address in 1837 and in 1838 and 1839 as residing at 65 North Fifth. The title page of the atlas in which his view of St. Louis ap-

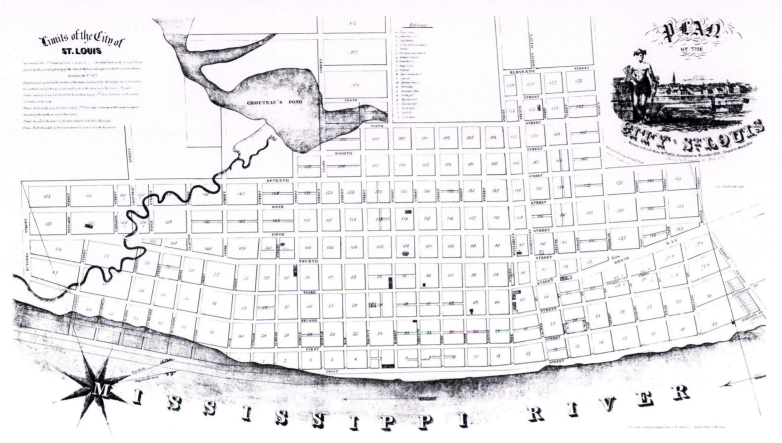

Figure 2–11. Plan of St. Louis in 1835, surveyed by R. Paul, drawn by G. Kramin, and printed in Philadelphia by Lehman & Duval. (Geography and Map Division, Library of Congress.)

lem, St. Louis at that time could hardly have been suffering from air pollution to the extent suggested in Dupré's lithograph.

The view at least conveys the impression of a busy and successful place, a St. Louis transformed from a small town to a true city. A map showing the city in 1835 and reproduced as Figure 2–11 provides evidence of continued demand for city lots. New streets in the upper town occupying the flat land above the

river further extended the already augmented grid along the river. There J. B. C. Lucas laid out another portion of his vast land holdings in 1833 to include an area defined by Seventh, St. Charles, Ninth, and Market streets.

A surprisingly large number of these city streets were paved with brick or stone or had been "McAdamized," as a new process for street surfacing was called. In 1838 Henry B. Miller reported, "Market, Main, Second, Third, Chestnut, Pine, Olive, & Locust are paved, as well as Walnut, Elm, & Myrtle; the cross streets are paved back as far as 4th street with the exception of Market which is paved back as far as Sixth or Seventh street."[35]

Miller thought that Broadway, extending northward from a new market at Oak and Third, would become a major thoroughfare: "This street is 80 feet wide and will be very beautiful; it runs along the high ground; already there are a number of very elegant and spacious buildings erected and erecting along this

peared gives 1 January 1838 as the publication date. What was apparently his first advertisement for the volume was published on 12 February 1838. In June 1839 he produced a map of Iowa Territory, and in January 1840 he advertised for sale a portrait of the Right Reverend Joseph Rosati. Evidently he terminated his printing activities in 1840 because that May he took over a store selling men's clothing and dry goods. The St. Louis city directories do not list him from 1840 until 1845, when the directory identifies him as "Clerk in the Land Office." Arrested on a morals charge in 1845 and sentenced to three months in prison, he escaped only to be arrested again. A lawsuit brought by his wife's brothers resulted in a court judgment in 1849 that his property be seized and sold at public auction. There are no further notices or records about Dupré after that year.

35. This and other quotations from Henry Miller's journal appear in Thomas Maitland Marshall, ed., "The Journal of Henry B. Miller."

street which may in time rival any of the others for beauty." Miller also described how the city's water system was being extended by the construction of water mains on all the principal streets leading from the principal supply pipe. This led from the intake on the Mississippi a mile and a half to the north southward as far as Spruce. Miller claimed that the water was "very wholesome" but admitted that it was "sometimes very muddy."

Another observer who lived in St. Louis during 1834–1836 helps us understand the location of activities in the city at this time. His words can best be followed by referring to Figure 2–11, a survey of the city in 1835 and the source of the illustration reproduced earlier as Figure 2–8.

> Even at this early day there were many large, magnificent steamers engaged in the New Orleans trade; and the levee was usually closely packed with steamers from all directions. The heavy wholesale grocery and commission houses were scattered all along the levee from Market street, north to Washington Avenue. The dry goods and hardware houses were the most of them found along the line of Market street, which was at this time only built up as far back as Sixth street. Fourth street was quite compactly built up some four or five blocks above Market street. The Planters House was built on this street in 1836.[36]

The Planters Hotel on Fourth Street between Chestnut and Pine was only the latest of several large hotels that served businessmen and travelers. The National Hotel on the southwest corner of Market and Third, the City Hotel near the northeast corner of Third and Vine, and the Union Hotel and Missouri Hotel sharing a half-block bounded by First, Prune, Oak, and an unnamed street to the west, all provided accommodations, restaurants, and saloons.[37]

Several accounts mention the expansion of the urban community beyond even the enlarged city boundaries that extended to the west side of Seventh Street. One visitor in 1839 noted that, while "the city proper now contains about fifteen thousand inhabitants," nearly that many lived outside the city limits "in the immediate neighborhood." He observed, "Many hundreds of houses were built last year . . . , and many more are going up this year."[38]

Henry Miller also recorded that on the last day of September 1838 he "walked round" Chouteau's Pond, a prominent feature of early St. Louis whose irregular limits can be seen on the map in Figure 2–11. Miller noted that "a

number of lots [had been] laid out beyond" the pond and predicted that "ere long some part of the Pond will be in the City limits."[39]

It was this rapidly developing and quickly changing city that E. W. Playter sketched sometime after the mid-1830s for the skillfully executed lithograph reproduced in Figure 2–12, which was printed in Boston by Thomas Moore. The exact date of publication cannot be determined, but Moore operated his Boston lithographic business only from July 1836 to May 1840. Previously, Moore served as bookkeeper to William Pendleton, a pioneer Boston lithographer. He bought the business in 1836 and, in turn, sold it in 1840 to Benjamin W. Thayer. The drawing itself suggests Playter visited St. Louis in 1836, for the owners of the steamboat *Mogul* that the artist depicted so prominently in the foreground abandoned or dismantled the vessel in that year.[40]

The view admirably fits Edmund Flagg's impressions in 1838 as he arrived from Boston and found St. Louis so captivating that he decided to make his home in the city, where he edited one of its newspapers. Flagg recalled "rounding a river bend" to behold

> the lofty spire and dusky walls of the St. Louis Cathedral . . . , the gilded crucifix gleaming in the sunlight from its lofty summit, and then the glittering cupolas and church domes. . . . For beauty of outline in distant view, St. Louis is deservedly famed. The extended range of limestone warehouses circling the shore gives to the city a grandeur of aspect, as approached from the water, not often beheld.[41]

Playter's view of the buildings that Flagg so admired begins at the far left with the southern part of the city. He omitted showing the eastern end of Elm Street, but Walnut Street with its Cathedral spire can be seen running inland

36. S. W. McMaster, 60 *Years on the Upper Mississippi. My Life and Experiences,* as quoted in "Two Years in St. Louis—1834–1836."

37. Miller described the two last-named hotels as "old houses and . . . not so much resorted by strangers as the other[s] . . . ; their appearance is rusty and rather forbidding. They no doubt once were the principal houses in the city, but like ancient Babylon, their Glory has departed." See Marshall, ed., "Journal," 253.

38. Rev. Dr. Humphrey, *Letters by the Way,* as quoted in Stevens, *Building of St. Louis,* 43.

39. Marshall, ed., "Journal," 271. The pond figured in one of the most fascinating descriptions of St. Louis during this decade. Professor John Russell in 1830 wrote a vision of St. Louis in the year 2130. He described awakening from a three-century-long sleep and exploring the brave new world that opened before his eyes. He sought out Chouteau's Pond, which he recalled as "a romantic little Lake." When he reached the vicinity, he found that "thick clouds of smoke hung over that portion of the city, caused by the thousand fires of the steam engines which the lake supplied with water. Here was the theater of the most extensive manufactures of the West." He "rejoiced" to see that "employment and sustenance was afforded to so numerous a population," and he "remembered with exultation" that he had "warmly advocated every plan that was suggested to induce immigration to the West, even giving the lands, which belonged to all, as a bribe to entice settlers. Now was the good policy of these measures apparent." See John Russell, *Illinois Monthly Magazine,* as quoted in Stevens, *Building of St. Louis,* 29–31.

40. For Moore, see David Tatham, "The Pendleton-Moore Shop—Lithographic Artists in Boston, 1825–1840," 30. The *Mogul* served as a passenger steamboat only from 1834 to 1836, according to William M. Lytle, comp., *Merchant Steam Vessels of the United States, 1807–1868,* 130.

41. Edmund Flagg, *The Far West: or, A Tour Beyond the Mountains,* as quoted in Stevens, *Build-*

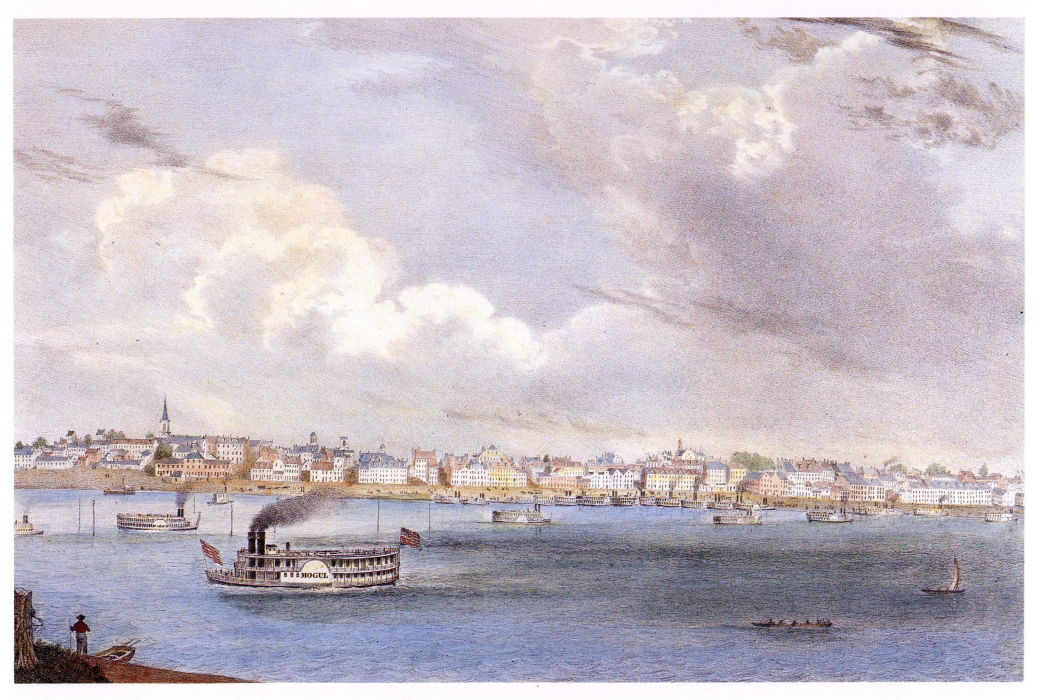

Figure 2–12. View of St. Louis ca. 1836, drawn by E. W. Playter and printed by Thomas Moore in Boston. (Missouri Historical Society.)

from the river. Between Walnut and Market facing the Mississippi stands the building housing the Market and City Hall. Between it and the next street—Chestnut—two projections interrupt the skyline. The cupola marks the Courthouse, finished in 1833; the other is the square Gothic tower of Christ Church, completed in 1839 on a site across Fifth Street from the Courthouse. The cupola to the right, between Chestnut and Pine, belongs to the former Christ Episcopal Church, which by the time Playter drew the city was being used by the Baptists. The other church tower much farther to the north belongs to the Presbyterian Church located at the northwest corner of St. Charles and Fourth streets.

Playter's view extends up river beyond Laurel and Prune streets. The buildings at the far right and in the background are probably intended to represent the Union and Missouri hotels on First Street. Imposing stone warehouses line the waterfront for the entire sweep of the lithograph. They and the steamboats in midstream and nosed into the landing testify to the city's importance

as a wholesaling center for its extensive commercial hinterland.

These few views showing St. Louis in its adolescence give the barest hint of the scores of images that artists produced during the last six decades of the century. If in their numbers the handful of images just reviewed hardly prepare us for the wealth of illustrations that came later, at least they serve to fix in mind the basic structure of the city and the location of some of its major buildings and activities.

We now enter a period of St. Louis viewmaking in which more is known about the artists who captured the image of this growing city. Many of them were itinerants who merely added St. Louis to their list of subjects by spending a few days or weeks sketching the city. They included illustrators for magazines and books as well as those who specialized in producing single-sheet prints intended for framing or mounting.

More interesting are views created by those who lived and worked in the city, at least for periods of one to several years. It was at the beginning of the 1840s that one such artist—John Caspar Wild—settled in St. Louis for a time. He left behind an entire series of views of the city and of nearby communities. His images of St. Louis provide a graphic record unsurpassed in any American city for the period during which Wild worked. The next chapter traces his career in Philadelphia and Cincinnati and then examines in detail the several fine views he produced of St. Louis.

ing of St. Louis, 42. Flagg also noted, "The finest point from which to view the little 'City of the French' is from beneath the enormous sycamores upon the opposite banks of the Mississippi. . . . The city, retreating as it does from the river's brink—its buildings of every diversity of form, material, and structure, promiscuously heaped the one upon the other, and the whole intermingled with the fresh green of forest-trees, may boast of much scenic beauty. The range of white limestone warehouses, circling like a crescent the shore, form the most prominent feature of the foreground, while the forest of shruboaks sweeps away in the rear."

JOHN CASPAR WILD AND ST. LOUIS IN THE EARLY 1840s

In 1831 the compiler of a dictionary of French artists included this brief entry for one of his subjects: "Wild (Gaspard), Painter of landscapes, 1 Boulevard Montmartre, born in Zurich, Switzerland, in 1804. This artist specializes in watercolor landscapes."[1] Very little else is known about the personal life or the career in Europe of this artist who created some of the most attractive images of American cities and in doing so left us a precious heritage of information about their appearance and character. Other European biographical dictionaries state that he produced several views of Venice and other Italian towns, and that Friedrich Salathée executed an aquatint of Wild's *Panorama de Venise.* Some sources place this painting in the museum of Montargis, France, but it is not now in the collection, and there is no record that it ever was.[2]

Far more is known about Wild's activities in America, but he remains a shadowy figure. Our knowledge of him comes from the lithographs he produced, an important book on St. Louis and its vicinity that he illustrated, a few newspaper notices and comments concerning his artistic, printing, and publishing ventures, and a brief appreciation of his life by an acquaintance of his last years.

Wild apparently came to America sometime in 1831, arriving in Philadelphia, where he remained for four years. Andrew M'Makin, the editor of the *Saturday Courier,* a Philadelphia weekly, described him as "an artist whose skill in sketching, drawing upon stone, and particularly his great proficiency in coloring, attracted considerable attention," and he referred to Wild's "paintings in water colours" as "of the finest order."[3] That this John Caspar Wild was the same person as the "Gaspard Wild" of the 1831 Parisian dictionary seems cer-

1. Charles Henri Joseph Gabet, *Dictionnaire des Artistes de l'Ecole Française au XIX Siècle. Peinture. Sculpture. Architecture. Gravure. Dessin. Lithographie et Composition Musicale,* 705. The entry is in French and reads: "WILD (Gaspard), peintre de paysages, boulevart Montmartre, 1, nè à Zurich, en Suisse, en 1804. Cet artiste s'occupe spécialement du paysage à l'aquarelle."

2. I have consulted the sources cited in this note and listed them in the order of publication. In Georg Kaspar Nagler, *Neues Allgemeines Künstler-Lexicon . . . ,* Wild is said to have studied in Paris and remained there as a practicing artist. His *Panorama de Venise* was one of a series that appeared in Paris from 1831 and was engraved in aquatint by Friedrich Salathée. According to Carl Brun's *Schweizerisches Künstler-Lexikon,* Wild "painted landscapes with architecture, mostly domes and other distinguished monuments." This source also states that Wild is not mentioned in the register of the City of Zurich and suggests that he probably came from somewhere nearby, perhaps Wadenswil or Richterswil. In Emile Bellier de la Chavignerie, *Dictionnaire Général des Artistes de l'Ecole Française depuis l'Origine des Arts du Dessin jusqu' à nos Jours,* the translated entry reads: "painter of the French school, according to the catalog of the Montargis museum without stating his place of birth. Of this artist's work the museum owns a landscape bought by the city." Ulrich Thieme and Felix Becker, *Allgemeines Lexikon der Bildenden Künstler,* provide this information: "Studied in Paris and settled there. Made drawings for a series of panoramas published in Paris in 1831, also a 'Panorama of

Venice' which Fr. Salathée engraved in aquatint. There is a landscape of his in the Museum of Montargis." Finally, there are the entries in the various editions of Emmannuel Bénézit's *Dictionnaire Critique et Documentaire des Peintres. Sculpteurs. Dessinateurs et Graveurs . . .* that add nothing to the above material but repeat the statement that Wild's *Panorama du Venise* can be found at the Museum in Montargis. In May 1987 I visited the museum hoping to find not only the painting but also additional information about the artist. Unfortunately, the museum has no record of ever having owned this work. Its head, Sylvain Bellenger, has confirmed this to me in a letter dated 5 June 1987.

3. *Philadelphia Saturday Courier,* 1 August 1835, as quoted in John Francis McDermott, "John Caspar Wild: Some New Facts and a Query," 452. See also McDermott, "J. C. Wild, Western Painter and Lithographer," which also concentrates on Wild's work in the Midwest. An even more exhaustive analysis of the artist's many prints of Philadelphia can be found in Martin P. Snyder, "J. C. Wild and His Philadelphia Views." Snyder has been kind enough to provide a few other bits of information to me about Wild. My own brief biographical sketch in *Views and Viewmakers of Urban*

tain from M'Makin's reference to the artist's paintings of Italian towns and scenes, the same subjects in which the European Wild was said to have specialized.

About 1835 Wild moved to Cincinnati. A local newspaper mentioned him on 21 May 1836 as "among the distinguished artists of this western city" and one who specialized in landscapes. The city directory for 1836–1837 listed him at 133 Main Street and also identified him as a landscape painter.[4] Seven paintings by him in watercolor or gouache are in the local historical society. Four of these depict important streets of the city. One shows the Public Landing on the Ohio River using a distinctive perspective that Wild also employed later for his lithograph of the St. Louis waterfront.[5]

Wild also produced four nearly identical gouache views of the entire city of Cincinnati as seen from the hills on the south side of the Ohio River. They are skillfully executed and attractive in their composition. The river makes a double curve and vanishes in the distance, two points of land slope down to the water, a steamboat cruises along the Ohio in midstream while several others lie motionless at the Landing, and the city itself nestles by the river, marked by church spires and an occasional plume of smoke.[6]

Wild intended to have lithographic copies made of these and perhaps other scenes in and around Cincinnati. An acquaintance of the artist wrote to a friend in mid-November 1835 mentioning "a Frenchman, by the name of Wild, who has taken some views of our Town, from different points, and also some of our public & private buildings." He then described Wild's plan: "He will probably, at my suggestion, publish a series of views (lithographic)."[7]

No such series materialized, and the only evidence that even one of these paintings ever appeared in lithographic form is a single impression of a view of Cincinnati closely resembling Wild's painting of the Public Landing. The view's imprint identifies only the printer, but there can be no doubt that Wild was the artist.[8] Perhaps someone else published this after Wild left Cincinnati to return to Philadelphia. Like so many other aspects of Wild's career, we can only speculate about the reasons that caused him to move once again and to abandon his plans for a series of prints of which the single impression known may have been a proof copy.

In Philadelphia for the second time, Wild finally realized his hopes to produce a series of views of a major city and its important architectural monuments. Early in December 1837, the *Saturday Courier* announced that Wild and his partner, J. B. Chevalier, intended to issue twenty views of the city "for the very low price of $2.50." for the entire set.[9]

Four views appeared each month, beginning in January. Each measured about $5\frac{1}{4}$ x 7 inches. Wild drew each image from nature and then put it on stone. John Collins, a highly regarded lithographer, did the printing. The *Saturday Courier* also became involved (if it had not been before) when it offered the entire set of views to persons securing five new subscribers to the newspaper. Ezra Holden, one of the paper's proprietors, wrote a page of description for

America . . . , 216–17, draws heavily on McDermott's and Snyder's investigations, adding a tabulation of his city views by date of publication and the state in which his subjects were located. For the present study I made an additional search for newspaper notices and an unsuccessful attempt to locate other information about the man himself.

4. *Cincinnati Daily Gazette,* 21 May 1836, p. 2, col. 1, carried this brief notice: "Fine Arts In Cincinnati.—Among the distinguished artists of this western city, are Powers, an eminent self-taught sculptor; Douglas and Wild, in landscapes; Winter, in portraits and fancy illustrations; Dawson, in ditto; and young Frankenstein, in theatrical figures and modeling."

5. The paintings are in the collection of the Cincinnati Historical Society. Wild's painting of the Public Landing is reproduced as fig. 1 in McDermott, "J. C. Wild, Western Painter," and as pl. 58 in Ron Tyler, *Visions of America: Pioneer Artists in a New Land.* The Cincinnati Historical Society of Ohio has produced 22 x 28 inch color reproductions of three of Wild's street scenes and the Public Landing.

6. Two of these paintings are in the Cincinnati Historical Society. One was reproduced in Marshall B. Davidson, *Life in America,* 1:120. Two others are in the Karolik Collection of the Boston Museum of Fine Arts. See Boston Museum of Fine Arts, *M. & M. Karolik Collection of American Water Colors & Drawings, 1800–1875,* 308–9, for an illustration of one of these paintings along with a brief note about Wild. As of 1962, the fifth version was owned by Richard S. Hawes of St. Louis.

7. Letter from Nicholas Longworth to Hiram Powers, 13 November 1835, in the Hiram Powers Manuscripts, Historical and Philosophical Society of Ohio, as quoted in McDermott, "John Caspar Wild: Some New Facts," 453. In another letter dated 28 February 1836, Longworth wrote to Powers, "We have an artist here, Wilde [*sic*], a young frenchman, with much taste & tallent. He is taking views of our town & particular parts of it, with a view to make Lithographs from them which he will color."

8. The lithograph can be found in the Stokes Collection of the New York Public Library. It is illustrated and described in I. N. Phelps Stokes and Daniel C. Haskell, *American Historical Prints: Early Views of American Cities. etc. from the Phelps Stokes and Other Collections,* p. 86, pl. 65-A. The print bears the title *Cincinnati.* At the lower left appears this information: "Lith. of H. R. Robinson, 52 Courtlandt St. N.Y." It measures $18\frac{1}{2}$ x $25\frac{7}{8}$ inches, a large print for the time.

9. *Philadelphia Saturday Courier,* 2 December 1837, as quoted in Snyder, "J. C. Wild," 34. As Snyder notes on p. 33, the proprietors of this popular weekly publication advised its readers the previous July that they were "engaged in bringing out a complete series" of views of "many of the public buildings of this city." Snyder believes that Wild learned of this, went to the proprietors, and offered his services as the artist. McDermott suggests that the July announcement indicates that Wild had already become involved in the project and that therefore he must have returned from Cincinnati by that date.

each view, and his partner, Andrew M'Makin, added stanzas of poetry inspired by Wild's images. Their twenty pages of text made up the final installment of the serial publication, which reached the public by mid-May 1838.

As completed, the twenty plates and the accompanying passages of text appeared in a paper cover. The front cover carried a long title: *Views of Philadelphia, and its Vicinity. Embracing a Collection of Twenty Views. Drawn on Stone. by J. C. Wild, from his own Sketches and Paintings. With Poetical Illustrations of Each Subject. by Andrew M'Makin*. The cover also listed the plates, announced the price as $3.00, and identified the publishers as Wild and Chevalier.[10]

Evidently the demand for the views exceeded expectations, and Wild and Chevalier decided to issue them in an expanded version. The outside back cover of their volume announced this venture:

> MESSRS. WILD & CHEVALIER, beg leave to call the attention of their friends and the public to this important addition, which they propose to their Views of Philadelphia. This panoramic view, taken from the State House Steeple, will be four feet in length and, divided into four parts, viz:
>
> 1st View—NORTH, 3d Do.—SOUTH,
> 2d Do.—EAST, 4th Do.—WEST.
>
> Each part will be double the size of the Views of Philadelphia, being 12 inches by 6, executed and printed in the same style and form. A title page will be furnished, and the whole will be enclosed in a neat cover.[11]

For this revised and expanded edition Wild and Chevalier set June 1838 as the publication date, and they set the price at $1.25. However, it was not until the end of August that Wild was able to complete the four sheets. He sketched the city from the Statehouse spire, the images on the four sheets depicting what he saw when looking to the four cardinal points of the compass. This profusely detailed, high-level panorama is not quite a bird's-eye view in that the pattern of streets is not revealed, and it is drawn from a real rather than an imaginary vantage point, but it nonetheless anticipated the style of urban viewmaking that would become dominant after the Civil War.[12]

Wild's view differed from later views also in its unusual 360-degree scope, although adjacent sheets could be joined only imperfectly. Wild treated each segment of the view as a separate perspective drawing and did not adjust the images of buildings at the right and left sides so that details matched smoothly. Nevertheless, the lithograph provides a more intimate glimpse of Philadelphia than was available for any other American city.

Wild's work in Philadelphia established a pattern that he attempted to duplicate in St. Louis, an effort that met with considerable success. What led him to abandon precipitously his apparently profitable career in Philadelphia and move yet another time will probably never be known. All that the record reveals is that he transferred to Chevalier his share of their business and that shortly thereafter his lithographic stones came into the hands of J. T. Bowen, who reissued them several times under his own imprint with Wild and Chevalier's names removed. Here, too, as will be seen, his Philadelphia experience was to be repeated in St. Louis.[13]

The first notice of Wild's presence in St. Louis comes from an announcement late in April 1839 in the *Daily Evening Gazette*. From it, readers learned of the publication of "a very neatly colored lithographic drawing of St. Louis, as seen from the opposite shore. The lithographic work was executed by Mr. Dupré's well known establishment; where the sketch was drawn and colored by Mr. J. C. Wild."[14]

Figure 3–1 reproduces this first view of St. Louis by Wild, a distant panorama in which foreground figures, landscape elements, and the broad expanse of the Mississippi almost eclipse the image of the city in the distance. As nearly every visitor testified, the city appeared to best advantage from the Illinois side of the Mississippi, and Wild skillfully displayed its attractions from that viewpoint in this large and handsome print.[15]

Probably this lithograph appealed to many customers, and its sales encouraged Wild to think about creating a series of views showing St. Louis just as he had done for Philadelphia. Doubtless he did other work to make a living, but

10. Snyder, "J. C. Wild," 41, provides the title and other information concerning the appearance of this publication filed for copyright on 11 May 1838.

11. Ibid., 42.

12. Wild and Chevalier, according to Snyder in "J. C. Wild," issued the four sheets of the Philadelphia panorama with a title page and cover. Apparently they sold it separately in this form but bound most of the copies with the set of twenty earlier views of buildings with a title page reading *Panorama and Views of Philadelphia. and its Vicinity*. They charged $5.00 for the combined publication.

13. Bowen moved from New York to Philadelphia shortly before this occurred. He advertised his edition of *Panorama and Views* as "Published at J. T. Bowen's Lithographic and Print Colouring Establishment." Bowen first printed this in 1838, probably late in the year, and published it again in 1848. In "J. C. Wild," 54–75, Snyder provides the complete publishing history of all the Wild views of Philadelphia.

14. As quoted in McDermott, "J. C. Wild, Western Painter," 113.

15. The lithograph measured more than 20 x 27 inches and thus exceeded in size the 13 x 19 inch dimensions of the Playter-Moore view, by far the largest earlier printed image of St. Louis.

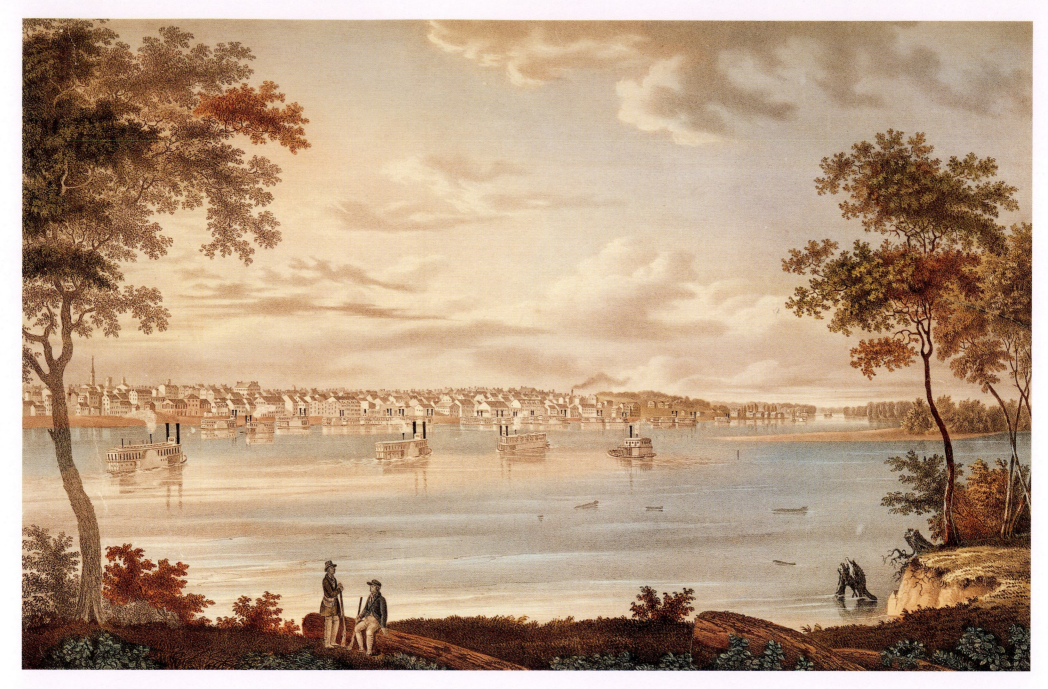

Figure 3-1. View of St. Louis in 1839, drawn, lithographed, and published in St. Louis by John Caspar Wild, printed in St. Louis by Eugene Dupré. (New-York Historical Society.)

he must have devoted much of his time during the remainder of 1839 and the winter and early spring of the following year to sketching for this far more ambitious project.[16] Late in April 1840 this newspaper announcement described the results of his efforts:

> Mr. Wild's Views of St. Louis.—This enterprising artist has placed in the Republican Reading Room his eight drawings of views in and about St. Louis. . . . These views he proposes lythographing [sic] and furnishing to subscribers . . . for the moderate sum of four dollars for . . . eight drawings plain, or eight dollars colored. We feel confident that every one who will take the trouble to examine the paintings . . . will not hesitate to encourage the work. With each drawing he has preserved accurately the land marks around, and in less than five years each will be of double value as showing something of what St. Louis was.[17]

Four of these paintings illustrated the Episcopal Church, the Cathedral, and two new buildings: the Second Presbyterian Church, completed in 1840 at the northwest corner of Fifth and Walnut streets, and the Courthouse, begun in 1838 but not finished for more than a decade. This imposing civic building occupied a site west of the existing courthouse on the block bounded by Fourth, Fifth, Market, and Chestnut streets. Wild's painting (and the eventual lithograph) showed the original design by Henry Singleton rather than the building as it ultimately appeared. Wild included the huge Planters Hotel in the background of this view. It occupied the entire block beyond the Courthouse to the north.

Of the four other paintings, one depicted Water or Front Street along the Mississippi as seen from a point south of the Market at Walnut Street. To judge from the lithographic version of it illustrated in Figure 3-2, Wild composed this lively scene in a fashion nearly identical to his painting of the Cincinnati Public Landing. The converging lines of the riverbank and the baseline of the buildings fronting the Mississippi pull us into the picture and invite us to join the throng of strollers, workers, boatmen, and others on this busy waterfront.[18]

Each of the other three paintings showed the city as it could be seen from different vantage points. Two placed the onlooker across the Mississippi on the Illinois shore, one to the northeast, the other to the southeast. The third portrayed St. Louis (at least what could be seen of it) from the south shore of Chouteau's Pond and therefore looked from the southwest toward the church spires, Courthouse dome, and other prominent buildings located between Walnut and Chestnut streets.

No record exists of what happened to these paintings. Nor have more than a few copies survived of the lithographic versions reproduced in Figures 3-3, 3-4, and 3-5, each of which measures approximately 12 x 15 inches. Wild controlled every aspect of their production. He not only painted each view, but he also put them on stone, printed them himself or had this done under his supervision at the press of the *Missouri Republican,* and served as his own publisher.[19]

Institutions and individuals owning any of the eight lithographs composing this set prize them for their generally high (although varied) quality of printmaking, their pictorial appeal, their historical importance as among the earliest images of St. Louis and its buildings, and their rarity. Two institutions have complete sets of the prints, the New-York Historical Society and the Missouri Historical Society. Only the latter set exists in bound form with a printed label on the front cover listing the titles of the eight prints. This set is also superbly

16. Wild produced another lithograph just after this period. This notice appeared in the *St. Louis Missouri Republican* on 9 May 1840: "Portrait of Harrison.—Mr. Wild has lithographed the portrait of Gen.Harrison from the portrait executed by Mr. Cavaness of Springfield, Ill." On 12 May 1840 the paper repeated the announcement: "Likeness of Gen. Harrison.—We invite the friends of the Old Hero to call and look at the lithographed likeness of the General now hanging in our Reading Room, by Mr. Wild." The artist may have given art lessons while engaged in drawing and painting the views of the city and its buildings, as this was one way artists of the time managed to maintain an income. He also must have attended to more routine printing tasks, as indicated by this advertisement in the *Missouri Republican,* 8 April 1840, p. 2, col. 6: "Business and Visiting Cards, Drafts, Checks, Notes, Bill heads, Letter heads, steamboat Manifests, etc., etc."

17. *St. Louis Missouri Republican,* 28 April 1840. According to McDermott, "J. C. Wild, Western Painter," p. 115, n. 10, this newspaper mentioned the views first on 8 April 1840. He also quotes from descriptions of the views that appeared in the *St. Louis Daily Pennant* for 20 April 1840 and the *St. Louis Daily Evening Gazette* for 28 April 1840. McDermott quotes the latter newspaper as follows: "We have seen some beautifully colored drawings of scenes in St. Louis executed by Mr. J. C. Wild, which are so very accurate and pleasing, that we cannot forbear calling attention to them. They are designed to show the plan of a set of drawings to be done on stone by Mr. Wild, provided sufficient encouragement be given for that purpose."

18. This view also provides the best record of the design of the curious building housing the Market and the City Hall. It shows clearly the covered market wings on either side of the three-story portion used for municipal offices and meetings.

19. Six of the views state: "Published and Lithographed by J. C. Wild at the Missouri Republican Office." Another reads: "Painted from Nature and drawn on Stone by J. C. Wild. Published at the Republican Office." A lithographic letterhead view of the building occupied by the *Missouri Republican* and its neighbors on each side can be found at the Missouri Historical Society. It is on a letter dated 20 May 1843 written by Chambers and Knapp to Mr. James L. Minor. Projecting above the cornice of the Republican building is a sign reading "J. C. Wild Lithographer."

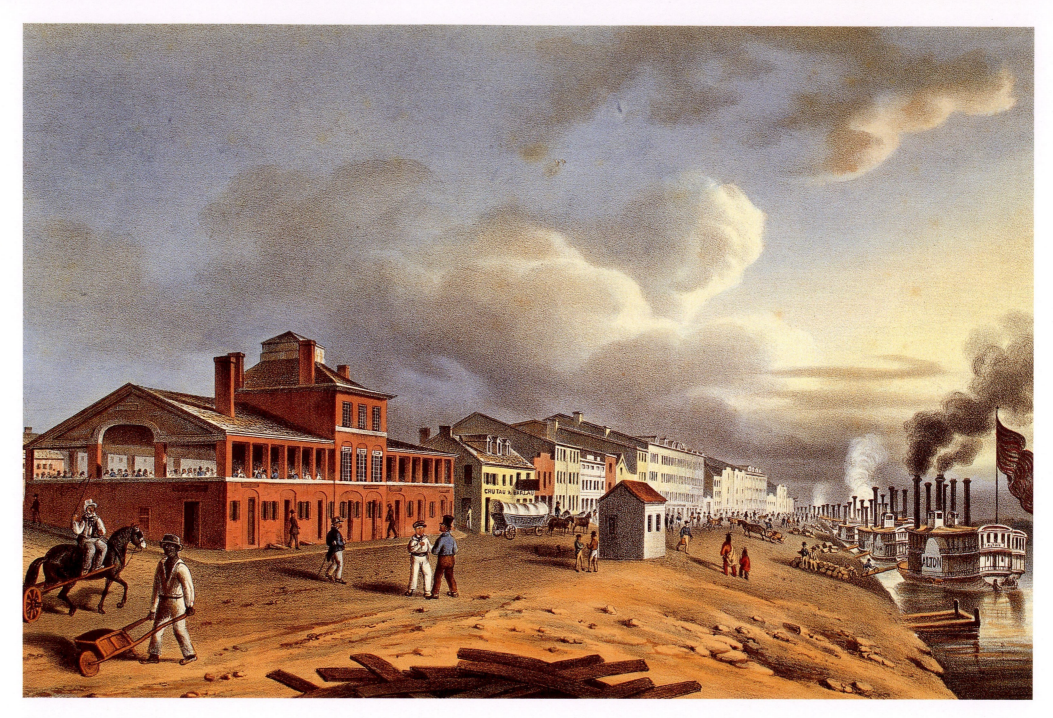

Figure 3–2. View of Front Street in St. Louis in 1840, drawn, lithographed, printed, and published in St. Louis by John Caspar Wild. (Missouri Historical Society.)

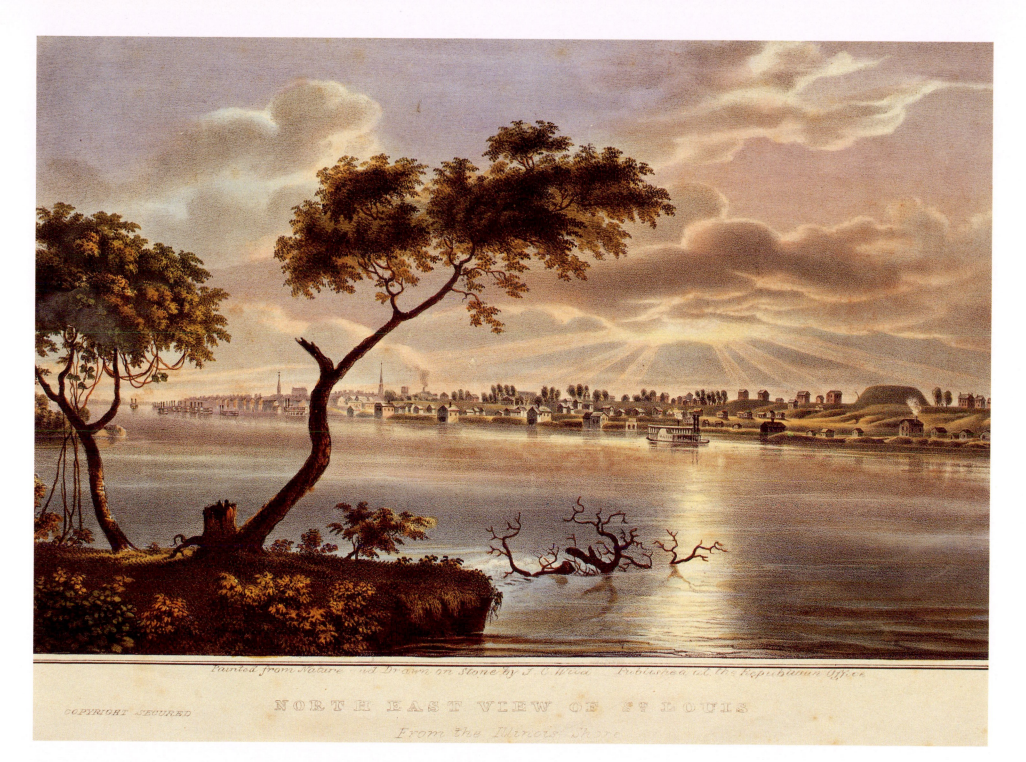

Painted from Nature and Drawn on Stone by J. C. Wild. Published at the Republican Office.

COPYRIGHT SECURED

NORTH EAST VIEW OF ST LOUIS

From the Illinois Shore

Figure 3–3. View of St. Louis from the northeast in 1840, drawn, lithographed, and published by John Caspar Wild, printed at the office in St. Louis of the *Missouri Republican*. (Missouri Historical Society.)

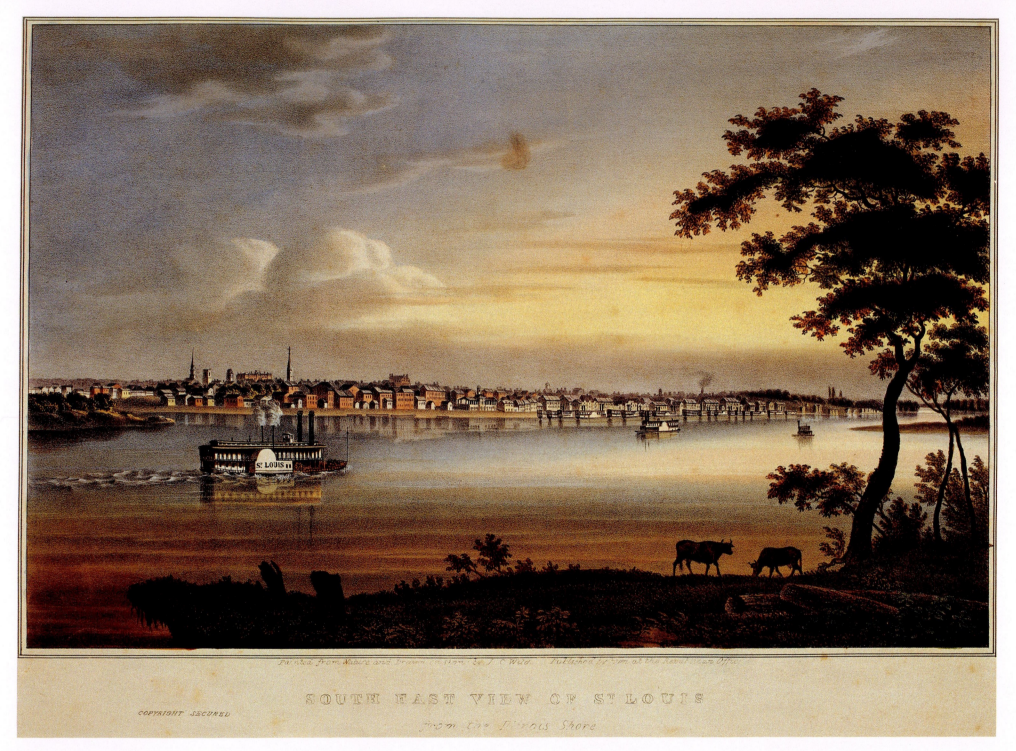

COPYRIGHT SECURED

Painted from Nature and Drawn on Stone by J. C. Wild. Published by him at the Rural Hotel Office.

SOUTH EAST VIEW OF St LOUIS

from the Illinois Shore

Figure 3–4. View of St. Louis from the southeast in 1840, drawn, lithographed, printed, and published in St. Louis by John Caspar Wild. (Missouri Historical Society.)

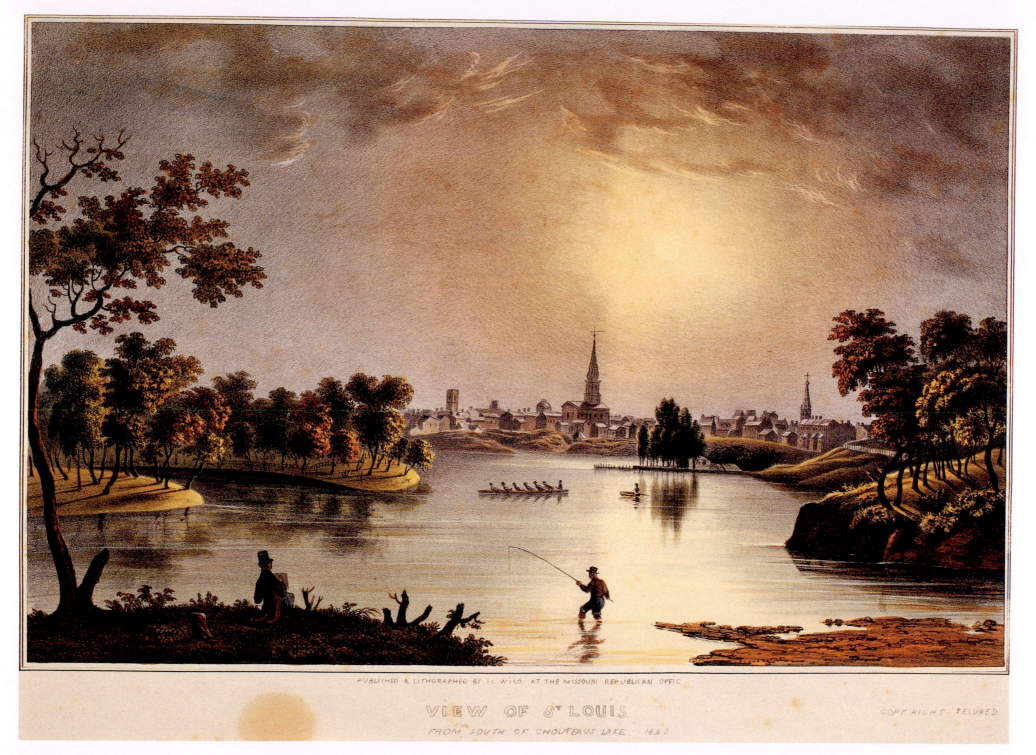

PUBLISHED & LITHOGRAPHED BY J.C. WILD AT THE MISSOURI REPUBLICAN OFFIC

VIEW OF St LOUIS

FROM SOUTH OF CHOUTEAUS LAKE 1840

COPY RIGHT SECURED

Figure 3–5. View of St. Louis from the southwest in 1840, drawn, lithographed, printed, and published in St. Louis by John Caspar Wild. (Missouri Historical Society.)

colored, doubtless by Wild himself as the final act before sale of a product for which he was solely responsible.[20]

Wild issued the lithographs in the fall of 1840. They must have been well received, for in December of that year he announced a second and expanded edition, explaining that he proposed to add views of the U.S. Arsenal, the Theatre, the St. Louis Hotel, and St. Louis University. For this set of twelve lithographs he intended to charge six dollars, or, if the prints were colored, twelve dollars.[21]

Wild seems to have abandoned this plan in favor of the even more ambitious idea of combining additional St. Louis views with depictions of many other places in the region. In March 1841 the *Missouri Republican* described this project for its readers:

> Mr. J. C. Wild . . . has commenced the publication of a work entitled "The Valley of the Mississippi," including all the most picturesque scenes, Natural curiosities, and also views of the principal cities and towns in the Great West; with historical descriptions. To be published in monthly numbers, each number containing four views. . . . The views for the first number are the same as those previously published, but are reduced in size to correspond with the work.[22]

The paper also announced that Lewis F. Thomas, "one of the most lively and accomplished writers of the west," would write a historical text and other commentary to accompany each installment of four views. Wild probably remembered the success of his Philadelphia lithographs issued in this manner and regarded such descriptions of the places he depicted as adding customer appeal to his work.

On 15 July 1841, Wild issued the first part of the *Valley of the Mississippi Illustrated*. For this he redrew at a much smaller size his first view of St. Louis published in April 1839 shortly after his arrival in the city. Reproduced in Figure 3–6, the print or its real-life counterpart inspired Wild's collaborator to these words:

> The compact portion of the city . . . presents a beautiful view, when beheld from the opposite shore. . . . The fleet of steam boats . . . lining the landing for a mile—the white-fronted warehouses extending for equal length—the dense mass of buildings in the rear seemingly mingling with the horizon in the distance, with here and there a church tower, a belfry, or a steeple looming to the skies, exhibit a panorama of exceeding beauty, that bursts upon the vision of the delighted beholder.[23]

This and other plates in the *Valley of the Mississippi* measured only about 4 1/2 x 7 1/2 inches, excluding borders, titles, and generous margins. Wild used several of his earlier St. Louis building views and simply redrew them at this small size. For example, in this first part of the new work two other views showing the Cathedral and the Courthouse came from the images he used in his series of eight lithographs published in 1840.

Additional parts of the *Valley of the Mississippi* appeared in August, October, and November 1841. Then came tragedy. Wild's wife, then only twenty years old, died early in January. Publication continued nonetheless with two parts issued the following February, another in April, and a final two parts in May.[24] Newspaper notices kept readers abreast of progress of the work.[25] They did not comment, however, on the abrupt halt to the publication of this series far short of what Wild had announced as its goal of two hundred pages of text and fifty views. Perhaps Wild and Thomas had a falling out, for his brother, J. E. Thomas, edited the last three parts.[26]

Wild intended to include views of many places throughout the American interior. The titles on the covers of each part promised that the series would include "Pictures of the Principal Cities and Towns, Public Building [and] Remarkable and Picturesque Scenery, on the Ohio and Mississippi River."

20. McDermott, "J. C. Wild, Western Painter," 115, states that the newspaper notices concerning the project make it clear "that Wild issued his first and second editions of the *Views of St. Louis* as books or portfolios with letterpress in addition to the lithos." He adds, "No copies of such a publication, however, have been recorded." There is no evidence that Wild intended to accompany the views with text, and I doubt that the second edition of the *Views* was ever issued.

21. The *St. Louis Daily Gazette* for 21 October 1840 mentioned that Wild had been working on the lithographs and that "they are now completed." The *Missouri Republican* told its readers about the proposed expanded edition in its issue of 10 December 1840, p. 2, col. 5. See McDermott, "J. C. Wild, Western Painter," 115.

22. *St. Louis Missouri Republican*, 13 March 1841, p. 2, col. 1. The editor advised his readers to support this new venture: "The merit of the work will doubtless commend itself sufficiently for the public favor all over the country. But when an artist such as Mr. Wild comes and establishes himself amongst us, he should receive our special encouragement. . . . It will form an elegant work to transmit to eastern friends to give those who have never been west an idea of western science, western scenery, &c."

23. J. C. Wild, *The Valley of the Mississippi Illustrated in a Series of Views*, 10.

24. McDermott, "J. C. Wild, Western Painter," 117–20, provides the dates of publication and the subjects of the plates in each part. He also cites an announcement in the *St. Louis Missouri Republican*

25. McDermott, in ibid., 117–19, notes the following: the *Daily Evening Gazette*, 15 July 1841; the *Pennant*, 5 October 1841; the *New Era*, 31 May 1842; and the *Missouri Republican*, 25 August, 6 October, 10 November, and 25 December 1841 and 2 February, 23 March, and 2 June 1842.

26. There may have been no such disagreement. In its issue of 6 October 1841 the *Missouri Republican* stated that the third part of the publication had been delayed owing to "the indisposition of the Editor." McDermott, "J. C. Wild, Western Painter," 118–20, quotes this while presenting some evidence for a break between Wild and Thomas.

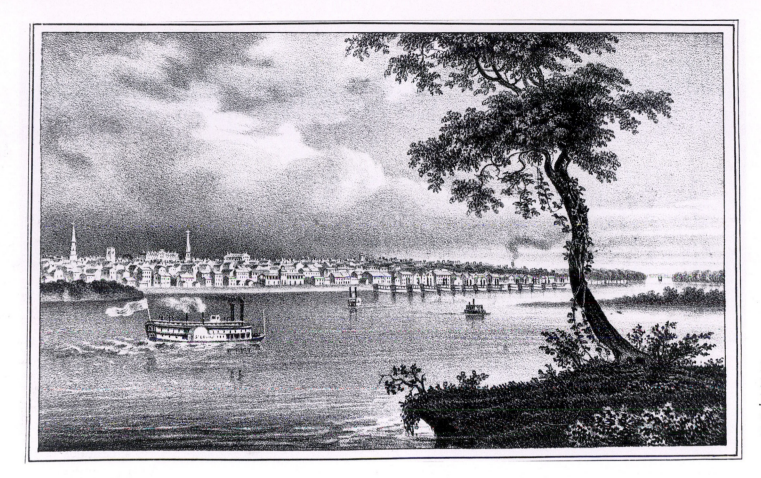

Figure 3–6. View of St. Louis from the east, drawn, lithographed, and published in St. Louis by John Caspar Wild, and printed by Chambers and Knapp of St. Louis in 1841. (St. Louis Mercantile Library Association.)

Apparently Wild also expected to portray Cincinnati in as much detail as he had used in the first part for St. Louis. One Cincinnati newspaper so interpreted his intentions in its review of the initial segment of *The Valley of the Mississippi.* Wild doubtless expected to use his earlier images of that city and to redraw them in the smaller size he had adopted for the book.[27]

27. I am grateful to Mary M. Rider, reference librarian of the Cincinnati Historical Society, for providing the text of a long review of part 1 that appeared in the *Cincinnati Daily Gazette* for 16 August 1841, p. 2, col. 3, and the *Liberty Hall and Cincinnati Gazette* for 19 August 1841, p. 2, col. 3. The highly favorable review included this passage: "We are informed that in a subsequent number that will be done for Cincinnati, which in the present one is done for St. Louis." The review also identified Lewis F. Thomas as "formerly of this city." Perhaps Lewis and Wild met in Cincinnati.

Although the series ceased after Wild issued the last two parts in May 1842, the artist provided a special treat for readers of those numbers. They contained four folded sheets, each with an image four or more times the size of the previously issued illustrations in the series. Each portrayed in great detail the portions of St. Louis that could be seen looking west, north, east, and south from the top of the Planters Hotel.

Figure 3–7 reproduces these lithographs with the four sheets treated as one and with their imperfectly matched join lines partially concealed in the center fold. They offer an extraordinarily detailed look at the St. Louis townscape and one rivaled in America only by the same artist's depiction of Philadelphia a few years earlier. This scene of St. Louis from the inside looking out allows us to

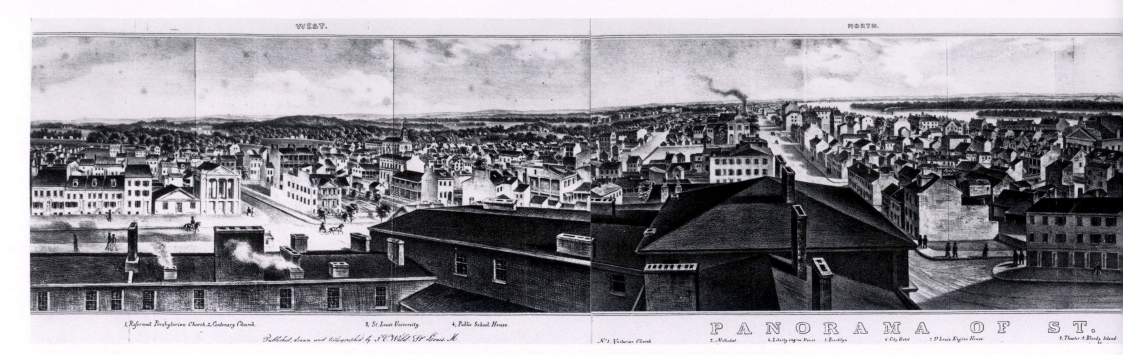

1, Reformed Presbyterian Church. 2, Centenary Church. 3, St Louis University. 4, Public School House.

Published, drawn and lithographed by J C Wild St Louis M.

N° 1. Unitarian Church 2. Methodist 4. Liberty engine House 5. Brooklyn 6. City Hotel 7. St Louis Engine House 8. Theater & Bloody Island

PANORAMA OF ST.

Figure 3–7. Panoramic View of St. Louis from the Planters Hotel in 1842, drawn, lithographed, and published in St. Louis by John Caspar Wild, and printed by Chambers and Knapp of St. Louis. Above: views to west and north. Opposite: views to east and south. (Research Collections, Lovejoy Library, Southern Illinois University, Edwardsville.)

move vicariously around its streets and buildings and to experience the atmosphere and character of the place. In the distant panoramas from across the Mississippi our role is that of a spectator. With this view we become participants in the life of the city.[28]

28. Evidently the two issues, parts 8 and 9, were issued simultaneously, although they are dated February and March. The editor of the *New Era* for 31 May 1842 observed that the artist drew the views from "the highest and most central point of our city," which allowed him "an excellent opportunity to ascertain the full extent of the city, and to convey to a stranger an idea of the number and respectability of its buildings." This writer added, however, that the text contained "such language" that should "never have been permitted in a work of this kind" and that it "is of a character to prevent its introduction into any family." He referred to a long passage that began the second paragraph of the text: "Turn your eyes to the E. N. E. by E. line and mark that house with low chimneys and of a dingy yellow color on one of its ends. Some twelve or fifteen years ago, an outbreak took place in the city. A mulatto, of rather notorious occupation, kept a *house of rendezvous* of this sort. One of the ordinary inmates was an Indian woman of violent passions, who, notwithstanding her temper and character and model of life, possessing personal charms, became

Wild faced west and north to sketch the two sheets reproduced in the left portion of Figure 3–7, and east and south for the scene he recorded on the sheets at the right of the illustration. To do so he looked over the roofs and chimneys of the Planters Hotel, whose several wings appear in the foreground of

popular and even a favorite. After what is related, it is not surprising to learn that she had a quarrel with the man who cohabited with her, and stabbed him." This portion of the text continued at length recounting what then occurred. Several other pages deal with another crime combining murder, burglary, and arson that was committed in a small house that appears on one of the sheets of the view. These passages make up the bulk of part 8 of *The Valley of the Mississippi*. Nearly all of part 9, the final issue, consists of a long quotation on the history of St. Louis taken from a variety of sources. It is disappointing that the editor of the volume almost totally ignored Wild's views in his comments about the city. The *Missouri Republican* on 2 June 1842 merely stated that because of "other pressing engagements" the paper was "consequently unprepared to express an opinion as to the merits of the editorial part of the work." The writer, however, felt that the panorama of St. Louis reflected "the highest credit upon Mr. Wild."

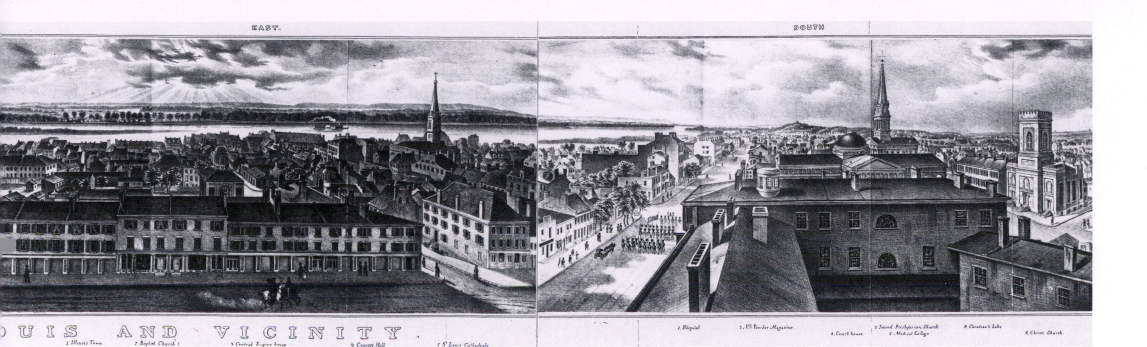

EAST. SOUTH

OUIS AND VICINITY.
1 *Illinois Town* 2 *Baptist Church's* 3 *Central Engine house* 4 *Concert Hall* 5 *S.t Louis Cathedrale*

1. *Hôpital.* 2. *U.S. Powder Magazine* 4. *Court house* 5 *Second Presbyterian Church* 7. *Chouteau's Lake* 8. *Christ Church.* 6 *Medical College*

three of the sheets. Legends at the bottom of each sheet identify important buildings.[29]

At the left two churches stand side by side at the corner of Broadway (then Fifth Street) and Pine. The one on the corner is the Centenary Methodist Church, begun in 1842 and finished two years later. Wild obviously "completed" it on

paper somewhat ahead of real time.[30] Its one-story neighbor to the south housed the congregation of the Reformed Presbyterian Church. To the right of center of this sheet is a large church with steeple and cross. This marks the site of St. Louis University at Ninth and Washington streets, a location this institution occupied until 1888. To its right and near the border of the sheet stands a simple, one-story building. This was one of two public schools in the city.

29. In Harry M. Hagen, *This Is Our Saint Louis,* 120–27, copies of the four Wild lithographs as redrawn by Charles Overall are reproduced. Hagen provides caption-commentaries for each, beginning with this passage: "One spring day in 1840 an artist named J. C. Wild lugged his grease crayons and four large stones to the roof of the Planters Hotel. . . . From this vantage point he surveyed all four directions and began to paint." No artists with any sense or experience "lugged" lithographic stones on sketching trips. Artists of city views sketched on paper, revised their first efforts, often exhibited finished drawings to obtain subscriptions for the intended print (and made corrections when criticized for omissions or errors), and only then redrew their designs on lithographic stone or transfer paper for printing. I have described the process in *Views and Viewmakers of Urban America,* chaps. 2–4, pp. 17–38.

30. Probably Wild relied on proposed designs for the church to guide him in his representation of the building. Perhaps George I. Barnett, the building's architect, modified its appearance as work proceeded, for the completed facade departed in many ways from the way Wild drew it for his lithograph. For an illustration of the church reproduced from a publication of 1854, see Lawrence Lowic, *The Architectural Heritage of St. Louis, 1803–1891,* 58. Lowic describes the facade as consisting "of a ground story of three entrances inserted between pedestals which carried paneled pilasters on the principal story. Above a full entablature, its pediment was backed by a parapet with small flanking scrolls."

This portion of the view reminds us that St. Louis in the early 1840s did not extend very far from the river. At the left, only scattered houses appear beyond what must have been Sixth and Seventh streets. Elsewhere in the print, Wild makes it appear that buildings extended all the way to St. Louis University at Ninth, but he seems to have distorted distances here by bringing the university building closer to the river on paper than it was in fact.

On the adjoining sheet we look many blocks north on Fourth Street. The intersection in the right foreground is the corner of Fourth and Pine. The First Presbyterian Church at the corner of Fourth and St. Charles is the tall building with the cupola; beyond and partly obscured by it is the Methodist Church facing Fourth Street. Strangely, Wild did not choose to depict the First United Presbyterian Church, begun in 1841 at Broadway (then Fifth) and Locust streets. The artist did include one of the city's largest buildings, which can be seen at the far right of the sheet, although an intervening structure partly obscures the massive columns that support the entrance pediment. This is the Theatre, designed in 1837 and built to face Third Street on the southeast corner of its intersection with Olive Street. Although the columns Wild shows were part of the original design, they may never have been constructed.

The next portion of Figure 3–7 is a particularly handsome delineation of the St. Louis urban scene. In it we look to the river from Fourth Street. Facing west in the foreground is a continuous row of three-story buildings with shops on the ground floor and living quarters above. Shutters on the windows provide a pleasing emphasis and add rhythm to the otherwise smooth walls that were probably of brick. In the center of this sheet is a small brick church with a cupola that was then used by the Baptists. Dominating this section of the city, however, the spire of the Catholic Cathedral soars proudly above the thickly built-up older portion of St. Louis. Directly below the bow of the steamboat in midstream is a large, square-shaped building with a dark roof. This is the concert hall. Below that appears a small bell tower that identifies the central fire station.

Turning to the final section of the view, we find ourselves looking south on Fourth Street, where a parade of uniformed guards is taking place. In the distance on the left, the last large building on the east side of Fourth Street represents the hospital at the intersection with Spruce Street. The legend also identifies the location of the U.S. Powder Magazine where Fourth Street meets the horizon.

Three major landmarks of St. Louis appear in the right half of this sheet. The Gothic revival Christ Church at Fifth (now Broadway) and Chestnut draws our attention with its square, crenellated tower. The legend tells us that the jail is nearby. It occupied a site west of the church in the same block at Sixth and

Chestnut. Two streets south of Christ Church at Broadway and Walnut stood the massive and imposing Second Presbyterian Church with its six Doric columns supporting its temple-like roof and tall spire.[31] Wild also shows us the new Courthouse as if it had been completed according to its original cruciform plan. This building remained unfinished for many years. A low-domed rotunda was opened in 1845, but five years later the building still had not been completed, and county officials had revised plans prepared. Finally, in 1862 the building assumed its present form with its dome supported by a high drum and surmounted by a cupola whose peak reached 230 feet above the elevation of the square the building occupied.

Wild offered these views, possibly colored by him, for sale in an unusual form. The writer of an article in the *Missouri Republican* for 2 June 1842 mentioned that the four views could be "united in one continuous map, lengthwise, and the two extremities . . . brought together, in cylindrical form." He then informed his readers that "Mr. Wild has worked off and put up in this panoramic form, a number of those views, which he has for sale singly." The writer advised "all, and especially those curious in watching progress of our city improvements . . . to supply themselves" with copies.

In his *Valley of the Mississippi* Wild paid tribute to his adopted home and its neighbors. In doing so he demonstrated his fondness for views showing entire towns and cities. In addition to the single-sheet reduction of his first view of St. Louis showing the city in 1839, and the four-sheet, 360-degree panorama of the city, Wild provided his readers with eight other city views. They showed Alton, Cahokia, Cairo, Illinois Town (later East St. Louis), and Kaskaskia, Illinois; and Selma, St. Charles, and Carondelet, Missouri. His lithographs have special significance, for they provide the earliest printed images of these places.

Carondelet later became part of St. Louis and is, therefore, entitled to special consideration here. Moreover, Wild's view of it is one of the few St. Louis city views for which corresponding paintings have survived. Figure 3–8 reproduces Wild's watercolor of Carondelet, a painting now in the collection of the St. Louis Mercantile Library. Figure 3–9 is the much smaller lithographic image of the settlement that appeared in *The Valley of the Mississippi*. To this still

31. Lewis Thomas listed the churches that existed in St. Louis at the time *The Valley of the Mississippi* appeared: "two Methodist, two Presbyterian, two Episcopal, two Roman Catholic, one Associate Reformed Presbyterian, one German Lutheran, one Unitarian, one Baptist, an African Methodist, and an African Baptist church. The foundation for another Catholic church has been laid, and the building is in progress" (Wild, *Valley of the Mississippi*, 11).

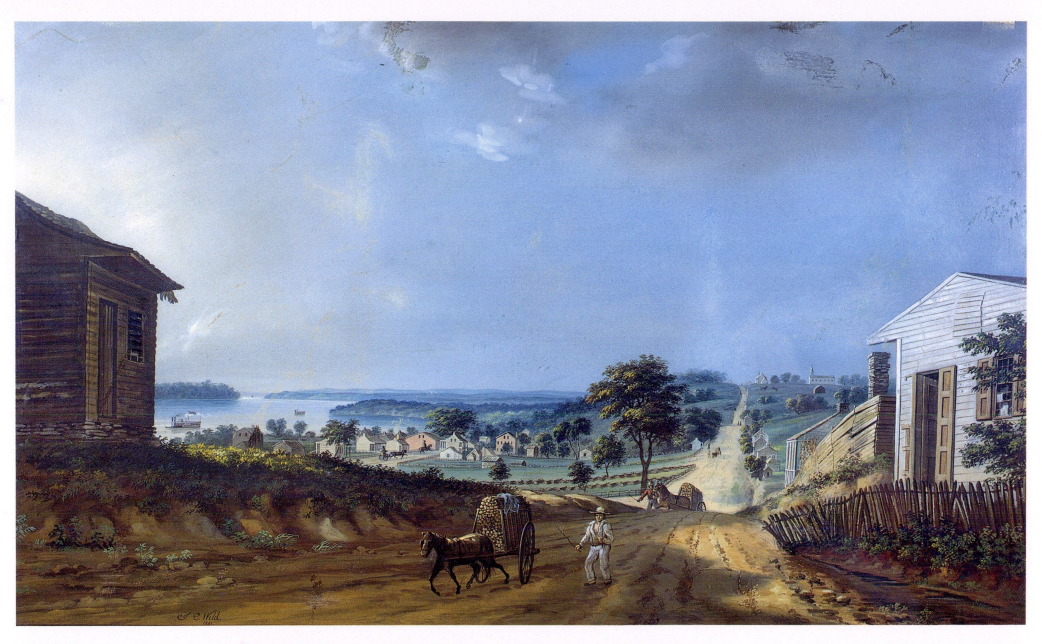

Figure 3–8. Watercolor view of Carondelet, Missouri, painted by John Caspar Wild in 1841. (St. Louis Mercantile Library Association.)

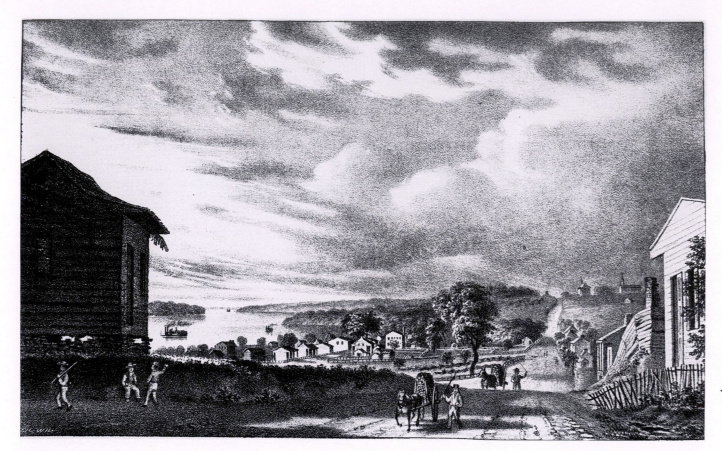

Figure 3–9. View of Carondelet, Missouri, drawn, lithographed, and published in St. Louis by John Caspar Wild, and printed by Chambers and Knapp of St. Louis in 1841. (St. Louis Mercantile Library Association.)

tiny community some five miles south of St. Louis, Lewis Thomas devoted three pages of text, including this descriptive passage:

> Its site occupies a slope . . . that rises like an amphitheatre from the water. . . . The village is regularly laid out, in [blocks] of about three hundred feet, in each of which there is generally a house of logs or weather boarding, surrounded with an orchard and garden; the whole presenting a very rural and picturesque appearance. There are but few buildings of brick or stone, and those are of recent construction.[32]

Wild seems to have busied himself in St. Louis with a variety of projects. In May 1841 he issued portraits of four murderers who were then in jail.[33] The

following month he released for sale a view of the steamboat *Missouri* passing by Selma, Missouri. In 1844 he prepared a lithographic view of a tobacco warehouse and a portrait of a St. Louis minister, and that fall he traveled to Minnesota where he painted at least two views of the Falls of St. Anthony and Fort Snelling.[34]

Probably he created images of many other things as well, since he advertised that in the medium of lithography he was prepared to execute "views of Buildings, Cities, Scenery, and Steamboats, &c. Also Maps, Professional Visiting and Invitation Cards, Bills of Exchange, Labels, Circulars, &c."[35] In addition to

32. Ibid., 45. There are other passages of interest: "In 1784," Thomas wrote, "we find it called *Vide Poche* or 'empty pocket,' which title, as legends inform us . . . , derived from the financial state of the domestic treasuries of its inhabitants." He also described a building Wild depicted in his view: "There is a nunnery at Carondelet . . . [It] is seen in the view just beyond the church. Both buildings are situated on the highest ground in the village."

33. *St. Louis Missouri Republican,* 12 May 1841.

34. McDermott, "J. C. Wild, Western Painter," 122–23, citing newspaper accounts in the *St. Louis Daily Evening Gazette* for 24 and 29 February 1844, a letter in the Sibley Papers of the Minnesota Historical Society, estate records, and a painting in the Minnesota Historical Society "formerly owned by the family of Boyden Sparkes of New York." Wild's lithograph, *Planter's Tobacco Warehouse, S. Louis, Mo.,* is in the Missouri Historical Society collections, as is his view of the steamboat at Selma, Missouri.

35. *St. Louis Missouri Republican,* 20 July 1841, p. 2, col. 5. It is interesting to compare this with

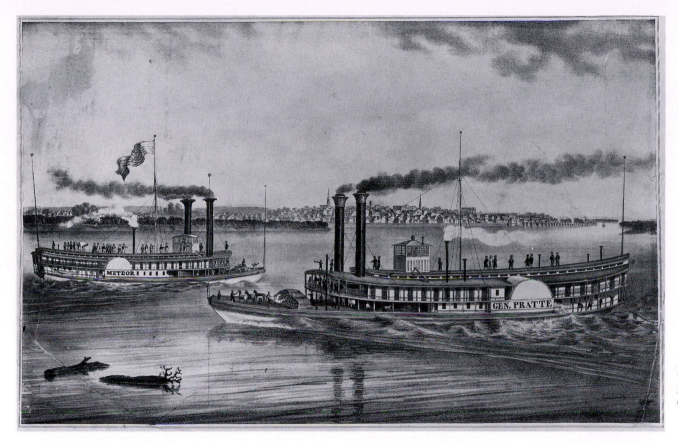

Figure 3–10. View of St. Louis from the South ca. 1841, drawn and published by John Caspar Wild. (Photographic Files, The Old Print Shop, New York City.)

whatever else he may have produced, one other portrayal of St. Louis came from his hands.

All of Wild's separately issued views are rare; this one is known only from a photograph. Figure 3–10 reproduces this lithograph, which is titled "South view of St. Louis. From the Mouth of the Cahokia, Illinois." Almost beyond doubt, this is the print a journalist referred to in November 1841 as one by Wild. The writer at that time described it as "a new view of St. Louis, taken opposite the Southern or lower part of the city."[36]

Students of steamboats may find this spirited image of the *Meteor* and the *General Pratte* more useful and attractive than will those concerned with the urban iconography of St. Louis. Nonetheless, this view suggests the extent to which the city stretched southward from the business center in the distance. For example, we can see (directly over the stern of the *Meteor*) a substantial number of houses that must represent suburban expansion or development within the southernmost limits of the city.

the advertisement Wild and Chevalier used in Philadelphia to state the scope of their business in 1838 as quoted in Snyder, "J. C. Wild," 39: "They are now fully prepared to execute every description of Lithography: such as Drawings, Writings, Maps, Bills, Cards, &c. on stone, in the fine style of the art."

36. *St. Louis Missouri Republican,* 27 November 1841. This was among the views Wild exhibited at the Mechanics Fair that month. McDermott, "J. C. Wild, Western Painter," p. 121, n. 25. I am grateful to Kenneth Newman, proprietor of The Old Print Shop in New York, for allowing me

access some years ago to his file of negatives used for illustrations in the catalogs issued regularly by his shop. It was there I came across this image of St. Louis by Wild. Newman was also good enough to let me use one of his two remaining prints (the negative having self-destructed) for study and for reproduction in this work. It would be helpful to learn of the whereabouts of the lithograph that the shop once sold, to find out if it is in private or institutional hands, and to learn if it is available for further study. Only in 1987 did I learn that McDermott had found the same photograph at the Old Print Shop, whose then proprietor, Harry Shaw Newman, extended to him the same courtesy his son did to me. See McDermott, "Some Rare Western Prints by J. C. Wild."

By the time he published this print Wild's name must have been well known in St. Louis, and he continued to make his home there for a few more years. The city directory for 1842 lists his place of business at 45 North First Street. This was part of or adjoined the *Missouri Republican* office. In 1845 the city directory identified Wild as a "Lithographic Printer" with premises upstairs on the east side of the first block of North Second Street.

However, no later than that summer Wild left St. Louis for Davenport, Iowa.[37] He may have gone there to live a year earlier despite the St. Louis directory listing to the contrary. Wild painted Davenport in 1844 and produced a lithographic version later that year. On the print he listed Davenport as his address.[38] In this region he also painted and lithographed other places, including Galena, Illinois, and Dubuque and Muscatine, Iowa.

Apparently Wild also was at work on another view of Davenport in 1846, which he probably intended to make available in a lithographic version. His illness and death, described in the following obituary from a Davenport newspaper, came before the artist could complete this project:

> We grieve to mention the death of Mr. J. C. Wild, well known for his views of Dubuque, Galena, Davenport, Rock Island, Moline, Bloomington [Muscatine], St. Louis, etc. He died yesterday of the dropsey after an illness of some months. At the time he was taken with his last sickness he was employed upon a most beautiful view of this place and surrounding scenery. Two or three days more of labor would have completed it. As an artist he had no superior in the west.[39]

All that we know of Wild's personality and appearance comes from the observations of an acquaintance in Davenport who, after Wild's death in 1846, described him as a "tall spare man of about forty years, with long raven black hair, whiskers and moustache, and restless brown eyes. He had, at times a worn and haggard look, the result, doubtless, of ill health, and a life-long battle with the world for the bare means of subsistence." Perhaps Wild had no business sense to match his artistic abilities. Possibly he was unfortunate in his choice of publishing associates. Probably he still grieved over the loss of his wife. For whatever

reasons, his companion could characterize him only as a person who "had neither humor of his own, nor an appreciation of humor in others. He looked tragedy, thought tragedy, and his conversation outside of business and art, was never much more cheerful than tragedy."[40]

Wild left few worldly goods. The probate court valued his oil paintings of six towns in Illinois and Iowa at $10.00 each and a number of unsold lithographs at from $.50 to $2.00. His most valuable possessions were a city lot in Davenport valued at $50.00 and three lithographic presses, one of which his estate inventory set at $25.00. His will provides one final scrap of personal information: that before his illness he was contemplating marriage, possibly to a relative. To "Miss Mary Jane Wild of Davenport," identified as his "intended wife," he gave his "watch and chain, . . . breast pin and . . . horse."[41]

Unknowingly, however, Wild bestowed a rich legacy to several other artists, printers, and publishers who appropriated his urban images as their own and almost never identified their source. What seems to be the earliest example occurred while Wild still lived. George Wooll used Wild's view of St. Louis's Front Street as either a billhead, letterhead, or lettersheet illustration, redrawing it at a much smaller size. As can be seen from the reproduction in Figure 3–11, he printed only the first three digits of the date, and on the only known impression someone added a "2" to make the date 1842. Thus, Wooll must have published his version not long after Wild issued his original lithograph.

The city directory for 1842 identified Wooll as a "print seller and gilder" at 71 Market Street. Perhaps Wooll acquired from Wild the right to reduce and redraw his Front Street view when he came into possession of the lithographic stones used by the artist for at least two of the eight views of St. Louis that Wild issued in 1840. These show the city from the northeast and from the southeast. They appear to be identical with those printed by Wild, except that Wooll removed the artist's name and used his own in the imprint. The view from the northeast is reproduced in Figure 3–12.

Only single impressions exist of these later states of the two Wild prints, but it is possible that Wooll reprinted the entire set. Since both lithographs give Wooll's address as 71 Market Street, he probably published them no later than 1844, for the city directory issued the following year indicates that he had moved to a different address.[42] The circumstances of their reissue recall Bowen's use in

37. According to McDermott, "J. C. Wild, Western Painter," the *St. Louis Weekly Reveille* for 11 August 1845 mentioned "the artist, Wilde, formerly of St. Louis."

38. Wild's superbly executed painting is in the Putnam Museum, Davenport. He signed and dated it 1844. The lithograph follows the painting closely. The printed title of the view indicates its scope: "Fort Armstrong on Rock-Island, Ill. East View of Davenport, Iowa T[erritory]. Town of Rock-Island, Ill. Moline." The Davenport address following Wild's name as printer of the lithograph is far from conclusive. Itinerant viewmakers frequently used a local address, possibly because they thought it might help sales.

39. *Davenport Gazette*, 13 August 1846.

40. [A. H. Sanders], "Artistic," in Franc B. Wilkie, *Davenport Past and Present*, 307–10.

41. Copies of Wild's will and probate records were obtained by John Francis McDermott and are among his papers in the library of Southern Illinois University, Edwardsville.

42. The city directories for 1845 and 1848 list his occupation as "carver and gilder," at 14

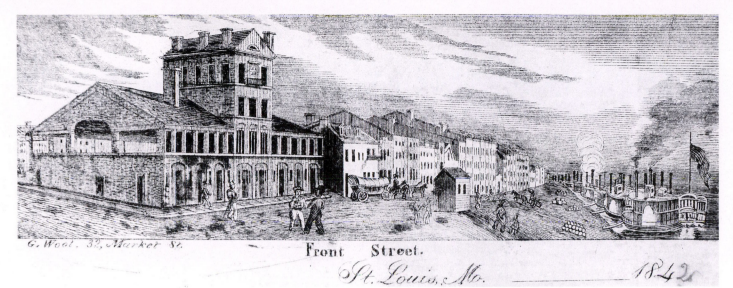

Front Street.

St. Louis, Mo. 1842

G. Wool. 32, Market St.

Philadelphia of Wild's images with the only change being in the imprint of each lithograph.

A Belgian publisher in Malines copied another Wild lithograph, the view of St. Louis in the first part of *The Valley of the Mississippi* that the artist based on his large print of 1839. This appeared in 1844 to illustrate an account of Father Pierre-Jean de Smet's travels to the Rocky Mountains. As can be seen from the reproduction in Figure 3–13, this was an almost exact duplicate of Wild's print previously illustrated in Figure 3–6. It differs from Wild's lithograph only in its smaller size and in a slight extension of the view to the right. Wild's name does not appear, only that of the lithographic printer.[43]

On another view of St. Louis that was published after Wild left the city the artist did receive credit. Perhaps this indicates that Wild authorized its use and

received payment for it. A copy of the engraving published in the January 1845 issue of the *Ladies Repository* appears in Figure 3–14. This does not resemble any other Wild view, and he may have newly drawn it for this use. It is a highly romanticized portrait of the city with major buildings exaggerated in size and church steeples attenuated for dramatic effect.[44]

Wild's first view of St. Louis from the Illinois shore as he simplified and reduced it for his *Valley of the Mississippi* still served as a model for other artists more than a decade after it first appeared. The second volume of Charles

North First Street in 1845 and at 112 North Fourth in the latter year. The 1847 directory identifies him as "gilder & framer, etc." at the Fourth Street address. The only other listing I have found is in the directory for 1840–1841, where after the name of George Wooll are the words *boarding house 24 Greene*. Wooll's version of the southeast view of St. Louis is in the collection of the Missouri Historical Society. Wooll's venture into print-selling seems to have lasted only a short time. In my *Views and Viewmakers of Urban America,* I erroneously dated the two prints (numbers 2034 and 2035) as [1846]. That should read [1841–1844].

43. See Pierre de Smet, *Voyages aux Montagnes Rocheuses . . . ,* opposite p. 1. This lithograph measures 3 11/16 x 6 1/16 inches. It was printed by Vandenbossche in Alost [Aaist, in East Flanders]. I have examined the copy in the Department of Rare Books, Olin Library, Cornell University. Father de Smet lived for a time in St. Louis. There are several biographies of him, including John Upton Terrell, *Black Robe: The Life of Pierre-Jean De Smet Missionary, Explorer & Pioneer.*

44. McDermott, in "J. C. Wild, Western Painter," observed, "No lithograph of this *Ladies Repository* view has ever been recorded; it forms a curious exception in his [Wild's] career." The *Ladies Repository* was published in Cincinnati, and Wild may have been known by its editor or others associated with the journal. This was an early use of city views by the publication, which in the 1850s provided its readers with engraved reductions of many of the large lithographs issued by the Smith Brothers, including one of St. Louis to be noted later. As with those, the magazine included a page of text describing the city as drawn by Wild. A portion of that reads: "The buildings of this city are generally substantial and tasteful, mostly of brick, but some of stone quarried on the spot. Some of the public buildings are of ample dimensions, and tasteful architecture: such as the Court House, the Roman Catholic Cathedral, and several of the churches. The City Hall, on a square which was reserved for the purpose, affords, in a basement, a convenient market. The Court House is in the middle of a public square in the center of the city. . . . We know of no site for a city, on the banks of the Mississippi, more beautiful or advantageous than that occupied by St. Louis. The engraving is imperfect. It represents only the densely populated portion of the city, and gives but a very inadequate idea of its commerce. We are informed that it is not uncommon to see twenty or thirty steamboats at its wharves."

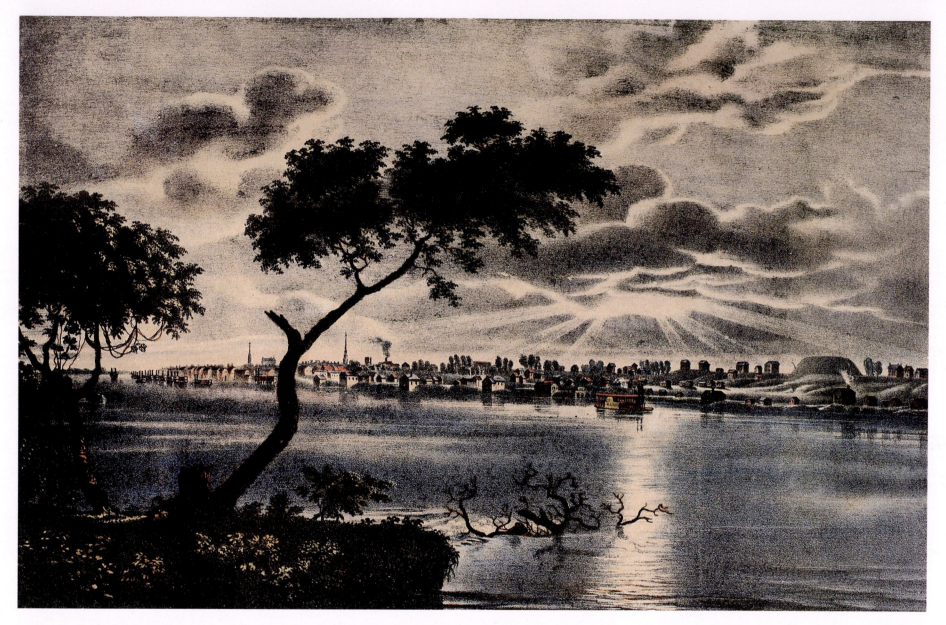

Figure 3–12. View of St. Louis from the northeast, published 1842–1844 in St. Louis by George Wooll after
the lithograph of John Caspar Wild. (Preston Player Collection, Knox College, Galesburg, Illinois.)

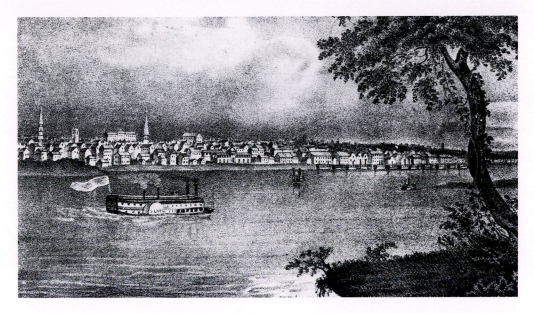

Figure 3–13. View of St. Louis, lithographed in East Flanders by Vandenbossche after a lithograph by John Caspar Wild, and published in Malines by P. J. Hanico in 1844. (Rare Book Room, OlinLibrary, Cornell University.)

Dana's *United States Illustrated* of 1853 included many views of Western towns and cities, St. Louis among them. The small engraving reproduced in Figure 3–15 follows Wild's portrayal of the city almost exactly. Readers of this elaborate publication in the early 1850s had no way of knowing that the city no longer resembled this attractive image.[45]

Other artists followed Wild in depicting St. Louis during the latter part of the 1840s and in the decade to follow. The city grew at this time at an exceedingly rapid pace and changed almost beyond recognition. A dozen or more view-makers—some residents, others itinerants—recorded the transformed face of the

city as it entered the Civil War period. Most of these views captured the appearance of St. Louis much as Wild and his predecessors did—that is, by sketching its buildings from ground level or from a somewhat more elevated position in a tall building.

As skills in drawing and painting cities developed, such views became more attractive. St. Louis can boast of several remarkable urban portraits of this type. By 1850 artists in other parts of the country had begun to portray cities and towns from higher angles by imagining viewpoints that they could not themselves reach except by stretching their artistic skills in unusual applications of the techniques of perspective drawing. Early examples of this style could be found in Boston, New York, and New Orleans.

It was an ideal time for this approach to reach St. Louis, for this method of delineating cities allowed artists to show cities in depth. No longer need St. Louis be shown as a strip of urban development along the river where only buildings in the immediate foreground could be displayed in any detail. The city was now growing westward, and artists working with the new bird's-eye view perspective provided us with an aerial record of how this took place and with what results.

The first of the two chapters to follow will explore the more conventional views of St. Louis that artists working in St. Louis or visiting the city produced before the Civil War. The second will examine views showing the city as if seen from high in the air. Together, these images of St. Louis record its remarkable development during the decade and a half after Wild's departure.

45. Charles A. Dana, ed., *The United States Illustrated: In Views of City and Country. with Descriptive and Historical Texts*. Vol. 2, *The West: or the States of the Mississippi Valley and the Pacific*. Dana's work grew out of the publication of *Meyer's Universum* by Joseph Meyer in Germany and by his son, Hermann, in America. This appeared in parts, each with text describing several steel engravings that pictured buildings, cities, and landscapes. See David Boutros, "The West Illustrated: Meyer's Views of Missouri River Towns" for an account of Hermann Meyer's American career and reproductions of the St. Louis view and those of other towns in Missouri. For additional information on Meyer's publications, see Robert E. Cazden, *A Social History of the German Book Trade in America to the Civil War*, 427–37. Cazden states that in 1851 Joseph Meyer "contracted with Conrad Witter in St. Louis for a series of sketches with explanatory texts of scenes along the Mississippi River." According to Cazden's sources, Witter "traveled more than 1,000 miles along the Mississippi River accompanied by the artist Th. Anders." Witter was a German-born St. Louis bookseller and publisher. See also Heinz Sarkowski, *Das Bibliographische Institut: Verlaggeschichte und Bibliographie. 1826–1976;* and Angelika Marsch, *Meyer's Universum: Ein Beitgrag zur Geschichte des Stahlstiches und des Verlagswesens im 19. Jahrhundert.*

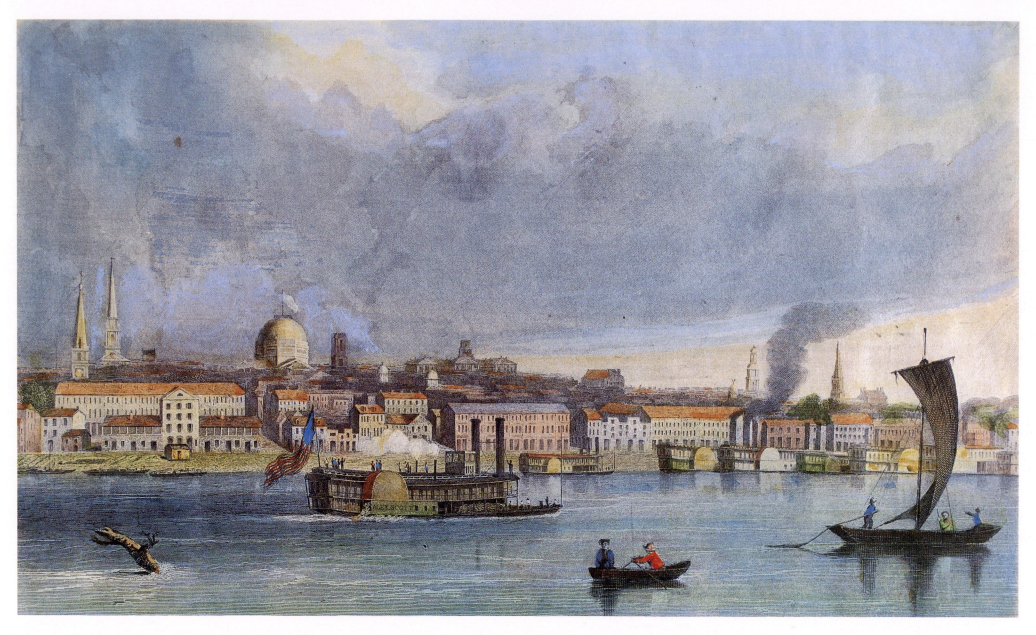

Figure 3–14. View of St. Louis, drawn by John Caspar Wild, engraved by J. T. Hammond, and published in Cincinnati in 1845. (Eric and Evelyn Newman Collection.)

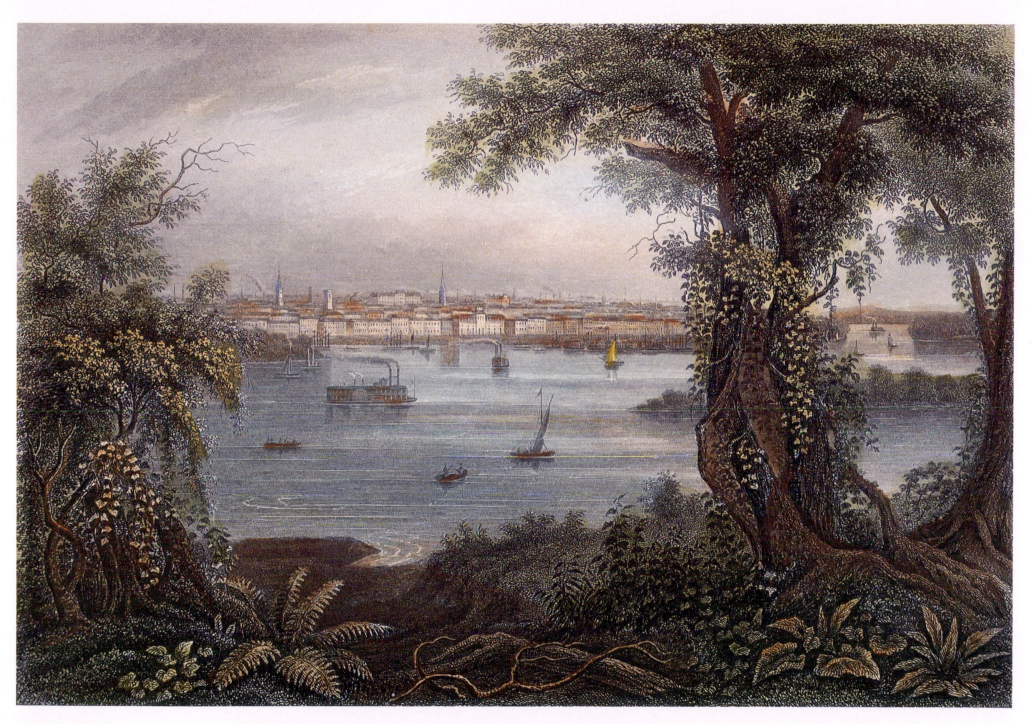

Figure 3–15. View of St. Louis, published in New York by Hermann J. Meyer in 1853. (Eric and Evelyn Newman Collection.)

ST. LOUIS VIEWMAKERS IN THE YEARS BEFORE THE CIVIL WAR

Wild so dominated the market for urban views of St. Louis from the time he arrived in the city until his departure in the mid-1840s that only one other printed depiction of the community appeared during this period. Figure 4–1 reproduces this view, one probably used on an illustrated lettersheet. The imprint at the lower left reads "St. Louis Lith. S. Second St. No. 140," but it does not identify the artist. In a date at the lower right (not shown here), the "2" is in manuscript, so we know that the view was published sometime during 1840–1842.

It was this scene that greeted Charles Dickens when he reached St. Louis by steamboat in 1842. In his *American Notes,* he left us impressions of what he saw when he explored the older part of town pictured in this view:

> In the old French portion . . . the thoroughfares are narrow and crooked, and some of the houses are very quaint and picturesque. . . . There are queer little barbers' shops and drinking-houses too . . . and abundance of crazy old tenements with blinking casements, such as may be seen in Flanders. Some of these ancient habitations, with high garret gable-windows perking to the roofs, have a kind of French shrug about them; and being lop-sided with age, appear to hold their heads askew, besides, as if they were grimacing in astonishment at the American Improvements.

These improvements, Dickens noted, consisted of "wharfs and warehouses, and new buildings in all directions." He found that "some very good houses, broad streets, and marble-fronted shops" were being completed to the west beyond the original French colonial settlement, "and the town bids fair in a few years to improve considerably." However, he suggested, "It is not likely ever to vie, in point of elegance or beauty, with Cincinnati."[1]

1. Charles Dickens, *American Notes for General Circulation,* chap. 12.

Although other visitors also found the French quarter of St. Louis charming and full of interest, most of them were more impressed by the large and thoroughly modern city rising from the prairies near the western edge of settlement. The speed with which this growth took place was amazing. In the year Dickens visited St. Louis the city suffered from a business depression as a result of finally having been affected by the financial panic of 1837. Nevertheless, in that year builders erected five hundred dwellings. By 1847 the number had risen to twenty-six hundred.[2] The St. Louis that Wild knew and drew underwent many changes as a result.

That perceptive English traveler, James Silk Buckingham, visiting St. Louis in 1841, declared that the new sections of the city were "as regularly laid out, and as well executed, as any town of similar size in the Union." He found the Courthouse "large and beautiful" and pointed out that the Planters Hotel, then still under construction, "has a longer frontage, and covers more ground, than the Astor House at New York." He described the still incomplete Theatre as "immense" and stated that it appeared to him "to be as large as the Opera House in London."

Buckingham observed that much of the city's growth could be accounted for by "fresh arrivals of German and Irish emigrants." He informed his readers that "no less than 340 Germans . . . arrived in one boat . . . from New Orleans, during our stay at St. Louis."[3] Eight years later Lady Emmeline Stuart Wortley

2. Lawrence Lowic, *The Architectural Heritage of St. Louis, 1803–1891,* 48.
3. J[ames] S[ilk] Buckingham, *The Eastern and Western States of America,* 3:119–20. Not everything in St. Louis was to Buckingham's liking. He singled out the nine hotels for criticism,

Figure 4–1. Lettersheet View of St. Louis printed ca. 1842 by the St. Louis Lithographic Company. (Missouri Historical Society.)

wrote that she had learned that "the German immigration this last year has been truly enormous."[4]

Substantial numbers of Germans already lived in St. Louis, more than six thousand by 1837. The census of 1840 revealed that Germans made up about 30 percent of the city's population of 16,469. During the decade of the 1840s they came in increasing numbers. By 1850 the city's population was almost five times what it had been at the start of the decade. Of the 77,860 persons living in St. Louis in 1850, 22,534 were German-born.

A German historian and travel writer, Franz von Löher, came to St. Louis in 1846 to observe conditions among his countrymen. He found many of them "densely concentrated around the city's center" but noted that Germans were also settling beyond "the central city" in "poorer sections, where lots are not yet so expensive." There he saw "entire streets, one after another, where only Germans live." Löher also mentioned a German suburban community along the Mississippi called New Bremen.[5] In addition, Löher observed that "a consider-

able number of Germans also inhabit the wealthiest parts of St. Louis." Indeed, Germans lived everywhere in the city. Although they were more concentrated in the far northern and southern wards, a great many Germans in St. Louis did not live in well-defined ethnic neighborhoods.

Irish immigrants contributed to the city's growth, too. In 1850 they numbered more than eleven thousand and accounted for nearly 15 percent of the total population. Some Irish could be found in almost every part of St. Louis, but many lived in neighborhoods that came to be known as "Kerry Patch" or "Tipperary," both adjacent to the northwestern border of downtown.[6]

claiming, "Even the best of them, the National Hotel, [was] greatly inferior to the second and third-rate hotels of the Eastern cities" (p. 126). He also described some of the business and industrial activities: "There are 2 large iron founderies, several boat-builders' yards, 2 floating docks for steamers, 2 good markets, a Chamber of Commerce, a State Bank, 9 Insurance Companies, and a Gas Light Company; so that St. Louis possesses all the elements of a rising and flourishing city" (pp. 126–27).

4. Emmeline Stuart Wortley, *Travels in the United States, etc. During 1849 and 1850*, 111. Lady Emmeline added, "A gentleman observed the other day the Germans, or the 'Dutch,' as he called them are 'eating up the West,' and sometimes driving the Americans out of their own towns. 'The greater part of the West,' he said, 'will actually be in their hands soon.'"

5. Translated passages on St. Louis in 1846–1847 from Franz von Löher's *Land und Leute in der Alten and Neuen Welt: Reiseskizzen* [Land and People in the Old and New Worlds: Travel

Sketches] can be found in Frederic Trautmann, "Missouri Through a German's Eyes: Franz von Löher on St. Louis and Hermann." Trautmann cites George H. Kellner, "The German Element on the Urban Frontier: St. Louis, 1830–1860," which I have not had an opportunity to examine. James Neal Primm, in *Lion of the Valley: St. Louis, Missouri*, 150, has this to say about Bremen, one of several settlements platted beyond the city boundaries during the 1840s: "In 1844 Bremen, a German enclave, was incorporated about 2.5 miles north of Market, between the river and Broadway from Buchanan to Salisbury. The river curved back sharply to the west of this site and Bremen's developers . . . insisted on using the river as a base line instead of building their streets north and south, east and west. The result was a maze of odd little triangles, parallelograms, and dead ends as they encountered the differently-angled streets of other subdivisions. Later developers would do the same, and the jumble of streets at subdivision intersections became characteristic of both north and south St. Louis (where the river also curves back to the west). Rare indeed is the St. Louis street that is oriented to the cardinal points of the compass."

6. German and Irish migration to the city is treated in the early pages of a study concentrating on Italians in St. Louis. See Gary Ross Mormino, *Immigrants on the Hill: Italian-Americans in St. Louis, 1881–1982*. Mormino notes that many Germans lived in the "Soulard district, near the breweries" on the south side of St. Louis (p. 16). See also Margaret Lo Piccolo Sullivan, "St. Louis Ethnic Neighborhoods, 1850–1930: An Introduction." Sullivan mentions that "shortly after

Other Europeans found places to live in St. Louis as well, and in 1850 residents of the city who had been born abroad outnumbered native-born Americans.[7] There were, of course, many of the latter, and a substantial portion of them had been born elsewhere in the United States. This large and steady inflow of population from outside the city's boundaries could not be accommodated by the limited number of streets and blocks of pre-1840 St. Louis, and owners of land adjoining the city soon found it profitable to subdivide their property by laying out streets and dividing the resulting blocks into building sites.[8]

The undated map with views of St. Louis reproduced in Figure 4–2 shows the results of urban development up to 1848, the year when this engraving appeared in the city directory. It is apparent from the parquet-like pattern of streets that no overall development plan existed and that private owners created additions to the city in whatever form they pleased. Awkward and potentially dangerous connections between adjacent subdivisions and scores of difficult-to-use building sites are legacies of this period. If the city attempted to use any of its powers to avoid this disarray, it is not apparent from the evidence on the ground.[9]

The view of St. Louis from the Illinois side of the Mississippi occupying

1800 approximately one hundred Irish business and professional men, many of whom were veterans of the French army, moved easily into local society" (p. 65).

7. See Lowic, *Architectural Heritage of St. Louis*, 47; and Primm, *Lion of the Valley*, 149, 173. The 1850 census indicated that 40,414 persons, or 52.1 percent of the population, were foreign-born.

8. "In 1833 Judge Lucas opened a new addition west as far as Ninth Street, and three years later the Soulard addition on the south side and additions by John O'Fallon and William Christy were opened between Washington and Franklin Avenues. Many new additions opened beyond the city limits, but without control over platting, there was no continuity in the location or direction of streets or in the size of blocks. As a result, streets had jogs, dead-ends and various widths, creating problems which had to be corrected at great expense in later years through widenings and cut-offs." St. Louis City Plan Commission, *History: Physical Growth of the City of Saint Louis*, 13.

9. Boosters of St. Louis at the time saw nothing wrong with how the city had developed. The anonymous author of *The Western Metropolis; or St. Louis in 1846* concluded, "As a whole, the site of St. Louis is excellently adapted to the display of a well planned city, and the more modern portion of the place is laid out with regularity and symmetry" (p. 58). This volume included a *Map of the City of St. Louis, Mo.* engraved by Julius Hutawa, whose work will be reviewed shortly. Hutawa gave his address as "Second St. Cor. of Pine." New Orleans, which occupies a similar curving site and needed to adjust the angles of successive grids up- and downriver from the original settlement, provides a more successful example of efforts by municipal authorities and plantation owners to create an integrated street system. New Orleans also used lands in public ownership to lay out additions to the city. Some of this land was originally part of the French and then Spanish common that the Congress conferred on the new municipality after the Louisiana

the top half of Figure 4–2 displays several new skyline elements, some of which can be seen in more detail in the border vignettes surrounding the general view and map. Presumably the J. M. Kershaw whose name appears in the map title as having "drawn, engraved, and printed" this engraving was responsible for the view as well. The border vignettes that Kershaw placed around the plan and skyline view, several of which come from images created by Wild, help make this engraving a highly informative catalog of St. Louis building development and urban progress.[10]

A version of this view appeared as an illustration on an undated lettersheet that identifies one H. Fisher as the engraver but lists neither artist nor publisher. Doubtless this was the work of the Henry Fisher who was listed in the city directory for 1848 as residing at the Virginia Hotel and who the 1850 directory identified as an engraver at 204 Franklin Avenue. Figure 4–3 reproduces Fisher's rare and attractive lettersheet view. It differs from Kershaw's delineation only in reversing the positions on the horizon of the Courthouse dome and the square tower of Christ Church.

An unknown correspondent used this lettersheet to write to a Miss Wilkins in Pennsylvania. In doing so, he identified for the recipient the buildings whose spires and dome towered over the low buildings in the foreground. Apparently the writer was correct except for what seems to be an error in transposing in the list the Second Presbyterian Church (the first steeple on the left) with the Catholic Cathedral just to the left of the Courthouse and the flagstaff. The square tower of St. Paul's Episcopal Church and the elongated broken rectangle of the Planters Hotel appear above the City Market on the river.

Farther north, eight steeples then punctuated the skyline, two of them partly obscured by smoke from steamboat stacks. From left to right they represent Christ Episcopal Church, the Baptist Church, St. Xavier's Church of St. Louis University, the German Lutheran Church, the First Presbyterian Church, the Third Presbyterian Church, and St. Patrick's Catholic Church. Far to the right stands a prominent St. Louis landmark in the northern part of the city, the shot tower.

Both this engraving by Fisher and the view published by Kershaw seem to be based on another earlier print—a very rare undated lithograph of the city

Purchase, and some came into public ownership through municipal purchase shortly before the land was needed for urban expansion.

10. The city directory for 1845 lists "M. Kershaw" as an engraver at 28 North Second Street. Directories for 1847, 1848, 1850, and 1851 all identify him as James M. Kershaw located at 34 North Second St.

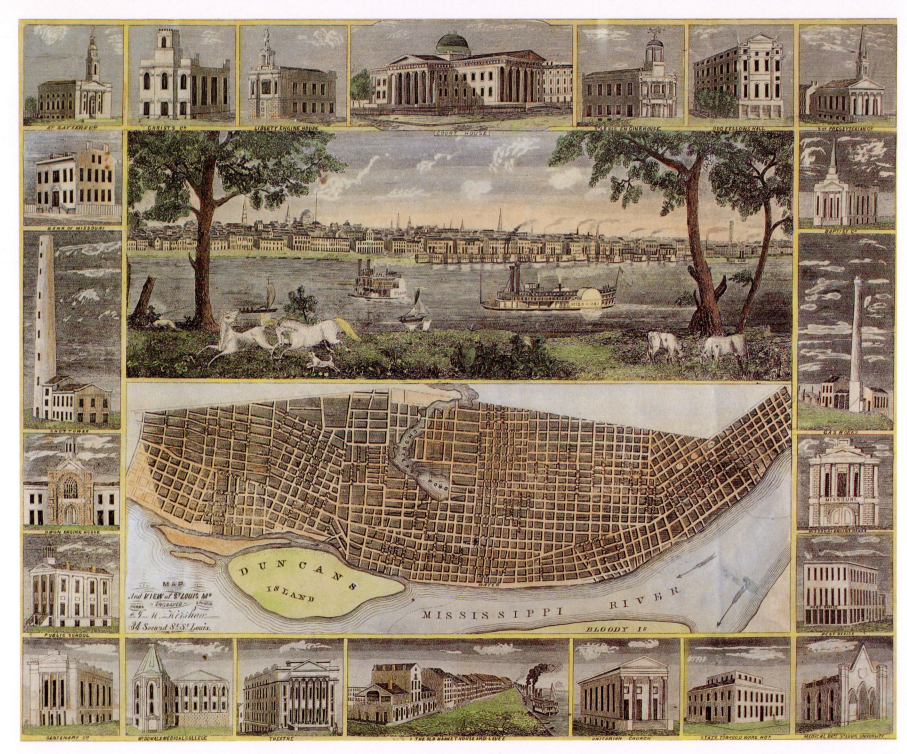

Figure 4–2. Plan and Views of St. Louis ca. 1848, drawn and printed in St. Louis by James M. Kershaw. (Eric and Evelyn Newman Collection.)

The first steeple on the left is the Cathedral (Catholick)
" Second " " " " Second Presbyterian Church
" third is the rotunday of the Court House
" fourth is the flag Staf on hickoy pole
" fifth " St Paul's Church Episcopalian
the next large house with wings at each end and Cupola on top is the Planters hotel
" Sixth Steeple is the Christ Church Episcopalian
" Seventh " " the Baptist Church
" Eight " " " Catholick Colledge & Church
" ninth " " " luthearan german "
" tenth " " " first Presbyterian C "
" Eleventh " " " third "
" twelfth " " " St Patrick's Church Catholick
" thirteenth " " " fourth Presbyterian Church
" the high spire at the extreme right is the Shot tower

To Miss Mary E. Wilkins
Mecersburg.
Franklin Co
Pennsylvania

Figure 4–3. View of St. Louis ca. 1848, engraved in St. Louis by Henry Fisher. (Missouri Historical Society.)

printed and probably drawn and published by Julius Hutawa. This view, known in only two impressions, is reproduced in Figure 4–4 and probably appeared in 1846 or 1847. Fewer church spires appear on the horizon, indicating—if the artist was not unbelievably careless—that this is an older depiction of the city than either the Kershaw or Fisher views.[11]

Not much is known of Julius Hutawa, the creator of the lithograph. He came to Missouri from his native Poland with his brother, Edward, about 1832. The city directory of St. Louis for 1838–1839 lists Edward, and in 1842 Julius's name appears, with him identified as a "lithographer." He also painted, so he probably drew the view of St. Louis in Figure 4–4. Doubtless he also put it on stone and printed it at his shop either at 8 South Third Street, the address of both Julius and Edward in 1845; on Second Street at the corner of Pine, an address Julius gave on a map printed in 1846; or at 45 North Second Street, where Julius could be found from 1847 through 1851. Hutawa remained in business as a lithographic printer for many years, and his name appears on a number of items, of which maps appear to be the most numerous.[12]

Clearly, this represented an early effort by Hutawa, for the lithograph is rather crudely executed. Hutawa also directly "borrowed" the vignette images of the Courthouse and the Theatre without attribution from the lithographs that Wild produced several years earlier. Nevertheless, these features do not detract from the importance of the print. The perspectives in the lower left and right vignettes provide fascinating glimpses down Main and Market streets, while the vignette just above the title displays the handsome facade of the Planters Hotel and shows us the "observatory" on the roof where Wild sketched his 360-degree panorama of 1842.

11. The view could not be earlier than 1846, the year in which the steamboat *Pride of the West* was built in Cincinnati and began service with St. Louis as her home port. The other vessel identified in the view, the *Missouri*, was also based in St. Louis and began service in 1845. The *Pride of the West* was destroyed by ice on 13 February 1853, while the *Missouri* burned on 8 July 1851. See William M. Lytle, comp., *Merchant Steam Vessels of the United States, 1807–1868,* 129, 156, 228, 230.

12. Hutawa seems to have specialized in lithographed maps. The city directory for 1853 lists his enterprise at 49 North Second Street as "map publishing office." In 1850 he issued a "Plan of the City of St. Louis, Mo." drawn by him and published by him and Leopold Gast, whose work will be examined shortly. I have also noted advertisements of his "Map Publishing Office" in city directories for 1863 and 1864, and there were doubtless others. Finally, two news accounts in the *St. Louis Daily Democrat* for 25 July and 30 August 1853, both on p. 2, describe at some length the map of the Indian reservation in Nebraska Territory printed by Hutawa. There is a brief passage about him—not entirely consistent with the facts as just stated—in Charles van Ravenswaay, *The Arts and Architecture of German Settlements in Missouri,* 489–91.

Hutawa's choice of a ground-level viewpoint confined his attention to the streets located close to the Mississippi. Although this part of the city contained most of the older and more important buildings, newer portions of the city, still only partially built-up, then extended well beyond the original narrow band of settlement along the river. New houses and shops occupied portions of subdivisions laid out beyond the brow of the slope rising from the Mississippi. On this nearly unbroken stretch of prairie the city began to expand north, west, and south.

Traditional panoramas by conventional townscape artists sketching the city from the Illinois shore provided an adequate record of early St. Louis when it confined itself to the original linear grid of the colonial plan. As the city broke out of its first boundaries, however, this method of representation became increasingly unsatisfactory. New buildings beyond the break in topography did not appear unless they were very tall.

This situation called for the skills of the bird's-eye view artist, but until the mid-1850s no delineator of St. Louis employed this technique of drawing cities. For nearly a decade after Wild, therefore, we must rely on traditional ground-level panoramas, using contemporary descriptions to provide additional information about the appearance of and conditions in various parts of the city. One such account coincides in time with the map and view in Figure 4–2 and is particularly helpful. It appeared in the *St. Louis Business Directory for 1847* and is signed only "By A Traveler."[13]

After visiting the levee (Water Street on the map in Figure 4–2 and Front Street on that in Figure 2–11), this observer explored Main (or First) Street. Here he found "Printing offices, Dry Goods stores, Auctioneers, Book Stores, Paper sellers, Artizans, Druggists and Apothecaries, Hardware establishments, etc., etc." On this narrow street he also encountered several banks, "a batch of Insurance Companies," and "Hotels, Jewelleries, and generally appendices to general commerce."

On Olive, Pine, and Locust between Main and Third streets he discovered "Printing Offices, Justice Offices . . . and Lawyers Offices" as well as some "doctors offices, and hotels and boarding houses." Second Street merchants and craftsmen represented diverse occupations: "In it are found some private dwelling houses, manufacturers, fruiterers, metal workers, locksmiths and artizans—also employments tributary to the arts and literature, as lithographic and engraving businesses; house painters, dry goods, and grocery stores."

On Third Street he observed "some ground not yet appropriated to good

13. See "A Walk in the Streets of St. Louis in 1845."

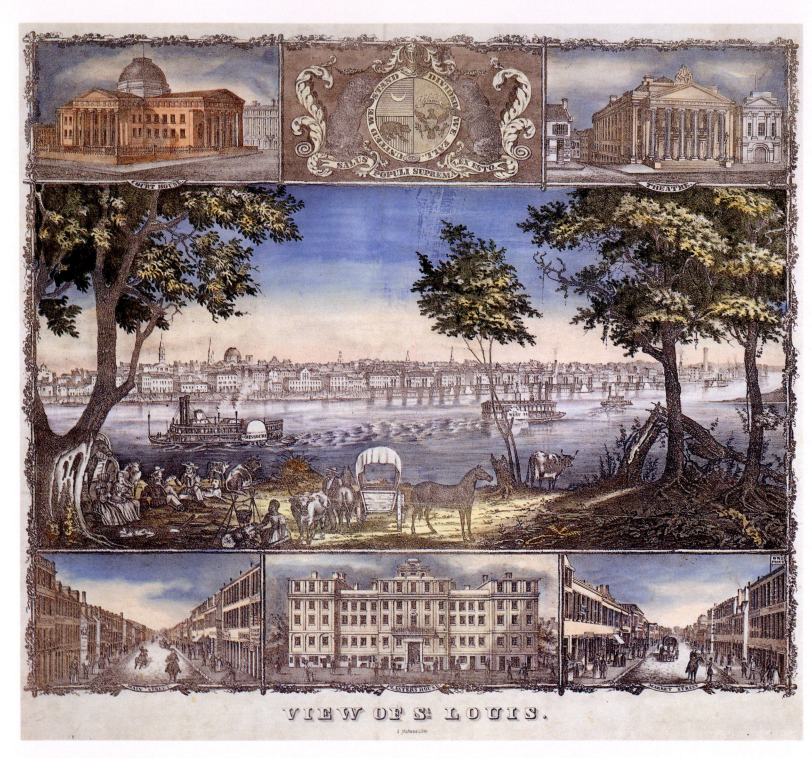

Figure 4–4. Views of St. Louis ca. 1846–1847, printed in St. Louis by Julius Hutawa. (Chicago Historical Society.)

buildings, or to any—yet." He did see "one or two splendid and tasteful urban villas . . . of which one is the residence of Merewether Lewis Clarke, Esq." Here also he saw the City Hotel with its "very fine lawn for a lounge, an exceedingly ornamental, as well as comfortable, appendage to a public establishment of this sort," and the "new market, a most growing place, having increased in its products, deposit and surrounding population, with a most wonderful rapidity."

Our guide asserted that Fourth Street "in its width and consequent free air, the neatness and freshness of the buildings, and in their architectural superiority, may be just, styled the Bond street, old style, and Broadway, N.Y., new style of St. Louis." He noted that the Courthouse and the Planters Hotel were located here, as were "stores, of every description," and many "superb" private houses.

On Fifth Street he listed "some six or seven places for religious worship, chiefly cornering upon other streets," as well as two others "in their incipient stages, and yet unfinished": "the North Baptist Church and the Associate Reformed Presbyterian Church." Here also he observed "several buildings in an unfinished state, of superior materials, with granite mouldings, and ornamented in a tasteful manner, with escutcheons and armorial bearings."

Our anonymous authority concluded with some comments on Broadway, a thoroughfare that then continued Third and Fourth streets north of Washington Street:

> This northernly section of St. Louis city, has obtained, in a short period of time, a very rapid growth and settlement, and . . . has contributed to the support of the new market, [for] contrary to the general law predominant in the settlement of towns in the west, the north part of the city has been comparatively neglected by the masses, and the greatest acession of population has accrued to the aid of the south.

A few years later, in 1849, a visitor to St. Louis recorded how the city had expanded to the west. He found that the city limits extended five miles along the river and from three to four miles inland. He stated, "A distance of more than two miles exclusive of the Central district is entirely occupied by substantial buildings." To the west he noted that "the ground is thickly covered as far as the sixteenth street, and even to the twentieth street good and handsome buildings are by no means rare." This part of the city was "fast becoming a pleasant and fashionable quarter for private residences."[14]

No views published in the 1840s provide any information on the appearance of these western neighborhoods, as artists continued to concentrate on the city as seen from the Mississippi River. Henry Lewis produced one such portrait of St. Louis and another of Carondelet. Although they did not appear until some time during 1854–1857, Lewis drew both places in 1846 or 1847, and a discussion of them and of the remarkable artist who drew them is more appropriate here than later in the chapter.

Born in Shropshire in 1829, Lewis came to Boston with his father. They moved to St. Louis in 1836 when Lewis was seventeen. There he seems to have worked first as a carpenter, perhaps in one of the theaters, and then possibly as a set painter. He then decided to become an artist. Apparently he was self-taught since he stated, "There was no one in St. Louis when I first took up art as a profession to give lessons."[15] He specialized in landscapes and by the mid-1840s was referred to by local newspapers as "a landscape painter of more than ordinary merit" and one whose paintings were "lifting him rapidly to a high rank in his profession." His painting *Correct View of St. Louis as Seen from the Illinois Shore* won Lewis a prize at the St. Louis fair in 1846.[16]

Lewis's lithograph based on that view is reproduced in Figure 4-5. It came from a press in Düsseldorf, where Lewis settled in the early 1850s after touring America and Europe to exhibit his painted panorama of the Mississippi River. He began work on this in 1846, making sketching trips on the river from Minnesota to St. Louis and commissioning Charles Rogers, another artist, to draw towns and river scenes on the lower Mississippi.[17]

In 1855 Lewis decided to lithograph portions of his panorama to illustrate a book. After many delays his publisher in Düsseldorf issued this work, *Das*

14. Letter from Otis Adams to the Reverend Thomas Curtis Biscoe, written onboard the steamboat *Boston*, 13 October 1849, in "St. Louis in 1849." Adams alludes only indirectly to the fire that destroyed much of central St. Louis the previous May, observing, "The whole Central district will very soon be rebuilt. Several large blocks have already been completed and are now occupied." Doubtless he knew that his correspondent was aware of the disaster.

15. Henry Lewis to Warren Upham, 7 March 1902, MS in Minnesota Historical Society, as quoted in Bertha L. Heilbron, *Making a Motion Picture in 1848: Henry Lewis' Journal of a Canoe Voyage from the Falls of St. Anthony to St. Louis*, 2. Information on Lewis's early life is mainly speculative. I have relied on these sources, in addition to the one just cited: Marie L. Schmitz, "Henry Lewis: Panorama Maker"; John Francis McDermott, *Seth Eastman's Mississippi: A Lost Portfolio Recovered, The Lost Panoramas of the Mississippi* and "Henry Lewis's *Das Illustrirte Mississippithal*"; Bertha L. Heilbron, ed., Introduction to *The Valley of the Mississippi Illustrated by Henry Lewis*, 1–33; Lila M. Johnson, "Found (and Purchased): Seth Eastman Water Colors"; and William J. Petersen, *Mississippi River Panorama: The Henry Lewis Great National Work*.

16. *St. Louis Missouri Republican*, 15 March 1845, and *St. Louis Weekly Reveille*, 8 March 1847, as quoted in Schmitz, "Henry Lewis," 37. I am grateful to Schmitz for providing in her article some material about Lewis not previously published. The oil painting of St. Louis referred to in the *Reveille* article is in the collection of the Missouri Historical Society.

17. The sketches made by Lewis and Rogers are in two collections. Those of places from Iowa to Minnesota are in the Buffalo Bill Historical Center, Cody, Wyoming. Those from Iowa to the mouth of the Mississippi are in the Missouri Historical Society.

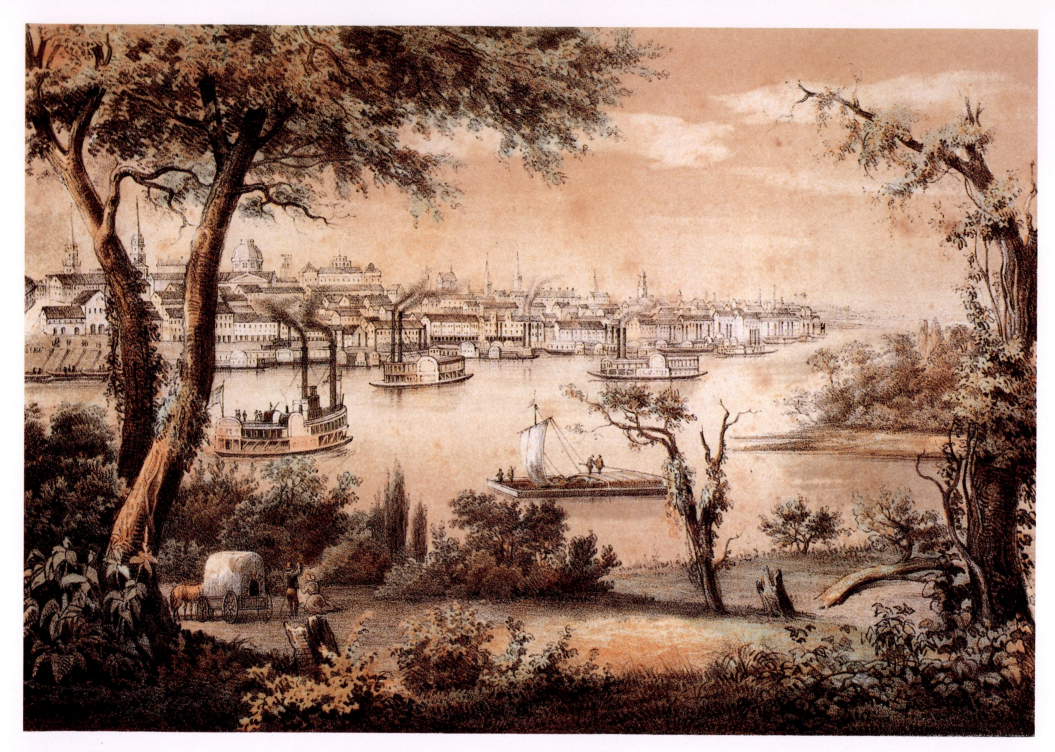

Figure 4–5. View of St. Louis ca. 1846–1848, drawn by Henry Lewis, printed in Aachen by C. H. Müller, and published in Düsseldorf by Arnz & Co. in 1854–1857. (Research Collections, Lovejoy Library, Southern Illinois University, Edwardsville.)

Illustrirte Mississippithal (The Mississippi Valley Illustrated), in 1857. Among the many views of towns along the river, in addition to that of St. Louis, it also contained the view of Carondelet reproduced in Figure 4-6. Of that small French settlement, a few miles below and then still independent of St. Louis, Lewis had this to say:

> In recent times several substantial brick buildings were erected there, which contrast sharply with the dilapidated shacks of the early French settlers. Immediately above the shore rises an enormous bluff . . . , and on its summit several attractive dwellings may be seen. One of the buildings is a well-known seminary for young ladies. It has a rather striking style of architecture. . . . At some distance from it, standing alone on top of the bluff, is another structure with a matching exterior. Called Montesano House, this is an amusement place for the residents of St. Louis.[18]

The "well-known seminary" mentioned by Lewis was that operated by the Sisters of St. Joseph. In Lewis's view of Carondelet, it occupies the hill to the left. The first members of the order had arrived in the village in the spring of 1836, when they organized their first school with twenty pupils. Five years later the sisters replaced the log building in which they taught with a brick structure that housed both a day academy and a boarding school.[19]

Lewis also included in the text of this volume a detailed list of the major buildings depicted in his St. Louis view (Figure 4-5) as seen from left to right. Although visible on Lewis's lithograph, these landmarks can be located and identified with greater ease on another far larger view showing the city from an almost identical vantage point. The work of Julius Hutawa, whose earlier work we have discussed, this more precisely rendered portrait of St. Louis, probably published in 1849, is reproduced in Figure 4-7.[20] Although rather clumsily drawn and unskillfully lithographed, Hutawa's print conveys much of the bustle and vitality of St. Louis at midcentury. Like Hutawa's earlier view it is a rare print, with only three impressions recorded in St. Louis collections.

The impressive urban scene depicted in this print is nicely supplemented by Lewis's description of his own very similar but much smaller view. Lewis listed the structures appearing on the skyline beginning at the left:

> The Catholic Cathedral, the first Presbyterian Church, the Courthouse with its great dome, the Episcopalian Church, the Planter's Hotel . . . , the Unitarian Church, the theater with the flag on the roof, the Methodist Church, St. George's Church, the Odd Fellows Hall, the second Presbyterian Church, St. Xavier's Cathedral, with its Jesuit College, and Mound Church.

Lewis also pointed out that in the distance one could see "chimneys of the various foundries and engine manufactories" as well as "the tall shot tower . . . the most extensive and complete establishment of the kind in the world." The text then mentioned that "in the extreme distance appear some of the country houses of the wealthier classes, occupying a beautiful plateau commanding a fine view of the river and neighboring shore." Finally, Lewis identified "the old brick Market House" that stood "on the extreme left near the water."[21] In his lithograph of St. Louis, Hutawa shows a portion of the next block beyond the Market to the south; otherwise his view and the one by Lewis closely resemble one another in what they reveal of that portion of the city visible from the river.[22]

All this was to change dramatically in the spring of 1849 when a fire that originated on a steamboat at the levee spread quickly through a large part of the older sections of St. Louis. Before this holocaust could be brought under control

18. Lewis, *Valley of the Mississippi,* 325–26.

19. See Marcella M. Holloway, CSJ, "The Sisters of St. Joseph of Carondelet: 150 Years of Good Works in America." Sister Marcella includes an illustration—doubtless a conjectural reconstruction—of the two-room log building the nuns first occupied in Carondelet. In the Lewis view two towers rise from the steep slope of the hill on the right. One of these was a shot tower. On the original sketch Lewis made of Carondelet, the major structures on the hills are identified.

20. Tentative dating of the Hutawa view is based on the steamboats depicted in the river. Among those whose names can be easily read are the *Illinois* (built in 1847 and destroyed by fire in New Orleans on 8 October 1849) and the *Ohio* (not commissioned until 1849). These dates are from Lytle, comp., *Merchant Steam Vessels,* 89, 143, 232. Since a large number of the buildings appearing in the view were destroyed by fire on 17 and 18 May 1849, the view must have been published earlier that year.

21. Lewis, *Valley of the Mississippi,* 47–48.

22. Indeed the views are so similar that the issue of plagiarism immediately comes to mind. Certainly Lewis did not hesitate to appropriate the work of others. Although he bought many sketches of places on the upper Mississippi from Seth Eastman, he passed them off as his own work. Toward the end of his life, in 1901, he sent a painting to the Missouri Historical Society stating that it was "a picture of St. Louis as it appeared when I sketched it in 1847." In fact, it is a copy of one of Wild's paintings (which we know only as a lithograph) showing the city as seen from Chouteau's Pond. On this latter example, see the illustration caption in Schmitz, "Henry Lewis," p. 42. It is possible, of course, that Lewis was employed by Wild and actually did the original sketch. Similarly, Lewis may have used Hutawa's lithograph as the basis for the view he prepared in Düsseldorf some ten years later. However, the Lewis painting of this scene in the Missouri Historical Society and his lithograph are nearly identical. It may have been Hutawa who copied from Lewis, using the painting as his model. This is suggested by the treatment of the portions of the city at the extreme left of Lewis's painting and Hutawa's lithograph. Both show portions of the block immediately to the south of the old Market, although in the Lewis painting much of this is obstructed by a tree trunk on the Illinois bank that frames the composition on the left side.

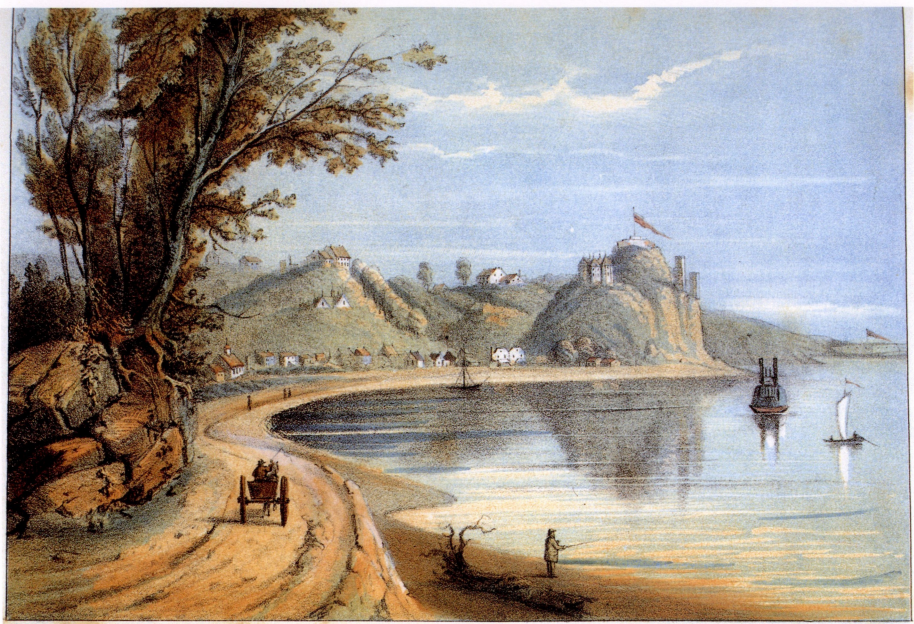

H.Lewis pinx. Lith. Jnst Arnz & Cº Düsseldorf

CARONDELET or VIDE-POCHE. CARONDELET oder VIDE-POCHE.
MISSOURI. (Die leere Tasche) MISSOURI.

Figure 4–6. View of Carondelet ca. 1846–1848, drawn by Henry Lewis, printed in Aachen by C. H. Müller, and published in Düsseldorf by Arnz & Co. in 1854–1857. (Research Collections, Lovejoy Library, Southern Illinois University, Edwardsville.)

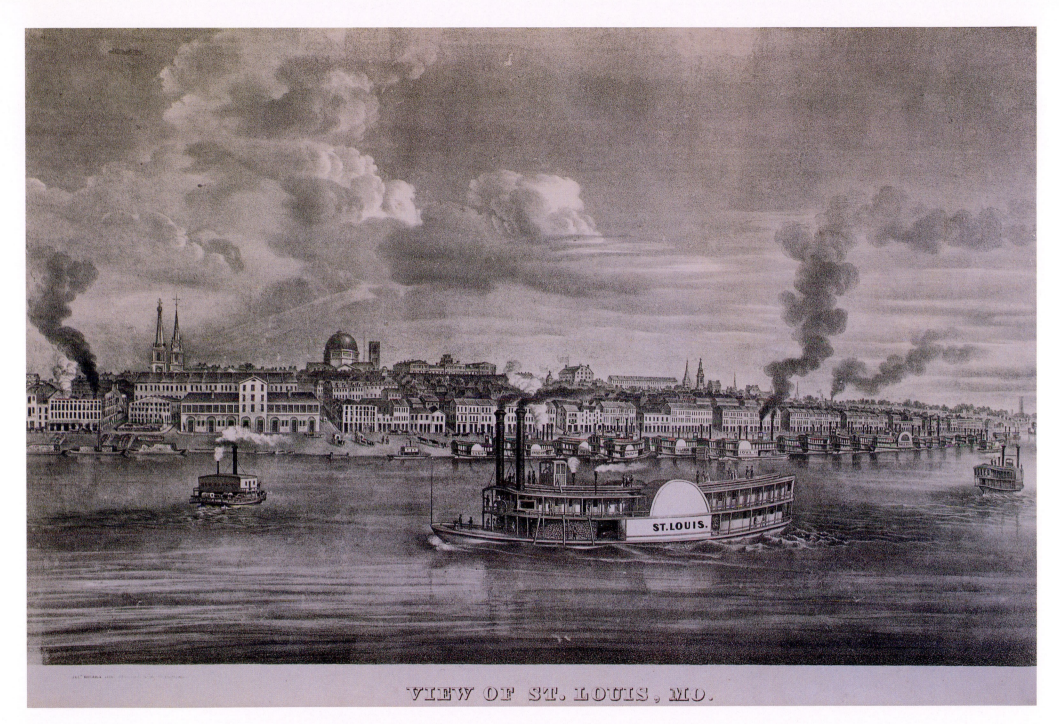

VIEW OF ST. LOUIS, MO.

Figure 4–7. View of St. Louis ca. 1849, printed in St. Louis by Julius Hutawa. (Collection of A. G. Edwards & Sons, Inc., St. Louis, Missouri.)

it left fifteen blocks ravaged, 430 buildings (including 136 dwellings) leveled, and twenty-three steamboats and a variety of other rivercraft destroyed.

Hutawa must have rushed to publish a record of this tragedy, which occurred on 17 and 18 May, although the exact date when his print appeared is not known. Figure 4–8 reproduces his efforts: a map of the burned district and a view of the city with smoke and flames rising from the buildings in the path of the fire. Leopold Gast, who worked with Hutawa, made the plate for this engraving from his own drawing of the fire, and he drew the map of the city as well.

This disaster attracted national attention, and the New York firm of Currier & Ives issued the lithograph reproduced in Figure 4–9 to capitalize on the desire in the East for knowledge about it. Theirs is a much more dramatic (but probably less realistic) scene than the Hutawa and Gast version. The raging inferno along the waterfront strikes the viewer with all the more intensity because of the contrast with the dark sky and water and the burned-out hulks of the destroyed steamboats adrift on the river.

News of the St. Louis fire reached Henry Lewis during the exhibition of his panorama in Cincinnati. His associate, Charles Gaylor, had already prepared extensive notes about the scenes shown in the panorama, but he was able to add this footnote to the printed program:

> The city of St. Louis has lately been visited by a terrible conflagration which broke out in the neighborhood of the gas works, on the steamboat White Cloud—and from her communicated to other boats at the landing, hence to the produce on shore from which the buildings took fire. The loss is immense, being estimated six millions of dollars. The whole of that part of the city bordering on the river for three quarters of a mile was destroyed, and Lewis' mammoth Pamorama [sic] gives probably the very best representation of the city as it was before the fire. This fact adds double interest to the picture.[23]

Figure 4–10 reproduces a lithograph of St. Louis in flames that Lewis included in his *Valley of the Mississippi Illustrated*. Of course, he drew this from descriptions and by using his imagination, for he did not himself witness the event. That did not prevent him from writing a vivid account of the fire in his book suggesting that he had been present. He also quoted at length from a report on the disaster that appeared in the *St. Louis Daily Union* on 18 May 1849.

23. Charles Gaylor, *Lewis' Panorama. A Description of Lewis' Mammoth Panorama of the Mississippi River, from the Falls of St. Anthony to the City of St. Louis . . . ,* p. 15, note. An interesting watercolor view of the burned portion of St. Louis is in the collection of the St. Louis Mercantile Library Association. Apparently painted shortly after the event, this 5 x 46 inch view is signed by Lamasson.

At the time of the fire St. Louis had just passed through another tragedy, 8,423 persons having died during an outbreak of cholera earlier in 1849. Despite these twin catastrophes, the city continued to grow in population, expand in size, and change in appearance. In the burned-out district public authorities widened the levee and extended it as well, arranged for portions of First Street to be made sixty feet in width, and passed a new fire code.

Property owners quickly rebuilt the fifteen blocks that the fire destroyed. Lady Emmeline Stuart Wortley visited St. Louis at this time and was astounded by the volume and speed of building activity in the central city. She recorded seeing from her downtown hotel

> a long view of gigantic, and gigantically-growing-up dwellings, that seemed every morning to be about a story higher than we left them on the preceding night: as if they slept during the night on guano, like the small boy in the American tale, who reposed on a field covered by it, and whose father, on seeking him the following day, found a gawky gentleman of eight feet high, bearing a strong resemblance to a Patagoman [sic] walking-stick.[24]

Three images of the reconstructed waterfront and the rebuilt city appeared in the first half of the 1850s. They testify to the speed with which St. Louis property owners and the municipal government transformed the face the city presented to those arriving by river. The earliest, reproduced in Figure 4–11, decorated the top of a large map of the city drawn by Julius Hutawa and published by him and Leopold Gast.

If we are to accept the evidence of this view, by 1850 no gaps existed in the solid rows of imposing buildings lining the waterfront. In looking at the foreground of the central portion of this lithograph, therefore, we see nothing but newly constructed buildings erected after May 1849. There are reasons to believe, however, that Hutawa simply turned ahead the hands of the clock of progress to show how the city would appear when reconstruction was complete. The evidence, circumstantial as it is, can be found in the artist's treatment of one important building for which adequate documentation exists.

This is the City Building, constructed to replace the old Market on the south side of Market Street at the waterfront, a site not affected by the fire. In 1849 the city demolished this familiar landmark. The new building, constructed with funds from a bond issue, faced the river like its predecessor. One can see the image of this imposing, five-story structure below the twin spires of the Cathedral and the Second Presbyterian Church. At the time Hutawa published his view, however, the building remained incomplete, and it only reached three

24. Wortley, *Travels,* 111.

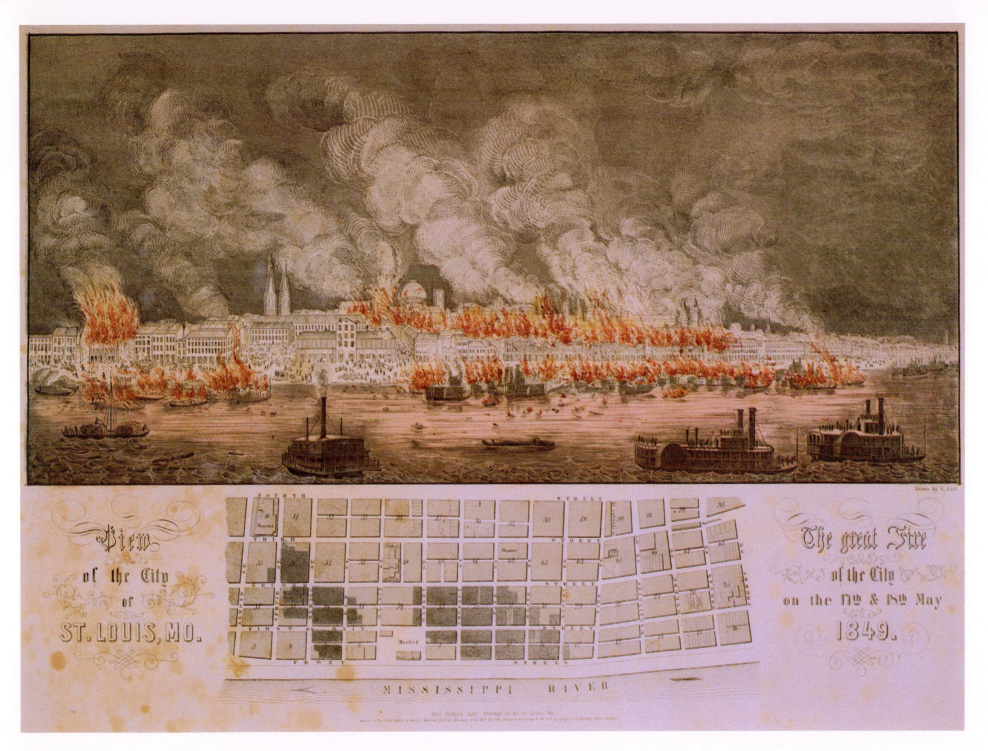

Figure 4–8. View of the St. Louis Fire of 1849 and a Plan of the Damaged District, drawn by Leopold Gast and printed and published in St. Louis by Julius Hutawa in 1849. (Collection of A. G. Edwards & Sons, Inc., St. Louis, Missouri.)

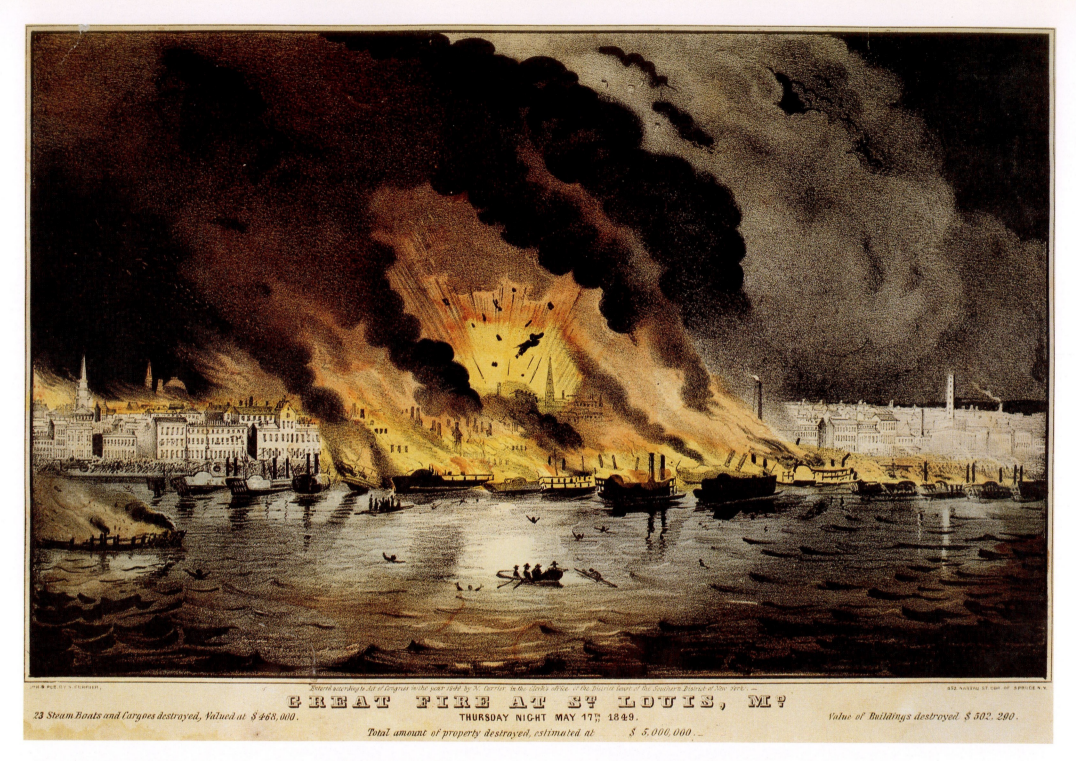

GREAT FIRE AT ST. LOUIS, MO.

THURSDAY NIGHT MAY 17TH 1849.

23 Steam Boats and Cargoes destroyed, Valued at $468,000.

Value of Buildings destroyed $502,290.

Total amount of property destroyed, estimated at $5,000,000.

Figure 4–9. View of the St. Louis Fire of 1849, printed and published in New York by Nathaniel Currier in 1849. (Collection of A. G. Edwards & Sons, Inc., St. Louis, Missouri.)

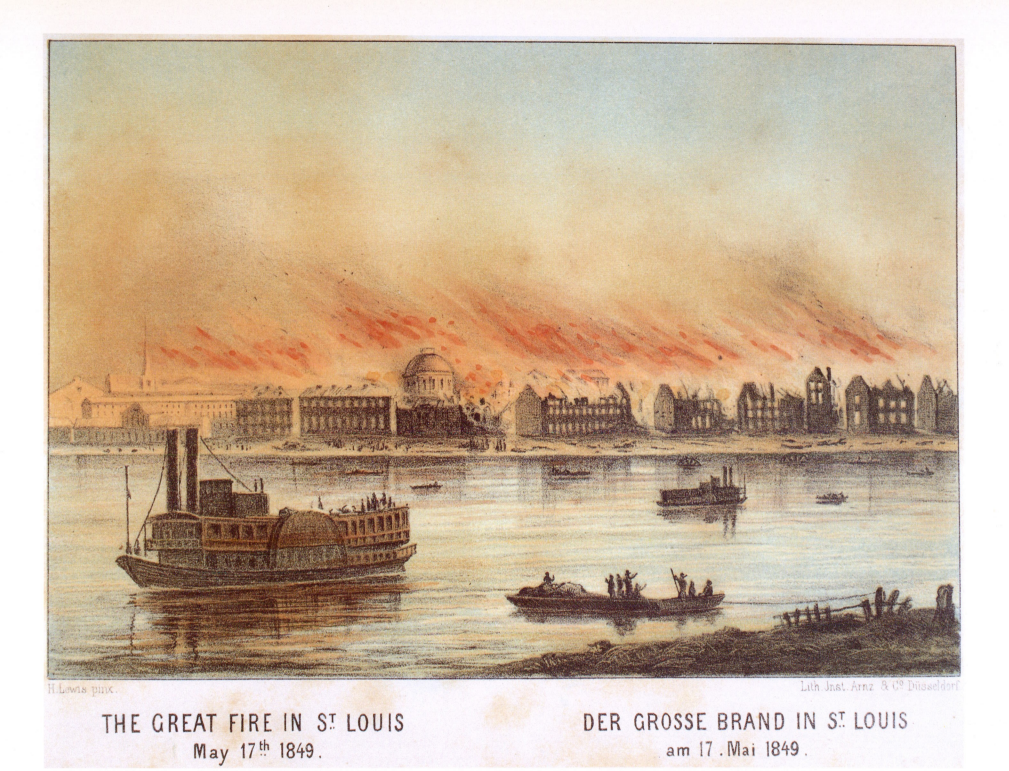

THE GREAT FIRE IN ST. LOUIS
May 17th 1849.

DER GROSSE BRAND IN ST. LOUIS
am 17. Mai 1849.

Figure 4-10. View of the St. Louis Fire of 1849, drawn by Henry Lewis, printed in Aachen by C. H. Müller, and published in Düsseldorf by Arnz & Co. in 1854–1857. (Research Collections, Lovejoy Library, Southern Illinois University, Edwardsville.)

Figure 4–11. View of St. Louis in 1850, drawn by Julius Hutawa and published in St. Louis by Julius Hutawa and Leopold Gast. (St. Louis Mercantile Library Association.)

stories in January 1851. Two additional stories were added shortly thereafter, topped by a pediment over the central section of the five divisions of the facade that the pilasters defined. The city abandoned its plans to use the top two floors for municipal offices and meeting rooms. Perhaps that was just as well, for the building burned in 1856 and was replaced by a row of warehouses. St. Louis would not acquire a permanent city hall for another forty years.[25]

We can place more confidence in the large and attractive lithograph reproduced in Figure 4–12. Eduard Robyn drew and put on stone this view that he and his brother Charles printed and published at their upstairs shop on the west side of Second Street between Chestnut and Pine.[26] Eduard and Charles

came from a Huguenot family that had moved from France to Westphalia, where Eduard was born in Emmerich in 1820. He arrived in St. Louis with Charles in 1846, and the two stayed for a year with their brother William before moving to Philadelphia.[27] There they either learned lithography or perfected skills they had already practiced in Germany. Probably Eduard came to America knowing how to draw well, for he is the artist of a lithographic view of a Philadelphia building published about 1847. In 1851 or 1852 Eduard and Charles returned to St. Louis to establish their own business.[28]

Like similar small lithographic enterprises, the Robyn shop advertised its ability to produce such items as "Portraits, Landscapes, Animals taken from

25. The date of another Hutawa map with an inset view of the city is a puzzle. An impression is in the Missouri Historical Society titled *City of St Louis from February 15, 1841 to Decr 5 1855.* Presumably the dates refer to the municipal boundaries of the city established in those years, and therefore the map must have been published no earlier than 1855. However, the view of St. Louis within an irregular oval at the lower left shows the city as it appeared before the fire of 1849, and the map shows Chouteau's Pond, which had been drained by 1855, partly overlaid with streets. Moreover, the title cartouche gives Hutawa's address as 45 North Second Street, an address he last used in the city directory for 1852 before he moved to 49 North Second. These anomalies are impossible to explain.

26. The Robyns do not appear in city directories for 1848 or 1851. The 1852 directory gives their address as 44 Second between Chestnut and Pine upstairs. The directory for 1853–1854 shows Eduard Robyn at 40 ½ North Second Street and residing at 212 South Second. His address appears in 1857 as 42 North Second, in 1860 as 19 Chestnut, and in 1864 as Chestnut on the

corner of Third. There are no entries for 1865, 1866, or 1867. G. A. Robyn, engraver, is listed in the 1871 and 1874 directories; in the latter year his first name is given as Gustav. He was a son of Eduard and his wife, Julie (or Jullie) Grafe, and was born 19 February 1853.

27. Transcription in the Missouri Historical Society of biographical notes dated 16 October 1939 by descendants of Eduard Robyn; van Ravenswaay, *Arts and Architecture,* 491–92; Ernst C. Krohn, ed., "The Autobiography of William Robyn."

28. William Hart printed the view signed by Eduard. It shows the Odd Fellows Hall in Philadelphia. See Nicholas B. Wainwright, *Philadelphia in the Romantic Age of Lithography: An Illustrated History of Early Lithography in Philadelphia . . . ,* entry 248, p. 173. Two of Eduard's children were born in Philadelphia, Wilhelmina on 22 January 1849 and Julius Ernst on 31 May 1850. Exactly how long Eduard remained in Philadelphia is not known, but it seems likely he was there from 1846 to shortly before 1853, when he and his brother established their own business in St. Louis.

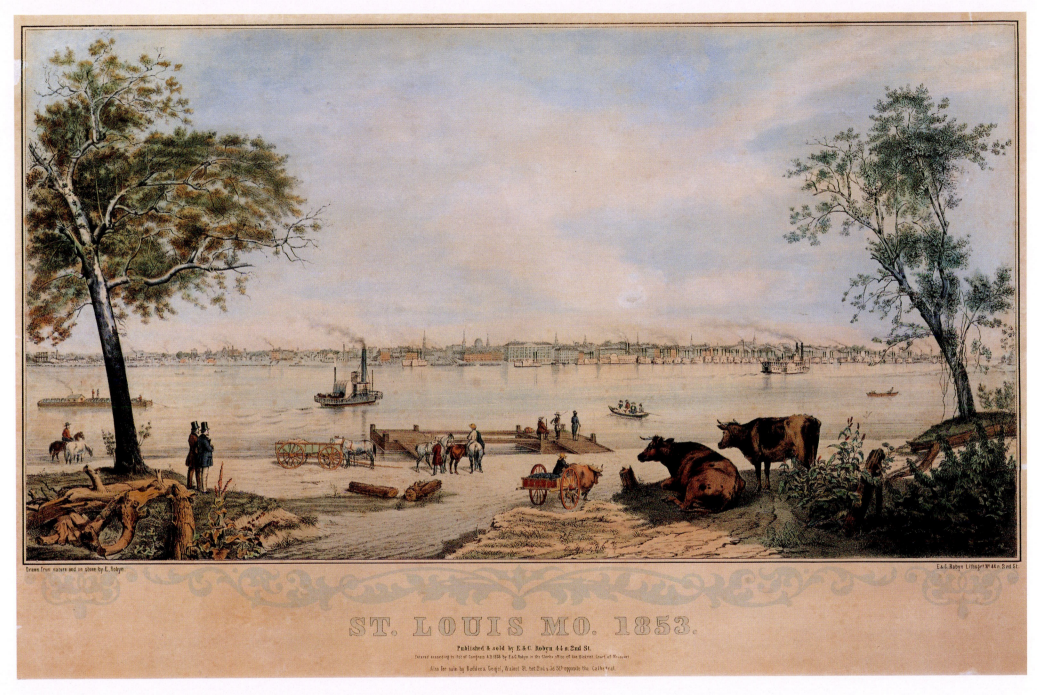

STIL LOUIS MO. 1853.

Published & sold by E.&C. Robyn 44 n.2nd St.

Figure 4–12. View of St. Louis in 1853, drawn and lithographed by Eduard Robyn and printed and published in St. Louis by Eduard and Charles Robyn. (Amon Carter Museum, Fort Worth, Texas.)

Figure 4–13. View of St. Louis in 1853, drawn by Eduard Robyn and printed St. Louis ca. 1853 by Eduard and Charles Robyn. (Special Collections, Olin Library, Washington University.)

life, Music, Vignettes for Books, drafts, Showbills, Labels, [and] Visiting Cards."[29] The Robyns did not list city views among their products, but one of the young firm's early and most elaborate products was its splendid St. Louis lithograph of 1853, referred to by a local publication as "an excellent print of St. Louis . . . , beautiful and true."[30]

29. Transcribed notice or advertisement in the Missouri Historical Society from the *Western Journal & Civilian* (December 1855): 75. This same transcription contains this entry perhaps used as the heading for an advertisement: "Lithographic, Drawing, Engraving and Color Printing Establishment, No. 42 North Second Street, below Pine, St. Louis, Mo." Philadelphia was the scene of some of the earliest American color lithography using multiple stones. The Robyns would have been well aware of these techniques, which by 1850 were becoming widely used in the East. Probably they introduced color lithography to St. Louis. The Robyn lithographic city views are so rare that I have been able to study them only through color transparencies and cannot determine whether they were entirely printed in color or all or part of the color was added by hand. The impression of the St. Louis view of 1853 in the Amon Carter Museum has a decorative border in light blue that has obviously been printed from a separate stone. Probably at least some of the other colors were also applied in this way. For a brief summary of early color

Robyn followed the tradition of all previous views of St. Louis (except for Wild's unique panorama from the Planters Hotel) in portraying the city from the Illinois shore of the Mississippi. The bucolic foreground details of the ferry landing in Illinois Town (now East St. Louis) contrast sharply with the intensively urbanized riverbank on the opposite side of the mighty river. Almost directly across from us stands the City Building whose completion Hutawa anticipated three years earlier in his view. From there, steamboats taking on and discharging passengers and cargo line the levee as far as the eye can see to the north.

Although Eduard Robyn either drew, printed, or published five other large and engaging Missouri city views (one of which we will examine later), he

lithography in the United States, the techniques used, and citations to nineteenth-century literature on the subject, see my *Views and Viewmakers of Urban America . . .* , 28–31.

30. Transcribed notice in the Missouri Historical Society from the *St. Louis Presbyterian,* 28 April 1853.

drew no more urban portraits of St. Louis. However, he and his brother did issue a much smaller version of his lithograph. This lettersheet view, one of the most attractive of the several views of St. Louis in this form, is reproduced in Figure 4–13.

Probably Robyn spent much of his artistic energies in working with Ferdinand Welcker, another St. Louis artist, on a mammoth panorama called *An Artist's Travels in the Eastern Hemisphere.* Painted on canvas eight feet high and 350 feet long, it was designed to be displayed like the Lewis panorama of the Mississippi: unrolled behind a frame while a narrator described each scene.[31] Although no more delightful view of St. Louis exists than Robyn's superb example of lithographic craftsmanship, its appeal lies in its artistic composition and nostalgic charm rather than in the information it provides about the character and atmosphere of this still rapidly growing Western metropolis. For that kind of portrayal, we must turn to the third and last of the river-level city views of St. Louis that appeared by the mid-1850s.

Figure 4–14 shows what was by far the most detailed river-level panorama of St. Louis to be produced. This line engraving (probably on stone) measures 7 ¾ by 51 ⅜ inches and reveals the appearance of more than two miles of the city's waterfront. It illustrated a booklet containing a collection of articles written by John Hogan that originally appeared in the *St. Louis Daily Missouri Republican.* In 1854 the newspaper issued the articles under the title *Thoughts About the City of St. Louis . . . ,* and they received wide distribution in the United States and Europe in English and foreign-language editions.[32]

Although Hogan's booklet bears the date 1854, the view itself has the title *Saint Louis, Mo. in 1855.* This discrepancy probably resulted from the involvement of two publishers in this venture, since the engraving came from the firm of Leopold Gast & Brother, which held its copyright. Doubtless the Gasts sold separate copies of the view as well as making it available to the *Missouri Republican* for folding and binding with copies of Hogan's booklet. Leopold and his brother, August, also printed the view, and it is likely that one or both of them engraved the plates or stones for this multisheet panorama as well. The print does not identify the artist.

The Gasts, like the Robyns, came from Germany. Leopold arrived in St. Louis by May or June 1849, since he engraved the plan and view of the fire that Hutawa issued shortly after that event occurred in May. In 1850 Leopold established his own lithographic printing firm, although that year and the next he continued to maintain some kind of business relationship with Hutawa. By 1853 he and August were listing their firm as Leopold Gast & Brother, and the two remained partners until August bought out Leopold's interest in 1866.[33]

31. The Robyn-Welcker panorama is now in the collection of the Missouri Historical Society. One panel is reproduced in van Ravenswaay, *Arts and Architecture,* 492, which also reproduces two of Robyn's city views showing Washington (1859) and Hermann (1860), Missouri. The Cape Girardeau view of 1858 was drawn by A. Bottger. Charles Robyn is identified as the printer; Eduard's name does not appear, although he probably acted as co-publisher with his brother. The other views are of Jefferson City in 1860 and Carondelet the same year. Except for the St. Louis view, each one of the Robyn urban lithographs appears in a frame of small vignettes illustrating important buildings of each town. The *St. Louis Post-Dispatch* for 31 March 1940 reproduced a number of sketches by Robyn that had been discovered by van Ravenswaay earlier that year in the family home in Hermann where Robyn went to live in 1858 and where he died three years later. The sketches are lively portraits bordering on caricature of persons Robyn observed in St. Louis and Hermann. One is a fine self-portrait that reveals Robyn's considerable skills as an artist. All of these now can be found in the Missouri Historical Society. In 1857 the Robyn brothers sold their business to Andreas August Theodor Schrader, an employee who began work for them in 1853. For Schrader's view of Carondelet, see Chapter V.

32. Copies of the booklet, [John Hogan], *Thoughts About the City of St. Louis, her Commerce and Manufactures, Railroads, &c.,* are now scarce, but the text has been reprinted, with notes about the author, in Isaac H. Lionberger and Stella M. Drumm, "Thoughts About the City of St. Louis."

See also "The Cover." Born in Mallow, County Cork, Ireland, in 1802, John Hogan came to Baltimore when he was eight. He became a Methodist minister and moved to Illinois about 1826. Retiring as an active minister in 1830, he entered a career as a merchant, first in Edwardsville and then in Alton, Illinois. In 1835 Hogan became president of the Alton branch of the State Bank of Illinois. In 1836 he served in the state legislature, and in 1841 President Harrison appointed him commissioner of federal lands in Illinois, an office he held until 1844. Following the death of his wife, Hogan moved to St. Louis, where he became a partner with his brother-in-law in a wholesale grocery business. In 1854 he established a savings bank, possibly the first institution of its kind in St. Louis. It was then he wrote the series of articles for the *Daily Missouri Republican.* Although promotional in tone and clearly intended to advertise the advantages Hogan believed St. Louis possessed, the articles contain a wealth of factual information about the city in the middle of the last century. In later years Hogan ran for mayor of St. Louis, served as the city's postmaster, and won a seat in Congress in 1864. His interest in civic affairs and in his church continued until his death in 1892.

33. According to the brief anonymous note on Hogan and the Gasts, "The Cover," p. 5, both Gasts were born in Belle, a community in the German principality of Lippe-Detmold. Transcriptions of biographical notes on the Gasts in the files of the Missouri Historical Society seem to conflict with some of the few known facts about the beginning of the Gast enterprise in St. Louis. Citing John Thomas Scharf, *History of St. Louis City and County . . . ,* 2:1335, one note states the Gasts "came to U.S. after the Revolution of 1848" and then "spent a few months in New York, 1½ years in Pittsburgh, and came to St. L. in 1852." Leopold's presence in St. Louis in 1849 is established as he was the engraver of the Hutawa view. My guess is that he was an employee of Hutawa when he first came to St. Louis. The 1850 directory lists him as a lithographer at 21 Market Street. That same year he and Hutawa jointly published a large map of the city with a panoramic view of the waterfront at the top. Also in 1850 the firm of "Juls. Hutawa & L. Gast Lithrs. St. Louis, Mo." printed a view of Burlington, Iowa, drawn by Fr. Berchem Lucrode, an

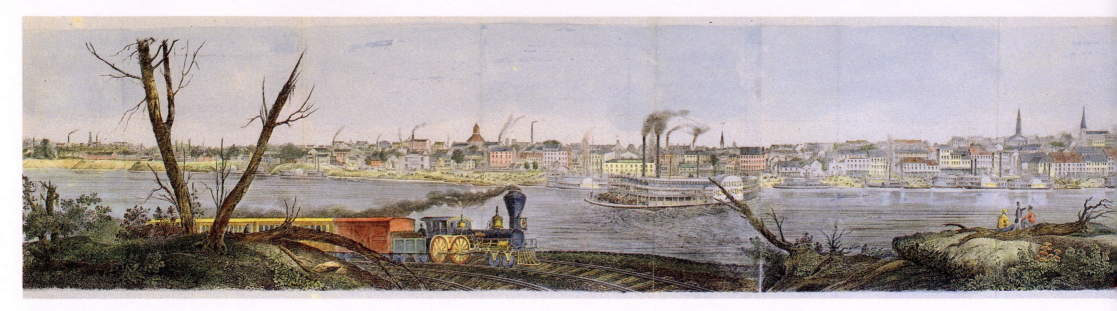

Figure 4–14. View of St. Louis in 1855, printed and published in St. Louis by Leopold Gast & Brother. (Collection of A. G. Edwards & Sons, Inc., St. Louis, Missouri.)

In his booklet Hogan described how rebuilding after the fire transformed the older parts of the town, changes that one can see on Gast's view:

> The narrow streets were widened, and the houses that have arisen on those ashes are now business palaces, built in continuous blocks of stone, brick and iron. . . . If a person . . . who had left here before that great fire, were to return now, he would be lost; none of the old "land marks" being left to guide him. The narrow streets, the inconvenient houses, have given places to rows of four and five story brick stores, equal to the business purposes of those of any city in the land.[34]

St. Louis developed as a major industrial center in the 1850s. The Gast view does not show all the factories of the city, but many located near the Mississippi do appear, particularly at the left and the right—the southern and northern flanks of the city near the river. When Charles Mackay came to St. Louis just three years after the Gasts printed their panorama, the number of industries impressed him deeply. He summarized what he saw in these words:

> The manufactures of St. Louis are numerous and important, and comprise twenty flour-mills, about the same number of saw-mills, twenty-five founderies, engine and boiler manufactories and machine-shops, eight or ten establishments engaged in the manufacture of railroad cars and locomotives, besides several chemical, soap, and candle works, and a celebrated type foundery.[35]

impression of which is in the library of Loras College in Dubuque, Iowa. The 1851 directory indicates that Gast still had some kind of association with Hutawa, listing him as "Gast Leopold (Hutawa & Co.) es 2d Carond. av, s of Lafayette." The 1852–1853 directory lists both Leopold and Augustus as living at "2nd Carondolet av b. Geyer ave & Lafayette" and as doing business as Leopold Gast & Brother, Lithographers, at 36 South Fourth Street. By 1857 this listing reads Leopold Gast & "Bros.," although only the names of Augustus and Leopold appear in the directory. In 1865 the directory listing is Leopold Gast, Bro. & Co., with four persons identified as principals of the firm: Leopold, August, and John Gast and Charles F. Moeller. It was then a company of "engravers, lithographers, and artists" located on Third Street, at the northeast corner of Olive. The following year, according to notes in the Historical Society, Leopold sold his interest in the firm to August. That company continued to do business for many years, appearing in the city directory of 1878 as August Gast & Co., with August Gast, Edward E. Wittler, and Louis J. W. Wall as principals.

34. Lionberger and Drumm, "Thoughts About the City of St. Louis," 163–64. A Canadian

who visited St. Louis in 1857 came away with a similar impression: "Although most of the traces of the French rule have passed away, one now and then drops upon a prim-looking stone house, with its high dormer windows and its green *jalousies*, with its architraved porch, and its *perron* of steps, reminding you of the structures still to be seen in numbers in the Montreal suburbs, and in the Lower Canadian villages—a sure sign of the presence of a lawyer or doctor. But they are now of rare occurrence in St. Louis, and as I strolled about, looking for the old residences of the first settlers, I was disappointed to find that they were so seldom to be met with." William Kingsford, *Impressions of the West and South, During a Six Weeks' Holiday,* 32.

35. Charles Mackay, *Life and Liberty in America: or, Sketches of a Tour in the United States and Canada in 1857–58.* Even this impressive list failed to do justice to the city's industrial diversity.

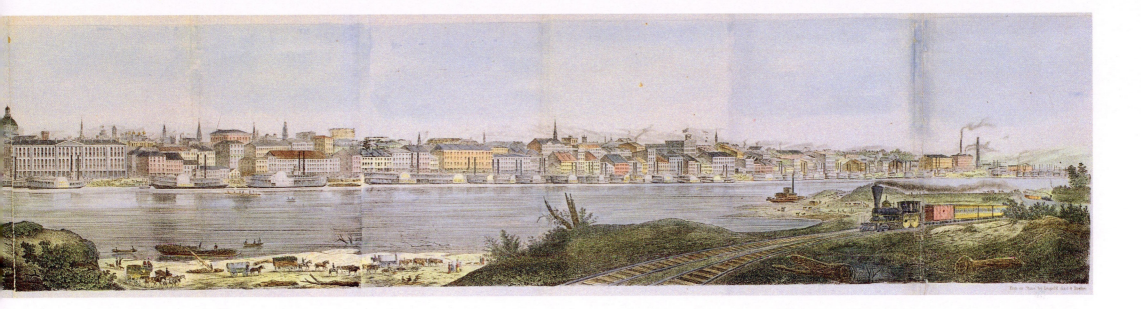

Three years before the Gasts produced their long panorama of St. Louis the first bird's-eye viewmakers visited the city and introduced to its residents a new way of looking at and depicting cities. We will examine these extraordinary prints in the next chapter; in the remaining pages of this one we will turn to a miscellaneous group of much smaller views that illustrated books and periodicals before the Civil War.

Although many of these views lacked pictorial merit, some were badly out-of-date at the time of publication, and most contained substantial inaccuracies, all of them shared a common characteristic: they were the views that made St. Louis known to the outside world. Unattractive, dated, and erroneous as they might be, these images probably reached ten times as many persons as even the

most popular separately issued lithographs or engravings designed to be used as a wall decoration.

Robert Sears used a wood engraving of St. Louis among the scores of other similar illustrations in his *Pictorial Description of the United States,* a popular book first published in 1848 and reissued several times thereafter. Figure 4–15 reproduces this 4 x 6 inch image, which accompanied more than three pages of text treating the city's history, economy, and population. This unsigned illustration offers little more than a stylized representation of a town that might be almost any place along the river.[36]

36. The illustration appears in Robert Sears, *A New and Popular Pictorial Description of the United States,* 573. Sears provides population figures for St. Louis prefaced by this comment: "On this subject there has been a most serious mistake in all the published statistics since 1840. At that time the *chartered* limits of the *city* did not extend over one third of its present area. Nearly half of the population lived out of the chartered limits, and the population of this portion, in the United States census, was placed under the head of the *county.* The population of the chartered limits was only 16,469—but the population then within the present chartered limits would have equalled 26,000." Sears then presents the following table, using his corrected figure for 1840 and explaining that "the number for 1846, is by census accurately taken."

1804	800	1828	5,000	1837	15,300	1846	47,833
1810	1,400	1830	5,853	1840	26,000	1848	60,000
1815	1,800	1833	8,397	1844	34,140		
1820	4,598	1835	10,500	1845	36,255		

Ten years before the Gast view appeared, *Green's Saint Louis Directory for 1845* (St. Louis, 1844), as quoted in "St. Louis in 1844," provided this inventory of industrial activities: "Flour, white-lead, red-lead, linseed oil, lard oil, castor oil, &c are manufactured here, and the business of iron casting, sugar refining, tanning, stone cutting, boat building and repairing, brick making, sawing of lumber, planing, &c. are carried on here to a considerable extent. . . . There is a cotton factory in progress. . . . There are, for the repairing of vessels and steamboats, one inclined way, and one floating dock. There are about fourteen flouring mills, propelled by steam-power. There are about twelve steam saw mills located along the river, within the city limits. There are six breweries, two planing machines, one hemp, cotton bagging, and rope factory, two white lead factories, &c. . . . There are two packing establishments." All or most of the industries mentioned here and not listed by Mackay probably existed at the time of his visit.

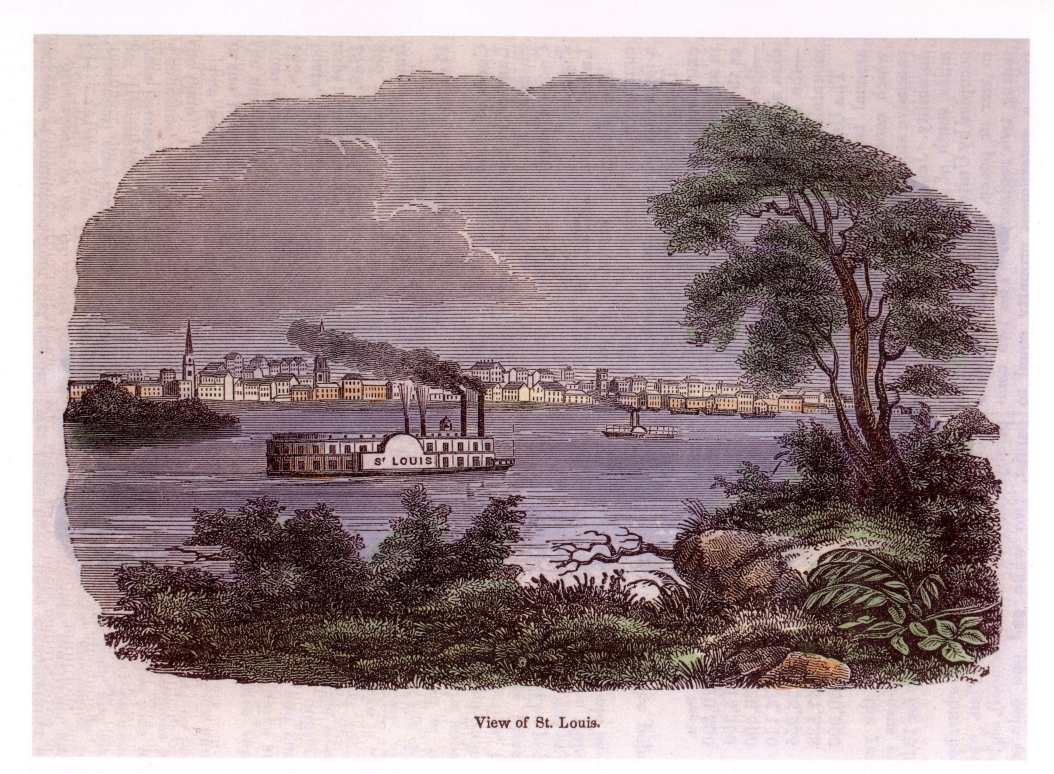

View of St. Louis.

Figure 4–15. View of St. Louis in 1848, published in New York by Robert Sears. (Collection of A. G. Edwards & Sons, Inc., St. Louis, Missouri.)

This view is perhaps the earliest wood engraving of St. Louis. A wood engraver uses many of the same tools employed in engraving on a metal plate but puts the artist's design on a smooth wood surface made up of one or more pieces of end-grain wood, preferably fine-grained boxwood. When two or more blocks are used, these are bolted together on the underside. Lines are created as on a woodcut by leaving them in relief, but the use of engraving tools and the dense end-grain of the wood permit finer detail than on the planks used for woodcuts. This technique of printmaking became widely used by publishers needing illustrations for books, magazines, and newspapers.[37]

In the spring of 1854 the editors of *Gleason's Pictorial,* an illustrated weekly journal published in Boston, used a far more convincing and realistic wood engraving of St. Louis. Figure 4–16 reproduces this as engraved by Pierson on wood from a sketch by Wade. This view includes many recognizable buildings and, unlike several others, does not exaggerate the height of the land sloping upward from the levee.[38]

Frederick Piercy sketched St. Louis in 1853 as he journeyed north from New Orleans by steamboat before setting out across Iowa on his way to Salt Lake City. His view as engraved on steel for a book published in 1855 appears in Figure 4–17. It is an attractive scene, made more dramatic by the low level assumed by the artist and by the smoke from factories and steamboats mingling with the dark clouds overhead. Piercy's drawings of other towns faithfully re-

produce their appearance at the time, and there is no reason to think otherwise of his image of St. Louis. Unfortunately, he chose to show only that part of the city north of the Market.[39]

Harper's Weekly, the illustrated periodical that would dominate all others in the nineteenth century, also used a view of St. Louis a few years after it began publication. This unsigned wood engraving appears in Figure 4–18. Although it manages to convey a sense of the commercial vitality that characterized the city, the clouds of smoke that symbolize that prosperity interfere with the clarity of the view. Other and better artists would produce far more attractive and informative portraits of St. Louis for this influential journal after the Civil War.

Finally, two other wood engravings complete this survey of low-level panoramas of the city in the years before the Civil War. These represent what must have been several book or pamphlet illustrations of the time that served to convey some idea about the appearance of St. Louis to persons living elsewhere as well as to remind residents of the city's importance. Figure 4–19 comes from a steamboat directory of 1856 published in Cincinnati. The artist, who signed himself R. Telfer, chose to emphasize the church towers and spires, the Courthouse dome, factory smokestacks, and the shot tower, and he exaggerated the height of each of these vertical elements for dramatic effect.[40]

37. For a summary of wood engraving, see J. Luther Ringwalt, ed., *American Encyclopaedia of Printing,* 495–501.

38. In this respect the illustration in *Gleason's Pictorial* (15 April 1854, 232–33) differs from one that appeared in an 1854 issue of a German periodical, *Die Gartenlaube.* Here the anonymous artist makes the street leading from the levee to the Courthouse almost alpine in appearance. This wood engraving seems to be based loosely on the 1849 lithograph by Hutawa but with the horizontal dimension compressed and one church spire omitted on the left. I have seen only a photocopy of this illustration from the original in The Mariners Museum of Newport News, Virginia, and cannot identify more than the year of publication. The reporter for *Gleason's* amplified for his readers some of the features of St. Louis that the view revealed: "With the beginning of the business districts, lies a long line of steamers, large and small. . . . This fleet . . . extends entirely out of view, to the north—it is immeasurable the largest to be found in any western port." He mentioned some of the city's industries: "One after the other, we pass the rolling-mill . . . , extensive docks, a tall shot tower, the sugar refinery—the latter, the largest in the United States, and, for aught we know to the contrary, in the world; and finally, the various iron and copper founderies which continue to crowd upon us until we arrive at the commercial centre." Although the artist did not copy the Robyn lettersheet view of the town, he did use one detail almost exactly as it appeared on that presumably earlier delineation: the steamboat on the left even bears the identical name of *Humbolt.*

39. Frederick Piercy was only twenty-three when he came to America to sketch scenes along one of the routes the Mormons used to reach Utah. He was already an accomplished portrait painter, having exhibited at the Royal Academy of Arts in London five year earlier. A Mormon missionary group in England sponsored his American trip. Following his return to England he continued his career there until 1880. The Missouri Historical Society and the Boston Museum of Fine Arts have the bulk of his American drawings and watercolors. In the latter institution they form part of the M. & M. Karolik Collection of American Water Colors and Drawings. See Boston Museum of Fine Arts, M. & M. *Karolik Collection of American Water Colors & Drawings, 1800–1875,* 2:37–39. For Piercy's journey to Utah and his sketches made along that route see Jonathan Fairbanks, "The Great Platte River Trail in 1853: The Drawings and Sketches of Frederick Piercy." See also Wilford Hill LeCheminant, "'Entitled to be an Artist': Landscape and Portrait Painter Frederick Piercy." Several of Piercy's sketches were engraved on steel and used as illustrations in Frederick Hawkins Piercy, *Route from Liverpool to Great Salt Lake Valley.* As Fairbanks points out, Brodie's notes about Piercy in the reprint edition confuse him with his son, Frederick Hawkins Piercy. Piercy's views of Mississippi River towns are all informative and attractive. They show New Orleans, Natchez, Vicksburg, Memphis, and Nauvoo, in addition to St. Louis.

40. The print was in James T. Lloyd, *Lloyd's Steamboat Directory.* . . . I saw and photographed the copy in the library of the St. Louis Mercantile Library Association. This print is signed R. Telfer in the lower left, and dscattergood [D. Scattergood?] in the lower right. I am assuming that Telfer was the artist and Scattergood the person who engraved Telfer's design on wood blocks.

Figure 4–16. View of St. Louis in 1854, drawn by Wade, engraved by Pierson, and printed and published in Boston by *Gleason's Pictorial*. (Collection of A. G. Edwards & Sons, Inc., St. Louis, Missouri.)

Figure 4–17. View of St. Louis in 1853, drawn by Frederick Piercy, engraved by Charles Fenn, and published in London by F. D. Richards in 1855. (Collection of A. G. Edwards & Sons, Inc., St. Louis, Missouri.)

ST. LOUIS, MISSOURI.

Figure 4–18. View of St. Louis in 1857, published in New York City by *Harper's Weekly.* (Collection of A. G. Edwards & Sons, Inc., St. Louis, Missouri.)

Another book illustration almost shows less city than steamboat smoke. This can be seen in Figure 4–20 as reproduced from a publication advertising opportunities in and achievements of St. Louis. It is a wood engraving that, like many of the time, adds little to our knowledge of how the place looked, although it is such a curiosity and rarity that any print collector or library would find it an exciting acquisition. As in other examples we have looked at and several yet to be discussed, this image, too, was used more than once, and we will see it in a modified version when in Chapter VI we survey the views of St. Louis during and after the Civil War.[41]

As we noted before, views like those we have just examined increasingly ceased to do justice to the appearance of the city as it spread westward. Many major buildings and entire neighborhoods lay beyond the sight of persons viewing the urban scene from the traditional vantage point on the Illinois side of the river. A few artists in the 1850s realized that to display St. Louis most advantageously they needed a more elevated perspective. The next chapter will follow them as they began to capture the appearance of St. Louis from the air.

Figure 4–19. View of St. Louis in 1856, drawn by R. Telfer, engraved by D. Scattergood, and published in Cincinnati by James T. Lloyd. (St. Louis Mercantile Library Association.)

Figure 4–20. View of St. Louis in 1854, drawn by Devraux and published in St. Louis by the *Pictorial Advertiser* ca. 1858. (St. Louis Mercantile Library Association.)

41. The view illustrates the *St. Louis Pictorial Advertiser,* 1:184. I examined and photographed this in the Mercantile Library collection. It is in bad condition, with the title missing along with a portion of the lower part of the illustration. A portion of the imprint identifying the artist or printmaker can be seen. It reads: "Devereux, s." As will be noted in Chapter VI, the artist was a "Professor Devraux, of Philadelphia."

THE CITY FROM ABOVE

Sometime in 1852 the Smith Brothers published the very large view of St. Louis reproduced in Figure 5-1. Drawn by John William Hill and one of the four Smiths (probably Benjamin Franklin Smith, Jr.), it joined a few earlier lithographs produced by the Smiths in what became for its time the most extensive and distinguished series of city views issued by a single firm. All forty of their lithographs and the few additional engraved views they issued were, with only a couple of exceptions, skillfully drawn, attractively executed, and well printed.

The Smiths came from Maine. In 1846 the two oldest brothers, George and Francis, served as subscription and sales agents for an ambitious and energetic artist of city views, Edwin Whitefield. In that same year the youngest brother, Benjamin Franklin Smith, then sixteen, started to work in Albany as a lithographer and artist, but he soon joined his brothers, probably including David, in working for Whitefield. In 1848 and 1849 the Smiths and Whitefield published three of Whitefield's views.[1]

In the latter year the Smiths severed relations with Whitefield and began their own publishing enterprise with lithographs of Pittsburgh and New Haven, both drawn by Benjamin. In 1850 Benjamin collaborated with John William Hill in drawing two fine views of Philadelphia, and in 1851 Hill, working alone, prepared the drawings for the Smith Brothers views of St. John in New Brunswick and Charleston, South Carolina.[2]

In Hill the Smiths found a person whose artistic skills matched their own considerable abilities as salesmen and publishers. Hill's father, John Hill, came to America as a master of aquatint engraving and in that medium created many fine city views. He trained his son to be an artist, and the younger Hill pursued this career while working for the New York State Geological Survey. He began his association with the Smiths at the age of thirty-eight and was ultimately responsible for more than half of the firm's numerous views.[3]

Hill and the Smiths spent a busy year in 1852, the date when the St. Louis view appeared. The firm published two superb lithographs of New Orleans that B. F. Smith drew with Hill and one of Cincinnati that Hill drew by himself. The Smiths used a generous format for their prints, that of St. Louis measuring an impressive 26 x 42 inches. This lithograph from the press of Francis Michel-

1. I have written brief biographical notes on Whitefield, Hill, and the Smiths in *Views and Viewmakers of Urban America . . . ;* see pp. 215–16, 183–84, and 206–8. That on Whitefield is based almost entirely on Bettina A. Norton, *Edwin Whitefield: Nineteenth-Century North American Scenery.*

2. The Smiths published views through 1855. In 1858 Francis established a bank in Omaha,

and Benjamin joined him the next year in a flourishing enterprise providing supplies for persons bound for the Colorado goldfields. The two other brothers apparently joined Francis and Benjamin in investing in Omaha real estate and stockyards. In the 1880s they returned to their native Maine and established a family compound on a five-hundred-acre estate near Rockport, where each family occupied its own mansion. When Benjamin, the last of the brothers, died in 1927 he was reputed to be the wealthiest man in the state.

3. The son of John William Hill (1812–1879) wrote an appreciation of his father's work, but it contains little about his career with the Smiths as an urban viewmaker. See J. Henry Hill, *John William Hill, An Artist's Memorial.* A brief note on Hill and a reproduction of his watercolor view of Richmond, Virginia, are in Estill Curtis Pennington and James C. Kelly, *The South on Paper: Line, Color and Light,* p. 42, pl. 36. This watercolor is dated 1847 and thus precedes Hill's view of that city in 1853 that the Smiths published. The watercolor was taken from a different viewpoint than the later drawing, painting, or sketch used for the lithograph. For John Hill (1770–1850) see Richard J. Koke, "John Hill, Master of Aquatint 1770–1850." There is also a brief but informative note on this artist in Philadelphia Museum of Art, *Philadelphia: Three Centuries of American Art,* 249.

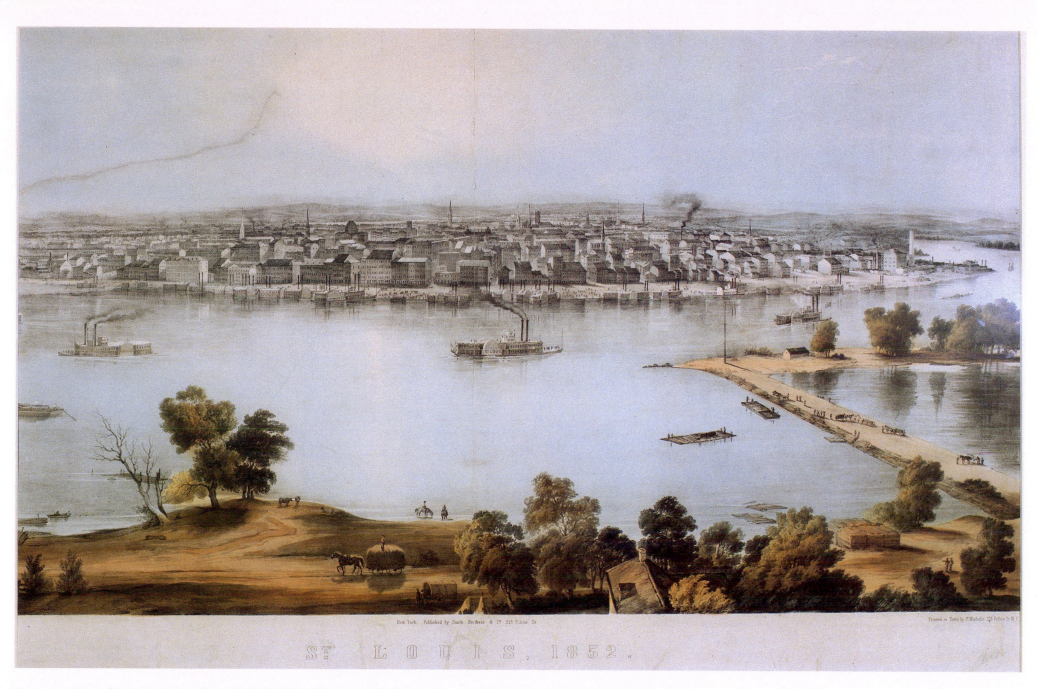

ST. LOUIS, 1852.

Figure 5–1. View of St. Louis in 1852, drawn by J. W. Hill and Benjamin Franklin Smith, printed in New York by Francis Michelin, and published in New York by Smith Brothers & Co. in 1852. Detail. (Collection of A. G. Edwards and Sons, Inc., St. Louis, Missouri.)

lin in New York far exceeded in size anything previously attempted for the city. It also represented the first effort by an artist to depict St. Louis from an elevated viewpoint that the delineator himself could not reach.[4]

Normally this is referred to as an "imaginary" viewpoint. "Inaccessible" would be a more accurate designation. Drawing views like this *does* require imagination, of course. The artist must reconstruct what the city would look like if he could see it from an existing but—to him—unattainable viewpoint in the air. The creation of such a realistic image demands far more of the artist than a traditional low-level townscape requires.

Such conventional townscapes present the city as the artist sees it from a single point. The artist draws or paints the buildings in the foreground, usually the only structures visible to him barring an occasional vista up a street or a vacant site that exposes a building behind the line of foreground objects. The artist can add only the upper stories of tall buildings, the spires of churches, and the domes or towers of such public edifices as the city hall, courthouse, or state capitol. The results, as art, may be pleasing or otherwise depending on the subject and the artist's abilities. However, such views tell us little about the pattern of the city's streets, the distribution of its population, the spatial rela-

tionships of various activities, the location and size of parks and other open spaces, the nature of the site on which the city has developed, the character and appearance of its neighborhoods, and a host of other features of urban life.

City views made from elevated vantage points provide much of this information. They look beyond buildings in the foreground and show the city in depth, not merely as a kind of stage set. Artists drawing such views must learn more about the city than can be obtained by looking at its buildings from a single spot. They must enter the city and move through its streets, drawing and sketching every building. Scholars can use views created in this manner for a variety of purposes, although their full potential has not been adequately explored.[5]

It is worth reflecting on the impact these views made on people seeing such an image of their city for the first time. In our own era when a large fraction of the population flies over cities one or more times a year, when television or motion-picture scenes often show cities from the air, when the daily newspaper occasionally prints a view of its city from an airplane, and when popular journals of geography and travel frequently use urban air photographs, we forget how novel and exciting a nineteenth-century printed view would have been.

Then, for the first time, a resident, visitor, or person entirely removed from the scene in another city could appreciate how the many individual components of the city fit together in the complex mosaic of urban life. Although city maps provide information of this kind, the average person finds views far easier to understand. A street map shows the city as seen from a point directly overhead, but as an abstraction without any buildings, vehicles, vegetation, or other familiar landmarks by which people orient themselves. High-level views included these helpful clues to the urban pattern and by doing so became more attractive and useful.

The Hill-Smith view of St. Louis in 1852 represented only the first step in this direction. Although the artists departed from previous delineations that portrayed the city from ground level on the Illinois shore, they did not adopt a very elevated viewpoint. Thus, while we can see that the city extends well beyond the first north-south streets of the original settlement, we glimpse only the roofs and top stories of buildings in the newer sections of St. Louis.

4. I have been unable to determine the month of publication in 1852 of the St. Louis view. The two views of New Orleans reached the market at different times, the first in late April and the second in June. The following notice appeared in the *New Orleans Times Picayune* for 27 April 1852: "Views of New Orleans.—We have received from Messrs. Smith, Brothers & Co., a colored engraving [*sic*] representing a view of New Orleans taken from the tower of St. Patrick's church and looking northward. It was undertaken two years ago, and has entailed much labor on the projectors. The large size of the picture, the faithful manner in which every object has been delineated, and the superior style of the execution, render this view one of the best of the kind ever brought to completion in this country. The views for subscribers will be ready, we are informed, in the course of next week. Messrs. Smith & Co. have in progress another view of the city, taken from the Lower Cotton Press, and on a much larger scale than a similar one which many of our readers may have seen. The new view will be of the same size as that taken from St. Patrick's." A notice of the second view was in the *New Orleans Daily Delta* for 3 June 1852: "Smith Brothers & Company. Second View of New Orleans—We have seen the second of the two views of the Port of New Orleans, engraved by Smith Brothers & Company. These pictures are certainly the most beautiful specimens of art and give the only just and accurate views, we have ever seen of our Port. These two pictures ought to be in the offices or drawing-rooms of all our citizens. Together, they afford a full picture of the city. The two pictures may be obtained at Hall's Store, No. 48 Canal Street." Searches of microfilm copies of some St. Louis newspapers from 1852 failed to reveal similar notices, but they almost surely appeared. The Smith Brothers, as did all urban viewmakers of the period, relied on such notices to help sales. Editors normally welcomed material of this kind as an indication of the importance of the town and because readers would find news about the availability of these views useful. I have described how publishers of views obtained publicity like this in *Views and Viewmakers,* chap. 5, pp. 39–44.

5. Some suggestions on how bird's-eye views can be used for scholarly purposes compose the last chapter of my *Views and Viewmakers.* In subsequent unpublished studies I have, with the help of several graduate students at Cornell, pushed beyond the scope outlined in that essay. Those using city views today for research purposes normally care far more about their accuracy than about their artistic merits, but we should not overlook the pleasures offered by a beautifully drawn and well-executed city view in our zeal to find utilitarian purposes they can serve.

Nevertheless, this view conveys an image of a large and imposing community with all the urban character of any city in the East. It was this atmosphere that led William Kingsford to conclude after his visit in 1857,

> Throughout St. Louis there is what is wanting in Chicago— the air of a city. It is not a wide scattered place, but well built, closely and connectedly. There is perhaps no Michigan or Wabash Avenue, but there is what is better— substantial houses, and streets branching off from the main streets, with shops containing all one would need.[6]

Distant views like Hill's tended to romanticize the appearance of the city and to smooth over wrinkles on the municipal countenance. All rapidly growing cities confronted problems in their physical makeup, and St. Louis had its share. During William Kingsford's visit in 1857 it struck him "as extraordinary, that the sewers should discharge their filth in open drains, which in the summer must poison the atmosphere." He also criticized the new dome being constructed for the Courthouse as an addition that "will only have the effect of disfiguring" the building.[7]

One new resident of St. Louis in 1857 complained about the condition of the city's streets. Although he noted that the first three streets running parallel to the river "were paved with a limestone block," Fourth Street and all the others to the west had been paved "with a soft limestone that was soon crushed into dust by the traffic, and when the wind blew was distributed in clouds over the city."[8]

On the occasion of Jenny Lind's visit in March 1851, her manager, C. G. Rosenberg, also criticized street conditions, but for quite different reasons. He concluded, "St. Louis is muddier in wet, and dirtier in dry weather, than any part of the United States." He found "the city . . . in one of its muddier phases" following a twenty-four-hour rain and described the perils of crossing downtown streets:

> The cross-ways had vanished, or made their appearance here and there through the half-liquified roads in the shape of an isolated block or two of stone. Some few, indeed, of the streets were closed against all but pedestrianism of the most daring class. Indeed, did I phrase it correctly, I would say that a man who had not yet sounded the mysteries of their navigation, and attempted, in complete and utter ignorance, to steer safely through their thousand perils, would run no small risk of drowning.

After fair weather dried the streets, Rosenberg "began to take a juster view of St. Louis" other than "as a huge reservoir, devoted to the manufacture of mud on a wholesale scale." He proclaimed,

> St. Louis is, in point of fact, a large, handsome, and rapidly growing city. . . . Nothing could well be grander than the width and general character of all the streets to the west of Fourth—the principal street of the city. . . . Land, as I should presume, must have been cheap when the upper portion of the city was laid out, and very wisely those who possessed the ground did not think fit to stint it in placing their buildings. . . . In its style of building and manner of living, it bears far more resemblance to New York than any city which I have yet seen.[9]

This was exactly the kind of impression intended by artists of prints like those produced by the Smith brothers. They cast their subject in a favorable light by selecting the most advantageous viewpoint, displaying its buildings to best advantage, and discreetly omitting any features that might detract from an image of a prosperous and beautiful community. Publishers of views at that time believed, correctly by all accounts, that more persons would purchase their work if they represented such ideal conditions rather than being severely realistic.

Nevertheless, the Smith Brothers view of St. Louis does not seem to have been a successful venture in view publishing. Local newspapers seemingly ignored the project, not publishing the normal notices that the artists were at work on the view or that they had completed their drawing and were now seeking subscriptions for the intended lithograph. Possibly potential customers found their print too large and expensive. Whatever the reasons, few impressions of the Hill-Smith view exist in public collections, and probably not many more copies were printed than were necessary to supply the needs of those who subscribed to the lithograph.[10]

However, this image of St. Louis did achieve national circulation when *The Ladies Repository* published a much reduced but well-done engraved version in its January 1855 issue. Figure 5–2 reproduces the results. Unlike most periodicals whose editors simply pirated whatever illustrations appealed to them and reproduced them without credit to the original artist or publisher, the *Repository*

6. William Kingsford, *Impressions of the West and South, During a Six Weeks' Holiday,* 33.

7. Ibid., 31–32.

8. Thomas L. Rodgers, "Recollections of St. Louis—1857–1860," 111. Rodgers came to St. Louis from Pittsburgh in 1857 and worked as a bookkeeper for Tatum & Company, a firm of commission merchants.

9. As quoted in "Jenny Lind in St. Louis, 1851," 48.

10. Although no evidence has been found that the Smith brothers solicited subscriptions to their view of St. Louis, this was their practice and that of Whitefield, from whom they learned the business of viewmaking. No impressions of the view are in the Library of Congress or the Stokes Collection in the New York Public Library. I have located impressions in public collections only in The Mariners Museum of Newport News, Virginia, the Missouri Historical Society, and Knox College in Galesburg, Illinois.

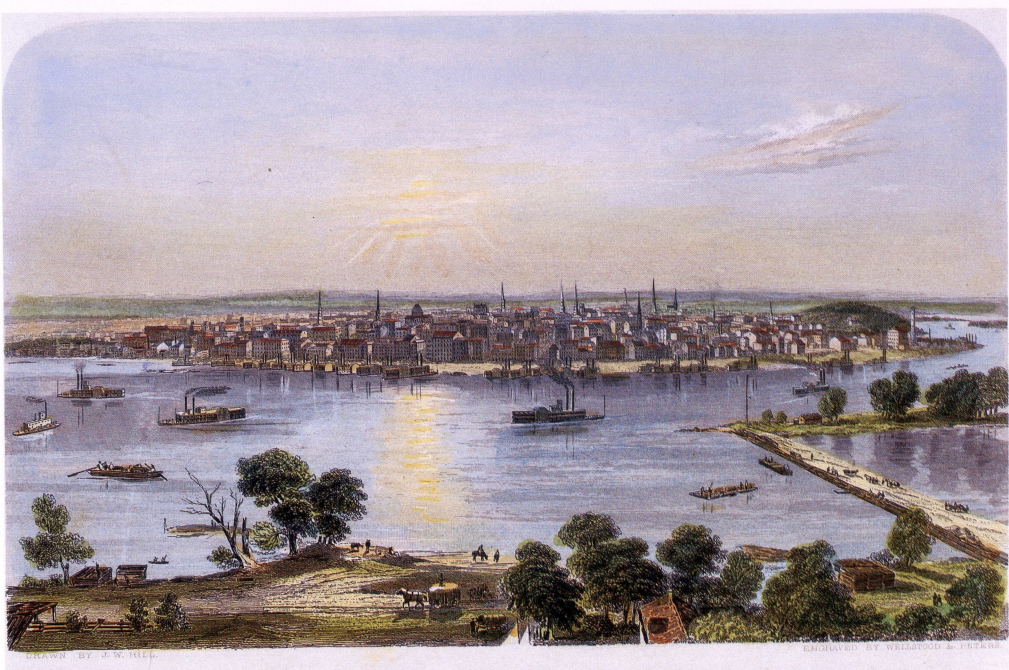

Figure 5–2. View of St. Louis in 1852, drawn by J. W. Hill and Benjamin Franklin Smith, engraved by Wellstood & Peters, printed in Cincinnati by Middleton Wallace, and published in Cincinnati by the *Ladies Repository* in 1855. (Eric and Evelyn Newman Collection.)

made it a practice to identify its sources of graphic material. As we have seen in Chapter III, this magazine included Wild's name on a print of St. Louis it used in 1845. In the mid-1850s the magazine copied many Smith Brothers lithographs, each time including an acknowledgment that the firm had granted permission for this purpose.[11]

The editor of the *Repository,* as was his custom, added some notes about the city for the benefit of his readers. He estimated the population to be "about 90,000" with "some fifty churches." It was, he wrote, a city "admirably situated for trade," a center of transportation for river steamboats where "the number of arrivals in a single year have amounted to nearly a thousand," and "a large manufacturing place."[12]

Although attractive, the large lithograph of St. Louis by Hill and Smith lacks the vitality that characterizes most of Hill's work and the Smith Brothers publications. One sees the city only from a distance, and it appears almost like a model, devoid of movement and activity. Even the steamboats and other river craft seem frozen in space. Only the figures in the foreground give any life and realism to the print.

The contrast between this and the view published in 1854 and reproduced in Figure 5-3 could, in this respect, scarcely be greater. This spirited scene sparkles with energy in its portrayal of a lively and bustling city. One can almost hear the hubbub rising from the levee where hundreds of figures can be seen going about the myriad tasks needed to load and unload cargo in a great port. This large (25 x 36 inches) print is remarkable also for two other features. In an age when lithography had all but driven out other methods of producing separately issued popular prints, this view stands out as one of the few engravings. Also noteworthy is the lofty vantage point chosen by the artist. Although his view fails to reveal the pattern of all the city's streets, the elevation of the spectator is high enough to permit inclusion of far more building facades than Hill and Smith displayed in their earlier view.

This engraving reached customers in St. Louis early in 1854. A notice in the *Daily Missouri Democrat* on 26 January of that year announced to its readers in these words that they could expect to see the publication shortly:

Yesterday we were shown the proof plate of a beautiful steel engraving representing a view of the city of St. Louis. It is by far the most accurate of any we have yet seen, and gives a very truthful idea of the appearance and size of the city and the business aspect of the levee. It is acrediable [*sic*], and will, we hope, prove a remunerative work to the gentlemen who produced it. The artists are Mr. Hoffman, portrait painter, and Mr. Krausse, engraver. The publisher is Mr. Charles A. Cuno.

A few facts are known about the creators of this handsome image of St. Louis. In 1853 Charles A. Cuno, one of the publishers, operated a dry-goods store located on Main Street between Walnut and Elm. The imprint gives this address at 31 South Main as the place of publication after listing the publishers as "C. A. Cuno, Krausse & Hofmann." Cuno also was a partner in Cuno & Kuhn & Co., owners of the St. Louis Chemical Color Works. Their plant on Clark Avenue between Twelfth and Thirteenth streets produced a variety of colored pigments. A year later the firm became Cuno, Krausse & Co., proprietors of the St. Louis Chemical Works.

Cuno's new associate was Emille B. Krausse, the engraver of the view, who is first listed in the St. Louis directory for 1853–1854. By 1857 he had acquired Cuno's interest in what was then called the Western Color Works. Two years later the company became Krausse, Kueck & Co. Probably Emille Krausse was related to the Hermann Krausse who clerked at Cuno's dry-goods store in 1854. One can only speculate at his training and background, but the quality of the engraving indicates that he was a highly skilled craftsman. Perhaps he had once worked for William Pate, who printed the view in New York and was himself an engraver in the firm of Neal & Pate.

Almost certainly the "G. Hofmann" listed on the print as the artist and identified in the newspaper account as "Mr. Hoffman, portrait painter" is the "George Hofman, portraitpainter" the 1854 city directory lists at 315 South Fourth Street. His training and experience remain unknown, as does the correct spelling of his name, which by 1873 had become *Hoffmann* in the city directory. For our purposes the spelling as it appeared on the engraving will be used.[13]

One other name appears on the print: Thomas M. Easterly, an early and energetic daguerreotypist who recorded scores of buildings, streets, residents, visitors, steamboats, and other elements of St. Louis life from about 1845 to

11. No such acknowledgment appears, either to Smith Brothers or to the *Ladies Repository,* on another version of the view published in 1876. This is a wood engraving measuring 4 7/8 x 7 7/8 inches in *Saint Louis Illustrated . . . ,* 12. It is titled *Saint Louis in 1851* and has five unnumbered references below the image. I have seen this in the Department of Special Collections, Olin Library, Washington University, St. Louis.

12. *The Ladies Repository* 15 (January 1855): 63.

13. For the above material on Cuno, Krausse, and Hofmann I have consulted the following: Wm. L. Montague, *The Saint Louis Business Directory for 1853–54; The St. Louis Directory, For the Years 1854–5;* and *Kennedy's Saint Louis City Directory for the Years 1857.* For William Pate, see George C. Groce and David H. Wallace, *The New-York Historical Society's Dictionary of Artists in America, 1564–1860.*

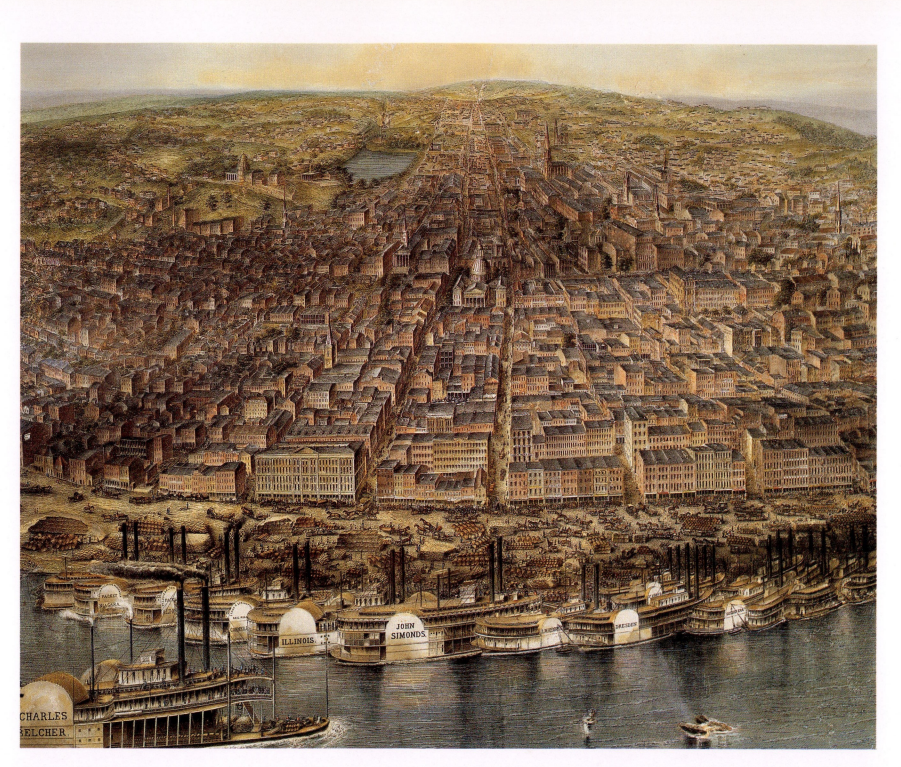

Figure 5–3. View of St. Louis in 1854, drawn by George Hofmann from a daguerreotype by Thomas M. Easterly, engraved by Emille B. Krausse, printed in New York by W. Pate, and published in St. Louis by Charles A. Cuno, Emille B. Krausse, and George Hofmann in 1854. Detail. (Collection of A. G. Edwards and Sons, Inc., St. Louis, Missouri.)

1855. On the engraving the imprint states that the image was drawn by G. Hofmann "taken partly from Daguerreotype by Aesterly." Obviously, Easterly would have been unable to position his camera to take such a view, and the sense of this credit line must be that Hofmann used a daguerrean image of St. Louis, probably one of the waterfront taken from the opposite side of the Mississippi.[14]

Hofmann used a single-vanishing-point perspective system in constructing this view so that all the east-west streets of the St. Louis grid converge on a single point in the center. He placed that point at what normally would be the horizon, but here it appears to lie on a hill he created from the flat expanse of prairie and farmland beyond the city limits. Using this perspective system had some advantages. It made it possible to show the most westerly additions to St. Louis without the necessity of rendering each building at these locations in great detail. With lines parallel on the ground converging in the view sharply toward the vanishing point, buildings in the middle and background become very small. Such structures both need not and cannot be rendered in anything like the detail required for convincing representations of streets and buildings in the foreground.

Hofmann also took liberties with the edge of the city along the Mississippi, curving it sharply so that the site of the city as he drew it resembled a pie crust. The artist may have done this for practical reasons. By bending the street grid Hofmann could include in his print more of the city than would otherwise have been possible at the large scale he elected to use. If he had not done this the far ends of St. Louis would have fallen beyond the left and right borders, even with the generous dimensions of the finished print.

Distorted or not, the view provides an animated and exciting portrait of the city. It also helps us to understand more fully the wonder and admiration with which so many visitors wrote of their first impressions of St. Louis. Hofmann offers a particularly convincing portrait of the levee, a scene described a few years later by an amazed Charles Mackay:

> The levee of St. Louis extends along the right bank of the Mississippi for nearly six miles, about half of which length is densely built upon. No city in the world offers to the gaze of the spectators such a vast assemblage of river steam-boats. As many as one hundred and seventy, loading and unloading, have been counted along the levee at one time.[15]

Thomas Rodgers, who came to St. Louis in 1857, recalled that at this period in the city's development

> The old levee was . . . the most inspiring sight on this continent. For more than a mile it was thickly lined with steamers loading and unloading the products of the West and East, and for all that distance one could walk over the piles of produce and not set foot on the ground. There were bales of hemp, hogsheads of tobacco, piles of bacon, huge piles of grain in bags, and boxes, bales, &c. of merchandise from eastern points for consumption in the city, and to be forwarded to the far West.[16]

Beyond the levee Hofmann's view offers an excellent prospect of the mercantile buildings facing the older streets of the colonial grid. Many of these replaced structures destroyed in the fire of 1849, while others represented efforts by property owners to secure greater income from their land by the construction of taller and more substantial warehouses or places of business.

In 1854, the year of Hofmann's view, John Hogan called attention to new materials and construction methods used to transform this portion of St. Louis:

> It is . . . curious to notice how largely the use of iron has contributed to the beauty and safety of our public and private buildings. Many of our stores have no wood work in their exterior—not only are the doors, the jambs, and the shutters of iron, but also the window frames and window sash; while the cornice is constructed of stone, copper or zinc, and the roofs covered either with slate, metal, or fire-proof composition.[17]

Many of these and later buildings in this part of St. Louis erected with cast-iron fronts survived until the 1930s when clearance of the site for the Thomas Jefferson National Expansion Memorial Park resulted in their wholesale demolition. Hofmann's view allows us to understand how this part of the city—now a vast expanse of open land around the Arch—once appeared when it constituted the economic heart of St. Louis.

Beyond this densely built-up warehouse and wholesale merchandising section stood the Courthouse with its new dome soaring from a drum base and topped by a lantern that reached 230 feet above street level. This stately building, at last essentially complete, provided an impressive symbol of the city's power and position as the great metropolis of the region.

A line of large buildings led north on Fourth Street from the Courthouse. In his *Thoughts About the City of St. Louis*, John Hogan refers to this as "a beautiful, wide, American street, which began to be built up for residences some

14. For a note on Easterly, see Charles van Ravenswaay, "The Pioneer Photographers of St. Louis."

15. Charles Mackay, *Life and Liberty in America: or, Sketches of a Tour in the United States and Canada in 1857–8*, 144.

16. Rodgers, "Recollections," 116–17.

17. Isaac H. Lionberger and Stella M. Drumm, "Thoughts About the City of St. Louis," 168. For information concerning John Hogan, see Chapter IV, n. 32. The metal and stone construction described by Hogan followed regulations adopted after the fire in 1849.

twenty-five years ago, [and] is now being turned entirely to business." Only a few houses remained, "apparently to remind the stranger how vast the difference, both in magnitude and beauty, between the best class of houses first erected some twenty years ago, and those of the present date."[18]

Hogan mentions several new business structures recently erected on this wide thoroughfare, among them the "Ten Buildings," a new commercial block "extending from Locust to Vine Streets." He notes that "the buildings are all four stories high" and that their "beautifully imposing appearance" was "not exceeded probably by any . . . in the West, and few, indeed in the East."[19] Investors and developers built a number of these long, multiple-use buildings. Glasgow Row faced the Ten Buildings across Fourth Street. Verandah Row at the northwest corner of Washington and Fourth opened in 1854. This business block consisted of six stores, each two stories high and with a third story above. A canopy above the second story supported by slender cast-iron columns provided shelter from rain and sun. Although Hofmann's view certainly suggests a busy and highly developed Fourth Street, it fails to show these buildings in recognizable form.[20]

In calling Fourth Street "the Broadway of St. Louis, and . . . not a mean likeness of the great original in New York," Hogan described the goods and services that one could find there:

> If daguerreotypes are wanted, the galleries on Fourth Street are sought. Jewelry is abundant . . . ; silks and laces, and all sort of fancy articles seem indigenous. . . . Hotels and boarding houses are abundant. . . . Eating houses, drinking houses, fruit stores, candy shops, soda founts for hot sunny days, and water-proof awnings for rainy days are to be found all along Fourth Street.[21]

Details in the view become less legible beyond this point, but near the horizon and left of center one can see the remnants of Chouteau's Pond, which

city officials began to drain two years after the cholera epidemic in 1849. Here and beyond the city limits, which then extended to include the western frontage along Eighteenth Street, land was beginning to be subdivided and already contained substantial numbers of residents.

Hogan claimed that on the ground one could not see any difference in urban development when crossing the western municipal boundary:

> The limit is an ideal line, with streets and houses, and business extending in many parts for a long distance, say from a half to one mile beyond, as densely built and populated as are the same streets within the city—nor can the stranger visiting here tell where the line is, as there is nothing to mark it, except perhaps the *gas lamps,* that only go to the limits. I doubt whether many who have lived here for years, can show where the line passes through many densely populated streets.[22]

Hofmann's view shows this most clearly in the distant portions of the built-up area above the center of the engraving beyond and to the right of the Courthouse. A large church with what appears to be the tallest spire in the city stands out as the most prominent object. This is the Unitarian Church of the Messiah constructed in 1852 at the northwest corner of Ninth and Olive streets. West of the church the view shows the city thrusting into open countryside along a corridor centered on Market and Chestnut streets.

Finally, Hofmann shows another outlying building important in the early days of St. Louis. This curiously domed structure can be seen south of the eastern end of the pond. This was McDowell's Medical College, described by a journalist as "a dispensary connected with the Medical Department of the University of Missouri." The college, he added, occupied a site "opposite the Pacific Railroad terminus."[23]

18. Ibid., 164–65. 19. Ibid., 153.

20. These and other commercial buildings of the time are illustrated in Lionberger and Drumm, "Thoughts." These illustrations along with photographs and prints from additional sources are reproduced in Lawrence Lowic, *Architectural Heritage of St. Louis, 1803–1891,* 84–89

21. Lionberger and Drumm, "Thoughts," 176–77. This portion of Hogan's booklet first appeared in the *St. Louis Missouri Republican* for 15 September 1854. He prefaced this passage with the following: "Fourth Street is one of our principal thoroughfares for business and promenade. The ladies are favorable to Fourth Street because it affords so many facilities for shopping; children like Fourth Street because it presents so many objects attractive to the eye, in the shop windows. Young men swell on Fourth Street on account of the throngs of beautiful ladies to be seen there in the afternoons. Lovers meet and smile on Fourth Street. Old men sun themselves on Fourth Street; ladies bloom on Fourth Street; and dandies shine in finger rings, moustaches, and gold-headed canes on Fourth Street" (p. 176).

22. Lionberger and Drumm, "Thoughts," 155. Hogan estimated that if this population outside the city limits were counted, the population of the urban area would exceed 120,000. The census of 1850 enumerated, he said, "only over 97,000 inhabitants." He claimed that many persons inside the limits had not been counted and that he had no doubt the population there was "nearer 110,000." According to Lionberger and Drumm in "Thoughts," 155, n. 7, the boundaries of the city in 1854 were as follows: "North line, from a point on Main, between Dock and Buchanan Streets to the River; west line, from Main Street, between Dock and Buchanan southwardly to Chouteau Avenue, one hundred feet west of Second Carondelet (now 18th Street) Avenue; thence along Second Carondelet Avenue to Wyoming; thence to the River at the foot of Anna Street." The boundary was extended in 1855. This action "made Keokuk Street the southern boundary, and a line six hundred and sixty feet outside of Grand Avenue the western, with the northern along a line running due east from the intersection of the western boundary and the Bellefontaine Road to the River."

23. "St. Louis, Missouri," in *Ballou's Pictorial Drawing-Room Companion,* 152–53. Wood engravings illustrating this article show the Courthouse, the High School, the Mercantile Library

The view shows no such feature. Instead, barely visible beyond the pond, the railroad tracks stop at what would be Fifteenth Street. There on 4 July 1851 construction began on the Pacific Railroad with a ceremony attended by twenty thousand people. Two years later the line reached Pacific (then Franklin), Missouri, forty miles west of St. Louis, and by 1855 the line connected St. Louis with the state capital of Jefferson City 125 miles away. Within the city the railroad extended the line east from Fifteenth to a station at Seventh Street.[24]

Two much smaller and cruder derivatives of the Hofmann view do not include any sign of the railroad. These omissions are difficult to explain. City views almost always depicted cities in a favorable light, occasionally anticipating events and showing buildings or civic improvements in progress as if they had been completed, sometimes well before the fact. For St. Louis the railroad offered enticing possibilities for new economic opportunities and further urban growth. It seems inexplicable that views that so obviously celebrated other substantial accomplishments in city building omitted the railroad that promised future achievements of similar magnitude.

Charles Magnus of New York published what is probably the earliest of the derivatives of the Hofmann view, although his engraving bears no date. As the reproduction in Figure 5–4 (see next page) makes obvious, he borrowed heavily from Hofmann, although simplifying many of the details appearing in the prototype. The major change made by Magnus indicates his unfamiliarity with river conditions, for he placed most of the steamboats at right angles to the bank instead of with their sterns angled downstream.[25]

Richard Edwards and M. Hopewell used a nearly identical version of the

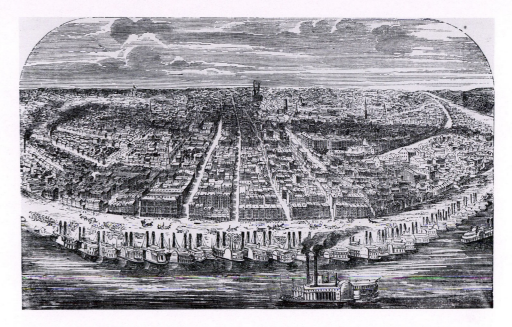

Figure 5–5. View of St. Louis by George Hofmann, published in St. Louis by Richard Edwards and M. Hopewell in 1860. (Olin Library, Cornell University.)

view in their publication of 1860, *Edwards' Great West*.[26] Although published by Edwards in St. Louis, the book was printed by a New York firm. Doubtless a wood engraver working for the printer also prepared the illustration reproduced in Figure 5–5, possibly using the Magnus version as his model. This artist, however, departed from reality even more than did Magnus, for he drew the sterns of the steamboats pointing upstream. Edwards also published St. Louis city directories, and he used the same illustration in some of these volumes, among them the directories for 1864 and 1865.[27]

that had just been built at Fifth and Locust, the Biddle Market, and the medical building of St. Louis University, in addition to McDowell's College.

24. James Neal Primm, *Lion of the Valley: St. Louis, Missouri*, 218–20. To celebrate the completion of the line to Jefferson City a special train left St. Louis on 1 November 1855 loaded with "many prominent business and professional men, various state and county officers, and a number of officials from other railroads." On the way to the state capital the tracks crossed a temporary bridge over the Gasconade River, a stream swollen by a violent rainstorm. The bridge collapsed, plunging the locomotive and thirteen passenger cars into the water. Many passengers died in the accident, and dozens of others received serious injuries. See van Ravenswaay, "Years of Turmoil, Years of Growth: St. Louis in the 1850s," 314.

25. Magnus seems rarely to have drawn any city image himself when one by another artist existed that he could pirate. He borrowed freely from Edward Sachse for images of Washington, Baltimore, and Annapolis and from John Bachman for views of New York. There must be many more examples of his artistic plagiarism. Moreover Magnus often used the same image in different ways. He issued many views on single sheets with white margins. Others are printed on paper with black borders, sometimes with hand-painted gold accent lines so the print appears to

be matted. He also used city views for illustrated lettersheets. In Lowic, *Architectural Heritage*, 72, the caption for the reproduction of this view gives the date as 1853. Although this may be accurate for the date of depiction, Magnus must have published his version sometime after the Hofmann view appeared in 1854.

26. Richard Edwards and M. Hopewell, *Edwards' Great West and her Commercial Metropolis, Embracing a General View of the West, and a Complete History of St. Louis . . .* , 239. Another view of the city from river level is opposite p. 65. Edwards used wood-engraved views as well for Pittsburgh, Cincinnati, Chicago, Milwaukee, and Detroit. The Chicago view is based on the four-sheet lithograph by James T. Palmatary, whose St. Louis view is discussed later in this chapter.

27. The view in the 1864 directory has no title. The view in the 1865 directory has this title below the image: *View of the City of St. Louis from Illinoistown*. I have not examined all the Edwards directories, but those for 1868 and 1869 did not include this view.

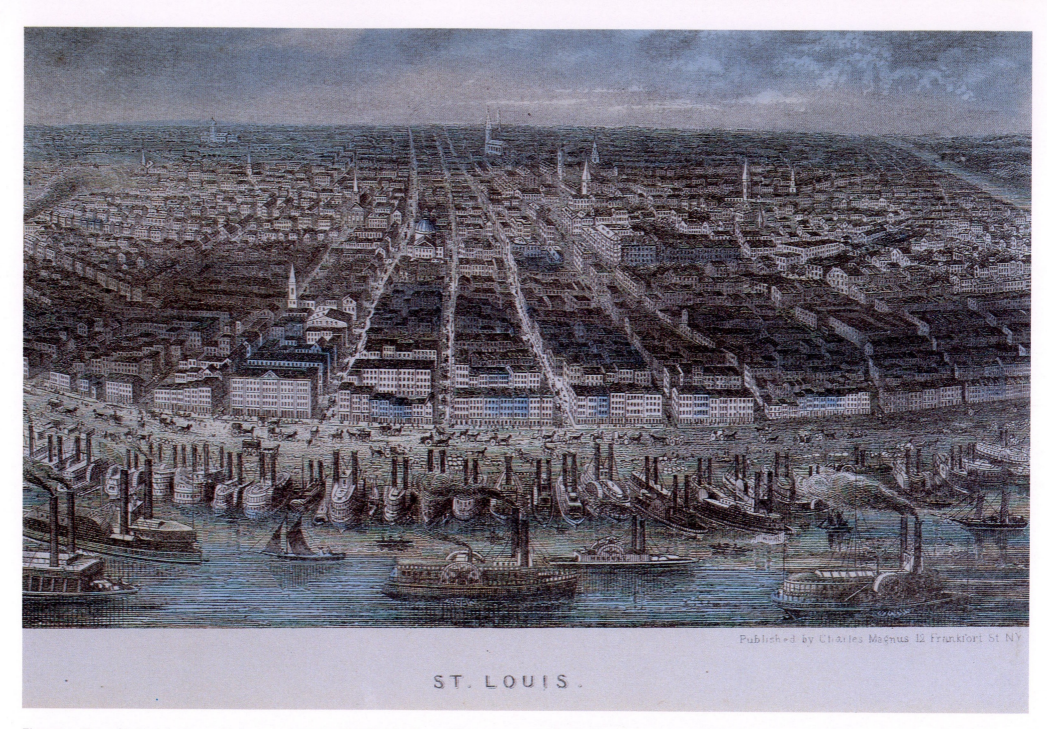

ST. LOUIS.

Published by Charles Magnus 12 Frankfort St NY

Figure 5–4. View of St. Louis by George Hofmann, published in New York by Charles Magnus ca. 1854. (Collection of A. G. Edwards and Sons, Inc., St. Louis, Missouri.)

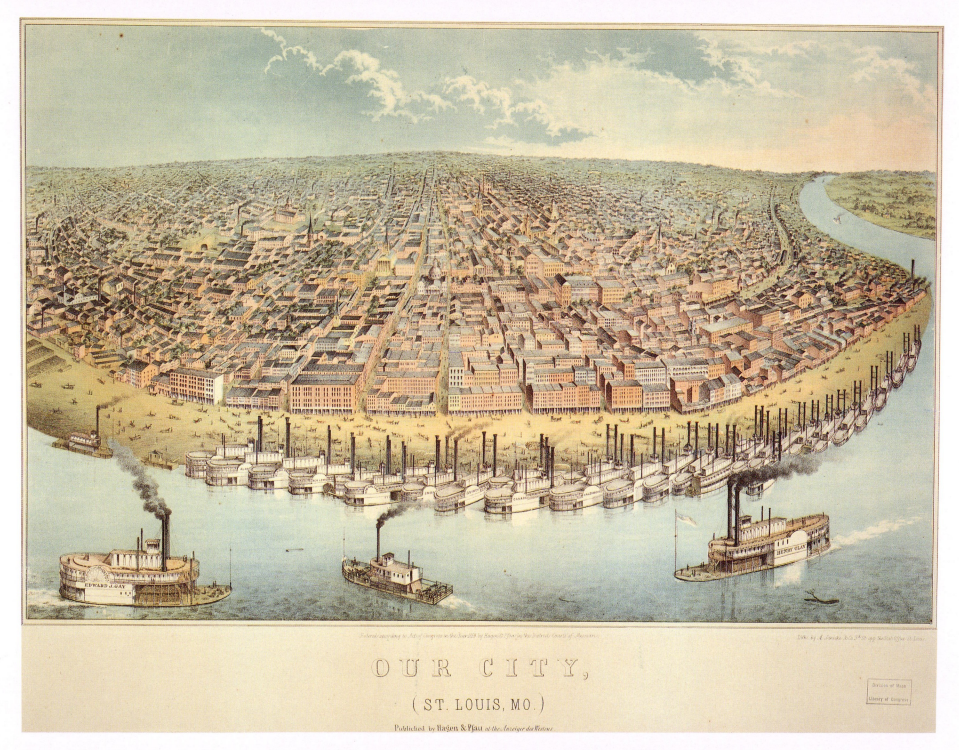

OUR CITY,

(ST. LOUIS, MO.)

Published by Hagen & Pfau at the Anzeiger des Westens.

Figure 5–6. View of St. Louis, printed in St. Louis by A. Janicke & Co. and published in St. Louis by Hagen & Pfau in 1859. (Division of Prints and Photographs, Library of Congress.)

The proprietors of the leading German-language publication in St. Louis, the *Anzeiger des Westens*, published a third derivative of Hofmann's view in 1859. Reproduced in Figure 5–6, this fairly large lithograph came from the press of A. Janicke & Co., located on Third Street opposite the Post Office. This is a close copy of the larger prototype, but it does include a tiny locomotive approaching the station on Seventh Street over the tracks that disappear on the horizon. In addition, the steamboats along the levee assume their proper positions, although elsewhere this print fails to duplicate the energy and excitement conveyed by the original engraving. Impressions of this print are recorded in only two public collections, the Missouri Historical Society and

the Library of Congress. Like several other St. Louis views, its rarity may indicate that it appealed to few customers and was a commercial failure.

Even this version of the view is inadequate in showing how the railroad fit into the urban pattern of St. Louis. For this we need to turn to the map of the city in 1859 reproduced in Figure 5–7. This shows the line of the Pacific Railroad leading to the station at Poplar and Seventh. Its tracks ran almost directly east-west following the valley of Mill Creek, which once emptied into Chouteau's Pond. A slightly later rail line, the North Missouri Railroad, entered the city from the north.

This map also reveals the uncoordinated and discontinuous network of

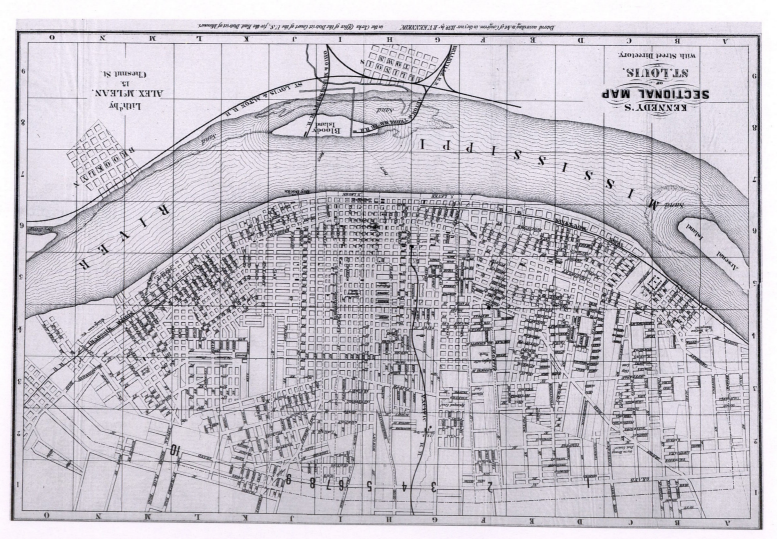

Figure 5–7. Plan of St. Louis in 1859, printed in St. Louis by Alex. McLean and published in St. Louis by R. V. Kennedy in 1859. (Missouri Historical Society.)

grid streets that resulted from an almost total lack of public control over private development combined with an absence of imagination when the city itself laid out new streets. A complete stranger looking at this map might have concluded that everyone involved had conspired to produce a street system without logic or beauty. We need to understand how this system developed to appreciate more fully the importance of the next view to be considered.

Most of the land shown on the map had been recently subdivided. Much of it had once belonged to the city, which had assumed title to the former commons of the French and Spanish colonial town following the Louisiana Purchase.[28] This tract extended west of Fourth Street to Tenth Street and from Clark Avenue to Park Avenue. Later, officials extended the tract to embrace a much larger area bounded on the west by what became Grand Avenue and on the south by Meramec Street.[29]

The city sold most of the commons in 1836 but reacquired virtually all the land when purchasers failed to make payments. A few other parcels were sold in 1842, but it was not until 1854 that the city finally disposed of its public domain. In doing so, the city stamped a rigid grid pattern on the huge tract of land lying southwest of the original settlement. Acting under authority from the state legislature, the City Council created a Board of City Common. It empowered the board to lay out streets no less than sixty feet wide with alleys at least twenty feet wide and to divide the resulting blocks into lots measuring twenty-five by one hundred and twenty-five feet. In periodic auctions beginning June 1854 and ending July 1859, the city sold more than thirty-eight hundred acres of land, with the new owners paying a total of $670,000.[30]

Elsewhere private landowners like Auguste Chouteau, J. B. C. Lucas, Julia Soulard, John O'Fallon, and William Christy subdivided their large holdings from time to time, adding to the availability of subdivided land. In laying out streets, all of them used the utilitarian if unimaginative grid pattern that earlier

town developers employed in almost every new or expanded town in America. For example, in 1852 surveyors laid out the Stoddard Addition west of Jefferson Avenue in a vast checkerboard of seventy-two blocks created by straight streets intersecting at right angles.[31]

In the mid-1850s several other landowners in the northwest divided their farms and estates into building lots. They intended to benefit from the steady increase of land values caused by the new fairgrounds located in 1855 on a fifty-acre acre site near the northwest city limits at what became Grand Avenue and Natural Bridge Road. Rapid population growth promised a market for urban land that seemed almost insatiable.[32]

One example of wise city planning stands out near the top of the map in Figure 5–7. This is Grand Avenue, located just inside the western and northern boundaries of the city. Conceived in 1850 by Hiram Leffingwell and Richard Elliot, two engineers and early real estate developers, this great circumferential thoroughfare was intended, as Leffingwell boasted, to become "the greatest street in the world." Originally proposed to be 120 feet wide, Grand Avenue was reduced to 80 feet by the county legislature, whose members lacked the vision of the two promoters.[33]

The map also shows Lafayette Park, bounded by Park, Mississippi, Lafayette, and Missouri avenues. This early public park occupied land once part of the city commons. The City Council first reserved it as a parade ground, designated it for park purposes in 1844, but did not formally dedicate it for this use until 1851. The improvements that followed stimulated residential development nearby, although two choice sites became cemeteries rather than subdivisions.[34]

28. French settlements in North America usually had both common fields and commons. Auguste Chouteau explained the St. Louis system in testimony before the Board of Land Commissioners in 1808: "The land immediately adjoining the village on the northwest, being the most suitable, was set aside for cultivation, and conceded in strips . . . and each applicant allotted one or more. . . . This was called the common-field lots, and the tract extended from a little below Market Street on the south to opposite the big mound on the north, and from the Broadway to Jefferson Avenue, east to west. The land lying southwest of the village, being well watered with numerous springs and well covered with timber, was set aside for the village commons, in which the cattle and stock of the inhabitants were kept for safety and convenience." Quoted in J. Thomas Scharf, History of St. Louis City and County . . . , 1:163.

29. St. Louis City Plan Commission, History: Physical Growth of the City of Saint Louis, 5.

30. Scharf, History of Saint Louis, 2:1027–28.

31. Primm, Lion of the Valley, 149–50, lists and locates some of the major additions to the city from the early 1830s: "Beginning with J. B. C. Lucas's extension of his subdivision to Ninth Street in 1833, thirty-one additions to the city were made by 1845; the most important being those of Julia (Cerré) Soulard, from the river to Fourteenth Street between Park and Geyer; John O'Fallon, from Seventh to Twelfth streets between Franklin and Biddle; E. T. and William Christy, Ninth Street to Jefferson (twenty-four blocks west of Main) between Franklin and Lucas; and Lucas's third addition, Ninth to Eleventh streets between Market and St. Charles."

32. The St. Louis Agricultural and Mechanical Association sponsored the annual October fair, beginning in 1856, the year after a number of younger community leaders founded the organization. They purchased the site from Col. John O'Fallon. It was located far beyond the outer edge of urban development. See van Ravenswaay, "Years of Turmoil," 321.

33. Leffingwell is quoted from an unidentified source by van Ravenswaay in "Years of Turmoil," 305. The original and modified dimensions are cited in St. Louis City Plan Commission, History: City of Saint Louis, 16.

34. The map identifies the two cemeteries as St. Vincent's and the Episcopal Cemetery. For

Hoffmann did not show either Grand Avenue or Lafayette Park on his view, nor was he able to portray anything more than a suggestion of another important project of the 1850s. This was Lucas Place (now Locust Street), which James Lucas began in 1851 as an exclusive residential street. It extended westward four blocks to Eighteenth Street from Missouri Park, a landscaped square—bounded by Thirteenth, Fourteenth, St. Charles, and Olive streets—that Lucas dedicated to the city. The St. Louis Public Library now occupies the southern half of the park.[35]

That brief summary on the progress and pattern of land development at the urban fringe provides a basis for understanding what can be seen in an extraordinary view of St. Louis published in 1858. This work by James T. Palmatary exists in only one known impression and because of its extreme rarity is not as well known as it deserves to be. It is noteworthy for many features: it is extremely large in size and provides details that smaller prints lack; it is the first true bird's-eye depiction of the city and therefore reveals street patterns and other aspects of the urban structure that earlier views did not show; and it captures the likeness of the city after two decades of rapid and nearly uninterrupted growth. It is significant also in that it presents an image of St. Louis on the eve of a war that would have a profound effect on the city's urban development.

Figure 5–8 reproduces the entire view. Printed on four sheets, the original lithograph is four and one-half feet high and just under eight feet wide. Although most of its surface is now faded and toned and its colors were once clear and bright, if one can judge from a few portions of the print and from examples of other city views in better condition printed—like this St. Louis lithograph—by the firm of Middleton, Strobridge & Co. of Cincinnati, one of the country's finest lithographic printers. At least four colors can be distinguished, so a minimum of sixteen lithographic stones were used to print the four sheets.[36]

The imprint does not identify a publisher, and efforts to find contemporary newspaper accounts that might do so have yet to yield results. Neverthe-

An excellent study of Lafayette Park and the neighborhood around it, known as Lafayette Square, see Stephen J. Raiche, "Lafayette Square: A Bit of Old St. Louis," which includes several old photographs of the area, the first notice of a public auction of lots in the neighborhood in 1856, and descriptions of the damage done to mansions and smaller houses during the tornado in 1896.

35. The library, designed by Cass Gilbert in Italian Renaissance style, was built in 1912.

36. For the work of this firm, see John W. Merten, "Stone by Stone Along a Hundred Years with the House of Strobridge"; Benjamin F. Klein, Lithography in Cincinnati; and T. A. Langstroth, The History of Lithography Mainly in Cincinnati.

less, we can safely conclude from information about his method of operation elsewhere that the artist, James T. Palmatary, not only drew the view but also published it or intended to do so. The absence of news accounts and the existence of only one impression suggest that Palmatary might have been unsuccessful in obtaining enough subscriptions for his venture. The unique impression in the Missouri Historical Society may, therefore, be a proof copy of a view that was never printed for commercial distribution.

A close examination of the view confirms this conclusion, for while many printed business signs and identifications can be found on individual buildings, all of the street names and numbers are in manuscript. It seems highly unlikely that Palmatary would have issued such an otherwise highly detailed urban portrait without street names, and the most likely explanation for their absence in printed form is that he wished to check them for accuracy before the final printing.[37]

Perhaps the failure of his St. Louis view caused Palmatary to abandon city viewmaking, a career he had pursued for several years. He began work in 1850, like the Smiths, as an agent and possibly artistic assistant to Edwin Whitefield. Three years later he published a view of Lancaster, Pennsylvania, and that same

37. Most artist-publishers would not have gone to the expense to have lithographic copies made of a view that failed to attract subscribers after a display of a pencil drawing or a more finished rendering. However, Palmatary may have felt that no drawing could do justice to his work and might have skipped the usual stage of soliciting subscriptions by such a display. Possibly he then discovered that not enough customers existed to justify printing the view in multiple copies. The depression that began in 1857 would have affected the market for such items, and the huge size of the view would have made it undesirable for home decoration. No copyright deposit copy of the view exists in the Library of Congress, although this is not conclusive evidence that Palmatary never published it. There is another reason for thinking that the one known impression is a proof state. The color of the upper left sheet differs from that in the other three, and this sheet is also irregular in shape along the right and lower sides where it butts or overlaps the two adjoining sheets. This suggests that Palmatary was still working on some of the details shown in the lithograph or was modifying in some way the join lines between sheets. He did some strange things during his viewmaking career. For Sandusky, Ohio, in 1855 or 1856 he produced two views, identical in content except that one extends the image on one side. He had one printed in Baltimore and the other in Cincinnati. There is no satisfactory explanation for this except for a local legend that he found the smaller view unsatisfactory, expanded its scope, and had it printed by another firm. My research on Palmatary has been as frustrating as the information is fragmentary. Some of it is described in my "Cities by Sachse: The Urban Views of a Baltimore Lithographer," which will appear in a volume edited by Laurie Baty containing the proceedings of the Baltimore meeting of the North American Print Conference. This supplements and expands somewhat my biographical notes on Palmatary and Sachse in Views and Viewmakers, 194–96, 204–6.

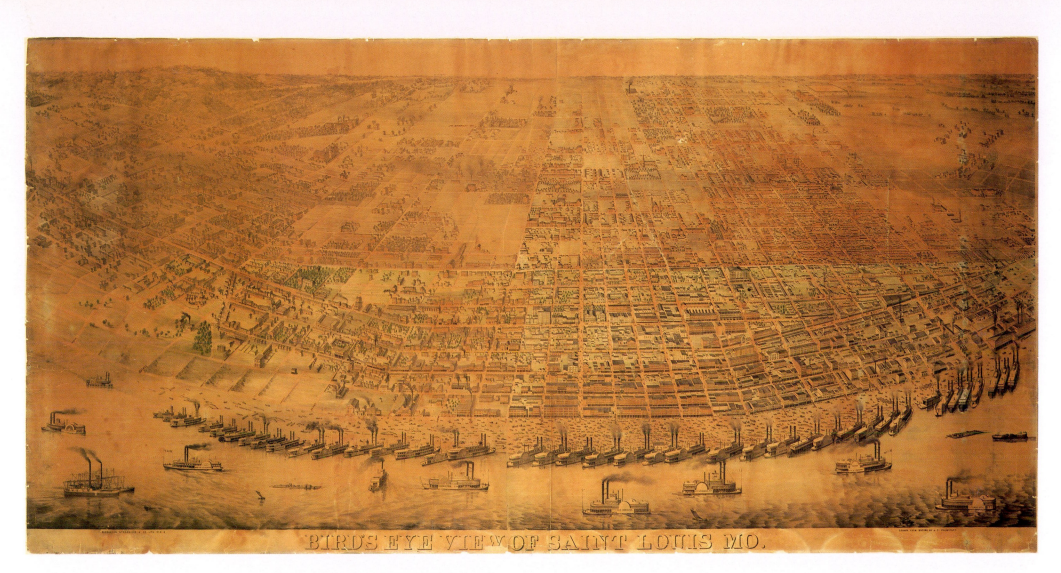

Figure 5–8. View of St. Louis in 1857, drawn and published by James T. Palmatary and printed in Cincinnati by Middleton Strobridge & Co. in 1857. (Missouri Historical Society.)

year he began an association with Edward Sachse, a Baltimore artist, litho-
grapher, printer, and publisher.

Palmatary drew views of Baltimore and of Alexandria, Virginia, that were
skillfully printed in color by Sachse, who signed his name to the lithographs as
the artist while identifying Palmatary as publisher. One can only speculate at
the reasons for this deception. The two then collaborated on several beautifully
drawn and superbly printed colored views of cities in the Midwest before Pal-
matary began to draw and publish views on his own.

In his work with Sachse and for his first lithographs done independently, Pal-
matary confined his views to large folio-size single sheets. At least two of
these required very large lithographic stones and presses. His view of Louisville,
Kentucky, in 1855 measured 33 x 52 inches, and his 1856 view of Milwaukee was
30 x 52 inches. Then, in 1857, Palmatary drew and published a four-sheet litho-
graph of Chicago that at 45 x 82 inches exceeded in size anything previously
attempted. It was the following year that he produced his even larger St. Louis
view.[38]

One can see from the reproduction of the view that Palmatary adopted the
same simplified perspective approach used by Hofmann. Both looked west,
using a street line as the central axis for their compositions, and both used a
single vanishing point at the end of that axis. However, Palmatary located his
vanishing point beyond the horizon, and this enabled him to show buildings in
the background at larger size than would have been possible if, like Hofmann,
he had observed the conventional rules of linear perspective. Palmatary also
chose a much higher vantage point than did Hofmann. This allowed him to
show all the streets of St. Louis, as well as either the front or rear facade of
nearly every building in the city. We see, therefore, the essential structure of St.
Louis as it existed before the Civil War: street pattern, parks, churches, public
buildings, business district, levee and river, established neighborhoods, new
development at the urban fringes, and the surrounding countryside.

In the center foreground the north-south streets of the colonial grid and its
later additions appear as parallel lines. As called for by the techniques of per-

38. Palmatary produced no other recorded work from 1858 to 1864. In that year he visited
Syracuse, New York, and began sketching for a view he proposed to publish of that city. When
the view finally appeared in 1868 it identified two Syracusans as the artists. At that time Palma-
tary worked in Baltimore for Sachse, who printed the Syracuse lithograph in four sheets. In 1869
the Sachse firm published a twelve-sheet view of Baltimore. It seems likely that Palmatary
worked on this enormous view, although neither the imprint on the view nor the contemporary
newspaper accounts mention his name.

spective drawing, the space between them steadily diminishes in the distance to
create the feeling of the third dimension. Palmatary did not distort the appear-
ance of the additions to the city on the north and south as did Hofmann. In-
stead, he correctly showed slight bends in these streets to conform to the gentle
crescent shape of the riverbank.

Although somewhat static and mechanical in its feeling and style, this view
presents St. Louis very much as it must have appeared to William Hyde, a
young journalist who in the summer of 1859 looked down on St. Louis from an
ascending balloon:

The city . . . was an imposing and magnificent spectacle, showing that, large as I knew
her extent of territory to be, filled up with the most substantial evidences of commercial
power and wealth, I had not, from passing through her streets and viewing the mighty
arteries throbbing with all the elements of busy life and trade, formed any adequate con-
ception of her real greatness.[39]

As can be seen in the detail from his view reproduced in Figure 5-9, Pal-
matary did full justice to the levee, showing it lined with steamboats, their
sterns angled downstream in response to the river's current. The space leading
to the solid rows of warehouses facing the water swarmed with people and ve-
hicles. A four-block section of the levee from Market to Locust had only recently
been completely rebuilt, a project completed in the spring of 1857. A St. Louis
newspaper boasted of "this magnificent work" that had transformed the levee
from "a narrow, unpaved and irregular spot" to

a levee which has not its like in the United States. . . . It was necessary not only to extend
the wharf into the river, but also to fill up the ground several feet, and upon this a solid
and durable pavement was . . . laid. . . . Merchants can now do their business with some
comfort, the boats can discharge and receive their freight in one-half the time and in good
condition, and the draymen can pursue their laborious calling without delay and without
being constantly jammed against each other.[40]

For the expanding business district beyond the waterfront, Palmatary's
view permits a far more detailed and revealing examination than any previous

39. William Hyde, "The Great Balloon Experiment: Details and Incidents of the Trip," 95.
This account originally appeared in the *St. Louis Daily Missouri Republican*, 7 July 1859.

40. *St. Louis Missouri Republican*, 20 March 1857, as quoted in Scharf, *History of St. Louis*,
2:1059. According to Primm, *Lion of the Valley*, 165, the city used proceeds from a bond issue of
$200,000 in 1854 to pave the wharf "for nearly a mile; but the pressure for space was still in-
tense. In 1857, by reclaiming several feet from the river by a build-up of paving stone at the
water's edge the city engineer extended the wharf sufficiently to reduce loading time by one-
half."

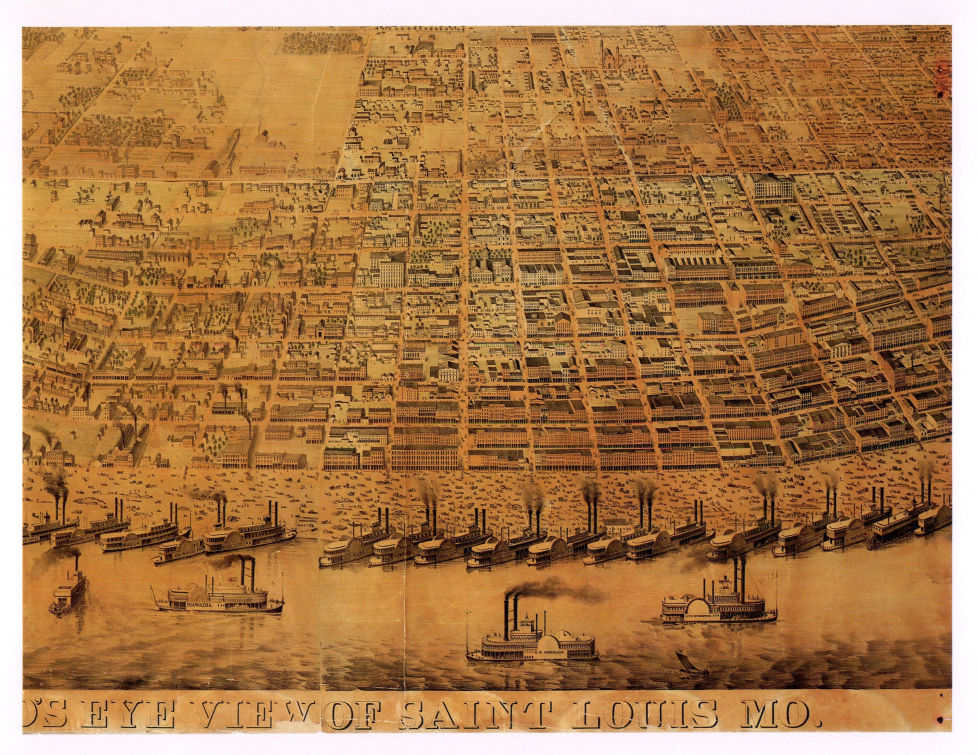

O'S EYE VIEW OF SAINT LOUIS MO.

Figure 5–9. View of St. Louis in 1857, detail of central and northern parts of the city, drawn and published by James T. Palmatary and printed in Cincinnati by Middleton Strobridge & Co. in 1857. (Missouri Historical Society.)

delineation. It shows clearly the major buildings identified in connection with earlier views of St. Louis, but many more appear as well. They include two huge hotels planned in the late 1850s. Palmatary showed them as if complete, although several years elapsed from the time he published his view until the hotels actually opened.

One, the Southern, can be seen between Elm and Walnut streets in the second block south of the Courthouse. This six-story building began in 1860 towered above its neighbors and, when it was finally completed in 1866, brought further distinction to Fourth Street as a major business thoroughfare. After its destruction by fire in 1877, its owners replaced it with the first fireproof hotel built in St. Louis.[41]

Well beyond the Courthouse to the north at Sixth Street and Washington Avenue stood the Lindell Hotel, on which construction began in 1856. On its completion in 1863 its architect claimed it to be the largest hotel in the country. Its location so far to the west of the commercial center in the old town and even of the evolving Fourth Street business and shopping district foreshadowed the more general movement of commerce in this direction that would gather momentum later in the century.[42]

Palmatary did not need to push the hands of time quite so far ahead when he added to his view the image of the new Post Office, Custom House, and Federal Courts building. Begun in 1854 and completed in 1859, this structure occupied the site of the Theatre at the southeast corner of Third and Olive.

Many additional commercial and public buildings of this period added richness and variety to the St. Louis townscape. Another, shown by Palmatary as a light-colored building at the southwest corner of Fifth and Locust streets, reflected the city's regard for learning and knowledge. Erected in 1854 by the Mercantile Library Association to house its large and growing collection, this structure also provided on its third floor a public hall and meeting place in which many important events took place.[43]

Palmatary's view also proves invaluable as a guide to the evolving pattern of land development beyond the more densely built-up part of the city. This can be appreciated best by examining the detail reproduced in Figure 5–10. Looking west down Market Street, the central axis of the view, we see a landscaped park not quite halfway between Seventh Street and the horizon. This is Washington Park, bounded by Clark Avenue, Thirteenth and Market streets, and what was then Twelfth Street (now Tucker Boulevard). The St. Louis City Hall now occupies this site.

Four blocks to the right (north) and slightly farther to the west a similar landscaped rectangle appears. This is Missouri Park, marking the eastern end of the Lucas Place neighborhood that the Hofmann view failed to show with any clarity. Palmatary captured in its infancy the image of a neighborhood that provided a model for dozens of later residential projects whose developers used deed restrictions to impose regulations designed to protect the character of the neighborhood. Unlike Lucas Place, many of the subsequent private street projects included a private park strip as well.[44]

Lucas Place quickly became the most fashionable residential quarter of the city, although today only the Campbell House remains of the many mansions and townhouses that wealthy community leaders once occupied. Lucas himself moved from his recently finished home at Ninth and Olive to 1515 Lucas Place. Deed restrictions imposed by him permitted churches, and in 1855 the congregation of the First Presbyterian Church erected a new place of worship facing the foot of Lucas Place across Fourteenth Street from the park, a building that Palmatary included in his view. Eventually, Christ Church, begun in 1859, faced Missouri Park from a location on the east side, and the Second Presbyterian Church, built in 1868–

41. See Lowic, *Architectural Heritage*, 81, for a photograph of the original building designed by George I. Barnett. Earlier, Barnett designed another six-story hotel, Burnum's Hotel at Second and Walnut, finished in 1854.

42. The Lindell Hotel was the most luxurious in St. Louis. Two dining rooms, each 233 feet long, could be joined for special events. Its accommodations for twelve hundred guests went up in flames in 1867. Its owners, like those of the Southern Hotel, rebuilt the Lindell, but it never recaptured its former dominance. See Lowic, *Architectural Heritage*, 80, for a photograph of the first building and descriptions of its architectural design by Thomas Walsh.

43. For photographs and detailed architectural descriptions of the Custom House and the Mercantile Library, see Lowic, *Architectural Heritage*, 75–78. In 1885 a six-story building on the same site replaced the original three-story Mercantile Library building.

44. On private streets or "places" in St. Louis, see Charles C. Savage, *Architecture of the Private Streets of St. Louis: The Architects and the Houses They Designed*. Although Savage concentrates on the buildings and their architects, he also includes reproductions of the original plats for many private street developments. See also Norman J. Johnson, "St. Louis and Her Private Residential Streets"; S. L. Sherer, "The 'Places' of St. Louis"; and Robert Vickery, "The Private Places of St. Louis."

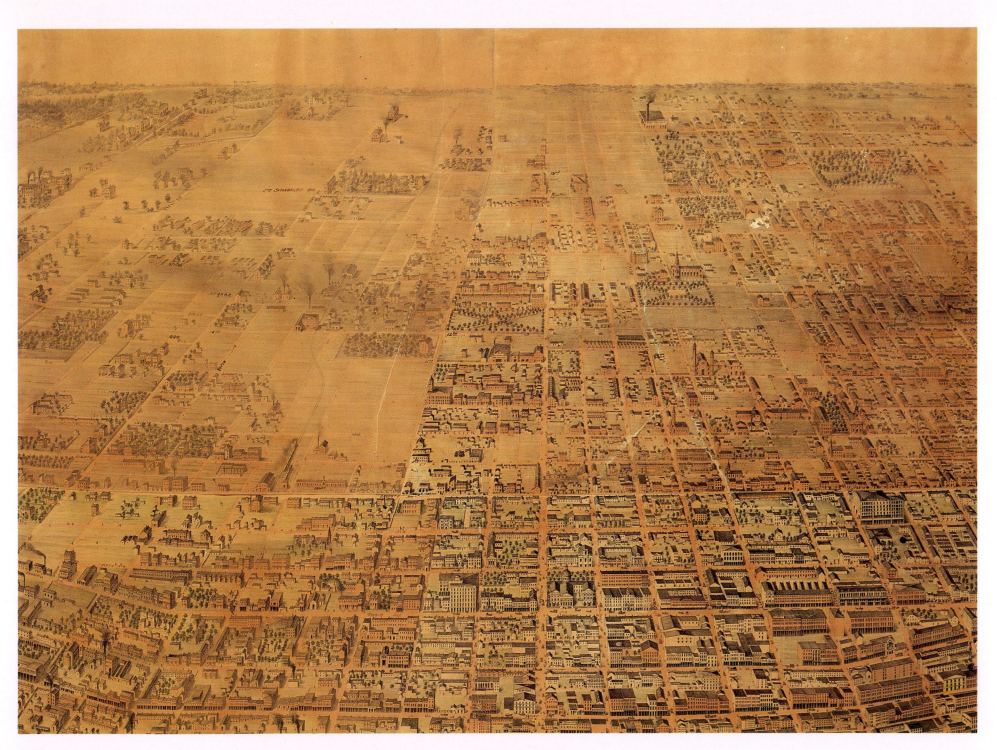

Figure 5–10. View of St. Louis in 1857, detail of western and central neighborhoods, drawn and published by James T. Palmatary and printed in Cincinnati by Middleton Strobridge & Co. in 1857. (Missouri Historical Society.)

1869, occupied a site on Lucas Place at Seventeenth. This neighborhood also provided the location for the city's first public high school, an elaborate Gothic structure at Fifteenth and Olive, just a half-block from the homes of the city's aristocrats on Lucas Place. Palmatary's image of this building appears somewhat distorted. It was completed only in 1856, and possibly the artist did most of his sketching for the view while the building was still under construction.

Towers and spires from these new buildings thus joined the dozens of similar features throughout St. Louis that gave interest and vitality to the city's skyline. These included the churches serving less affluent neighborhoods in the northwestern sections of the city. Palmatary's view reveals that this area then consisted of block after block of small houses beginning to fill in the enormous street grid that land developers and speculators had platted in this part of the city.

Lafayette Park is barely visible in Figure 5–8, located just at the horizon on the upper left sheet of the view. One can see there a few houses on the north and south sides of this early and important public open space. Here, in later years, far-sighted developers would create two of the first private residential streets in the city, developments that so many others would imitate in the period after the Civil War. The image of a very large building can be seen not far away at Thirteenth Street. This is the city hospital, built well beyond what were then the outer limits of urban growth, but which by 1857 was rapidly being approached by new residential construction as the city relentlessly expanded westward.

Finally, among the dozens of other elements of St. Louis that Palmatary displays for identification, study, and interpretation, he shows the line of the Pacific Railroad leading westward from the station on Seventh Street (near the lower left corner of Figure 5–10) over what was once Chouteau's Pond and along the valley of Mill Creek. The whistles of the locomotives and the smoke pouring from their stacks surely seemed like signs of certain progress and prosperity.

The railroad did indeed promise and deliver both, but in St. Louis, as in other cities, the railroad's arrival also caused substantial changes in the urban fabric, and it altered city life in many other ways. Eventually it brought a virtual end to the Mississippi steamboat traffic that had been responsible for much of the growth the city had enjoyed. In the chapters ahead we can follow these events through the eyes of viewmakers who continued to record the evolving face of the city and who have left us the results of their efforts to learn from and to enjoy.

VIEWS OF ST. LOUIS IN THE ERA OF WAR AND RECONSTRUCTION

The Civil War brought urban viewmaking in the United States almost to a halt. Certainly at this time St. Louis would have seemed unattractive to any itinerant artist. Torn by bitter antagonisms between abolitionists and those who supported slavery, the city spent most of the war years under martial law. A correspondent for the *Atlantic Monthly* described life during that period:

> The blockade of the river reduced the whole business of the city to about one third its former amount; and yet nothing could prevent refugees from the seat of war from seeking safety and sustenance in the impoverished town. Families were terribly divided. Children witnessed daily the horrid spectacle of their parents fiercely quarrelling over the news of the morning, each denouncing what the other held sacred, and vaunting what the other despised.[1]

Such conditions explain why during the war years no views of significance appeared. Indeed, during the entire decade of the 1860s artists created only a limited number of new images of St. Louis. With a very few exceptions, these possessed neither artistic excellence nor historical importance. In the first half of this period most of the published views of the city took the form of bookplates or lettersheet illustrations that merely copied older lithographs or engravings.[2]

Hofmann's view of 1854 provided the most often used model. One version of this can be found in the *Souvenir Album of the Visit to America in 1860 of Albert Edward, Prince of Wales*.[3] Another version is the wood engraving already reproduced as Figure 5–5 that seems to have made its first appearance in 1860 as an illustration in Richard Edwards and M. Hopewell's *Edwards' Great West* and that reappeared in several of Edwards's city directories.

Aside from its misleading depiction of steamboats with their sterns pointed into the current, this delineation of St. Louis did not adequately represent how the city had spread to the north, west, and south by the beginning of the Civil War to accommodate its growing population. The 1860 census credited the city with a population of just over 160,000, making it the eighth largest

1. "The City of St. Louis."

2. In John Warren Barber and Henry Howe, *Our Whole Country: A Panorama and Encyclopedia of the United States*, 2:1271, there is a small, partial view of the St. Louis waterfront with a caption stating, "The view was taken . . . near the Railroad Depot, on the Illinois side of the Mississippi, and shows the steamboats lying at the Levee, in the vicinity of the Custom House, and the Court House, the upper portion of which is seen in the distance." Working individually or together,

Barber and Howe previously produced illustrated volumes describing Connecticut, Massachusetts, New York, New Jersey, Pennsylvania, Virginia, and Ohio. In this new work that drew on their previous efforts but added much new material on the West, Barber claimed that "with the book in hand" any reader could "place himself within a yard or two of the precise spot from whence each was drawn." He also explained that the two had taken great care "that every engraving should be truthful" and that they had avoided "fancy sketches and artistic representations" (1:vi). I have found little written about them, but see John T. Cunningham, "Barber and Howe: History's Camp Followers."

3. I know this illustration only from a negative in the files of The Old Print Shop in New York City. My efforts to find a copy of the publication have so far been fruitless, but the view is illustrated in the *Portfolio of the Old Print Shop*, 111. The notes accompanying the negative and the catalog illustration give the size as ca. 5 x 8 inches.

city of the nation, only a few hundred people smaller than its nearest river-city rival, Cincinnati. Chicago then lagged behind St. Louis in total population by almost 50,000 inhabitants. Even the expansive mood of Hofmann's engraving with its aura of urban energy and vitality could not convey the generous proportions of the city in 1860 following two decades of sustained growth. The much smaller and considerably cruder wood engraving that Edwards used several times proved even less effective in this respect and, of course, grew ever more out-of-date with the passage of time.

Edwards used at least two other views of St. Louis in his various publications. The earlier of these is reproduced as Figure 6–1, a wood engraving he included in his *Edwards' Great West* in addition to his version of the Hofmann view. This view made no attempt to represent the city as it looked in 1860, the year Edwards published his book. Instead, the imprint informs us that the engraving was made "from a Beautiful Painting by Professor Devraux, of Philadelphia, Taken in 1854, Expressly for this work."

Devraux (or Devereux) was the artist of another view of St. Louis in 1854, one published about 1858 and reproduced previously as Figure 4–20. It seems doubtful that he drew the city "expressly for" *Edwards' Great West.* Instead, Edwards probably copied the drawing for his own purpose from some unidentified source. Doubtless Edwards expected the reader to compare this restricted image with the more revealing and exciting view borrowed from Hofmann (with an implied date of 1860 rather than its original date of publication, also 1854) and be impressed by the changes wrought in St. Louis in six years.[4]

The other view used by Edwards, also a wood engraving, offered within its quite restricted compass (only ⅞ x 4 ¼ inches) a slightly better impression of the size and character of the city. Reproduced in Figure 6–2, this title headpiece to a gazetteer and commercial directory of the Mississippi published in 1866 suggests something of how the city must have looked from a ferry crossing the Mississippi from Illinois.[5] Yet it, too, lacks conviction and any sense of dynamism and seems to be based on much earlier panoramas.

In the year Edwards published this view the city's population exceeded 204,000, indicating that even during the chaos of war St. Louis continued to attract many new residents.[6] Some of them were Union sympathizers who fled the Deep South just before or during the war. Many others came from abroad to join their countrymen from Germany, Ireland, or elsewhere in Europe who earlier had made St. Louis their home.

An English author, Edward Dicey, visited St. Louis in 1862 and, despite the disruptions caused by the war, came away full of admiration for what he encountered. Declaring the city to be "a constant marvel," he called St. Louis "the capital city of the great West, the frontier town between the prairie and the settled country." He was astonished that here, "eleven and twelve hundred miles from New York," he found himself "in a vast city, as civilized and as luxurious as any city of the New World." Although the war had severely limited river commerce, Dicey found that "the wharf was lined with . . . huge river-steamboats . . . [and] there were boats enough coming and going constantly to make the scene a lively one." From the levee Dicey observed the city rising "in long, broad streets, parallel to the quay." After they "reached the hill's brow," these streets stretched "away far on the other side across the prairie."

In this modern city Dicey could find no trace of frontier conditions:

> There is no look left about St. Louis of a newly-settled city. The hotels are as handsome and as luxurious as in any of the elder States. The shop-windows are filled with all the evidences of an old civilization. . . . You may ride for miles and miles in the suburbs, through rows of handsome private dwelling-houses. . . . All the private houses are detached, two stories high, and built of Dutch-looking brick.

Dicey examined the city with more than a casual tourist's eye. He concluded, "There may be poverty at St. Louis, but there is no poor, densely-populated quarter." He perceived only one problem: "In Missouri, the smokeless anthracite coal is not to be had, and therefore the great factories by the riverside cover the lower part of St. Louis with an English-looking haze of smoke." Although Dicey added that the "sun is so powerful, and the sky so blue, that not even factory smoke can make the place look dismal," the problem of air pollution increasingly worsened, and visitors and residents alike complained of it with greater frequency as the city grew and became more heavily industrialized.[7]

6. James Neal Primm, *Lion of the Valley: St. Louis, Missouri*, 280, does not cite a source for the figure of 204,327.

7. Edward Dicey, *Six Months in the Federal States*, 2:95–99. Dicey may not have found the worst housing in St. Louis because, according to Primm, *Lion of the Valley*, 190, in the 1850s "there were poverty pockets on the northwest fringes of the downtown area, called 'Wildcat Chute,' 'Clabber Alley,' and 'Castle Thunder,' inhabited by what respectable people called 'denizens' or 'vicious characters.' One entered these regions at night at risk of life and limb; but most of the crimes there were intramural." A more famous English author who visited St. Louis at the same

4. The three steamboats in the view, the *J. H. Lucas,* the *Kansas,* and the *Wm. McKee,* are not listed in William M. Lytle, comp., *Merchant Steam Vessels of the United States, 1807–1868.* Probably Edwards added their names when the wood engraving was being prepared.

5. The view itself bears no title but is part of the title block of *Edwards' Descriptive Gazetteer and Commercial Directory of the Mississippi River From St. Cloud to New Orleans. . . .* John Hoover, librarian of The Mercantile Library in St. Louis, kindly drew my attention to this publication.

Figure 6–1. View of St. Louis in 1854, drawn by Devraux and published in St. Louis by Richard Edwards and M. Hopewell in 1860. (St. Louis Mercantile Library Association.)

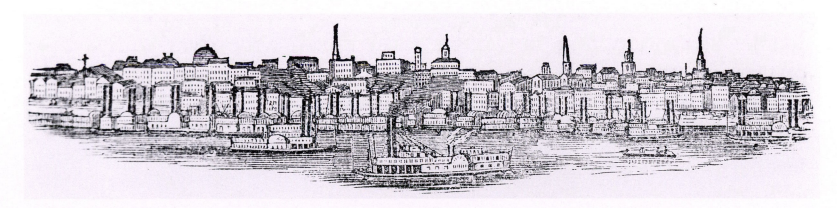

Figure 6–2. View of St. Louis in 1866, published in St. Louis in *Edwards' Descriptive Gazetteer . . . of the Mississippi. . . .* (St. Louis Mercantile Library Association.)

Five small views published in the 1860s add little to our knowledge of the city, although three are rare curiosities and another, originating in France, is an attractive example of steel engraving. The most unusual is reproduced in Figure 6–3. Charles Magnus, a prolific New York publisher of city views and other images, published it some time during the Civil War on one of the many patriotic envelopes he issued. This tiny engraved image provided no details of the city but offered recipients some idea of how St. Louis appeared from across the Mississippi River.[8]

Figures 6–4, 6–5, and 6–6 illustrate three other views of this period. One provides the top illustration of an elaborately decorated engraved lettersheet published and sold by Conrad Witter, whose book and stationery shop occupied a corner at the intersection of Walnut and Second streets from about 1853 to 1866. It was apparently this unsigned depiction, said to be "drawn from nature," that provided the model for the French book illustration that will be discussed shortly.[9]

The second view in this group (Figure 6–5) appeared on another undated lettersheet published by one Eli Adams, probably in 1865. Adams gave his address as No. 267 1/2 Broadway "under Keevil's Big Hat," a reference to the gigantic hat used by a merchant on top of his building to advertise his stock-in-trade. Palmatary's view of St. Louis clearly shows this distinctive feature of the St. Louis mercantile scene. The hat appears in Adams's lithograph rising above the rooftops at the end of a pole. One can see it on the skyline directly above the "B" in the words *Big Hat* lettered in the imprint below the image.[10]

The third view in this group (Figure 6–6) helped to advertise the Western Transit Insurance Company in 1867. It shows the city, as did so many earlier depictions, from the Illinois bank of the Mississippi and presents the skyline to us much as it had looked a decade earlier. The unknown artist of the insurance company view, however, provides—probably unconsciously—both a summary and a forecast of transportation in the Mississippi valley.

The raft in the river, the stagecoach in the left foreground, and even the steam-powered ferry and sleek packet vessel were all being challenged by the railroad. Its dominating presence at the bottom of the view symbolized the coming era when this new means of transport would soon replace older methods for moving people and cargo. In the process, the influence of the Mississippi River on domestic commerce greatly weakened, the axis of trade in the Midwest shifted from its prevailing north-south orientation to one that linked east and west in ever stronger ties, and St. Louis lost ground to Chicago in its race for regional urban supremacy. The disruption of river traffic during the Civil War began this transition; the development of a national rail network speeded its pace enormously.

Probably none of these views by St. Louis artists was completely up-to-date. Certainly that was true of the work of a Frenchman named Boullemier who about 1866 or 1867 produced a view of St. Louis probably used as a book illustration. The imprint on the charming but by then partly obsolete little image reproduced in Figure 6–7 identifies him as both artist and platemaker of this steel engraving. The odds are that Boullemier came no nearer St. Louis than his Paris studio and simply concocted his view from the lettersheet that Witter had issued a few years earlier.[11]

time received a less favorable impression. Anthony Trollope stated, "I cannot say that I found it an attractive place, but then I did not visit it at an attractive time. The war had disturbed everything, given a special colour of its own to men's thoughts and words, and destroyed all interest except that which might proceed from itself." Nevertheless, he called the town "well built, with good shops, straight streets, never-ending rows of excellent houses, and every sign of commercial wealth and domestic comfort,—of commercial wealth and domestic comfort in the past, for there was no present appearance either of comfort or of wealth." Along the levee he saw a line of steamboats that "seemed to be never ending . . . , but then a very large proportion of them were lying idle. . . . There they lie in a continuous line nearly a mile in length along the levee of St. Louis, dirty, dingy, and now, alas, mute. They have ceased to groan and puff, and if this war be continued for six months longer, will become rotten and useless as they lie." Trollope also wrote that the Lindell Hotel building was complete "as far as the walls and roof are concerned, but in all other respects is unfinished. I was told that the shares of the original stockholders were now worth nothing." Anthony Trollope, *North America*, 385–86.

8. Eric Newman first called my attention to this view. Later, Helena Zinkham sent me a copy of the impression in the Division of Prints and Photographs at the Library of Congress and pointed out that Magnus used the identical illustration to decorate a patriotic songsheet that he doubtless also published during the Civil War. A small illustration of this is in Edwin Wolf II, *American Song Sheets, Slip Ballads, and Poetical Broadsides, 1850–1870: A Catalog of the Collection of The Library Company of Philadelphia*, ill. 63, following p. vii.

9. It is possible that Witter issued this view in the late 1850s. The steamship in the foreground whose name is partly obscured must be the *John Simonds*, a vessel that began service in 1852 and called at St. Louis until it foundered a decade later. See Lytle, comp., *Merchant Steam Vessels*, 102, 242. The depiction of the Courthouse dome suggests that the lettersheet belongs to the late 1850s, if it appeared in that decade. Witter's address appears in a variety of forms in city directories, but he seems to have occupied the premises at the southeast corner of Walnut and Second every year from 1852 to 1865 except for 1862, since his listing in the 1863 directory places him at 88 Market, between Third and Fourth streets.

10. I have looked without success for a listing of Eli Adams in St. Louis city directories for 1857–1869. There were no directories in 1861 and 1862.

11. I have not located the publication in which the Boullemier view almost certainly can be found as an illustration, but it is probably a volume of travels. It must be a very common work, for in visiting half a dozen print shops in Paris in the early summer of 1987 I came across an equal number of impressions of the print.

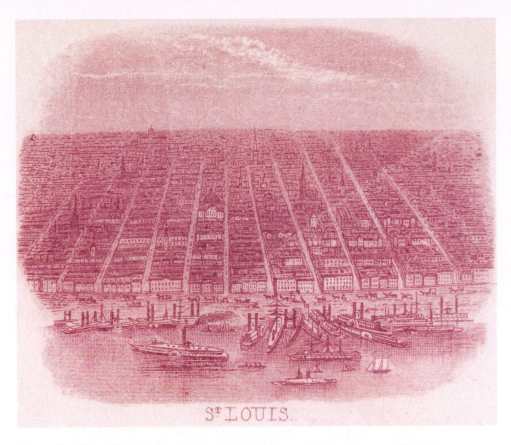

Figure 6–3. View of St. Louis, published in New York by Charles Magnus, 1860–1864. (Eric and Evelyn Newman Collection.)

Figure 6–4. View of St. Louis published in St. Louis by Conrad Witter, 1852–1862. (Division of Prints and Photographs, Library of Congress.)

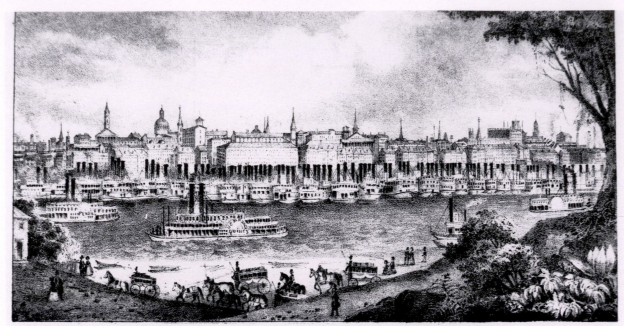

Published by *Eli Adams*, *Agent*. *No. 267½ Broadway under keevil's Big Hat*. *St. Louis*.

St Louis Mo

Figure 6–5. View of St. Louis in the 1860s published in St. Louis by Eli Adams. (Missouri Historical Society.)

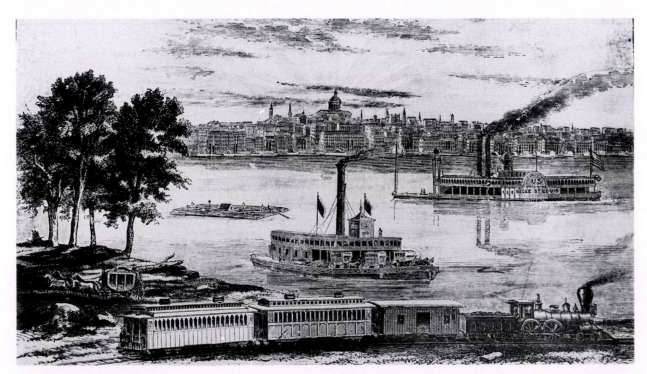

Figure 6–6. View of St. Louis in 1867, published by the Western Transit Insurance Company. (Missouri Historical Society.)

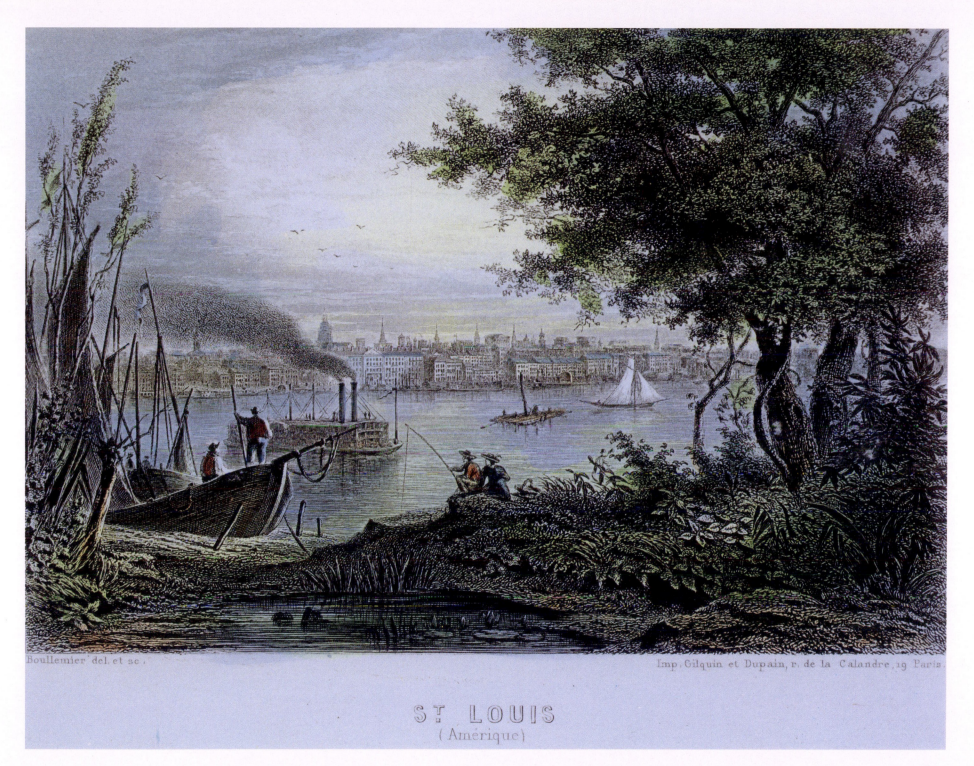

ST LOUIS
(Amérique)

Figure 6–7. View of St. Louis, drawn and engraved in Paris by Boullemier and printed in Paris ca. 1867 by Gilquin et Dupain. (Collection of A. G. Edwards and Sons, Inc., St. Louis, Missouri.)

Three views of the 1860s deserve more attention because of their size, content, or the conditions under which they came into being. One provides the only detailed printed depiction of Carondelet, the second offers us a chance to inspect the exclusive precincts of Lucas Place, while the third consists of a revised and at least partially updated version of the very long Gast skyline panorama of 1855.

The lithograph of Carondelet reproduced in Figure 6–8 has no date, but its publisher, Theodor Schrader, probably issued it in 1859 or 1860. Schrader began to work for the Robyns in 1853, bought the printing and publishing business from them in 1857, and by the end of 1860 had produced six handsome city views of places in Missouri and Illinois. The style of each resembled that of this view of Carondelet, consisting of a principal view surrounded by several vignettes depicting the appearance of selected buildings in the town.[12]

Andreas August Theodor Schrader came to America in 1851 at the age of thirty-nine after being trained first in music, Latin, and French and then as a lithographer who worked in Braunschweig, Vienna, Budapest, and Nuremberg before serving in the Prussian army in 1848. Schrader continued the business he bought from the Robyns until his death in 1897. His advertisement in 1865 among the pages of *Edwards' St. Louis Directory* gives some idea of the range of his printing and publishing activities. At that time Schrader offered his services in producing the following:

> Bonds, Maps, Plans of Cities and Real Estate, Show Bills, Portraits, Landscapes and other Drawings, Visiting and Professional Cards, Bills of Exchange, Notes, Checks, Illustrations, Titles, &c., &c., executed in the finest style, at reasonable charges. A great variety of Labels for Wine, Liquors, &c., constantly on hand.[13]

The anonymous artist who drew the Carondelet view that Schrader published (perhaps Schrader himself) chose to depict the town from a spot almost identical to that used by Henry Lewis in the view reproduced earlier as Figure 4–6. Comparing the two shows how much development had occurred in what was then still a southern suburb of St. Louis and not yet an official part of the city. Although much vacant land remained, houses, stores, factories, and public buildings now occupied many portions of the valley and hillside that Lewis had recorded as farm- or pastureland. Thus, while the view records that Carondelet had shed its rural costume for suburban garb, it remained a quiet, almost bucolic retreat far removed from the center of urban activity in St. Louis.

A second view of the mid-1860s contrasts sharply with Schrader's scene of suburban Carondelet and reminds us how far St. Louis had come in the century since its founding as a frontier settlement depending on the fur trade for its survival. Edward Sachse, the leading Baltimore view artist, printer, and publisher, printed the lithograph reproduced in Figure 6–9 in several colors. Edward Buehler of St. Louis published the print, probably in 1865.[14] The imprint does not identify the artist, and it might have been Sachse himself, for in the mid-1850s he visited two sons in St. Louis and might have returned a decade later.[15] It is also possible that James Palmatary drew this view. He favored the one-point perspective system used by the artist of the lithograph, he was familiar with St. Louis, and two years after this view appeared he is known to have

12. The views are as follows, with the catalog numbers from my *Views and Viewmakers of Urban America . . .* in parentheses: Belleville, Illinois (782); Highland, Illinois (894); Carondelet, Missouri (1988); Hermann, Missouri (1996); Jefferson City, Missouri (2000); and Washington, Missouri (2076). On each of these the imprint identifies Schrader as the publisher. Except for the views of Carondelet and Jefferson City, the imprint also shows him as printer. It seems safe to conclude that he printed the other two as well. None of the views identifies the artist.

13. For these biographical notes I have relied on "Theodor Schrader, St. Louis Lithographer." This gives his place of birth as Harbke, Prussia. The business address for Schrader at the time of his 1865 advertisement was 14 Chestnut Street. I have not examined all the city directories, but Theodore Schrader & Co. was at 15 North Third in 1874, at 106 Market in 1878, and at 112 Market in 1882. In that year he lived at 2720 Gamble. Next door at 2718 lived Charles Juehne, an artist and lithographer who created a large bird's-eye view of St. Louis published in 1894 and again in 1895. This is probably no coincidence, but one can only speculate about what the relationship may have been.

14. The imprint gives Buehler's address as "15 S. 4th St." Buehler's "French and German book store" first occupied these premises in 1864, according to city directory listings. The directory for 1865 identifies Edward Buehler as a bookseller and stationer. I have found no other listings for him.

15. Two very small undated lithographs of buildings in St. Louis are signed "Lith. inst. by Sachse brothers & son," with both Baltimore and St. Louis given as the address. A large view of the Mississippi River somewhere in Missouri has the imprint "Lith. by E. Sachse & Co. Baltimore." All three undated lithographs are in the Missouri Historical Society: *Mundung des Missouri in den Mississippi* (6 3/8 x 8 inches); *Courthouse at St. Louis* (3 1/4 x 5 1/4 inches); and *Odd-Fellow's Hall at St. Louis* (3 1/4 x 5 1/4 inches). The information about Sachse's sons in St. Louis comes from Lois B. McCauley, *Maryland Historical Prints, 1752 to 1889,* 232–34. There is also a biographical sketch of a Theodore Sachse (b. 1841), son of Julius Sachse (1810–1880), in *History of Southeast Missouri,* 798. Julius came to America from Germany in 1849, lived for a time in St. Louis, and then moved to Perry County, Missouri. It seems likely that Julius and Edward were related. Edward Sachse's artistic skills were highly developed. I have seen in a private collection near Baltimore several fine landscapes he did in oils, as well as some of the small lithographs he printed and published in Gorlitz, Germany, before he came to the United States about 1848.

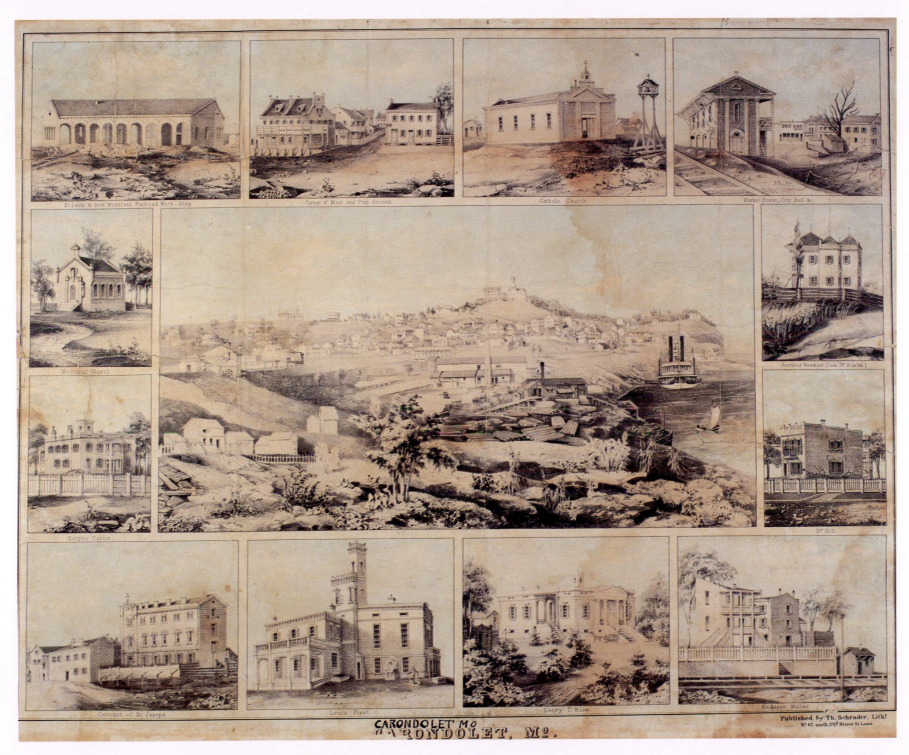

Figure 6–8. View of Carondelet ca. 1860, published in St. Louis by Theodor Schrader. (Missouri Historical Society.)

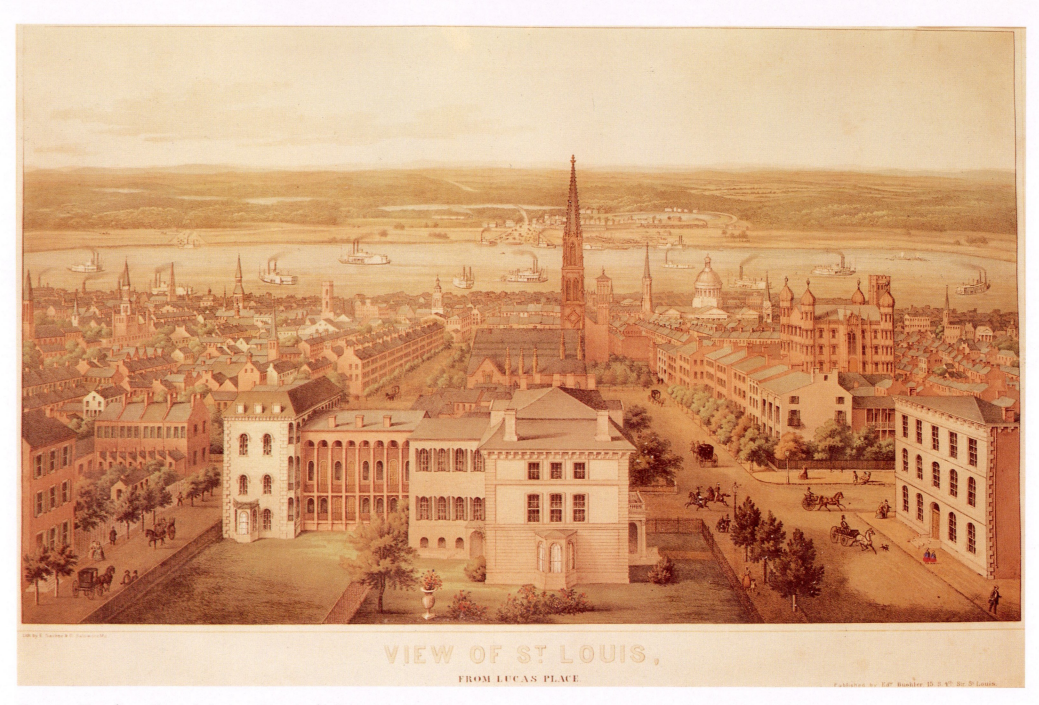

VIEW OF ST. LOUIS,

FROM LUCAS PLACE

Figure 6–9. View of Lucas Place in St. Louis ca. 1865, printed in Baltimore by Edward Sachse & Co. and published in St. Louis by Edw. Buehler. (Chicago Historical Society.)

been working for Sachse in Baltimore. Further searches in St. Louis newspapers may yet reveal the person responsible for this attractive and rare print.

Except for one section of Wild's panorama of 1842, this lithograph provides the only glimpse of the city from the west with the Mississippi in the background. We look down exclusive Lucas Place from a point west of its intersection with Sixteenth Street, shown in the right foreground. Mrs. Sarah A. Collier lived in the large mansion directly in front of us, a building completed in 1858 and typical in size and style of the houses that gave Lucas Place such a distinctive character. The tall, slender spire rising high in the sky above the Lucas Place houses belonged to the new First Presbyterian Church at Fourteenth Street on the west side of Missouri Park.

Immediately to the right of the spire is the square tower of the Union Methodist Church at Eleventh and Pine. The spire of the Cathedral and the dome of the Courthouse—completed at last—can be seen still further to the right. Halfway between the Courthouse dome and the right margin of the lithograph stands a large, rectangular building with turrets at each corner. This Gothic structure at Fifteenth and Olive was finished in 1856 and housed the first public high school of the city.

In the distance across the Mississippi we get a glimpse of Illinoistown, later East St. Louis, Illinois. The town was low-lying and flood-prone, and there was nothing to be seen there, according to one visitor, but "railroad tracks raised high above the possible swelling of the river, with pools of water between the embankments; a long, tidy station-house of painted wood; and the broad, roughly paved 'Levee,' steeply slanting to the river."[16] Here the ferries brought passengers and merchandise to and from St. Louis, a city that had begun to think about the necessity of bridging the river in order to maintain its commercial position.

Finally, the imposing building to the left of Mrs. Collier's residence provided quarters for the Episcopal Sisterhood of the Good Shepherd. The convent in fact faced Washington Avenue, one block to the north, not St. Charles, as shown here. Perhaps the artist decided to move it into view and disregard reality, or perhaps a lithographer in the Sachse shop misinterpreted the artist's sketch and erroneously placed the building in the wrong location.[17]

16. "The City of St. Louis," 655

17. An impression of this view with the buildings incorrectly identified in a manuscript addition is in the Missouri Historical Society collection. These have been explained and corrected in Ruth K. Field, "Some Misconceptions About Lucas Place." The suggestion that the

It was just this kind of St. Louis urbane townscape that so impressed a journalist writing in the *Atlantic Monthly* in 1867. He informed his readers,

> St. Louis is an immense surprise to visitors from the Eastern States. . . . It has stolen into greatness without our knowing much about it. . . . Having passed through its wooden period to that of solid brick and stone, it has a refined and finished appearance, and there is something in the aspect of the place which indicates that people there find time to live, as well as accumulate the means of living. Chicago amuses, amazes, bewilders, and exhausts the traveller; St. Louis rests and restores him.[18]

The basic structure of the city remained much as it had been before the Civil War. This writer described the wholesale business district "along the river, as far back as Third Street" and consisting of "rows of tall brick stores and warehouses." On Fourth Street he found "the principal retail stores, many of which are on the scale of Broadway." Fifth Street was "also a street of retail business." Beyond Fifth Street, this observer declared:

> the city presents little but a vast extent of residences, churches, public institutions and vacant lots; these last being so numerous that the town could double its population without taking in much more of the prairie. From the cupola of the court-house, the city appears an illimitable expanse of brick houses, covered always with a light smoke from forty thousand fires of bituminous coal.[19]

The third view of the 1860s of more than passing interest is a revised version of one we have already examined—the Gast panorama of 1855 reproduced in Figure 4–14. In 1868 Gast, now associated with Charles F. Moeller and doing business as Gast, Moeller & Co. at 225 Olive Street, decided to add new buildings to his panorama and reissue it. Although the first state of the view illustrated John Hogan's *Thoughts About the City of St. Louis,* Gast and Moeller evidently offered the new version as a separate publication.

The imprint of the original stated that it was engraved on stone, a variation of the basic lithographic process that made it easier to create very fine lines similar to those produced by engraving on a metal plate.[20] The new and revised print is unmistakably a lithograph with a tone stone used for the blue of the sky

lithographer may have misinterpreted the artist's sketch is my own. Field notes that the artist took a "most extreme liberty" and that, while "the move was a happy one artistically," it has been "frustrating historically."

18. "The City of St. Louis," 655.

19. Ibid., 658.

20. Peter S. Duval explains the process of stone engraving in J. Luther Ringwalt, ed., *American Encyclopaedia of Printing,* 281.

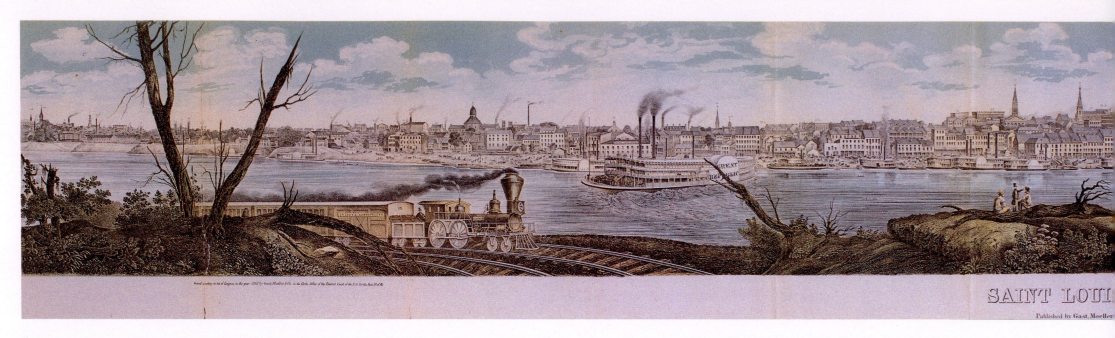

Figure 6–10. View of St. Louis in 1868, engraved, printed, and published in St. Louis by Gast, Moeller & Co. (Collection of A. G. Edwards and Sons, Inc., St. Louis, Missouri.)

and water. The basic design comes from the original image, which Gast must have saved. He either added the revisions to the original printing surface or obtained an impression from it on transfer paper. He then could have drawn in the new buildings and used the completed drawing to produce the revised image on a lithographic stone from which impressions could be pulled.[21]

This new version is reproduced in Figure 6–10. Gast provided numbers to identify many of the structures that can be seen on the skyline. Included among them are at least thirteen buildings constructed since he first issued the view. Strangely, Gast decided not to change the image of the City Building built to replace the Market. Although in 1855 Gast correctly showed this landmark's distinctive pedimented facade, a fire destroyed the building in 1856, and by 1868 a warehouse with no such architectural feature stood in its place.[22]

In the foreground the same primitive locomotives of 1855 chug toward each other from the left and right sides, and the same steamboat—changed only in name—glides across the river. However, the lithograph shows the pier for the Eads Bridge, then under construction, as well as the images of another dozen buildings whose outlines do not appear on the version Gast issued thirteen years earlier.

21. Duval describes the process of transferring a lithographic image from one stone to another in ibid., 284–85. The use of transfer paper was first mentioned in the *United States Literary Gazette* in 1826. See also "Lithography" and Alexander Miller, *The Hand-Book of Transfer Lithography.*

22. I have examined several impressions of the 1855 view, and all lack identifying numbers. The two impressions I have found of the 1868 view both have numbers, including one that locates the pier for the Eads Bridge on the St. Louis side of the Mississippi, a structure the view clearly shows. Accompanying one of the two impressions of the 1855 view in copies of [John

Hogan], *Thoughts About the City of St. Louis, Her Commerce and Manufactures, Railroads, &c.,* in the collection of Eric and Evelyn Newman of St. Louis, is a modern electrostatic copy of a contemporary printed key to the view. It does *not* list the Eads Bridge pier, and, of course, the 1855 view does not show it. Further, the title of the key reads in part: "References to the View of the City of Saint Louis in 1855. Engraved on stone and published by Leopold Gast & Brother, Lithographers." In 1868 Gast's firm styled itself Gast, Moeller & Co. Number 32 on the printed key identifies the place of business of "Leopold Gast & Brother's Lithographic Establ. No. 36 S. 4th Str. betw. Elm and Walnut." The 1868 view identifies the firm of Gast, Moeller & Co. by a sign on a building several blocks to the north, doubtless their premises at 225 Olive Street. Further, number 5 provides the address where Gast lived in the mid-1850s, which he left well before the publication of the 1868 edition of the view. This evidence justifies the conclusion that there were two states of the 1855 view, the one without numbers used in Hogan's book and one with numbers that the Gast brothers sold separately with a printed key. On this basis I have included the hypothetical second state of the 1855 view in the list of views not illustrated in this book. I have not been able to locate an original impression of the key.

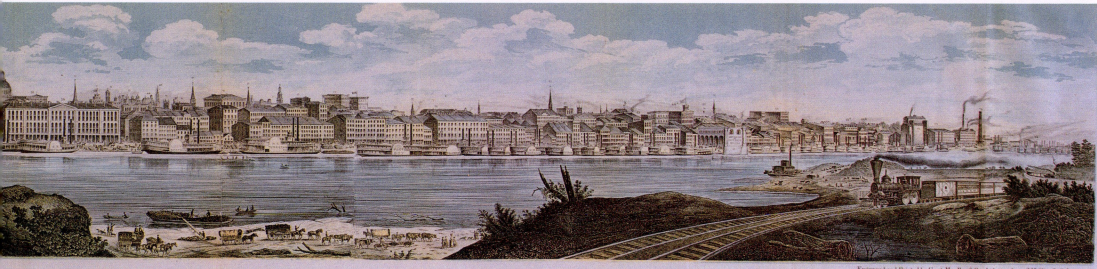

O. in 1868.

Engraved and Printed by Gast, Moeller & Co., Lithographers, 225 Olive St, St Louis.

...raphers, 225 Olive St. St. Louis.

This print, then, provides a curious example of a view that is both modern and out-of-date at the same time. Although for these reasons it should be used with caution by those seeking images of St. Louis as it neared the end of the 1860s, it is not without value in its numbered identification of church spires, hotels, and other buildings that formed the skyline of St. Louis in the mid-1850s and its depiction of the new buildings that had appeared between then and 1868.[23]

23. As explained in the previous footnote, a copy of a printed key to the 1855 edition of this view exists, although no impressions are known of that state of the view with numbers. However, since most of these numbers correctly identify buildings in the 1868 edition, I have transcribed them below, even though the reproduction in this book may be too small to permit the numbers to be read: 1. Ursuline Convent, State Street, between Arsenal and Ann Avenues; 2. St. Louis Cotton Factory, Adolphus Meier & Co., fronting on Lafayette, Menard and Soulard Streets; 3. St. Louis Gas Light Works; 4. St. Vincents Church, cor. of Decatur and Park Av; 5. Leopold Gast, Second Carondelet Avenue, betw. Lafayette and Geier Avenues; 6. Phoenix Brewery, Christian Staehlin, cor. of Lafayette and 2d Carondelet Avenue; 7. City Hospital, cor. of Lafayette and Linn; 8. Edward Bredell, Lafayette Square; 9. Empire Plow Works, Cronenbold & Co., 303 S. Third Street; 10. Locomotive Works, Palm & Robertson, fronting on Lombard, Third and [word illegible]; 11. Saxony Mills, Leonhardt & Schuricht, Lombard Str., betw. 3d and 4th Streets; 12. Hemp Factory, Douglass A. Beer, Stoddard Ave betw Hickory Street and Chouteau Av; 13. Public School, S. 7th Street, betw. Convent and Rutger; 14. R. W. Ulrici & Co's Distillery, Cedar, betw.

Main and 2d; 15. Mrs. Sogran, cor. of Chouteau Avenue and 8th; 16. St. Mary Church, Rev. Joseph Meicher, cor. of third and Mulberry; 17. Anthony S. Robinson, 8th Str. betw. Chouteau Av. and Gratiot; 18. Western Shoe Mills, 7th Str. betw. Chouteau and Gratiot; 19. Thomas O'Flaherty, 8th Str., betw. Chouteau and Gratiot; 20. Awrason Levering, 8th Str. betw. Chouteau and Gratiot; 21. Pacific Mills, A. D. Pomeroy, Nos. 177 and 179 Third Street, cor. of Cedar; 22. Edwin Harrison, cor of Gratiot and 8th Str; 23. Dr. McDowell's Medical College, cor. of Gratiot and 8th Str; 24. St. Josephs Academy by the Brothers of the Christian Schools, 8th Str. betw. Gratiot and Cerre; 25. Missouri Chemical Works. W. H. Chappell & Co., cor. of 14th and Austin; 26. Public School, 5th Str; 27. St. John's Church, Rev. F. I. Clerc, cor. of 6th and Spruce; 28. Hospital of the Sisters of Charity, cor. of 4th and Spruce; 29. Dr. Chas. A. Pope's Medical College, cor. of Seventh and Myrtle; 30. Archibald Gamble, cor of Elm and 4th Strs; 31. William Bennett, 4th Str. betw. Elm and Walnut; 32. Leopold Gast & Brother's Lithographic Establ., No. 36 S. 4th Str., betw. Elm and Walnut; 33. Second Presbyterian Church, Rev. N. L. Rice, cor. of 5th and Walnut; 34a. Cathedral or Church of St. Louis, Walnut Str. betw. 2d and 3th. [sic]; 34b. Florentin Schuster, Bookstore, 35 Walnut, betw. 2d and 3d; 35. Wyman's Hall and High School, Market Str., betw. 4th and 5th; 36. Barnum's St. Louis Hotel, cor. of 2d and Walnut; 37. St. Louis Courthouse, fronting on Fourth, Market, Fifth and Chestnut Streets; 38. Christ Church, Rev. D. G. Estes, cor. of 5th and Chestnut; 39. The City Stores, fronting on Walnut, Front and Market Strs; 40. Unitarian Church of the Messiah, Rev. Wm. G. Eliot, cor. of 9th and Olive; 41. Planter's House, fronting on Fourth, Chestnut and Pine Streets; 42. Union Presbyterian Church, Rev. Wm. Homes, cor. of 11th and Locust; 43. St. Louis High School; 44. Pechmann & Gauche, No. 8 Main Str., betw. Market and Chestnut; 45. First Presbyterian Church, Rev. Artemas Bullard, cor. of 14th and Locust; 46. Central Presbyterian Church, Rev. S. I. P. Anderson, cor. of 8th and Locust; 47. Missouri Republican, Chambers & Knapp Chestnut Str. betw. Main and Second; 48. St. George Church, Rev. Brown, cor. of

In the 1870s several itinerant artists came to St. Louis, some of them on assignments from editors of illustrated magazines with national circulations. Among them was Alfred R. Waud, an Englishman who served *Harper's Weekly* during the Civil War but who visited St. Louis in 1871 as a special artist for the short-lived but well-printed magazine *Every Saturday.* Waud was no stranger to the lower Mississippi, for in 1866 he produced descriptions and sketches of several towns in the region for *Harper's* while still affiliated with that publication. However, he did not sketch St. Louis for publication at that time.[24]

Waud and his companion, writer Ralph Keeler, arrived in St. Louis during the fall of 1871 after sketching and writing about towns and cities along the Mississippi on a trip that began in New Orleans.[25] In addition to a number of

illustrations for *Every Saturday* showing individual buildings, Waud produced one general view of major interest before he and Keeler left St. Louis.[26] That wood engraving is reproduced in Figure 6–11, a double-page illustration that *Every Saturday* published on 14 October. Keeler's accompanying description explained the scene to his readers:

> You will see by the side of the great river . . . the fourth or fifth city of this continent, covering an area of twenty square miles with a hundred and seventy-five miles of improved streets; extending fourteen miles along the river with an average width of two miles, and terminating everywhere in the most beautiful of suburbs.

Keeler noted that "owing to the peculiar bend of the river" it had been impossible for Waud to show the extensive industrial district to the north. Beyond the grain elevator "at the extreme right of our picture are scattered machine-shops, factories, and the water-works, none of which are represented." Readers also learned that "down the river . . . the city . . . goes on for miles past the arsenal and all sorts of factories, furnaces, machine-shops and lime-kilns to Carondelet." That once-independent town "with all her iron works and dust and coal smoke has been absorbed by her ambitious sister."[27]

The left side of the view depicts towerlike structures rising from the river, and a similar, single, but more elaborate configuration sits on the bank below the Courthouse dome. Keeler explained these engineering works to his readers:

> Down the river on the left are seen the piers and western abutment of the great bridge, as they are now. . . . It is designed to be one of the finest structures of the kind in this country or indeed in the world. It will be a two-story bridge, on cast-steel arches. The lower story will be occupied by the railways; the upper story will be the highway of street vehicles and foot passengers. . . . On the St. Louis side the railways will run beneath the streets to the great union depot yet to be built.[28]

7th and Locust; 49. Mercantile Library Hall, cor. of 5th and Locust; 50. Church; 51. St. Louis University and St. Xavier Ch., fronting on Washington Av., 10th, Green and 9th Str; 52. Odd Fellows Hall, cor. of 4th and Locust; 53. New Custom House (unfinished), cor. of 3d and Olive; 54. New Waterworks; 55. State Tobacco Warehouse, cor. of 6th and Washington; 56. First German Evangelical Church, Rev. L. E. Nollau, cor. of 15th and Carr; 57. Verandah Row, fronting on St. Charles, 4th Str. and Washington Av; 58. Second German Lutheran Church, Rev. F. Buenger, cor. of Franklin Av. and 11th Str; 59. Union Building, cor. of Main and Vine Strs; 60. Congregational Church, Rev. T. M. Post, 6th Street, betw. Franklin Av. and Wash.; 61. Bernard Adams & Peck, cor. of Second Str. and Washington Av.; 62. Boatman's Church, Rev. Ch. J. Jones, Green Str., betw. 2nd and 3d; 63. Church; 64. Virginia Hotel, John H. Spurr, fronting on Main, Green and Second Streets; 65. Corinthian Hall Big Hat, Broadway; 66. St. Patrick Church, cor of 6th & Biddle; 67. Old Reservoir; 68. Belcher's Sugar Refinery Ware House; 69. Belcher's Sugar Refinery Company, fronting on Lewis, O'Bate's Streets; 70. St. Louis Shot Tower, Kennett, Simonds & Co; 71. Illinoistown and Alton Extension Rail Road; 72. Ohio and Mississippi Rail Road; 73. and 74. St. Louis Ferry Boats; 75. Belleville and Illinoistown Railroad.

24. Waud's Civil War career as a battle artist is the subject of Frederic E. Ray, *Alfred R. Waud: Civil War Artist.* A biographical summary accompanies reproductions of many of his Louisiana drawings in "The Creole Sketchbook of A. R. Waud." Many of these drawings are in The Historic New Orleans Collection in New Orleans. A 1979 exhibition catalog for the collection lists and reproduces not only the Louisiana drawings but also those from several other states along the Mississippi and elsewhere in the United States. See *Alfred R. Waud, Special Artist on Assignment: Profiles of American Towns and Cities, 1850–1880.* There is one error in the catalog among the list of Missouri views. Number 56, a sketch identified as ["The Levee at St. Louis"] from William Cullen Bryant, ed., *Picturesque America; or, The Land We Live In,* is of Cincinnati. Other Waud drawings can be found in the Chicago Historical Society and in the Division of Prints and Photographs of the Library of Congress. A few of his sketches are in the Missouri Historical Society. See also Robert E. Hannon, "St. Louis in 1871 as Seen by a Noted Artist."

25. Portraits of city-view artists are rare, but Ray, *Alfred R. Waud,* includes a reproduction of a drawing of Waud made by Joseph Keppler in St. Louis for a German-language publication. He portrayed Waud sketching in the background and Keeler seated at a table in the foreground. An unidentified St. Louis newspaper, quoted in Ray (p. 59, n. 22), described Waud at that time as a "clever artist who, with pencil, is photographing all the salient points and characteristic features of our municipal body."

26. Their editor hastily dispatched Waud and Keeler from St. Louis to Chicago to cover the great fire that destroyed the city in October 1871.

27. The huge grain elevator at the right of Waud's view was built in 1864. It further strengthened the influential position of St. Louis flour millers throughout the lower Mississippi valley that began in the mid-1830s as wheat farming developed in the city's hinterland. According to Primm, *Lion of the Valley,* 202, "St. Louis flour's reputation for quality was attributable to the lower moisture content of western wheat and the establishment of the Miller's Exchange, the first grain exchange in the nation, which instituted a rigorous system of inspection of local mills and their products." He quotes a southern correspondent who wrote in 1851, "Here in east Tennessee . . . we are eating St. Louis flour."

28. Ralph Keeler and A. R. Waud, "St. Louis. I. A General View of the City," 380. Keeler goes on to give many details of the bridge and its construction. *Every Saturday,* 14 January 1871, published a view of how the bridge would look when completed. The complete series on St. Louis by Keeler and Waud appeared in *Every Saturday,* 14 October–25 November 1871.

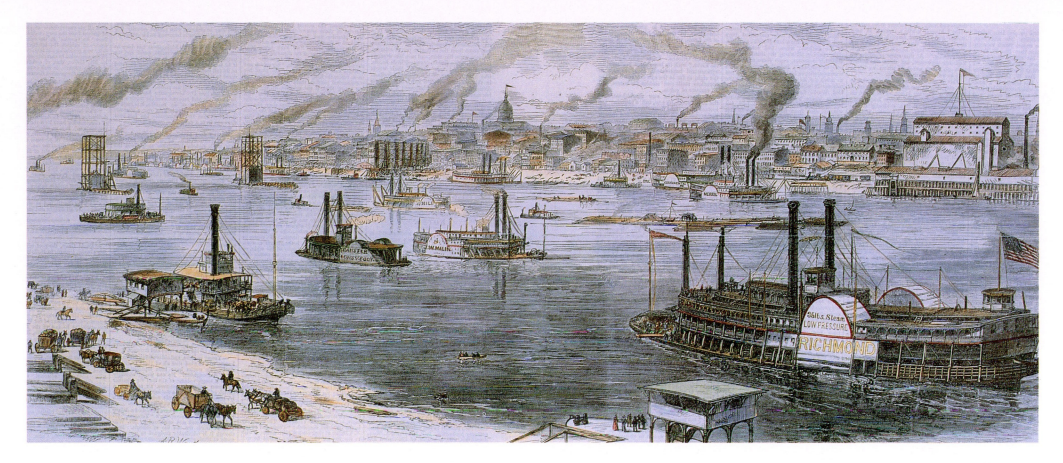

Figure 6–11. View of St. Louis in 1871, drawn by Alfred R. Waud, engraved by Kilburn, and published in Boston by *Every Saturday*. (Collection of A. G. Edwards and Sons, Inc., St. Louis, Missouri.)

Waud was a careful artist with a reputation for accuracy, and he drew St. Louis as he found it with a major construction project still unfinished. This was the great Eads Bridge, one of the most remarkable achievements of nineteenth-century engineering. Designed by James Buchanan Eads and begun in 1867, the bridge fulfilled the dreams and hopes of civic leaders and promoters who had schemed and worked for such a project since the subject of bridging the Mississippi first arose as early as 1839. However, construction of Eads's novel and daring design required years of work and encountered unforeseen delays. It was not until 4 July 1874 that the bridge could be opened to rail, carriage, and foot passage between Missouri and Illinois. City officials, officers of the bridge com-

pany, and tens of thousands of residents and visitors turned out to mark this event with parades and prolonged bouts of oratory.[29]

29. For an excellent summary of how the bridge was financed and built, see Primm, *Lion of the Valley*, 293–308. Primm also describes the festivities that preceded no fewer than seven speeches: "The parade, fourteen miles long, and requiring two hours to pass . . . , began with Grand Marshal Arthur H. Barrett escorted by police and twenty-two uniformed boys on ponies, and included a U. S. cavalry company, two national guard companies, the turners, the Knights Templar, fifteen hundred Odd Fellows and many other fraternal orders, a massive replica of the Merchants' Exchange, the Fire Department, the New Orleans Orchestra, six hundred members of the German singing societies, the U.S. customs-house officials in a full-rigged sailing ship on wheels, the Brewers Association . . . , several rowing clubs and dozens of craft and industrial

At least one artist, less responsible than Waud, "completed" the bridge on paper before the river had been spanned. This steel engraving has a copyright date of 1872, and D. Appleton and Company used it that year in *Picturesque America,* a lavishly assembled, printed, and bound two-volume publication edited by William Cullen Bryant. The artist of the view reproduced in Figure 6–12, A. C. Warren, not only drew the bridge as if it had been finished but also depicted it incorrectly with a single passageway instead of the two, one over the other, that separated rail from vehicular and foot traffic.[30]

Two years after the bridge opened, another artist for a national journal contributed his spirited portrait of the city to the growing list of St. Louis images. Reproduced in Figure 6–13, this wood engraving by Schell and Hogan from a drawing by Charles A. Vanderhoof provided readers of *Harper's Weekly* in July 1876 with a view looking northwest from East St. Louis. Vanderhoof was near the beginning of his career as an illustrator and artist when he drew St. Louis for *Harper's.* For that journal and for *Century Magazine* he produced many drawings that were printed as wood engravings. Later he specialized in dry-points, helped found the Art Students League, taught at Cooper Union in New York City, and wrote an article titled "Sketching from Nature" for *Art Amateur* in 1898. He died in 1918.[31]

Vanderhoof correctly rendered the bridge with its three immense spans crossing the river from Illinois to Washington Avenue at the northern end of the original French colonial street grid. He also accurately conveyed the extent to

which smoke then enveloped much of the city most of the time. The heavy industry developed after the Civil War, which contributed so much to the growth and prosperity of St. Louis, now threatened to stifle its inhabitants.

The description in *Harper's* accompanying Vanderhoof's view discreetly avoided mentioning the smoke problem, saying only, "The situation of St. Louis, as may be seen by our view . . . , is pleasant and, in a certain sense, picturesque."[32] Other visitors, however, did not hesitate to criticize the city in this respect. A Frenchman, after encountering the polluted air of St. Louis for the first time, complained,

> The air is so rich along the Mississippi, the pasty dust from American coal smoke falls so thick in the streets, that one is satisfied by an afternoon walk in St. Louis as if one had eaten a heavy dinner. . . . Everyone coughs . . . [in] an atmosphere charged with chimney emanations, in this capital, the name of which seems to betoken only charm and poetry.[33]

Publishers of two other views of St. Louis in the mid-1870s issued them individually as separate publications. Printed on large sheets of paper, these obviously were intended to be displayed as wall decorations. Both reached the market in 1874, the year the great bridge finally opened for traffic. Their publishers doubtless scheduled their release at that time in hopes that interest in the event would make residents of St. Louis want to purchase a suitable picture of the structure and the city it served.

One of these views is reproduced in Figure 6–14, a curiously naive and wooden image of St. Louis that Augustus Hageboeck probably drew and that he engraved, printed, and published at the shop he and his brother operated in Davenport, Iowa. Hageboeck's views of towns in Iowa, Illinois, and Minnesota in the years 1866–1873 reflect substantial abilities in topographic rendering and are convincing depictions of several places upriver from St. Louis.[34]

However, for his St. Louis engraving—probably done on stone rather than on a metal plate—Hageboeck managed to draw only the Eads Bridge more or less correctly. A great many of the other structures look alike, almost as if they had been created by a stencil or a stamp. The waterfront on both sides of the

groups. To a sustained roar from the crowd, a train of thirteen Pullman cars crossed the bridge and deposited its load of dignitaries at the reviewing stand" (p. 306).

30. The St. Louis view is in vol. 2 of Bryant, *Picturesque America,* as part of a chapter on the upper Mississippi River and its towns. Part of the text reads: "The public buildings [of St. Louis] are imposing, the warehouses handsome, the public parks singularly beautiful. Among the famous places are Shaw's Garden, with an extensive botanical garden and conservatory, and the Fair-Grounds. The Fair-Grounds are made the object of special care and cultivation, supplying in a measure the want of a large public park. . . . Shaw's Gardens are a munificent gift by a wealthy citizen to the public. . . . St. Louis is destined for a great future. The magnificent bridge just completed, one of the largest and handsomest in the world, over which all the trains from the East directly enter the city, will have a great effect upon its fortunes" (2:324). A version of this view exists in a wood engraving titled *View of St. Louis, Missouri.* This unsigned and otherwise unidentified view is in a St. Louis corporate collection. It is 5 ½ x 4 ½ inches, is hand colored, and has been dated ca. 1874.

31. An obituary for Vanderhoof was in the *New York Times,* 13 April 1918. Brief biographical notes about him are in several biographical dictionaries of American artists. See also another note in Estill Curtis Pennington and James C. Kelly, *The South on Paper: Line, Color and Light.* These state misleadingly that Vanderhoof joined *Harper's* only in 1881.

32. *Harper's Weekly,* 8 July 1876, p. 550. *Harper's* had previously used an illustration of the St. Louis waterfront, "The Levee at St. Louis, Missouri.—Photographed by R. Benecke, St. Louis," in its issue for 14 October 1871, the same year and month that Waud's *Every Saturday* illustrations appeared.

33. From a description of St. Louis in 1885 by Charles Croonenberghs, as quoted in Primm, *Lion of the Valley,* 358.

34. For a color reproduction of Hageboeck's view of Davenport in 1866, see Loren N. Horton, "Through the Eyes of Artists: Iowa Towns in the 19th Century."

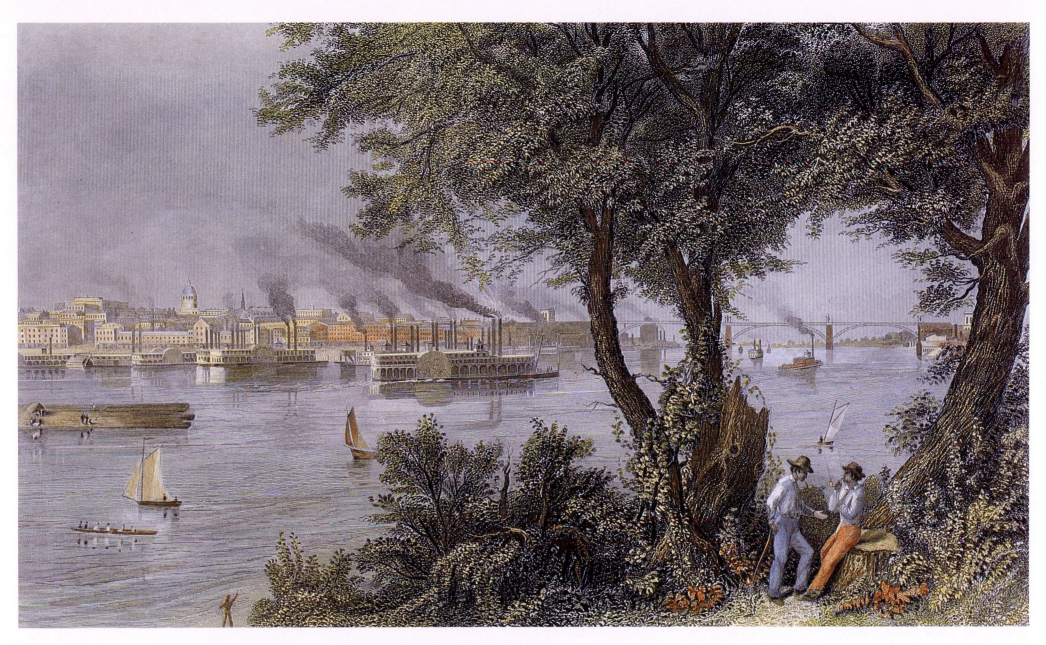

Figure 6–12. View of St. Louis, drawn by A. C. Warren, engraved by R. Hinshelwood, and published in New York by D. Appleton and Co. in 1872. (Collection of A. G. Edwards and Sons, Inc., St. Louis, Missouri.)

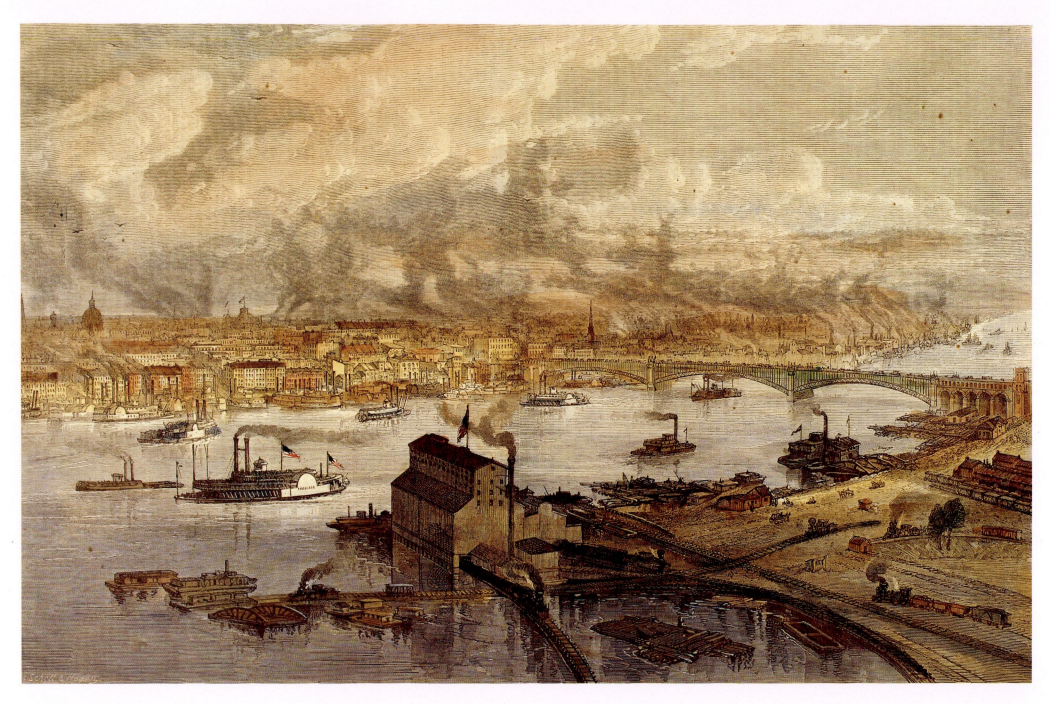

Figure 6–13. View of St. Louis in 1876, drawn by Charles A. Vanderhoof, engraved by Schell and Hogan, and published in New York by *Harper's Weekly*. (Collection of A. G. Edwards and Sons, Inc., St. Louis, Missouri.)

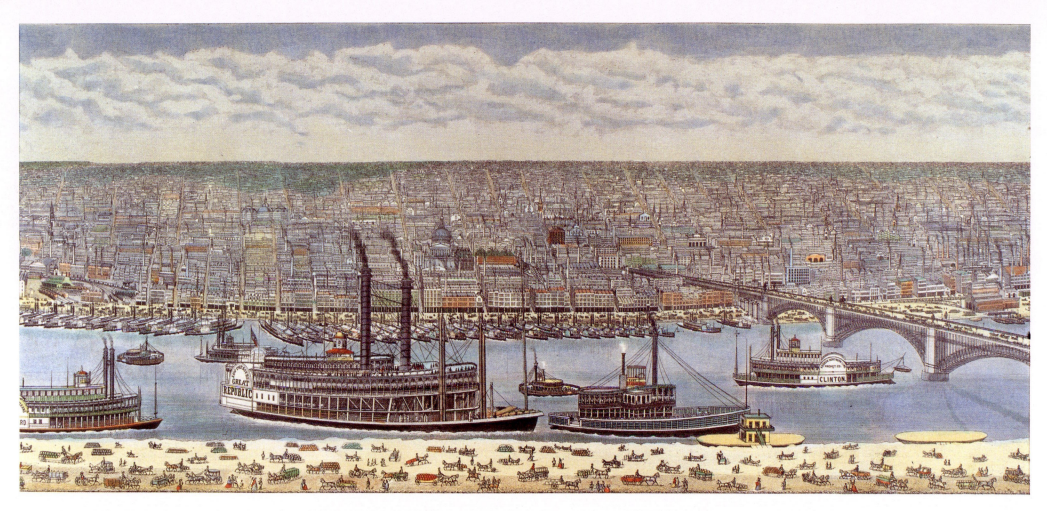

Figure 6–14. View of St. Louis in 1874, engraved and printed by Augustus Hageboeck and published by him in St. Louis. Detail. (Eric and Evelyn Newman Collection.)

Mississippi seems like the work of a child. Along the levee in St. Louis, Hageboeck depicted steamboats north of Market Street with their sterns into the current. On the Illinois side he populated the shoreline with an impossibly large number of wagons, carriages, coaches, and persons on foot.

The primitive and inaccurate character of this view is difficult to explain, because Hageboeck lived in St. Louis in 1859 and 1860. In the former year the city directory identified Augustus Hagebock [sic] as a lithographer and also listed a John Hagebock as a lithographic printer. The 1860 listing is only for Augustus, this time with his name spelled correctly.[35]

Possibly in 1874 he drew the warehouses and factories along the St. Louis waterfront from memory and simply added the stylized urban surroundings in a more or less arbitrary fashion. It is difficult to believe that anyone who knew St. Louis would have found this print accurate and attractive enough to buy. We can only guess the commercial fate of this curious artistic disaster, but the fact that it exists only in two impressions, one in the Library of Congress and the second in a private collection, strongly suggests that Hageboeck sold few copies.[36]

The St. Louis Times distributed a far more finished and satisfying view of St. Louis in 1874. This is a large print, measuring 14 1/2 x 37 1/2 inches, that seems to be a combination of stone engraving and lithography. It was printed from two stones, the second one adding to the finely drawn, ruled, and hatched lines of water and buildings a buff-colored tone that appears in the sky, ground, and decorative border. No artist's name appears, nor is there any identification of either the lithographer or the printer.

Because the unknown artist of this print, reproduced in Figure 6–15, looked toward the city from a point northeast of the bridge, the view provides us with an unusually detailed record of that portion of St. Louis in the first few blocks along the Mississippi north of Washington Avenue. This is the restored district known today as Laclede's Landing. This print also offers a particularly

revealing glimpse of the several railroad stations and associated buildings in East St. Louis whose fortunes the bridge altered by making possible direct rail access to St. Louis without the use of steamboats and barges.

This image proved to be so popular that several artists and publishers appropriated it as their own. For example, in 1876 Will Conklin, publisher of a book titled Saint Louis Illustrated, had a wood engraving made of the lithograph and used it among many other illustrations of prominent buildings in St. Louis. As can be seen from the reproduction in Figure 6–16, in his version the two upper corners are scalloped, and the wood engraver added rays from the sun beaming down on the bridge from the upper left. An almost identical wood engraving of uncertain origin exists with a conjectural date of 1878.[37]

A third version apparently differs from Conklin's engraving only in the renaming of the steamboat in the center from the Andy Johnson to the N. O. Standard and in the restoration of the two upper corners. The London Daily Graphic published this print in its issue of 6 January 1878, from a wood engraving signed by one William T. Keller in yet another of those acts of plagiarism that viewmakers so often committed. While the view itself is undeniably attractive, by the time it reached English readers it was already four years out-of-date.[38]

One other view of the great Eads Bridge, published in 1874, deserves to be considered, although it shows only a portion of the city. This lithograph is reproduced in Figure 6–17. Compton and Company of St. Louis published this view, which looks north from above the center of the Mississippi. The border

35. I am grateful to Eric Newman of St. Louis for calling my attention to Hageboeck's residence in the city. Newman has the only impression of the 1874 view of St. Louis known to me other than that in the Library of Congress.

36. The view has no plate mark, suggesting that it came from an engraved lithographic stone. Further, an advertisement in an 1861 Davenport city directory by "Hageboeck & Bro." states, "Every kind of Lithographic Engraving & Printing executed in the best style." At that time, Augustus and his brother John carried on their business at 29 Main Street. Efforts to locate additional information about Hageboeck have been unsuccessful. Carol Hunt, registrar of the Putnam Museum in Davenport, in a letter to me of 3 September 1981, cites from an unidentified source the only known description of him as "a little man wearing a tall silk hat."

37. Will Conklin may have been the author or compiler of Saint Louis Illustrated . . . as well. He used a reduced version of the view of St. Louis drawn by J. W. Hill and published by Smith Brothers as the source of an additional wood engraving in his book. Conklin may have used the large lithograph or the small steel engraving in The Ladies Repository to produce the illustration he titled Saint Louis in 1851. It measures 4 7/8 x 7 7/8 inches and has four unnumbered references in the margin below the image. The artist or printmaker is F. Merk. The St. Louis Globe-Democrat reviewed the book on 29 May 1876, calling it "A Book Which No Family Should Fail to Buy" in a subheading under the title of the book. The review mentioned the book's many illustrations: "Many of the engravings are of places of interest that have long passed away. Among them will be found Cathedral Square an hundred years ago, the same fifty years ago; a bird's-eye view of the city in 1851. . . . In strong contrast to this is pictured the city as it appears to-day from the same point of observation." An impression of the wood engraving that is a near-duplicate of the one in Conklin's book is in the Missouri Historical Society collection and measures 7 1/4 x 15 1/2 inches.

38. The printmaker's name is difficult to read, but it appears to be Telfer. This version, titled View of the City of St. Louis and the Mississippi River, Looking Down Stream, is the largest of the three derivatives at 8 1/16 x 18 1/4 inches. An impression of this view is in the Missouri Historical Society.

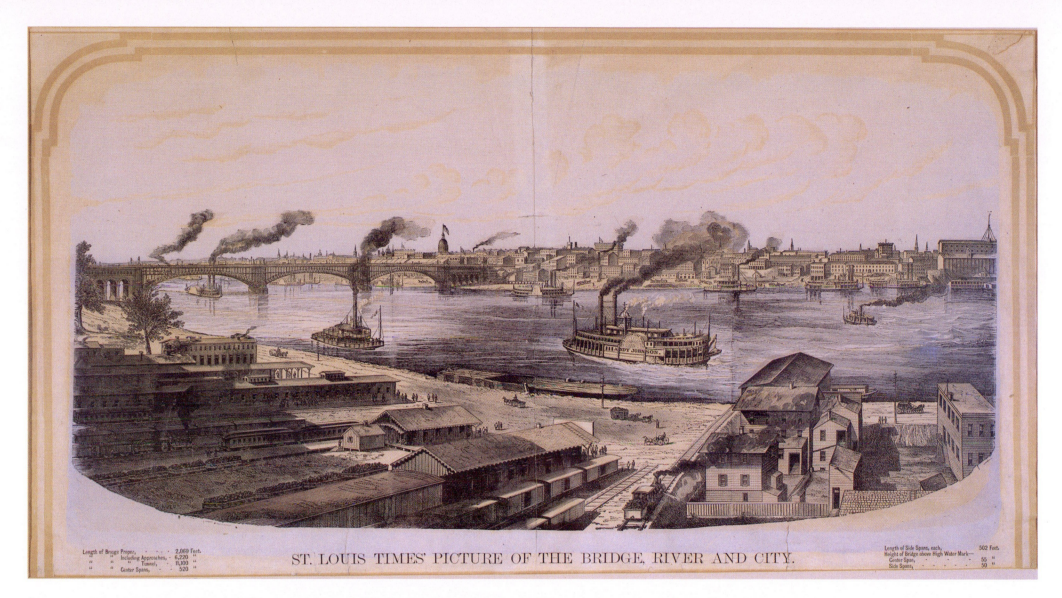

Length of Bridge Proper, 2,060 Feet.
 Including Approaches, 6,220 "
 Tunnel, 11,100 "
 Center Spans, 520 "

Length of Side Spans, each, 502 Feet.
Height of Bridge above High Water Mark—
 Center Span, 55 "
 Side Spans, 50 "

ST. LOUIS TIMES' PICTURE OF THE BRIDGE, RIVER AND CITY.

Figure 6–15. View of St. Louis ca. 1874, published in St. Louis by the *St. Louis Times*. (Collection of A. G. Edwards and Sons, Inc., St. Louis, Missouri.)

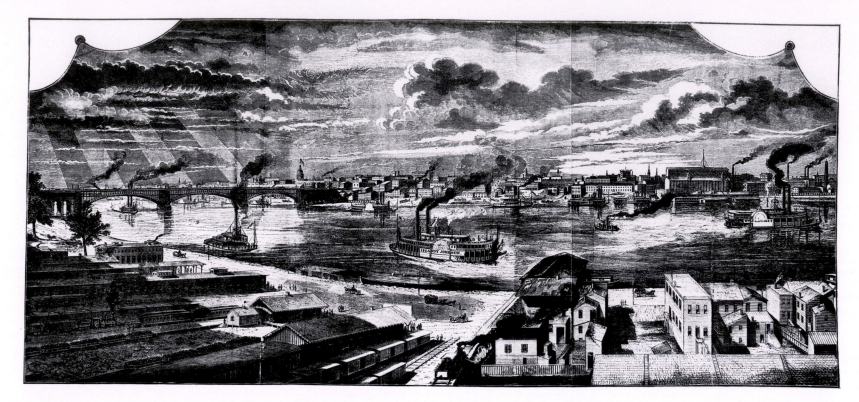

Figure 6–16. View of St. Louis ca. 1874, published in St. Louis by Will Conklin in 1876. (Research Collections, Lovejoy Library, Southern Illinois University, Edwardsville.)

vignettes provide interesting details of the construction methods devised by Eads in completing the structure. On the left can be seen several blocks of the St. Louis waterfront and, beyond, the northern portion of the city extending to the horizon.

Almost obscured in the dark portions of the print at the lower right is the signature of F. Welcker. Whether Welcker was the artist of the composition or the lithographer who put the drawing on stone is not known. Probably, however, he was Ferdinand Welcker, who, as mentioned in Chapter IV, worked with Eduard Robyn in the 1850s on a rolled canvas panorama of the Eastern Hemisphere.[39]

Although the nationwide financial depression that began in 1873 dampened somewhat the optimism of citizens of St. Louis about the economic devel-

opment expected from direct rail connections to the East, their faith and confidence in continued rapid growth remained. The 1870 census showed (although erroneously) that the city had become the fourth largest in the nation, and now that the Mississippi had been bridged the future of St. Louis seemed extraordinarily bright.[40]

The great Eads Bridge thus stood as a mighty symbol of civic pride and accomplishment and homegrown engineering genius. More than any other single view of the time, the one reproduced in Figure 6–18 expresses this pride in the city. C. K. Lord filed this view for copyright in 1876, probably on behalf

39. Inevitably, derivative images of the Compton and Welcker view made their appearance. One, with proper attribution to Compton, was used on the invitation to the official opening and dedication of the Eads Bridge. Another can be found on shares of preferred stock issued by the bridge company in 1879. Doubtless other versions were used elsewhere.

40. The census of 1870 recorded that in the previous decade the city's population had nearly doubled to 310,000, moving it to fourth place in size behind New York, Philadelphia, and Brooklyn. According to the Census Bureau, Chicago had grown at a faster rate than St. Louis, but in total numbers it had not caught up to its older midwestern rival. The St. Louis census count, however, resulted from fraudulent tampering with the records as part of a political deal. No one now knows the true population count, but the 1880 census found the population to be 350,000, an official gain for the decade of only 40,000 persons. See Primm, *Lion of the Valley*, 287–88. Based on twenty years of growth from 1860 to 1880, I estimate the 1870 population at around 260,000.

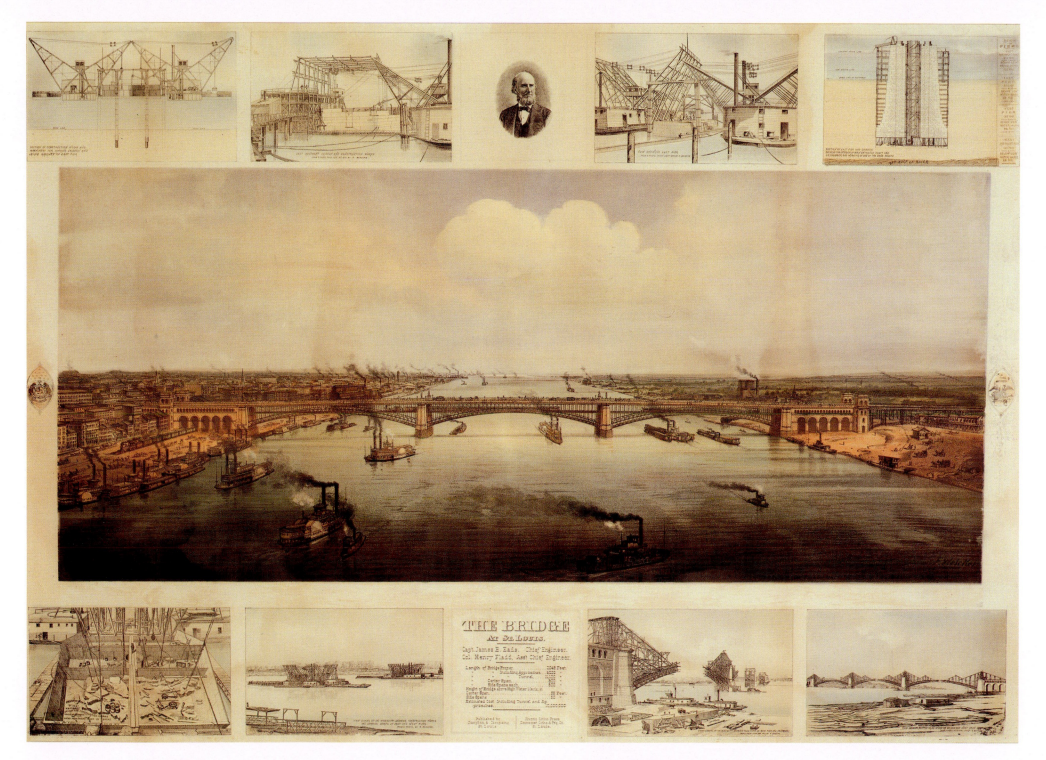

Figure 6–17. View of the Eads Bridge at St. Louis in 1874, published in St. Louis by Compton & Co. (Collection of A. G. Edwards and Sons, Inc., St. Louis, Missouri.)

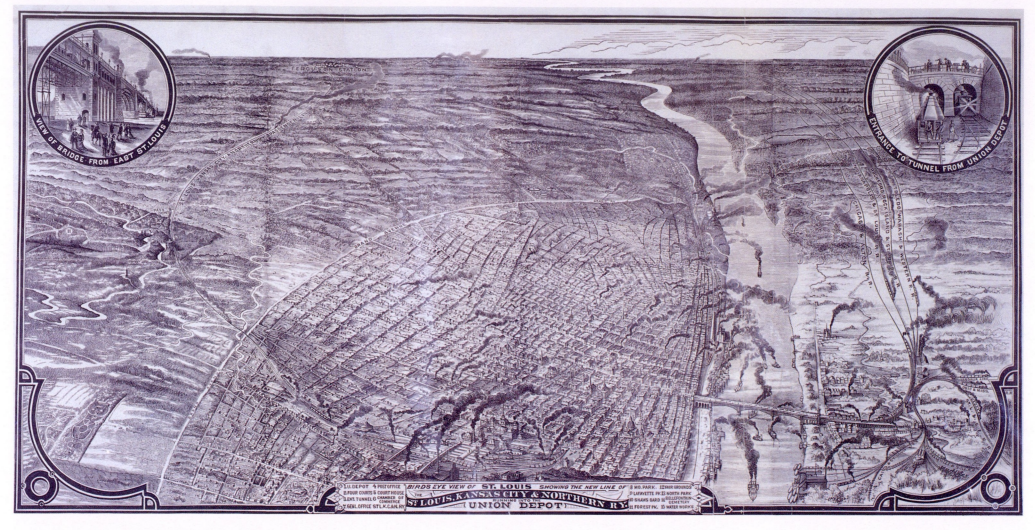

Figure 6–18. View of St. Louis and vicinity in 1876, copyrighted by C. K. Lord of St. Louis. (Division of Geography and Maps, Library of Congress.)

of the St. Louis, Kansas City & Northern Railroad, whose name appears so prominently in the title and for whom Lord served as assistant general passenger agent.[41]

The view shows almost all the land within the encompassing circuit of Grand Avenue to have been subdivided. The Union Depot (number 1 on Lord's view) occupied a site on Twelfth (now Tucker) and Poplar streets. Its extensive train sheds and yards can be seen immediately above the left portion of the title. It faced the vast Municipal Courts building (or "Four Courts," number 2 in the legend), finished in 1870 at Twelfth and Clark streets. This was the first of a new concentration of civic structures that would grow in subsequent years.

This view also clearly shows the railroad tunnel leading beneath the business district from the depot to the tracks crossing the bridge. In this way St. Louis avoided the serious disruptions to street traffic that became a major problem in so many other cities. Also apparent on the view are the rail lines to the west across the land formerly occupied by Chouteau's Pond.

Lord's view is the first to show the location near the Courthouse of the massive building housing the Chamber of Commerce and the Merchants' Exchange, the second structure built for this purpose in the city. Identified on the lithograph as number 6, this structure stood on Third between Chestnut and Pine streets and, when finished in 1875, rose over one hundred feet from the wide sidewalk that ran alongside its Chestnut Street facade.[42] Another important landmark was the Post Office and Custom House at Olive between Eighth and Ninth streets, begun only after much controversy concerning its location. Lord's view identifies this as number 4 and depicts it as if complete, although it took from 1874 to 1884 to finish this newest of St. Louis public buildings.[43]

Although the artist of Lord's perspective does not seem to have been entirely consistent and reduced many portions of St. Louis to almost diagrammatic simplicity, his rendition of the city nonetheless provides a helpful orientation to the locations of the major parks and open spaces used for recreation. Lafayette Park appears to the left of the title, identified as number 9. Lafayette Park was improved and landscaped only in 1869 after having been designated for park purposes more than thirty years before, and its surroundings were still only partly built up.

At the lower left-hand corner number 10 identifies Shaw's Garden, originally the private botanical garden of Henry Shaw and then given by him in 1859 to the city as the Missouri Botanical Garden. In 1868 Shaw offered to the city a much larger tract of nearly two hundred acres between the gardens and Grand Avenue. Named Tower Grove Park, this opened in 1870. For some reason Lord neglected to identify the park, perhaps because the curving border cuts through its site.

On the north side, Bellefontaine Cemetery (number 14 on the print) provided some landscaped respite from the industrial monotony of this portion of the city, but two other open spaces offered opportunities for more active recreation. Number 12, just north of Grand Avenue, locates the Fair Grounds, where events took place throughout the year on land decorated by attractive plantings. Beyond it, identified as number 13, lay O'Fallon Park, whose 159 acres were acquired just as the artist drew this view.

Largest, newest, and most distant of the St. Louis parks, Forest Park occupied nearly fourteen hundred acres directly west of the center of the city. Like O'Fallon Park and Carondelet Park, a 180-acre recreation area well south of Tower Grove Park and therefore not visible on Lord's view, Forest Park was purchased by the County of St. Louis in the years 1874–1875 under powers and procedures established by the state legislature. It opened its gates to the public in 1876.[44]

Lord's lithograph is as much a map as it is a view, but it is an excellent guide to the major landmarks of the city as it entered the last quarter of the nineteenth century. Other artists and topographical delineators in the 1870s produced their own versions of St. Louis as seen from the air, and it helps in understanding and interpreting them to use the Lord view for orientation purposes.

In the next chapter we will first examine two large, single-sheet lithographic portraits of St. Louis. We will then explore in detail the largest, most detailed, and ambitious bird's-eye view ever made of an American city. This extraordinary project provides historians, antiquarians, geographers, preservationists, and students of all other elements of the city with a resource of unrivaled character and surpassing interest.

41. Lord is so identified in the city directories of St. Louis for 1874 and 1878.

42. There are interior and exterior views of this building in Lawrence Lowic, *Architectural Heritage of St. Louis, 1803–1891,* 110–11.

43. See the view of this building, designed by Alfred Mullett, in ibid., 112.

44. Hiram Leffingwell, the real estate developer with the vision to lay out Grand Avenue in 1852, was a prime mover in this project, although many others were involved. See Caroline Loughlin and Catherine Anderson, *Forest Park.* The authors cite, among others, Susan R. Lammert, "The Origin and Development of Landscape Parks in 19th Century St. Louis," a source I have not been able to consult.

THE ST. LOUIS OF CAMILLE N. DRY

What is by far the most important city view of St. Louis made its appearance in 1875. It showed in meticulous detail and at great size thousands of buildings in every part of the city. No other American view came close to matching this in its careful delineation of almost every feature of the urban landscape. Unfortunately, its very size makes it unwieldy to consult, and it remains far less well known than it deserves to be. It will be easier to appreciate the accomplishments of its artist and publisher if we consider first two other bird's-eye views showing St. Louis in the same period. Their publishers issued both as single-sheet lithographs, and each view represents what by that time had become a generally accepted and understood style of depicting cities.

Figure 7–1 shows the first of these two views to be published, a lithograph about 15 x 23 inches copyrighted in 1873 by George Degan of New York. The print does not identify the artist, nor have newspaper accounts been found that might do so. Degan may have drawn it himself, although none of his other recorded lithographic single-sheet city views of Cincinnati and New York gives his name in that capacity. Since Degan had all of his other known views printed in New York City, his lithograph of St. Louis was doubtless done there as well, very likely by G. Schlegel at 97 William Street.[1]

Except for the addition of Eads Bridge—shown erroneously with only a single carriageway and drawn as if completed and open for traffic a year early—the layout of Degan's view strongly resembles that of Hofmann's engraving published in 1854. In both we look west along Chestnut Street, and in both the same system of using a single vanishing point on the horizon makes the east-west streets converge sharply toward the center of the print.

Although Degan probably used the Hofmann view as the basis for his own, he nevertheless introduced several changes other than adding the bridge. The bend in the river at the right differs from the presumed prototype, although this seems to have been done for pictorial effect rather than as an expression of actual topography. Degan also eliminated Chouteau's Pond, and his representation of the terrain in the western extensions of St. Louis more accurately reflects reality than the great domelike elevation that Hofmann drew.

From a distance this lithograph printed in several colors provides a satisfying picture of the city. However, even the most cursory examination at close range and with a magnifying lens reveals how superficially Degan or his artist created this image. Not even buildings in the immediate foreground seem convincing in the sketchy manner in which they have been rendered, while those in the background appear to have been drawn more as symbols than as attempts to render faithful likenesses. A very few landmark buildings like the Courthouse and some of the major churches can be seen, but others cannot be located. Most likely Degan found it difficult to sell many copies of his view, since only two impressions of his lithograph have been recorded in public collections, neither located in St. Louis.[2] Certainly anyone in the city looking for a view that

1. Degan's Cincinnati view of 1869 and one of New York City in the previous year give his address as 51 Chatham Street. Both of these views were printed by Deutz Bros. of 197 William Street. Two New York City views in 1873 and two in 1874 came from the press of G. Schlegel at 97 William Street. Three of these views give Degan's address at 22 Beckman Street. The fourth has no address.

2. Impressions are located in the Division of Prints and Photographs of the Library of Congress and in the library of Knox College, Galesburg, Illinois. Using information concerning size and imprint provided by correspondence, I erroneously cataloged the latter impression as a different image from that in the Library of Congress; see *Views and Viewmakers of Urban Amer-*

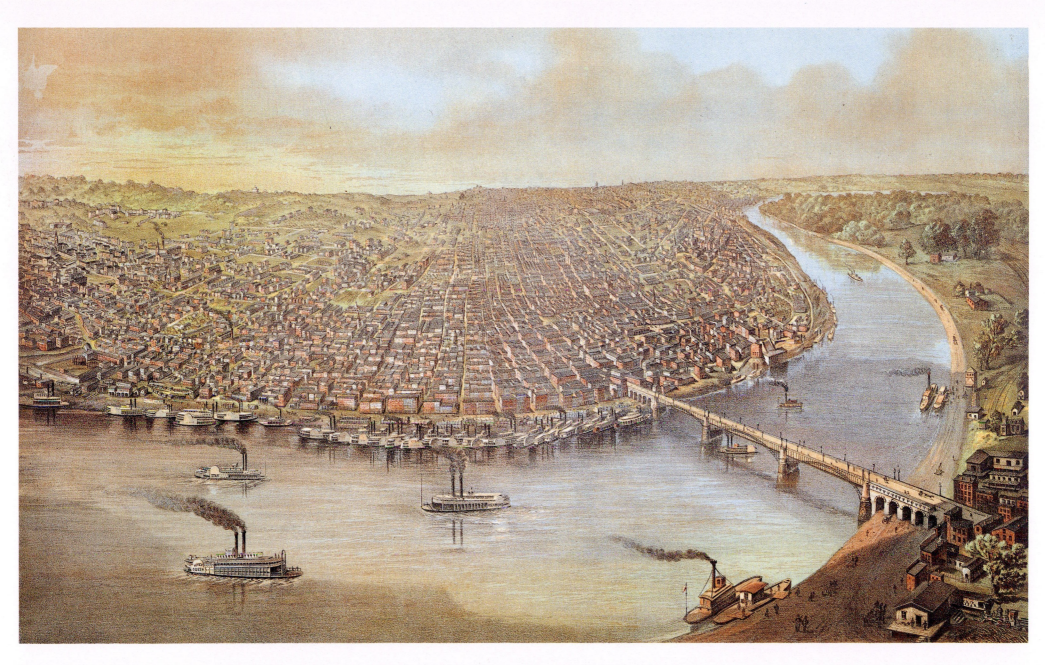

Figure 7-1. View of St. Louis in 1873, published in New York by George Degan. (Division of Prints and Photographs, Library of Congress.)

contained many recognizable features would have found Degan's to be a disappointment.

More satisfactory in this respect is the view that Currier & Ives published in 1874 and that is reproduced in Figure 7–2. The firm's artists of city views, Charles Parsons and Lyman W. Atwater, not only selected a higher viewpoint for their lithograph than that used in Degan's view of the year before, but they also used images of major public and religious buildings that looked like their real-life counterparts. Nevertheless, as we shall see, they, too, resorted to standardized shapes for structures in more distant portions of St. Louis whose size and style they did not know except in very general terms.

This print was one of a series of large-folio city views that Currier & Ives issued over a nearly forty-year period. Their St. Louis view was typical in its large size (not quite 22 x 33 inches), the restrained and dignified title, the absence of vignettes or a decorative border, the unnumbered legend beneath the body of the view with each item located below its image on the print, and the bright, pleasing colors of the multistone lithographic process.[3]

These prints all shared another characteristic: they were the work of Charles Parsons or his son, Charles R. Parsons, the latter doing some of the views in association with Lyman Atwater. It was the younger Parsons and his colleague (about whom nothing is known) who in 1874 executed the St. Louis view, as well as one of Chicago. A year earlier they produced a similar view of Boston, and the following year they drew one of Philadelphia. The two were also responsible for several views of New York City. Parsons alone added lithographs of San Francisco, Brooklyn, Washington, and Baltimore, and he probably drew the unsigned view of New Orleans that Currier & Ives published in 1885.[4]

The major buildings noted in previous chapters can be found on the Parsons and Atwater portrait of St. Louis, and the legend identifies and helps to locate several others. At least one of the artists or an assistant must have visited the city and taken the time to prepare detailed sketches of the principal structures, wherever in the city they might be located, and to draw as well the essential features of the street facades visible along the river and on the several parallel streets to the west.

However, just as they had done and would do in portraying other sprawling and heavily populated cities, Parsons and Atwater took artistic shortcuts when faced with the daunting task of drawing the tens of thousands of individual buildings in St. Louis. What they did instead was to use stereotyped images, either of individual buildings or of entire blocks. These become progressively less refined and detailed in the background, and the delineation of the street patterns there lacks any precision.

Artists doubtless regarded the idea of rendering such a huge city in any more detail as too burdensome and time-consuming, and to consider drawing every building with as much accuracy and at the same size as major landmarks must have seemed an insurmountable assignment too ridiculous to consider. Nevertheless, in 1874—perhaps earlier—a publisher and an artist began just such a project, and their efforts culminated in the most remarkable American city view ever produced. It alone would make a study of St. Louis viewmaking a rewarding subject; it becomes all the more valuable when considered in the context of the rich and varied heritage of views of the city prepared earlier, as well as when compared with several significant city views of later years.

Richard J. Compton published the view and wrote the text that supplemented the images of buildings, streets, and open spaces drawn by and under

ica . . . , catalog entry 2053. I have since examined both prints and have concluded that they are identical.

3. Most books and articles on Currier & Ives discuss the firm's system of hand coloring in which a master copy colored by an artist served as the guide to several women seated around a table. Each added one color to copies of the prints as they were passed from one to another. The artist then added any touch-up work that might be needed. While some of the large-folio city views issued by the firm may have some hand coloring dating from their time of publication, all of the many I have examined received their colors in the printing process. The literature on Currier & Ives is vast and growing. I found helpful Harry T. Peters, *Currier & Ives: Printmakers to the American People;* Frederic A. Conningham, *Currier & Ives Prints: An Illustrated Check List;* Jacques Schurre, *Currier & Ives Prints: A Checklist of Unrecorded Prints Produced by Currier & Ives, N. Currier and C. Currier;* Peter C. Marzio, *The Democratic Art: Pictures for a 19th-Century America;* and John and Katherine Ebert, *Old American Prints for Collectors.*

4. Parsons and Atwater published at least one of their own city views in 1874, the same

year they drew St. Louis for Currier & Ives. The view shows Newark, New Jersey, and the imprint gives the firm's address as 57 Beekman Street, New York. A year earlier they put on stone a lithograph of Seneca Falls, New York, drawn by O. H. Bailey that Endicott & Co. of New York printed. Parsons and Atwater may have lithographed or published some other works, but they could not have been very numerous. It may be of interest to note that Charles Parsons, the father, knew earlier artists and publishers of St. Louis views. He drew a view of Lancaster, Pennsylvania, that James T. Palmatary published in 1853. His associations with J. W. Hill and the Smith brothers were more numerous. Parsons drew and put on stone a lithograph of Portsmouth, New Hampshire, that Smith Brothers published in 1854. He put on stone three J. W. Hill drawings of Bangor and Portland, Maine, and Halifax, Nova Scotia, as well as doing the lithographic work for the view of Detroit published by Smith Brothers about 1855. See my biographical note on Charles Parsons, Charles R. Parsons, and Parsons and Atwater in *Views and Viewmakers,* 196–98.

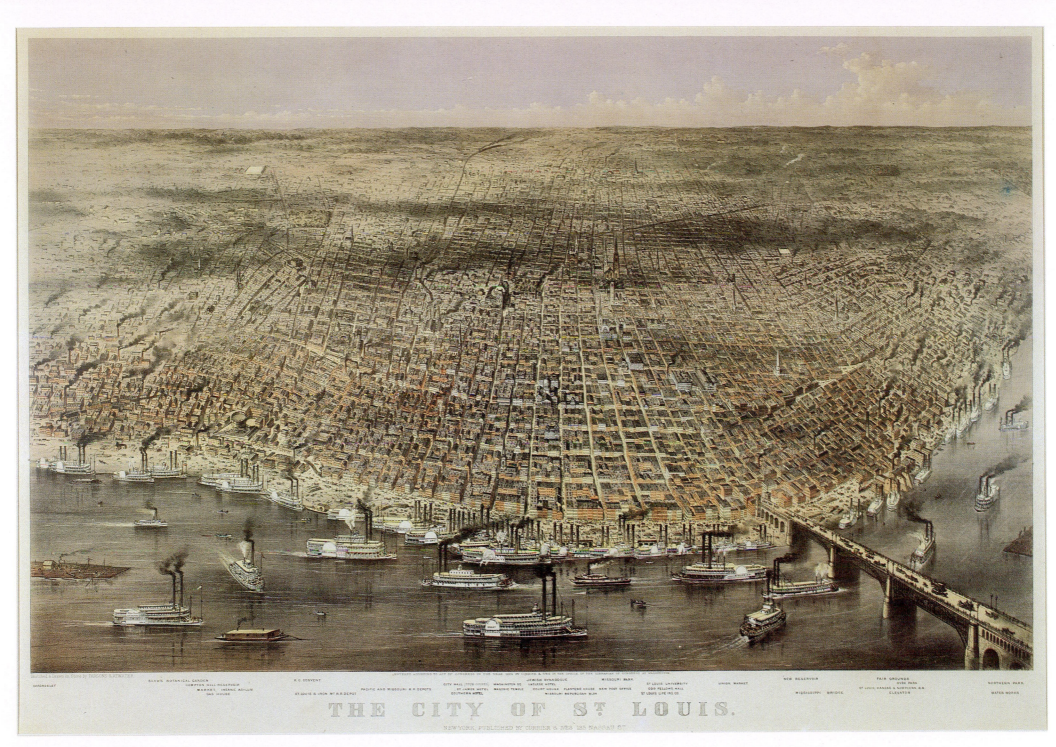

GARDENELET SHAW'S BOTANICAL GARDEN R.C. CONVENT [ENTERED ACCORDING TO ACT OF CONGRESS IN THE YEAR 1874 BY CURRIER & IVES IN THE OFFICE OF THE LIBRARIAN OF CONGRESS AT WASHINGTON] NEW RESERVOIR FAIR GROUNDS NORTHERN PARK
COMPTON HILL RESERVOIR CITY HALL (FOUR COURTS) WASHINGTON SO. JEWISH SYNAGOGUE HYDE PARK
MARKET, INSANE ASYLUM ST. JAMES HOTEL LACLEDE HOTEL ST. LOUIS UNIVERSITY UNION MARKET ST. LOUIS, KANSAS & NORTHERN R.R. WATER WORKS
GAS HOUSE ST. LOUIS & IRON MT. R.R. DEPOT PACIFIC AND MISSOURI R.R. DEPOTS SOUTHERN HOTEL MASONIC TEMPLE COURT HOUSE PLANTERS HOUSE NEW POST OFFICE ODD FELLOWS HALL MISSISSIPPI BRIDGE ELEVATOR
MISSOURI REPUBLICAN BLD'R. ST LOUIS LIFE INS CO.

THE CITY OF ST LOUIS.

NEW YORK, PUBLISHED BY CURRIER & IVES 125 NASSAU ST.

Figure 7–2. View of St. Louis in 1874, drawn by Charles R. Parsons and Lyman Atwater, published in New York by Nathaniel Currier and James Ives. (Collection of A. G. Edwards and Sons, Inc., St. Louis, Missouri.)

the direction of the artist, Camille N. Dry. Compton was a man of long experience in the printing business. The city directory in 1863 identified him as an engraver at 52 North Fourth Street, and he was prosperous enough the following year to pay for a one-third-page advertisement in the next issue of the directory.

Compton apparently began his publishing career by issuing music that he sold at a piano store where he began business in 1865. A credit investigator in November 1866 stated that Compton had been in business for "a number of" years and had established a good business in both pianos and music. By that time he was also manufacturing pianos in association with Jacob Endres. By 1867 he had become president of the St. Louis Piano Forte Manufactory and—in partnership with Valentine Walter—was both selling pianos and publishing music in a shop at 205 North Fourth.[5]

Sometime later Compton become president of the Democrat Lith. and Printing Co., which in 1873 was located on Fourth Street at the northeast corner of Pine.[6] At that time Compton resided in Alton, Illinois, a town some miles north of St. Louis on the other side of the Mississippi. The following year he

moved to St. Louis to board at the Planters Hotel and to manage the St. Louis Lithographing Co. after his previous business failed. By 1875 Compton had returned to Alton to live.[7]

At the same time that he served as manager of the St. Louis Lithographing Co. he operated another business under the name of Richard J. Compton & Co., and it was this firm that published the multisheet city view of 1875. The city directory located the offices of this business on Locust at the northwest corner of Sixth Street. This was the address of the St. Louis Life Insurance Company Building, and the legend on that sheet of the view lists "Compton & Co." as one of the tenants.[8]

Information about the artist of the view remains vague and unsatisfactory. His name was Camille N. Dry, although until he arrived in St. Louis, or shortly before, he spelled his family name *Drie*. Probably he was German or of German extraction and wanted it made clear that his name rhymed with *cry*. Otherwise, French-speaking persons in St. Louis would probably have pronounced it in the French manner to rhyme with *free*.

If Dry had a European background in viewmaking, nothing is known of it. His name first appears in 1871 as the artist (and probably the publisher) of

5. In 1866 Compton had just taken Valentine Walter into the business. Walter came from Alton, where he still had his house. Compton also lived in Alton at one time or another. St. Louis vol. 40, p. 64, R. G. Dun & Co. Collection, Baker Library, Harvard University Graduate School of Business Administration. The Dun collection consists of record books in which agents of this national credit-rating organization entered the results of their investigations and inquiries. As stated in Marzio, *The Democratic Art,* Compton may have begun his career as a printer and publisher in Buffalo, New York, and then moved to St. Louis because he "was forced to sell out to his landlords, the music publishers J. Sage and sons" (p. 188). However, I have not found any listings for Compton in the city directories for Buffalo. The St. Louis directories indicate that he had a number of short-lived partnerships. In 1865 his firm was Compton Endres & Co., identified as "piano forte manufrs" at 262 and 264 and 354 and 356 Market Street. In 1866 the directory lists Compton alone as both a piano forte maker and dealer, with a music store at 52 North Fourth. In 1867 the business appears as Compton and Walter, "piano dealers and music publishers," at 205 North Fourth. Evidently Walter had no business interest in the St. Louis Piano Forte Manufactory, which had its plant at the corner of Fifth and Papin. In 1868 the retail business had become Compton and Doan, "music publishers and dealers," with Thomas C. Doan replacing Walter. Neither that directory nor the one for 1869 lists the piano manufacturing business. In 1869 Doan continued in partnership with Compton selling "music and musical instruments" at their Fifth Street premises.

6. This company had been recently incorporated and had purchased the machinery and stock of the Missouri Democrat Company. That October the company borrowed $15,000 "to make additional improvements &c in its affairs on [account] of increases of [business]," according to a resolution passed by its board of directors. St. Louis vol. 40, p. 298, R. G. Dun & Co. Collection.

7. The 1878 directory is the first I found to identify Compton as manager of the St. Louis Lithographing and Printing Co., but records in St. Louis vol. 38, p. 4106.1 in the R. G. Dun & Co. Collection indicate that Compton served the company as manager as early as November 1873. A 4 May 1878 report by the Dun & Co. agent describes him as "virtual owner of the concern that he is now running."

8. The R. G. Dun records previously cited give two addresses for the St. Louis Lithographing Co.: 106 Market St. and 417 North Sixth. The former may have been the location of the printing plant. The latter address was either identical to that of Compton & Co. in the St. Louis Life Insurance Company Building or was a near neighbor. After the publication of the great St. Louis city view of 1875, Compton continued to manage both the St. Louis Lithographing Co., as its president, and the Compton Label Co., its successor incorporated in May 1878. In July 1882 this became the Compton Litho Co. See the R. G. Dun & Co. records in St. Louis vol. 44, p. 395. The firm had premises at 200–212 Locust. That firm became Compton & Sons Litho & Printing Co. and remained in business at least until 1896, perhaps longer, according to city directory listings. I had hoped that the R. G. Dun & Co. records would provide useful material not only on Compton but also on several of the other St. Louis firms that produced city views. Unfortunately, copies of the records kindly provided by Ann Chaney, reference assistant in the library's division of Manuscripts and Archives, proved disappointing. The Compton records are found in St. Louis vols. 38, p. 4106.1; 40, p. 298; and 44, p. 395. The only other record found of a St. Louis lithographer was for "Chas Robyne." He was then operating a grocery and saloon in a Missouri town whose name I cannot determine from the handwritten note. The note itself states that Robyn began this business in 1864 after he "came from St. Louis where he was a Lithographer." This is in St. Louis vol. 46, p. 47.

bird's-eye views of Galveston, Texas, and Vicksburg, Mississippi. He undoubtedly also drew the view he published of Columbus, Mississippi, that same year.[9] For that lithograph he used an axonometric projection—that is, one without vanishing points so that the grid streets of Columbus appear parallel in the lithograph rather than converging in the distance.

Dry traveled to the Southeast for his next subjects. In 1872 he drew Augusta and Macon, Georgia; Columbia and Charleston, South Carolina; and Raleigh, North Carolina.[10] An experienced publisher of views, J. J. Stoner, issued Dry's Augusta view, and Stoner's companion and a prolific artist of city views, Albert Ruger, published the Macon lithograph. Perhaps they also gave drawing instructions to Dry, for his three Carolina views are far better executed and more convincing in appearance than his previous work. In 1873 Dry both drew and published a view of Norfolk, Virginia, and he probably came to St. Louis shortly thereafter.[11]

How he and Compton met and decided to collaborate on their huge St.

Louis view will probably never be known. Nor do we have much information about how many persons were involved in its preparation, the methods by which Compton obtained subscriptions to the publication, how many copies he sold, how profitable the enterprise proved to be, or how purchasers regarded and used this unwieldy portrait of St. Louis. Most of our knowledge comes from a sample sheet that Compton distributed to stimulate sales, from statements made in the publication itself about how artist and publisher went about their business, and from one long newspaper account that in places does little more than paraphrase material from the other two sources.[12]

Compton issued the view of St. Louis bound in book form in a large, long folio of 222 pages priced at $25.00. He gave it a title to match its imposing size, calling it *Pictorial St. Louis: The Great Metropolis of the Mississippi Valley, a Topographical Survey Drawn in Perspective A.D. 1875*. The title page, reproduced in Figure 7–3, lists Camille N. Dry as the person responsible for the drawing and Rich. J. Compton as the designer and editor of the volume. Two dates appear in the volume. The preface is dated 20 December 1875, the presumed date of publication, and a full-page frontispiece image of the Eads Bridge by Dry is dated 30 April 1875 in a certification of accuracy written on the image and signed by James B. Eads, to whom Compton dedicated the book. The title page also contains a much reduced version of a view of the bridge that Compton & Company issued in 1874.[13]

9. On 5 July 1871 the city council of Columbus, Mississippi, passed a resolution to subscribe to six copies of "Camille Grie's [*sic*] Map of Columbus." A copy of these minutes was kindly provided me by Mrs. Douglas Bateman, director of the Lowndes County Library System in Columbus.

10. For a color reproduction of Dry's Charleston view and one in black and white of his Columbia view, see my *Views and Viewmakers*, color pl. 5 and pl. 90. I have also used the view of Columbia to illustrate how views can be used to interpret the character of the cities they depict. See ibid., chap. 10, 73–86.

11. For biographical notes on Stoner and Ruger, two pivotal figures in post–Civil War American viewmaking, see ibid., 201–4, 209–12. I have suggested that Stoner and Ruger met Dry in Georgia when the two visited Savannah. Ruger drew the city for a view dated 1871, and Stoner came to Savannah in February 1872 to promote sales. Ruger, not Stoner, published this view. That is true also of Ruger's 1871 view of Atlanta. On both views Ruger gives his address as St. Louis, as he did on three other lithographs at this time. Although in 1867 he drew Cairo and Alton, Illinois, and in 1869 Hannibal and several other cities in Missouri, Ruger never did a signed lithograph of St. Louis. In my biographical note on Ruger, I raise the possibility that Ruger was involved in the Compton-Dry view. The evidence is entirely circumstantial. In 1873–1875 Ruger produced only two views. By contrast, in 1870–1872 he produced forty-seven and in 1876–1878, thirty. Thus, his virtual retirement from itinerant viewmaking coincides with the period when work was underway on the multisheet St. Louis view. Further, Ruger was certainly the best-known city-view artist of the time. Moreover, he consistently used a system of perspective with two vanishing points, as did the big St. Louis view, while Dry's handling of perspective appears casual and informal. The project was obviously beyond the capacity of any single individual, and Dry must have had help from some source. However, Ruger's name does not appear in any of the St. Louis directories. This is not conclusive, since directory compilers often omitted the names of residents, or Ruger may have lived outside the city on the Missouri side of the river or in Illinois. Nevertheless, Ruger's possible involvement in this project rests on pure conjecture.

12. The R. G. Dun Co. records suggest that Compton lost money on the publication of the view. A note by the agent in 1878 mentions that Compton had "an old debt hanging over him in the shape of a stock note for 5m [$5,000] while a member of the Democrat Job Printing Co. a few years ago." St. Louis vol. 38, p. 4106.1. A later record of December 1882 states, "Rich J. Compton has been sued in the Circuit Court by the Globe Printing Co. for $4,832.84. This is an old matter." The St. Louis Globe-Democrat Job Printing Co. printed the 110-sheet view of 1875. I do not know the result of the suit or if the alleged debt was related to the publication of the view. The last reference to the matter in the R. G. Dun & Co. records is on 21 June 1883, when the agent noted, "The suit previously mentioned has not been dismissed, & is at present in judgt. [judgment]. This however, is against [Compton] individually, growing out of an old matter. . . . It is prob.[able] that they will be able to settle this for a nom.[inal] consideration, but [Compton] claims that he is not in honor bound to pay the debt." St. Louis vol. 44, p. 395.

13. A credit line below the small version of the Compton & Company view reads "Western Engraving Co. St. Louis." This refers to the small view, possibly meaning that this firm reduced it and issued it as an engraving either for *Pictorial St. Louis* or as a lettersheet or other illustration. The volume by Compton and Dry was, as previously noted, printed by the St. Louis Globe-Democrat Job Printing Co. I should note that Harry M. Hagen's *This Is Our Saint Louis* is a facsimile of *Pictorial St. Louis*, so working copies of the now fairly rare original can be found in a number of libraries.

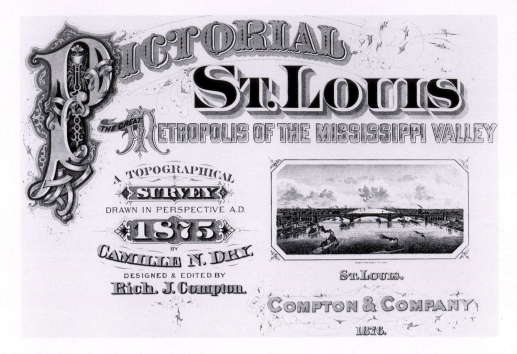

Figure 7–3. Title Page of *Pictorial St. Louis,* compiled and drawn by Richard J. Compton and Camille N. Dry, printed in St. Louis by the St. Louis Globe-Democrat Job Printing Co., and published in St. Louis by Richard J. Compton & Co. in 1875. (Special Collections, Olin Library, Washington University.)

The *St. Louis Globe-Democrat* described this publication for its readers on 2 January 1876.

> A historical sketch of the city . . . comprises a part of the work. The pictorial pages represent an area of nearly seventy square miles. Statistics are given, . . . the development of our commerce is delineated; figures are given showing our debt and resources, Custom-house receipts, vital statistics, and titles of real estate. . . . The engravings [*sic*] excite wonder by their number and accuracy. An index gives the key to the whole. The magnitude of the work surpasses comprehension. Nothing of the kind was ever before attempted, but the success has been in all respects complete and unparalleled.[14]

According to this newspaper story and the preface, "preliminary drawings for this work were made early in the spring of 1874." Sometime between then and December 1875—the date of publication—Compton circulated copies of the "Specimen Page" reproduced in Figure 7–4 as part of his campaign to so-

14. *St. Louis Globe Democrat,* 2 January 1876, p. 8.

licit subscriptions. Excluding the text at the bottom, this image measured about 11 x 18 inches, the approximate size of each of the 110 lithographic sections of the view as eventually printed. Compton noted that the space occupied on the specimen page by his promotional copy would be used for a legend that would identify objects on every page of the finished product. As printed, these legends name and locate over one thousand stores, factories, parks, engineering works, churches, schools, charitable institutions, hospitals, assembly halls, colleges and universities, and other features and places of St. Louis.

In his text Compton summarized what a subscriber could expect to find in a book "elegantly bound in muslin and gilt" for which he had to pay $25.00:

> The book will contain about one hundred and fifty pages like this showing collectively an area of nearly seventy square miles upon which all the building and topography of unoccupied property are accurately drawn.
>
> There will also be many pages of printed matter, descriptive of important public and private buildings, and all objects of interest. A fund of statistical information regarding the financial, manufacturing, and general business interests of the city will be introduced; and an exhaustive article on the past, present, and prospective value of real estate in all parts of the city will be a feature of a special value to land owners, investors, all interested in St. Louis property; which, with personal notes and biographical sketches, will make the work a complete compendium of St. Louis in 1875, and the most costly and magnificent publication ever issued in the interests of any city in the world.[15]

The specimen page reproduced in Figure 7–4 is identical to plate 19 of *Pictorial St. Louis* except for the absence of the legend and of the numbers in the body of the view that corresponded with the identifications in the legend. On this and other plates the lithographer simply scratched the numbers on top of the previously drawn roofs of the buildings. Almost certainly Compton received some kind of payment from the owners of these buildings for having them so singled out or obtained subscriptions from them for one or more copies of the view. The only exceptions would have been public buildings, churches, schools, and other nonprofit landmark structures.[16]

The size of the Compton-Dry view opened the way for another and related source of revenue for the publisher. One can find a number of buildings in the retail and wholesale districts of downtown with the name of the store or the nature of the business lettered on the image of the building. Thus, on plate 1 the legend identifies the building numbered 37 as the property of Bemis Bros. & Co.

15. The Missouri Historical Society has the only impression I have seen of the specimen page.

16. For collection of fees by viewmakers from persons who wished their property to be recognized in this manner, see my *Views and Viewmakers,* 53–55.

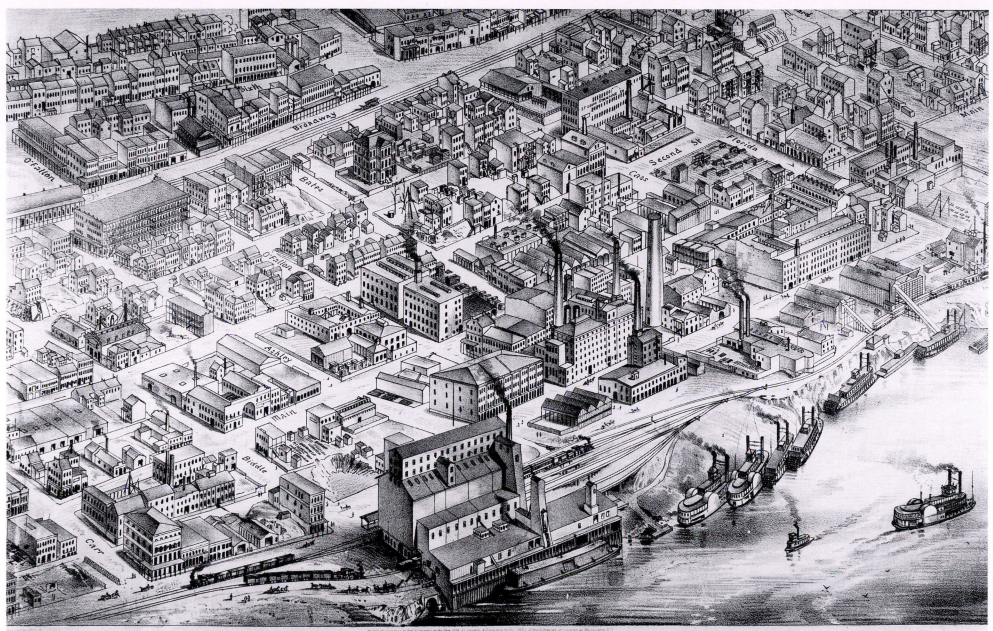

SPECIMEN PAGE, FROM MANUFACTURING PORTION OF THE CITY.

The Book will contain about one hundred and fifty pages like this, showing collectively an area of nearly seventy square miles, upon which all the buildings, and topography of unoccupied property, are accurately drawn. There will also be many pages of printed matter, descriptive of important public and private buildings, and all objects of interest. A fund of statistical information regarding the financial, manufacturing, and general business interests of the city will be introduced; and an exhaustive article on the past, present and prospective value of real estate in all parts of the city will be a feature of especial value to land owners, investors, and all interested in St. Louis property; which, with personal notes and biographical sketches, will make the work a complete compendium of St. Louis in 1875, and the most costly and magnificent publication ever issued in the interest of any city in the world.

Sold only by Subscription. Price, elegantly bound in muslin and gilt, $25.00.　　　COMPTON & COMPANY, No. 30, St. Louis Life Insurance Building, Cor. Sixth and Locust Streets.

Note.—The space occupied by this notice will be used for the reference numbers and foot notes to the buildings on the page.

Figure 7–4. Sample Page for *Pictorial St. Louis* by Compton and Dry, printed in St. Louis, probably in 1874. (Missouri Historical Society.)

A sign on top of the building reads *BAGS,* the product that Bemis produced.

An even more lucrative source of revenue for Compton must have been the numerous descriptions of business enterprises and professional offices that appeared in *Pictorial St. Louis* on the reverse side of the 110 sheets making up Dry's view. Many consisted of a single paragraph, but others required a half-page, and the text for Belcher's Sugar Refining Company occupied an entire page—for which the company surely paid.

A five-page index provided a guide for those seeking information about these clients as well as what presumably was a more complete listing of churches, schools, and hospitals. Text passages described each of these public institutions and offered much useful historical information about both the organizations and their buildings. The index indicated the plate number where each image appeared as well as the page where any descriptive text could be found.

It was not only its size and detail that made Compton and Dry's view remarkable. Alone among American viewmakers, they provided an explanation of the perspective system they adopted. They did this in their preface and through the illustration reproduced as Figure 7–5. At the lower right of this "Key to the Perspective" is a skeleton map of the city that indicates the generous area encompassed by the view. The top half reveals how the artist transformed the ground plan of the city into a perspective grid based on an assumed viewpoint located southeast of the city. The numbered rectangles identify which part of the perspective appears on which sheet of the view, so the perspective diagram also serves as an index map to the entire publication. The preface helps to explain these two illustrations:

> After a careful consideration of the subject, it was determined to locate the point of view so that the city would be seen from the southeast. Accordingly, the point of sight was established on the Illinois side of the river, looking to the northwest, and at sufficient altitude to overlook the roofs of ordinary houses into the streets.

This passage goes on to explain that "a careful perspective, which required a surface of three hundred square feet, was then erected from a correct survey of the city." Along the Mississippi the view stretched some ten miles from Arsenal Island on the south to the Water Works on the north. The view extended inland southwest to the Insane Asylum just beyond Kingshighway at the intersection of Arsenal Road, as far west as the eastern edge of Forest Park, and northwest to beyond Bellefontaine Cemetery.

These boundaries coincide almost exactly with those used for a very large survey of St. Louis published in 1874 by Leffingwell & Elliott. Drawn at a scale of 660 feet to the inch, this map showed every street, block, and lot line in the city as well as many important structures. It included an extensive legend locating public buildings, places of assembly, and churches. Its appearance just as Dry began his work must have helped him immeasurably in establishing the basic perspective grid, checking the accuracy of field sketches, and preparing the final drawings for the lithographic press.[17]

Compton stated, "Every foot of the vast territory within these limits has been carefully examined and topographically drawn in perspective." He claimed, "Absolute truth and accuracy . . . has been the standard and in no cases have additions or alterations been made unless the same were actually in course of construction." Compton indicated that such liberties with the facts were limited in number: "In a few cases, important public and private edifices that are not yet finished are shown completed, and as they will appear when done."

In this preface Compton refers to "Mr. C. N. Dry and his assistants," a confirmation of the commonsense conclusion that such a gigantic work could not have been accomplished by a single artist. Instead, Dry must have supervised a team of artists, each of whom must have spent many days or weeks drawing and sketching the hundreds of streets and thousands of buildings. Slight but noticeable differences in the ways adjoining sheets are rendered clearly indicate that more than one person took the finished drawings and put them on lithographic stones or zinc plates.

Although the exact number of Dry's assistants, as well as their duties, backgrounds, and contributions, will probably never be known, city directories of the period provide clues about the identities of some of those whose efforts Dry directed and coordinated. The 1875 directory identifies Camille N. Dry as one of two persons listed under the heading of "Draughtsmen (Mechanical)," with a place of business in room 48, 414 Olive Street. This was the address of the Insurance Exchange Building, located at the southeast corner of Olive and Fifth streets.

This building apparently provided studios for many artists. The 1871 city directory lists no fewer than eight artists at this address, nearly half of the eigh-

17. I have inspected the impression of this map, titled *Map of the City of St. Louis. 1874,* in the Library of Congress Division of Geography and Maps. Rather confusingly the imprint states: "Compiled and Drawn from Authentic Sources by E. A. Garvey 314 ½ N. Fourth St. and P. Maccallum, office 810 Olive St. Civil Engineers" and "This map was . . . compiled and drawn by Edward Charles Schultse, Surveyor & Engineer, 127, Chestnut Street." The St. Louis Lithographing Co. at 106 Market Street printed the map in nine large sheets.

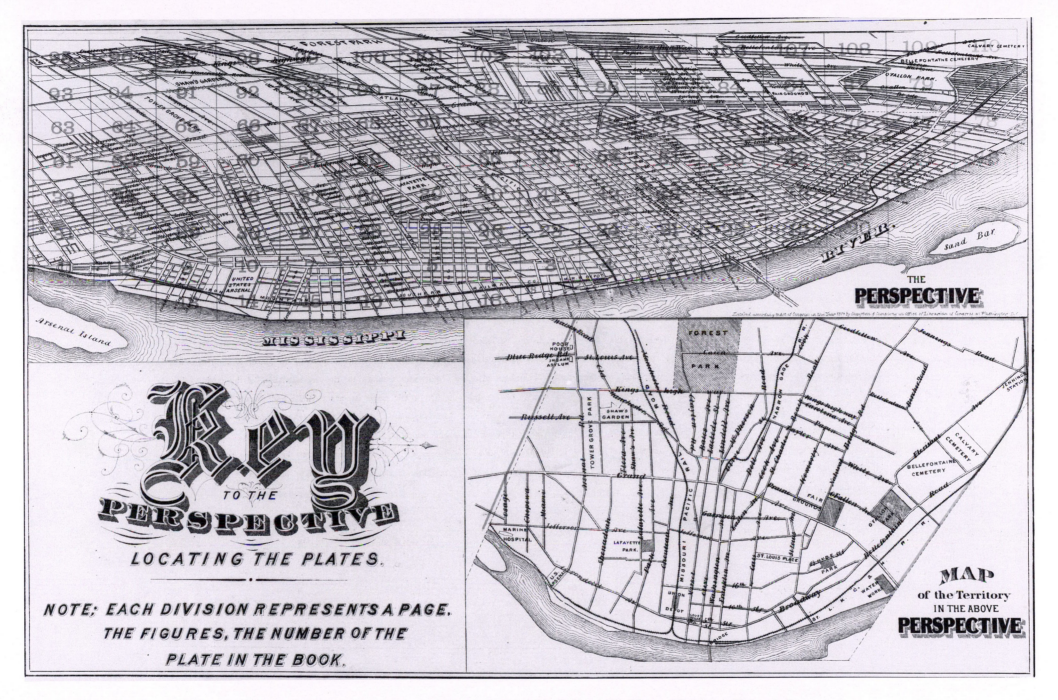

Figure 7–5. Plan of St. Louis and perspective diagram from Compton and Dry, *Pictorial St. Louis.* (Special Collections, Olin Library, Washington University.)

teen persons so identified under this occupational heading. Yet no artists gave their address at this building in the previous year.[18] During the period covered by the 1871–1875 city directories, twenty-six artists had studios here. The table below records the years the city directories listed each artist with an address in this building and (when available) their room number or numbers.

Artists with Studios in the Insurance Exchange Building, 1871–1875

Artist	Room number	Years
Becker, August H.	22	1874
Colton, Alpheus F.	46	1874
Conant, Alban J.	59	1874–1875
Eichbaum, George C.	45	1871–1875
Evans, E. S.		1871
Fairchild, Mary	52	1874
Gutherz, Carl	53	1875
Harney, Paul E.		1873
Hinchey, William J.	55, 46	1872–1873
Ives, Halsey C.	59	1874
Jacobs, L. R.		1871
Joes, Halsey C.	59, 60	1875
Kummer, J.		1871
McKellops, Josephine A.	53	1874
Meeker, J. R.	50	1871–1873
Mueller, Gottlieb	47	1875
Mulvany, John	39	1872–1873
O'Connor, J., Miss	49, 52	1873–1874
Pattison, J. W.	46	1871–1872
Powers, A. G.	48	1871–1872
Rabuske, T.		1871
Stainthorp, Thomas	57	1875
Stuart, James	53, 54	1872
Troendle, Joseph F.	52	1872
Turner, Florence B.	52	1874
Wise, James		1873

18. I should make it clear if it is not already obvious that there is a substantial time lag between the fieldwork necessary to compile a city directory and its publication date. Usually the publishers also advanced the date in the title so that it would appear more current than it was. Thus the directory for a given year might have been published early in the year and contain information gathered many months before. One should think of a directory for 1875, for example, as recording conditions sometime in 1874.

One other person is known to have occupied space in the building in 1874 and 1875. This was Charles Juehne, newly arrived from Albany, New York, where he worked as a lithographer. Two decades later he produced his own views of St. Louis, work that we will examine in the next chapter. The 1874 directory identified him as an engraver, employed by Robert A. Campbell, a publisher, with an office at 38 Insurance Exchange. The following year the directory listed him as a lithographer in room 42 of the same building, a room that could not be far from that occupied by Dry. Juehne may have worked on the lithographic stones or plates used to print the Compton-Dry view. Even if Juehne played no part in this project, he could scarcely have avoided knowing Dry and learning something about how that experienced viewmaker went about his work.

Who else may have been involved in the project? Any artist or lithographer in St. Louis *could* have been employed by Compton, but those who are listed in the table as first working in the Insurance Exchange Building in 1874 and 1875 would appear to be the most likely to have been recruited by Compton and Dry to help with the project. Some on the list can be tentatively eliminated because of their known stature as "serious" artists: Halsey C. Ives, Gottlieb Mueller, and August H. Becker.[19]

Conant is another matter, although he, too, was a St. Louis portrait painter of some stature. The city directories used various first names or initials in their listings of him under the category of *Artists:* A. J. in 1871, A. in 1872, Alden J. in 1873, Alvan J. in 1874, and Allan J. in 1875. In modern encyclopedias of American artists his name is given as Alban Jasper Conant, an artist born in Vermont, who lived for a time in Troy, New York, and then moved to St. Louis in 1857.[20]

19. Halsey C. Ives was then a new arrival in St. Louis, having just been hired as an instructor in the Polytechnic Department of Washington University. He later became professor of drawing in the Polytechnic School and director of the Museum and School of Fine Arts at Washington University. See *The Story of the St. Louis Artists' Guild 1886–1936* and "Department of Fine Arts. Prof. Halsey C. Ives, of St. Louis, Unanimously Elected Director," *World's Fair Bulletin,* September 1901, p. 16. Gottlieb Mueller was a portrait painter. J. Thomas Scharf, in *History of Saint Louis City and County . . . ,* mentions that he "did good work of this class" (2:1625). August H. Becker was a fresco artist according to a brief obituary in the *St. Louis Globe-Democrat,* 4 October 1903, p. 7, col. 2. George Eichbaum, who maintained a studio in the Insurance Exchange Building throughout the 1871–1875 period, can also probably be ruled out as a participant in the city-view project. See Scharf, *Saint Louis,* 2:1627, and William Hyde and Howard L. Conard, eds., *Encyclopedia of the History of St. Louis,* 2:666.

20. Biographical sketches of Conant appeared in the *St. Louis Post-Dispatch,* 28 June 1912, and *Frank Leslie's Illustrated Weekly Newspaper,* 13 November 1913. See also Hyde and Conard, eds., *Encyclopedia,* 1:446.

There is a reasonable possibility that this is the Conant whose name appears on a number of lithographic townscapes published prior to 1857 of places in Massachusetts and Connecticut and that this is the same Conant who drew a bird's-eye view of Sumner, Kansas, and probably two similar views of other Kansas towns about 1857. If so, his talents and experience would have made him a valuable addition to the Compton-Dry team.[21]

A year earlier Compton published a handsome view of the Eads Bridge, a lithograph discussed and reproduced in the previous chapter as Figure 6–17. Barely discernible at the lower right on the original is the name *F. Welcker*, either the artist or the lithographer of this print. As was mentioned in Chapter VI, this is probably Ferdinand Welcker, who worked in the 1850s with Eduard Robyn on a huge rolled canvas panorama of the Eastern Hemisphere. It seems a strong possibility that Welcker also played some role in the production of the Compton and Dry view of 1875. Almost certainly several other persons also contributed to its creation, but in the absence of further information about them it is impossible to be more precise.

The task facing "Mr. C. N. Dry and his assistants" would not have been easy even if St. Louis had sat still for its giant portrait. Instead, of course, builders began scores of new structures during the time needed to prepare the view. Compton explains that "all the buildings within the limits of the survey in July, 1875 are shown; and a very large number of those executed or commenced since that date have been also introduced, the plates having been constantly corrected up to the last possible moment before publication."

Finally, Compton mentioned how Dry coped with a problem that arose because the view had to be divided into pages. He explained that "where a building is but partially shown on one page, it is given complete on the adjoining page." What Compton did not point out is that, although the images at the edges of each page overlap with those on the pages adjoining, the sheets cannot be trimmed and physically joined because in most cases the lines of streets and buildings fail to match. Usually these discrepancies are so obvious and serious as to distract from the effect that would otherwise be gained by mounting two, four, or more of the sheets to create a single very large image of a section of St. Louis or, indeed, of the entire city. This explains why in this book the several reproductions showing combinations of adjoining sheets are printed with slight separations where normally the edges would have been brought together. The result is to minimize the distracting discontinuities that remain even after eliminating the overlapped portions. This device serves to maintain the impression of a single image for each neighborhood or district illustrated in this manner.

Why did Dry produce a view with this peculiar characteristic that makes it almost impossible to appreciate the totality of his enormous accomplishment? What purpose did he have in mind then that now, in practice, limits the use most persons make of his view to consulting individual pages or examining his images of particular buildings or short lengths of streets? Or did this result simply from careless draftmanship?

The reason adjoining sheets do not match is that Dry seems to have modified the perspective system described in the preface and illustrated in his diagram so that images of buildings and other features anywhere in the view (even in the distant background) could be the same size as structures of similar size located nearest the selected viewpoint. In effect, he moved closer to the scene depicted on each page so that the the objects falling within the boundaries of each sheet of the view remained the same distance from the viewpoint.[22] It is as

21. For a color reproduction of the Sumner view, see my *Cities of the American West*, pl. 18, or *Cities on Stone*, pl. 23. This undated, unsigned lithograph is attributed to an "Albert Conant" in Sheffield Ingalls, *History of Atchison County Kansas*, 85. This view was printed in Cincinnati by Middleton, Strobridge & Co. Although the imprint also identifies this company as the publisher, Ingalls states that the developer of this now-vanished town, John P. Wheeler, "engaged an artist named Albert Conant to come out and make a drawing of it, and this was later taken to Cincinnati, and a colored lithograph made from it, which was widely circulated." Unsigned views of Lawrence and Tecumseh, Kansas, both printed at this time by the Strobridge firm in Cincinnati, closely resemble the Sumner view and may also have been the work of Conant. Because A. Conant is named as the artist on a view of New Bedford, Massachusetts, put on stone by Fitz Hugh Lane in 1845, I asked Elton W. Hall, then curator of collections at the Old Dartmouth Historical Society Whaling Museum in New Bedford, if he could provide any information on Conant. Hall stated, in a letter of 25 January 1984, that he was "reasonably certain he is not the Alban Jasper Conant who appears in [George C.] Groce and [David H.] Wallace, [*The New York Historical Society's Dictionary of Artists in America, 1564–1860*]." Hall added: "Naturally I am unable to share with you his illustrated diaries of his trip to Kansas together with his annotated copy of *The Guide to Kansas Sporting Houses* because I am saving those to do an article myself." Apparently Hall has not completed what would surely be a seminal work.

22. Dry may have taken further liberties with his announced perspective system. There are some sheets where the centerlines of streets that are parallel on the ground do not seem to converge toward either of the two vanishing points that Dry presumably used. On at least a few sheets these streets actually seem to diverge in a kind of reverse perspective, much like one encounters with some nineteenth-century Japanese woodblock city views. Perhaps Dry used within these sheets the axonometric drawing style he employed for his Columbus, Mississippi, view of 1871. Of course, this would create problems with matching adjoining sheets. In *Views and Viewmakers*, I analyzed Dry's 1872 view of Raleigh, North Carolina, in these words: "In that print . . . streets in one direction are parallel. Those angled more steeply and leading toward the upper right converge toward a distant vanishing point, but they do so so gradually that the effect is

though a photographer in a balloon used progressively more powerful telephoto lenses to record the appearance of more distant sections of the city. Although any attempt to join the resulting photographic images to create a single unified photo mosaic with smoothly matching borders would be doomed to failure, an individual photograph, like the separate sheets of the Dry view, could be consulted for information about that portion of the city within its limits.[23]

Dry—almost surely with Compton's approval—probably adopted this approach in the belief that more copies of the view could be sold if it was constructed in this manner. Clearly, if more buildings were recognizable, more owners were likely to pay for having them identified in the legend or to purchase one or more copies of the volume. Building owners might also be persuaded to pay for more detailed advertising of their business or profession in the form of extended descriptive passages printed on the reverse side of the views.

Dry and Compton must have concluded that far fewer persons would ever want to mount the individual sheets of the view to create a single giant image of the city than would simply turn to the plate illustrating a building in which they had some interest. Probably they correctly estimated the needs and desires of most of their potential customers. It is an example of the needs of commerce influencing artistic style.

Before examining several portions of the city in 1875 as recorded in this view, three general observations may be helpful. These follow in no special order of importance. First, the view shows a number of street railways. At this time, of course, horse-drawn, not electrically powered, carriages served the public. Pages 35–42 of the text in *Pictorial St. Louis* provide a history of and detailed route information for each line then operated by the ten private companies competing for patronage.[24] Compton's text points out the effect that these lines had on residential development patterns after 1859, the year the first company received a charter to operate. He declared that "this mode of transit" stimulated the building of "numerous beautiful homes" and that "along our western limits have sprung up magnificent residences" surrounded by spacious grounds." Finally, Compton observed:

> public parks have been laid out and embellished in portions of the city, that have been made easily accessible by this cheap and convenient mode of conveyance. Delightful villas and well-kept lawns of our merchants and business men now greet the eye, where, but for street railways, would yet be seen broad fields of waving grain.

Second, Dry's view reveals to what an extent religious buildings dominated the skyline of the city. In an era before steel-frame construction and the electric elevator made tall office buildings both possible functionally and attractive financially, the number, size, style, and location of churches largely determined the architectural character of American cities. Because the view displays the city as if seen from a high angle, the visual impact made by churches in the townscape appears less dramatic than it was in reality. The sight of towers and spires and the sound of church bells must have been an unforgettable experience in many American cities. In St. Louis it must have been overwhelming. The index to *Pictorial St. Louis* lists all the city's places of worship, and Compton gives a capsule history of nearly every one in his text. The count by congregations is impressive:

Baptist, 9	Presbyterian, 13
Christian, 3	Unitarian, 2
Congregational 4	Roman Catholic, 28
Episcopal, 10	Roman Catholic chapels, 21
German Evangelical, 16	Roman Catholic, outlying, 10
Hebrew, 4	Missions, etc., 4
Methodist, 18	

almost the same as in an axonometric projection. The rectangular blocks thus appear as parallelograms. Buildings of equal size in the 'front' and the 'back' of the town are shown as of equal size in the drawing. The effect is a kind of warped plan-view, almost as if Raleigh were somehow clinging to a vertical surface, and the horizon line is completely artificial" (p. 20).

23. Aerial perspective "maps" of more than two hundred American college campuses have been drawn in the last few years using a system described in Carole Stone, "New 'Perspective' Map Gives Better than a Bird's-eye View," as "an infinite-vanishing-point, curvature-plane map, which means that lines don't resolve to just two points on the horizon. Instead, the scale is the same throughout" (p. 5). This article announced the creation of such a map-view of the Cornell University campus in Ithaca, New York, by the Hermann, Missouri, firm of Arnhold and Associates, headed by Ralph Arnhold, who is quoted as stating, "Even buildings way in the background are shown with the same importance because the scale is the same throughout." He explained that the curvature of the map follows the curvature of the earth. In a letter dated 4 December 1987, replying to my inquiry, Arnhold described his technique as "one using an infinite vanishing point curvature plane." He also referred to the Compton-Dry view: "I am, of course, very familiar with the vast drawing of Camille N. Dry. . . . As you surmised . . . [it is] a constant linear plane, isometric-type map which is probably the only way to do such a drawing at that time of 1875."

24. In the special census of cities taken in 1880, St. Louis reported that "the horse-railroads in the city have a total length of 119.6 miles. There are 496 cars, with 2,280 horses in use, and employment is given to 1,010 men. The total number of passengers carried annually is 19,600,000, and the rates of fare are 5 and 7 cents." U.S. Census Office, "Part II, The Southern and Western States," 581.

Third, a close examination of the buildings shown on individual sheets and a study of the legends below reveals a substantially different pattern of land use than one normally encounters today outside the central districts of cities. In most neighborhoods, even those of higher-income families, business and industry mingled freely. St. Louis was one of the first cities in the United States to pass a zoning ordinance, but that event lay more than four decades in the future when Dry prepared his view of the city.

This is one reason that persons of wealth attempted to exercise private control over the use of land in the vicinity of their homes. Some extremely wealthy merchant princes owned great estates at the city's outskirts and insulated themselves from noise, smoke, and intrusions into their privacy by maintaining gardens and private parks around their homes. Far more of the city's well-to-do found a solution in joining with their equals to create and maintain private streets. They limited traffic to those who resided there and to necessary commercial deliveries, and they jointly agreed by covenants in their deeds not to use their property for anything but residential purposes.

In St. Louis, Lucas Place provided the prototype for a large number of similar private developments, almost surely the most numerous private residential precincts of any city of the United States. We can begin our tour of Camille N. Dry's St. Louis in this neighborhood, which, as we have already seen, quickly became the most fashionable single neighborhood in the city after its creation in the mid-1850s.

Figure 7–6 reproduces Dry's plate of this area. Five churches, a synagogue, the castle-like high school, and the massive mansard-roofed building for Washington University provided an exciting and architecturally varied skyline. Mansions of old St. Louis families lined Lucas Place from behind shallow but tree-shaded yards. Missouri Park at the eastern end of Lucas Place offered a pleasant landscaped contrast to the now fully built-up and distinctly urban surroundings.

Yet only a block east of the park towered the chimney of a factory not identified in the legend. From its foot the noisy Lucas Market extended two blocks to the south, where it ended at McIlvain's Lumber Yard. On Market street, parallel with and only four blocks removed from Lucas Place, a planing mill, a cotton press, and a tobacco factory all sent smoky reminders into the air that in a city undergoing rapid growth older residential sanctuaries might have to give way to the relentless expansion of industry and commerce.

Dry also offers us a look at the newest private residential street of St. Louis, one that would soon become even more fashionable than Lucas Place.

Figure 7–7 reproduces plate 85 of *Pictorial St. Louis*, a portion looking west just beyond Grand Avenue in the foreground. Midway along this thoroughfare the view shows a gate and a fountain, behind which stretches a narrow strip of lawn defined by a row of trees on either side. This is Vandeventer Place, a development conceived in 1870 by Charles Peck, an architect and real estate developer. Napoleon Mullikin and Joseph McCune joined Peck in this venture and retained Julius Pitzman, an engineer educated in Germany, as their land planner. The Peck and Mullikin mansions can be seen flanking the entrance from Grand. Eventually the street was extended westward for a second block and provided eighty-six sites restricted to single-family dwellings costing at least ten thousand dollars each. In the 1870s that amount of money would buy large and elaborate family accommodations.[25]

Dry's view captures the appearance of this new neighborhood just before building resumed there following a lull in its growth during the Panic of 1873. Vandeventer Place soon attained an aristocratic air and became the most prestigious address in the city, remaining so until business changed the character of Grand Avenue and caused Society once again to seek privileged sanctuaries even further beyond the tide of urban expansion.[26]

Figure 7–8 reproduces four sheets of the view showing less luxurious housing on the north side of the city. At the center of the illustration lies St. Louis Place, which occupied a tract of land six blocks long with one-third of the site used for a long, narrow park stretching the full length of the development. Strips of equal width on each side contained residential lots. St. Louis Place was part of the Union Addition to the city, subdivided in 1850 by several property owners, including John O'Fallon.[27]

At the time Dry drew St. Louis, most of the building sites in this development still remained vacant, and, although property owners built many large residences here in the 1880s, this grandiose project never attained the success of such neighborhoods as Lucas Place or Vandeventer Place. Neither did a nearby development that had been created much earlier when three persons incorpo-

25. For the development of Vandeventer Place with many photographs of its houses, fountain, and entry gates, see Charles C. Savage, *Architecture of the Private Streets of St. Louis: The Architects and the Houses They Designed*, 22–32. Savage summarizes Pitzman's career and his influence on the private places of St. Louis on pp. 9–10.

26. James Neal Primm, *Lion of the Valley: St. Louis, Missouri*, 363–65.

27. Although St. Louis Place resembled several of the private places in form, neither its streets nor the linear park extending the length of the development remained in private ownership. O'Fallon dedicated both streets and park to the city, and their maintenance was thus a public responsibility.

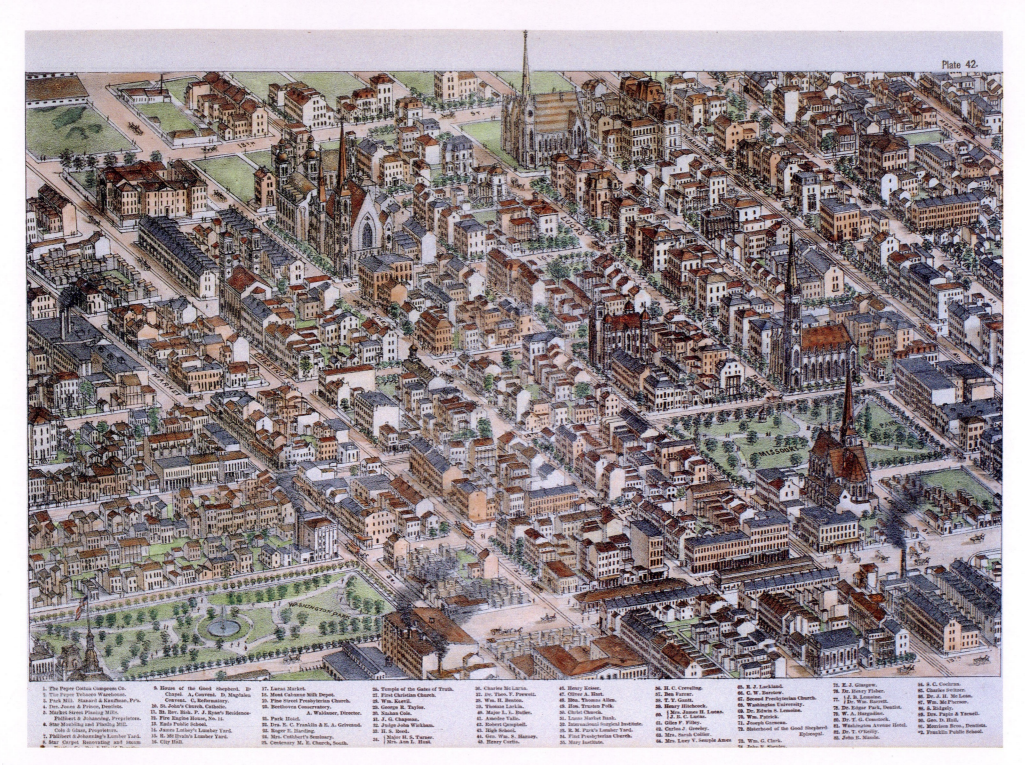

Plate 42.

1. The Peper Cotton Compress Co.
2. The Peper Tobacco Warehouse.
3. Park Mill. Stanard & Kauffman, Pr's.
4. Drs. Jones & Prince, Dentists.
5. Market Street Planing Mills. Philibert & Johanning, Proprietors.
6. Star Moulding and Planing Mill. Cole & Glass, Proprietors.
7. Philibert & Johanning's Lumber Yard.
8. Star Carpet Renovating and Steam
9. House of the Good Shepherd. B Chapel. A. Convent. D. Magdalen Convent. C. Reformatory.
10. St. John's Church Catholic.
11. Rt. Rev. Bish. P. J. Ryan's Residence.
12. Fire Engine House, No. 11.
13. Eads Public School.
14. James Lutley's Lumber Yard.
15. R. McIlvain's Lumber Yard.
16. City Hall.
17. Lucas Market.
18. Mont Cabanne Milk Depot.
19. Pine Street Presbyterian Church.
20. Beethoven Conservatory. A. Waldauer, Director.
21. J. G. Chapman.
22. Drs. E. C. Franklin & E. A. Grivenud.
23. Roger E. Harding.
24. Judge John Wickham.
25. H. S. Reed.
26. Temple of the Gates of Truth.
27. First Christian Church.
28. Wm. Keevil.
29. Thomas Allen.
30. George R. Taylor.
31. Nahan Cole.
34. { Major H. S. Turner. Mrs. Ann L. Hunt.
36. Charles McLaran.
37. Dr. Theo. F. Prewett.
38. Wm. H. Benton.
39. Thomas Allen.
40. Major L. L. Butler.
41. Amedee Valle.
42. Robert Campbell.
43. High School.
44. Gen. Wm. S. Harney.
45. Henry Curtis.
46. Henry Keiser.
47. Oliver A. Hart.
48. T. T. Gantt.
49. Hon. Thomas Allen.
50. Hon. Trusten Polk.
51. Lucas Market Bank.
52. International Surgical Institute.
53. R. M. Funk's Lumber Yard.
54. First Presbyterian Church.
55. Mary Institute.
56. H. C. Creveling.
57. Ben Farrar.
58. T. Y. Gantt.
59. Henry Hitchcock.
60. { Mrs. James H. Lucas. J. B. C. Lucas.
61. Giles F. Filley.
62. Carlos J. Greeley.
63. Mrs. Sarah Collier.
64. Mrs. Lucy V. Semple Ames.
65. R. J. Lackland.
66. C. W. Barstow.
67. Second Presbyterian Church.
68. Washington University.
69. Dr. Edwin S. Lemoine.
70. Wm. Patrick.
71. Joseph Garneau.
72. Sisterhood of the Good Shepherd Episcopal.
73. Wm. G. Clark.
75. E. J. Glasgow.
76. Dr. Henry Fisher.
77. { J. B. Lemoine. Dr. Wm. Barrett.
78. Dr. Edgar Park, Dentist.
79. W. A. Hargadine.
80. Dr. T. G. Comstock.
81. Washington Avenue Hotel.
82. Dr. T. O'Reilly.
83. John R. Maude.
84. S. C. Cochran.
86. Dr. J. H. McLean.
87. Wm. McPherson.
88. S. Ridgely.
89. Drs. Papin & Yarnell.
90. Geo. D. Hall.
91. Morrison Bros., Dentists.
92. Franklin Public School.

Figure 7–6. Plate 42 from Compton and Dry, *Pictorial St. Louis,* showing Lucas Place in 1875. (Collection of A. G. Edwards and Sons, Inc., St. Louis, Missouri.)

Plate 85.

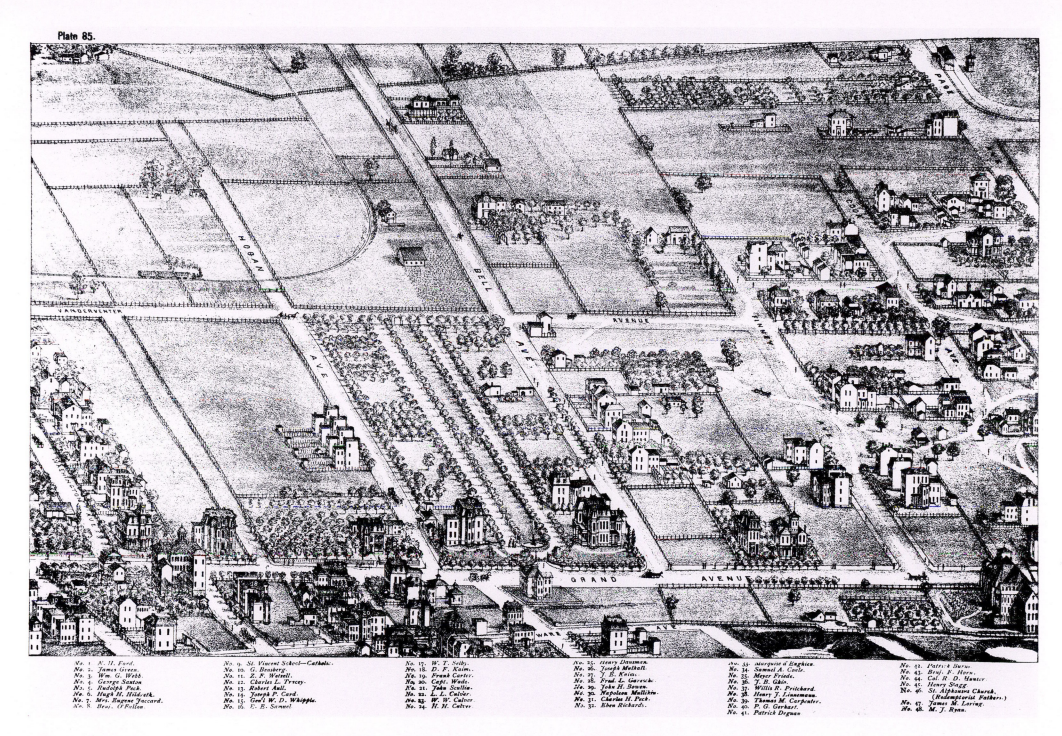

Figure 7–7. Plate 85 from Compton and Dry, *Pictorial St. Louis,* showing Vandeventer Place. (Special Collections, Olin Library, Washington University.)

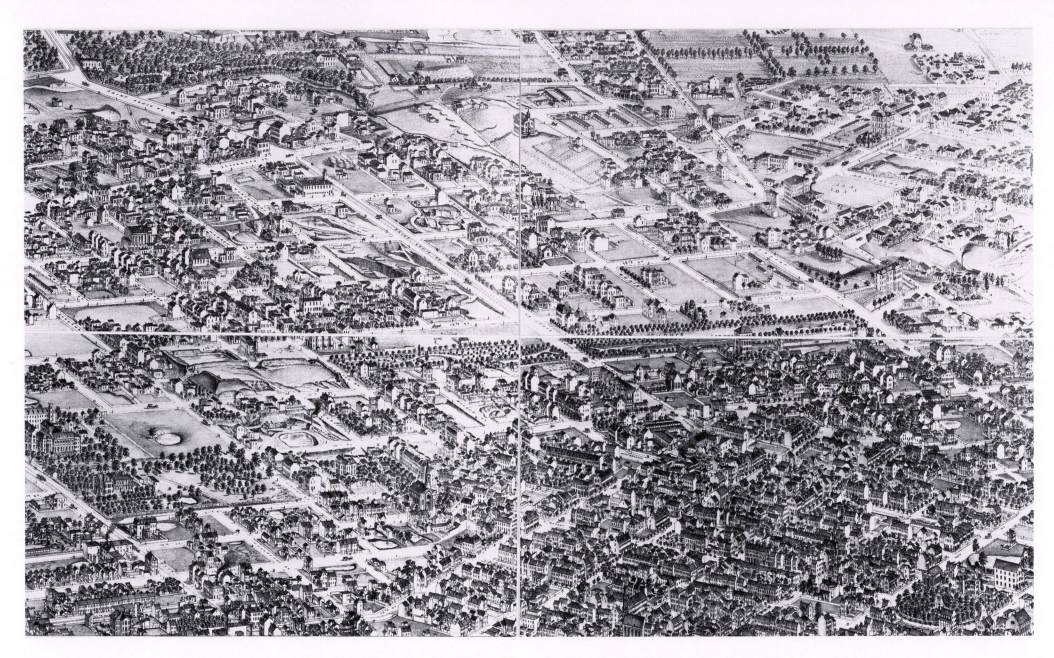

Figure 7-8. Plates 74, 75, 52, and 49 from Compton and Dry, *Pictorial St. Louis,* showing St. Louis Place and vicinity. (Special Collections, Olin Library, Washington University.)

rated the Village of North St. Louis in 1816, a municipality that retained its corporate identity until 1841. Some details of its plan can be seen on the map previously reproduced as Figure 4–2. It featured three circular residential parks, one of which appears in the lower right corner of Figure 7–8. By 1875 only one of the three survived as open space, with the other two being used for schools and churches.[28]

The city extended much farther north and east. Figure 7–9 shows how Dry depicted this portion of the city in the sheets at the extreme right-hand side of the view. Here the municipality had constructed and continued to enlarge its waterworks. To include the waterworks in his view, Dry used an inset at the lower right corner to show the settling tanks where operators of the plant were able to remove at least some of the mud from the waters of the Mississippi. St. Louis regarded its waterworks with pride, an example—along with Eads Bridge—of superior design by local engineers. The editors of at least one national guidebook agreed and recommended that visitors go to see for themselves. They described the buildings as "substantial" and declared, "The two pumping-engines, each with a capacity of 17,000,000 gallons a day, are worth seeing."[29]

This section of the view reminds us how important the lumber industry was to river towns, particularly those that enjoyed such rapid growth as St. Louis. The Mississippi still carried great rafts of logs from forests in the north to supply the saw and planing mills and door and windowsash factories of the city. Two rafts can be seen tied to the bank, and logs and stacked lumber are everywhere. St. Louis had also become an important center for animal slaughtering and meat processing. Just above the inset of the waterworks are the Union Stockyards, an enterprise that would grow substantially from the rather restricted site between two lumberyards that it occupied in 1875.

Figure 7–10 shows another, less well known part of the city, a portion of the Soulard neighborhood south of Mill Creek. This district occupied an area centering on Victor Street, beginning a short distance north of the U.S. Arsenal

and stretching back several blocks from the river. As the view shows, industry had preempted the waterfront. From left to right along the river and across Main Street we find among a few other nonidentified industries a varnish factory, a large plant making wooden ware, a glassworks, a stove factory, a manufacturer of billiard tables, a soap and candle factory, an icehouse, a foundry, a keg plant, and a quarry and granite works.

In the upper half of the view, mixed with modest working-class houses built on the street line, images of many other industries appear. There were five breweries, three stone companies, a flour mill, iron and brass works, a lime kiln, a tannery, a lumberyard, a forge and rolling mill, and a coalyard, among many others. An Episcopal and two Catholic churches, a public school, two parochial schools, and a private school offered religious and educational services to this diverse and eclectic neighborhood.

The business center of St. Louis lay roughly midway between this neighborhood and the waterworks and Union Stockyards. Two combinations of sheets from the Compton-Dry view show this heavily developed portion of the city. Figure 7–11 shows a portion of this area on the right where the large T-shaped Southern Hotel stands surrounded by some of the lesser business and mercantile structures at the southern end of the central business district. Along the river the Iron Mountain Rail Road runs north to its terminal on Main Street between Cedar and Plum.

The far more elaborate complex of freight and passenger depots and associated structures that grew from the original terminal of the Pacific Railroad dominates the center of this illustration. In the vicinity, three-story tenement houses, a grain elevator, a tobacco warehouse, markets, and other mercantile activities mingle with former mansions on Eighth Street and more humble dwellings closer to the river. At the top center, across from the old Union Station, stands the enormous Four Courts building that the city finished in 1870 as the first public structure in the vicinity of what would eventually become the St. Louis Civic Center.

It is Figure 7–12, however, that demonstrates the city's claim to recognition as one of the nation's great urban centers. These four sheets from the view center on the intersection of Washington Avenue and Third Street. At the lower right the great Eads Bridge connects St. Louis with the East, spilling its vehicular traffic into the heart of the business district. Near the left edge of the illustration is the Courthouse dome, no longer so dominant a landmark now that massive office buildings nearby rival it in size and height.

One of these buildings stands immediately across Fourth Street at the

28. Some of the information concerning this portion of St. Louis is from one of the more than twenty neighborhood studies written by Norbury L. Wayman and published in separate booklets by the St. Louis Community Development Agency. They are undated but were distributed about 1978. For St. Louis Place and the Village of North Saint Louis, see Wayman, *Old North St. Louis and Yeatman.* Wayman has studied the physical development of St. Louis during a long lifetime and has compiled and redrawn many maps and views that have been helpful to me in this volume.

29. *Appletons' Illustrated Hand-Book of American Cities; Comprising the Principal Cities in the United States and Canada,* 117.

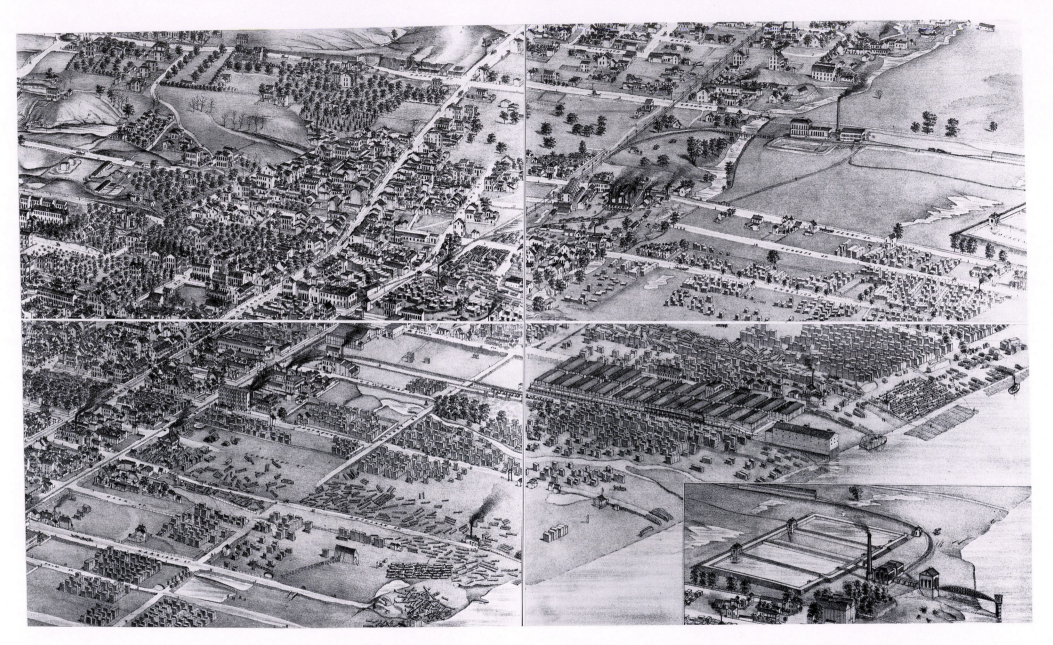

Figure 7-9. Plates 77, 78, 47, and 48 from Compton and Dry, *Pictorial St. Louis,* showing the St. Louis waterworks and vicinity. (Special Collections, Olin Library, Washington University.)

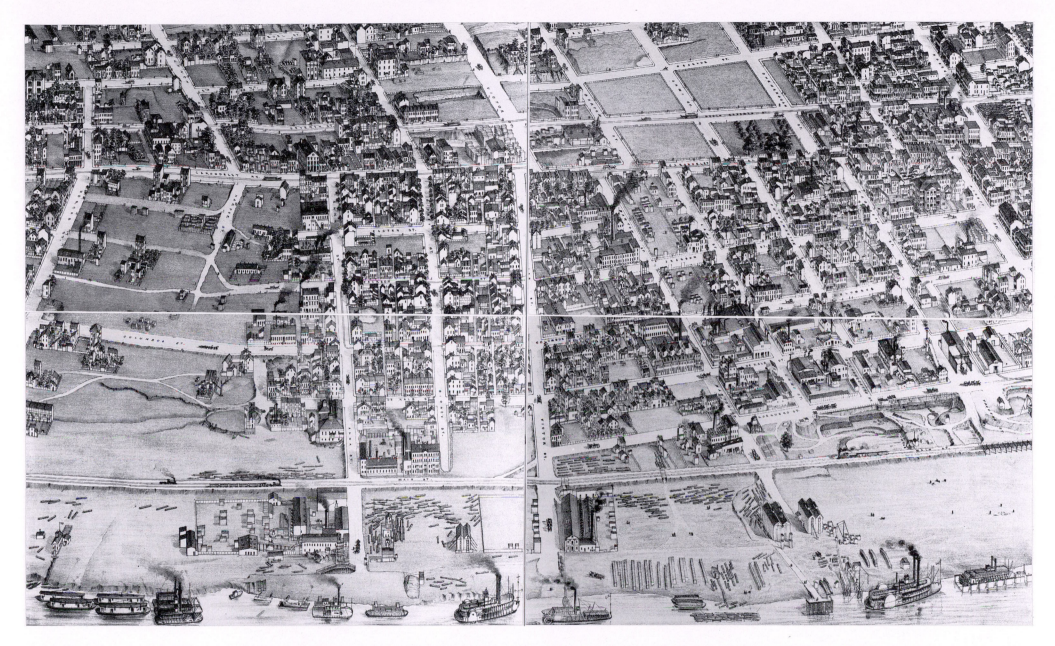

Figure 7–10. Plates 7, 8, 15, and 16 from Compton and Dry, *Pictorial St. Louis,* showing a portion of the South Side in the vicinity of Victor Street. (Special Collections, Olin Library, Washington University.)

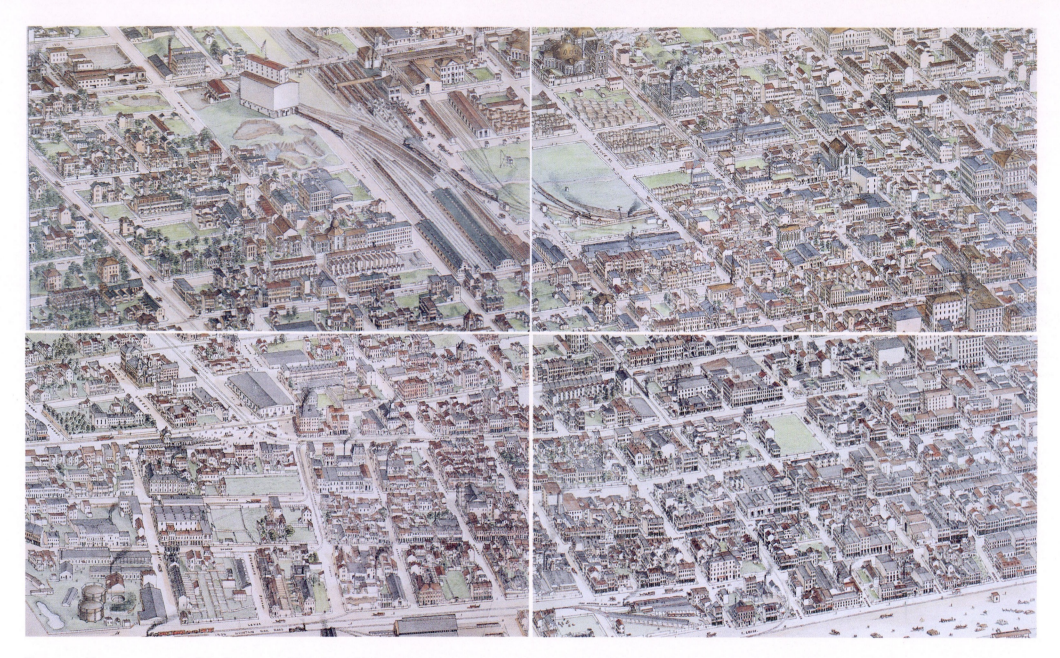

Figure 7–11. Plates 23, 24, 3, and 4 from Compton and Dry, *Pictorial St. Louis,* showing the railroad depots west of Seventh Street. (Collection of A. G. Edwards and Sons, Inc., St. Louis, Missouri.)

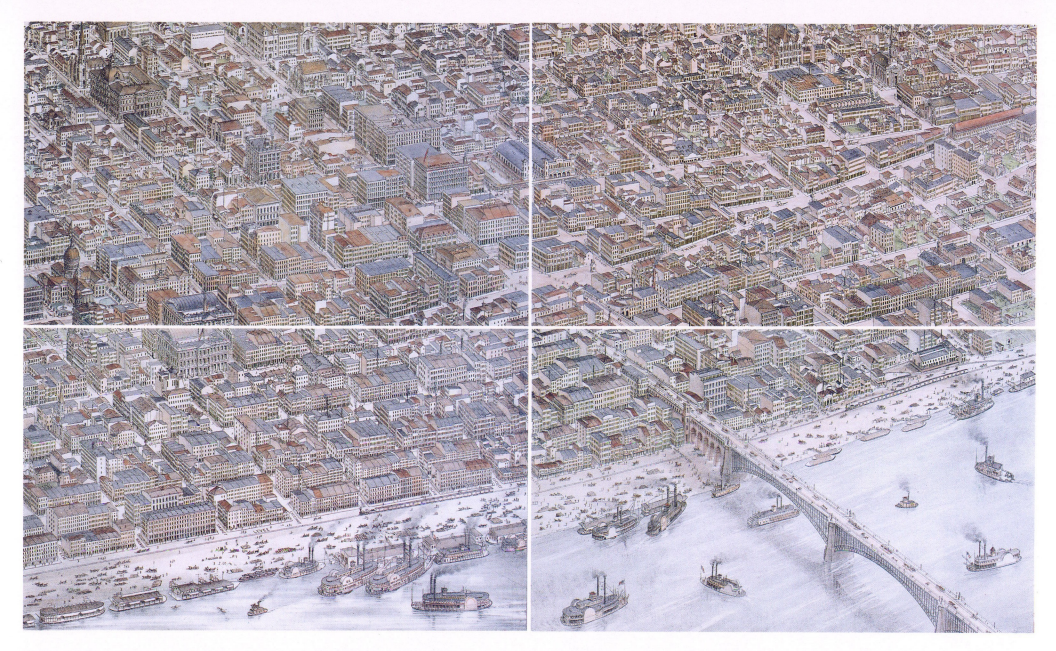

Figure 7–12. Plates 21, 22, 1, and 2 from Compton and Dry, *Pictorial St. Louis,* showing the central business district. (Collection of A. G. Edwards and Sons, Inc., St. Louis, Missouri.)

corner of Market, the bizarre McLean Building with its ungainly tower rising 180 feet into the air and thus competing directly with the Courthouse for attention. Although its owner, James McLean, began his building in 1874, he did not complete it until 1876. This must be one of the buildings that Compton referred to in his preface as having been completed on paper by Dry with guidance from the architect's elevations.

Above the Courthouse and slightly to the right is the image of the new Custom House and Post Office. To its right and at the upper edge of the illustration are the building of St. Louis University at Ninth and Washington and the adjoining St. Xavier's Church. In the corresponding position of the upper right-hand sheet another early Catholic church can be seen. This is St. Patrick's at Sixth and Biddle, opened for worship in 1845 and serving the largest Catholic parish in the city. Its parochial school, begun in 1871, stood a block away on Seventh between Biddle and Carr.

Several other old churches remained in this portion of the city, but the pressures of high commercial land values and the movement of so many persons to new neighborhoods in western additions continued to reduce their numbers. Commercial, not religious, structures would henceforth dominate the skyline of the city. Large new mercantile structures, or even older ones that were being remodeled, were regarded as being of as much architectural consequence as the new large public buildings. A St. Louis newspaper comment in 1876 under the heading "Architectural Progress" symbolizes this changed attitude:

> The year 1875 has been a fruitful one for St. Louis, in building improvements, which are . . . giving to the architectural appearance of the city decided improvement. . . . Standing prominently in the list of new buildings are the Merchants' Exchange and the Post-office and Custom-house, while first and foremost among those older . . . is the well-known carpet warehouse of A. McDowell & Co., No. 506 North Fourth street, in the Collier Building, which is being most beautifully remodeled. . . . Improvements of this character can but gain for themselves the appreciation they merit.[30]

30. *St. Louis Weekly Globe-Democrat*, 2 October 1876. On 3 May 1874, the daily edition of this paper (p. 6, col. 1.) commented on what it called in one of its headings the "Unparalleled Growth of the City Since the 1st of January": "The amount of building that has been going on in St. Louis . . . is unparalleled in the history of this or any other Western city, inclusive of Chicago and Cincinnati." The paper reported that in the first four months of the year eight hundred new buildings had been started, mainly two-story residences of brick. The story explained that "the panic [of 1873] having diverted the heretofore bank deposits and loans to real estate investment caused this unprecedented demand on the part of owners for small buildings." In its issue for 1 July 1874 the paper reported that in the first six months of the year the city had issued 1,100 building permits. These included permits for six five-story and eleven four-story buildings.

The profile of St. Louis as seen from the river revealed far fewer relatively isolated and unmistakable landmarks, instead showing a solid mass of large buildings clustered together and sometimes difficult to tell apart. The whole scale of St. Louis had changed, and Dry's view provides convincing evidence of this. For example, find the Planters Hotel immediately north of the Courthouse on Fourth Street. Once the largest building in the city and considered by visitors enormous even by eastern standards, in 1875 it seems almost shrunken with age.

John Caspar Wild in 1842 used the cupola of the hotel for a superb vantage point from which to draw his four-sheet panorama. Now, three decades later, an artist would find the view to the Mississippi almost totally obscured by the massive building housing the Merchants Exchange and the Chamber of Commerce. To the north where Wild looked down on a street composed almost entirely of two- and three-story domestic-style buildings, Dry depicts solid ranks of business and office blocks that defined Fourth Street as a major commercial corridor.[31]

St. Louis did not consist only of paved streets, brick and stone commercial buildings, and dense urban housing. Even in the northern and southern neighborhoods that we previously visited through Dry's view, vacant lots and other open spaces existed, including a few small parks and squares. In addition, the city offered its residents and visitors larger and more impressive facilities for recreation. The earliest was Lafayette Park, whose extent and surroundings Dry depicted on the four sheets of his view reproduced in Figure 7–13. By 1875 the park had become a popular spot for band concerts, walks, and relaxation. The author of an American guidebook published in 1877 called its thirty acres "the most beautiful" park in the city. He described it as "for pedestrians only, . . . admirably laid out and adorned, and . . . surrounded by elegant residences."[32]

Several of those "elegant residences" faced Benton Place, an elliptical landscaped private street formed by curving carriage drives leading north of the

31. For a detailed identification of buildings in this part of St. Louis associated with the life and work of James Eads, see John A. Kouwenhoven, "Downtown St. Louis as James B. Eads Knew It When the Bridge Was Opened a Century Ago," which uses the same four sheets of Dry's view to locate fifty-two places.

32. *Appletons' Illustrated Hand-Book of American Cities*, 116. An Australian visitor, Alfred Falk, in *Trans-Pacific Sketches: A Tour Through the United States and Canada*, referred to Lafayette Park as "being so well laid out" that its "thirty acres" seemed "of much greater extent that it really is" (p. 247). For a history of the square and recent improvements in the neighborhood, see Timothy G. Conley, *Lafayette Square: An Urban Renaissance*; and John Albury Bryan, *Lafayette Square: The Most Significant Old Neighborhood in Saint Louis*.

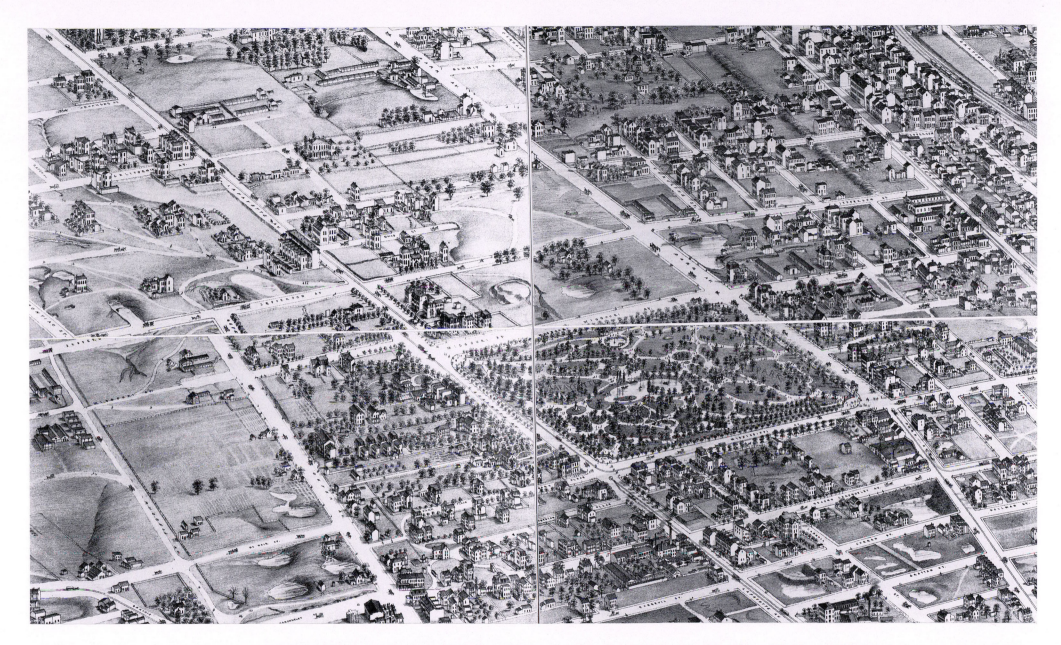

Figure 7–13. Plates 58, 55, 38, and 39 from Compton and Dry, *Pictorial St. Louis,* showing Lafayette Park and vicinity. (Special Collections, Olin Library, Washington University.)

park between Park Avenue and Hickory Street. This was the first of the St. Louis private streets to have its own linear park. Lots became available in 1868 when the owner of the land, Montgomery Blair, commissioned Julius Pitzman to lay out a street and building sites.[33] Other mansions occupied sites on two other exclusive private enclaves, Preston Place and Park Place, located southeast of Lafayette Park.

However, a nearby brickworks and the Phoenix Brewery of the St. Louis Brewery Company immediately to the east may have suggested to older residents that the time had come to move further west to escape being swallowed up by industry, stores, and tenement houses. It was a process of displacement that was to continue throughout much of the nineteenth century as St. Louis expanded and changed.

By 1875 many possibilities existed for those who were rich enough to maintain themselves in quieter surroundings. One was to buy land and locate somewhere in the vicinity of Tower Grove Park and Shaw's Garden. The four sheets of Dry's view reproduced in Figure 7–14 show this portion of the city, then almost totally unoccupied. The entire garden can be seen in the background, but this portion of the view omits the western end of Tower Grove Park, which extended as far as Kingshighway, a second circumferential thoroughfare roughly parallel to Grand Avenue.[34]

Henry Shaw understood the importance of money and that it could be made through real estate. When he donated the land for Tower Grove Park he stipulated that a strip of land two hundred feet deep around its perimeter be divided into lots for villas that would be available for rent on long-term, thirty-year leases. The income was to go to him, although he, in turn, intended to use it for the support of Shaw's Garden. The view clearly shows this reserved belt of land that Shaw hoped persons seeking quiet residential locations would find attractive. While legal difficulties hindered residential development on this land bordering the park, houses by the scores sprang up during the next two decades as other landowners subdivided much of the surrounding farmland to accommodate the steady demand for house lots.[35]

Dry's view of 1875 also shows the largest park in St. Louis, one that achieved official status only in the year that he produced his view. It was then that the wooded, rolling 1,375-acre Forest Park tract passed into public ownership, along with the smaller sites that became O'Fallon Park in the north and Carondelet Park in the south. Figure 7–15 looks down on the eastern end of Forest Park, located beyond Kingshighway and far to the west of the then built-up portion of the city. When Dry sketched this area for his view the official opening of Forest Park still lay one year in the future.[36]

That event coincided with a change in the city's boundaries that vastly enlarged its total area from just under eighteen square miles to over sixty-one square miles. On the west the border ran along a line six hundred feet west of what is now Skinker Boulevard. At the same time the state legislature authorized the election of a charter commission that would separate the city and country governments. No doubt everyone believed that these very generous new city boundaries would easily provide for any subsequent increase in population and eliminate the need for future boundary adjustments.

33. For a copy of the original plat, see Savage, *Architecture of the Private Streets of St. Louis,* fig. 7, p. 19. Blair, postmaster-general in Lincoln's administration, bought the land two years earlier.

34. Ralph Keeler, the *Every Saturday* reporter, visited Tower Grove Park in 1871 and recorded these findings and impressions: "The park has six entrances, three of them for carriages. The principal gateway is adorned with bronze lions, griffins and stags, from the founderies of Berlin, facing the city and the east. At the north carriage entrance are a pretty gate-house and a fine building for offices, &c. A casino for refreshments will be erected opposite this entrance, outside the park. A building in the flemish style, quaint and picturesque, stands at the western gate. Most of the trees are necessarily young yet, and the rolling prairie of much of the original ground gives little chance for great variety of scenery, or for those expensive gentlemen, the 'landscape architects.' Still, the park is a beautiful place, with a carriage drive of two and a half miles, and innumerable winding foot-paths, and with the usual attractions of ponds and fountains, music-stand and children's play-ground,—which latter is pleasantly shaded with vine-covered trellises. Then there is a maze on the plan of that at Hampton court." *Every Saturday,* 28 October 1871, 414. For a study of how this part of the city developed, see Norbury L. Wayman, *Shaw.* See also William Barnaby Faherty, S.J., *Henry Shaw: His Life and Legacies.*

35. Keeler concluded his description of the park with these words: "Around the park a belt of ground two hundred feet in depth will be cut up in plots of a hundred feet front for villas. Thus, thousands of children yet unborn will live to bless the name of the generous old bachelor who has provided them with this charming play-ground. No more magnificent gift has been given to any city by a private individual, and no city has a more simple-mannered, kindly old man that the giver." For a brief history of the park and the unusual conditions attached to the bordering land, see Theo. V. Brumfield, "A Study in Philanthropy: Tower Grove Park." Also helpful is James Neal Primm, "Henry Shaw, Merchant-Capitalist."

36. The acquisition, planning, and early years of Forest Park are covered in Caroline Loughlin and Catherine Anderson, *Forest Park,* chap. 1, pp. 3–21. A long and interesting news account of the inaugural ceremony can be found in the *St. Louis Weekly Globe* for 25 June 1876. Among the many persons recognized at this event was the designer, Maximillian G. Kern, "a landscape gardener and park architect—an artist of exquisite taste, liberal experience and such natural gifts as eminently qualified him for his great work." For additional information about early development in this part of St. Louis see Norbury L. Wayman, *Central West End.*

Figure 7–14. Plates 91, 92, 65, and 66 from Compton and Dry, *Pictorial St. Louis,* showing Tower Grove Park and vicinity. (Special Collections, Olin Library, Washington University.)

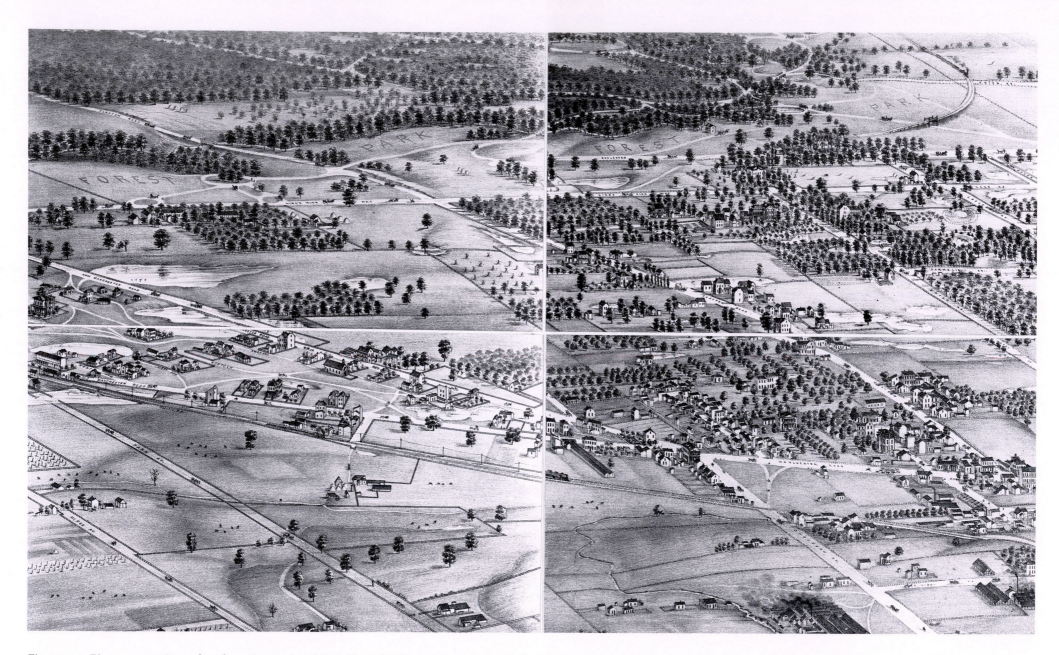

Figure 7–15. Plates 99, 100, 89, and 90 from Compton and Dry, *Pictorial St. Louis,* showing Forest Park and vicinity. (Special Collections, Olin Library, Washington University.)

In describing the major outlying parks of St. Louis, Compton articulated what others had apparently advocated as well:

> Together, they form a grand comprehensive plan, and when connected with each other by suitable boulevards and drives, will contribute to the health and recreation of our people more perfectly than any other system of parks on the continent. . . . A grand continuous boulevard connecting these larger parks . . . would not exceed seven miles in length. When that improvement is completed . . . they may all be visited in an afternoon's drive.

All other parts of the St. Louis of 1875 can be explored by the use of Dry's view supplemented by Compton's explanatory text.[37] The preparation and publication of such a view would be a remarkable achievement even today with modern surveying equipment and instruments and the availability of aerial photographs for reference purposes. More than a century ago it represented a near-impossible accomplishment that remains a monument to the artists, printers, and publisher who conceived and carried out the enormous task of picturing a metropolis in such all-encompassing detail.

Although St. Louis would not see any later views to rival this in either size or detail, viewmakers continued to record the appearance of the city in the last two decades of the nineteenth century and into the early years of the twentieth. It is to an examination of their work that we shall turn in the concluding chapter.

37. A recent book on St. Louis will be helpful in doing this kind of study, for, like Norbury Wayman, the author in part 1 of his work uses sheets from the Compton-Dry view in discussing how different parts of St. Louis developed. See Robert E. Hannon, comp. and ed., *St. Louis: Its Neighborhoods and Neighbors, Landmarks and Milestones.*

VIEWMAKING IN ST. LOUIS: THE END OF AN ERA

No city view that came after Dry's outstanding accomplishment could be other than an anticlimax. Perhaps for that reason viewmakers who specialized in separately issued prints avoided St. Louis as a subject for many years. The itinerant artists who visited and drew so many other towns along the Mississippi in the late 1870s and the 1880s failed to record on paper and stone their impressions of St. Louis.[1]

By contrast, journalists continued to pay visits to the city and to describe its features for their readers, occasionally including views of the city to illustrate their accounts. One of the more entertaining of these traveling writers was Capt. Willard Glazier, who led an expedition that he claimed discovered the true source of the Mississippi River. In two of his books, *Peculiarities of American Cities* and *Down the Great River,* Glazier used small views of St. Louis to enliven his descriptions of the place.

Figure 8–1 reproduces the earlier of these two views from the book published in 1883 recording Glazier's impressions of cities throughout the United States. Although it shows only a portion of the city, it is unusual in depicting the

levee from a point so far north of Eads Bridge. Perhaps he selected this illustration because the industries of St. Louis impressed him so deeply. About them he had this to say:

> St. Louis is among the first of our cities in the manufacture of flour, and is a rival of Cincinnati in the pork-packing business. It has extensive lumber mills, linseed-oil factories, provision-packing houses, manufactures large quantities of hemp, whisky and tobacco, has vast iron factories and machine shops, breweries, lead and paint works. In brief, it takes a rank second only to New York and Philadelphia in its manufactures, to which its prosperity is largely due.[2]

Glazier thought that while "Chicago is a western reproduction of New York," St. Louis resembled Philadelphia in its grid streets oriented to the river and its streets leading inland from the river named for trees. Moreover, he noted,

> The resemblance is preserved in more substantial particulars. Many of the buildings are large, old-fashioned, square mansions, built of brick with white marble trimmings. There is less attempt at architectural display than in Chicago, apparently the main thought of the builders being to obtain substantiality. Yet there are many handsome buildings, both public and private.[3]

Like several other visitors, Glazier recorded the general character of some of the main streets and districts in St. Louis. He noted that "wholesale business . . . is confined to Front, Second, Third and Main streets," the former being "one hundred feet wide" and "lined with massive stores and warehouses." Fourth Street remained the principal location for retail shopping. He described

1. Henry Wellge was the most active of these artists in the 1880s. For a summary of his career, see my *Views and Viewmakers of Urban America . . . ,* 213–15. To that I can now add a statement about his activities in Europe before coming at an undetermined date to the United States. The *Rock Island, Illinois, Daily Union,* 15 January 1889, described Wellge's view of that city and added: "Capt. Wellge was a staff artist of the Prussian army with the rank of Captain, during the Franco-German war, and was intrusted with the work of drawing some of the most important plans of that wonderful campaign" (p. 3, col. 3). This statement has yet to be verified and may be based on nothing more than Wellge's efforts to promote sales of his view. Only a few months after this news item appeared, three Nebraska newspapers, doubtless quoting from statements by Wellge or his sales agent, Charles J. Smith, identified Wellge as formerly a captain in the engineer corps of the *Russian* Army (italics mine). See *Views and Viewmakers,* pp. 214–15, n. 2.

2. Willard Glazier, *Peculiarities of American Cities,* 496–97.
3. Ibid., 498–99.

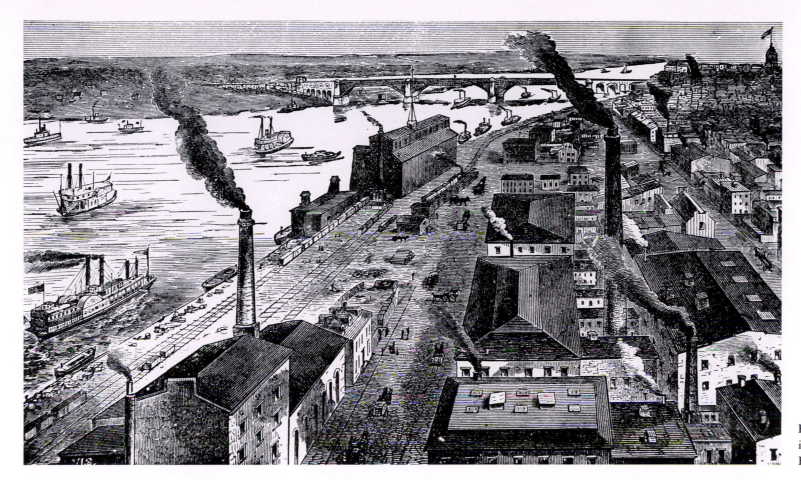

Figure 8–1. View of St. Louis in 1883, published in Philadelphia by Hubbard Brothers. (John W. Reps.)

Washington Avenue as "one of the widest and most elegant" streets in the city and noted that west of Twenty-seventh Street "many beautiful residences" could be seen along it. Fine houses also lined portions of "Pine, Olive, and Locust streets, Chouteau avenue and Lucas Place." The city's parks helped provide a suitable setting for some of these neighborhoods. Indeed, Glazier declared of St. Louis that the "public parks are one of its striking features."

In his book on the Mississippi published in 1888, Glazier used another illustration of St. Louis, a composite plate with a view of the city from the northeast in the center surrounded by vignettes of the Courthouse, the new Four Courts building, a church steeple on Olive Street, and glimpses of Shaw's Garden and Lafayette Park. This is reproduced in Figure 8–2.

Although Glazier repeated or summarized in this work many of the com-ments he used in his earlier volume, one passage is significant in emphasizing how important river traffic still remained long after the railroad provided direct connections across the Mississippi. Of the St. Louis waterfront, Glazier observed:

> The levee is one of the most interesting features of the city. It is a hundred feet wide, facing the river with a solid wall of masonry; and here we find continual bustle and the busy activity of an immense commerce. In front of this levee, from early spring until early winter, while navigation is open upon the Mississippi, immense numbers of boats are daily seen, loading and unloading, discharging and taking on board their many passengers, coming and going.[4]

4. Glazier, *Down the Great River; Embracing an Account of the Discovery of the True source of the Mississippi . . . ,* 328. However, when Mark Twain returned to St. Louis in 1882 he came away

Figure 8–2. Views of St. Louis in 1888, drawn by Thompson and published in Philadelphia by Hubbard Brothers. (Olin Library, Cornell University.)

The only separately issued view of St. Louis to become available between 1876 and 1893 appeared between the dates of publication of Glazier's two books. Its artist, Henry M. Vogel, gave the city quite a different appearance than it had had in any previous depiction, as can be seen from the reproduction in Figure 8–3. Vogel published his fascinating but excessively busy print containing images of more than thirty buildings in 1884.

Several of the buildings Vogel selected to include were mentioned in a review of urban improvements written at the beginning of the decade. This review listed important projects recently finished or nearly completed, beginning with industrial and mercantile activities:

> Among the larger erections . . . are the Union Depot and the new Pacific railroad depot on Seventh street, at least three grain elevators, two large tobacco manufactories, two cotton compress warehouses and a stately Cotton Exchange, a Real Estate Exchange, a Bessemer steel works, and the south St. Louis iron furnaces set in blast again.

This source then mentioned a variety of other developments, including

> the Southern hotel rebuilt (fireproof), and the Planters House remodelled and raised two stories, one large theatre built, another building, and a third in progress to be hatched and born, several new churches . . . , the new United States custom house and post office nearing completion and a United States assay office and mint provided for; and the Jefferson avenue bridge built.[5]

Vogel's lithograph celebrated the development of the city from its primitive French origins to the modern and prosperous metropolis it had become. The images on the left-hand side of the print purport to show buildings and street scenes from the distant past, including a bird's-eye view of the original settlement enclosed within an oval frame on which Vogel lettered the phrases "Westward the Course of Empire Takes Its Way" and "Wealth for Millions."

with a quite different impression of steamboat traffic. When he visited the levee he saw "half a dozen sound-asleep steamboats where I used to see a solid mile of wide-awake ones. . . . Half a dozen lifeless steamboats, a mile of empty wharves, a negro fatigued with whiskey stretched asleep, in a wide and soundless vacancy, where the serried hosts of commerce used to contend! Here was desolation, indeed." *Life on the Mississippi*, 159.

5. *The Review of Improvements in 1881*, as quoted in Walter B. Stevens, *The Building of St. Louis*, 67–68. This interesting summary of urban growth concludes: "Looking at the changes on Washington avenue, in the last five years, one who remembers back to the time when Main street was the ladies' promenade, and 'Quality Row' extended on Chestnut street from Main to Second, or when Market street became the fashionable walk, until after the great fire of 1849 it was transferred to Fourth street, may venture to predict that the Broadway of St. Louis will soon stretch westward from Fourth to the University on the hill, if indeed it should ever stop or shift again short of Grand avenue or the King's Highway."

Figure 8–3. Views of St. Louis in 1884, drawn and published in St. Louis by Henry M. Vogel and printed in St. Louis by J. E. Lawton Printing Co. (Division of Geography and Maps, Library of Congress.)

The corresponding oval enclosure around the depiction of the St. Louis of 1884 bears the mottoes "The Future Great Metropolis of the New World" and "Upward and Onward." At first glance this seems to be an image of a city suffering from a terrible fire, but closer inspection reveals that Vogel intended the clouds of smoke towering to the sky to symbolize the industrial prowess of the city whose commercial and professional accomplishments are represented by the tiny vignettes of modern mercantile and office buildings filling the balance of the right half of the lithograph.

Two national periodicals published views of St. Louis in June 1888 as the city received delegates to the Democratic National Convention. One of these illustrations, drawn by Charles Graham for *Harper's Weekly,* is reproduced in Figure 8-4. Like Alfred Waud, Graham traveled the country sketching places or events assigned by his editor. From 1877 to 1892 he served *Harper's* in this capacity while at the same time doing watercolors on his own. In 1893 the board of the World's Columbian Exposition in Chicago appointed him official artist of the World's Fair. Later he became a freelance artist, submitting work to several magazines, and worked as an illustrator in San Francisco for the Midwinter Fair in 1894. After 1900 he turned to oils, but city views were his favorite subject as an illustrator in the West.[6]

For *Harper's* in 1888 he produced a striking pair of views of St. Louis. The illustration at the top of the page looked north from the bridge toward the industrial district at the bend in the river. A more lively scene occupies the bottom two-thirds of the sheet. Here Graham looked down on the levee to capture the appearance of what was still the busiest part of the city and one of the most fascinating places along the Mississippi.

Whoever the writer assigned to accompany Graham was, he, too, had mastered the ability to convey some of the energy and spirit that permeated St. Louis a century ago. He observed, "St. Louis is fast losing its identity as a semi-Southern city." Instead, he found that "it is taking on manners and customs and vigor and breeziness that characterize the wide-awake Western towns." This observer noted many signs of change:

> In the business part of the city the two and three story buildings that so long lined its thoroughfares are passing away, and in their places are springing up magnificent structures of stone and iron, towering skyward, with all the advantages of the modern metropolitan style of architecture. Solid blocks of granite ring beneath the iron-shod hoof of the commercial steed, and no more do clouds of limestone dust arise to blind the pedestrian.

West of Grand Avenue the reporter saw "as many elegant and luxurious homes as can be found in any city in the country." He then commented on a matter that eventually would become a sore point to a city whose boundaries would be forever fixed at the limits established in 1875:

> As the city covers such a vast area of ground within its corporate limits, suburban towns are not numerous round about it, although Ferguson, Kirkwood, and Florrissant [*sic*] are sought to some extent for summer homes by residents of the city, and efforts are being made in the direction of establishing other towns by owners of property within or just beyond the city limits.[7]

Graham's two views, like a few others before them, suggest the murky atmosphere of St. Louis produced by the use of soft coal by railway locomotives, in scores of factories, and for tens of thousands of domestic heating systems. One visitor in 1883 admired the great public buildings of the city but remarked, "The smoke, ashes and dust, that have settled upon them give to the whole a dingy appearance."[8] This echoed Mark Twain's observation after he revisited St. Louis in 1882 that here, "as in London and Pittsburgh, you can't persuade a new thing to look new; the coal smoke turns it into an antiquity the moment you take your hand off it." Yet Twain professed to see some improvement over previous years:

> The place has just about doubled its size, since I was a resident of it, . . . yet I am sure there is not as much smoke in St. Louis now as there used to be. The smoke used to bank itself in a dense billowy black canopy over the town, and hide the sky from view. This shelter is very much thinner now; still, there is a sufficiency of smoke there, I think. I heard no complaint.[9]

6. Robert Taft, *Artists and Illustrators of the Old West, 1850–1900,* 177–83; Peggy Samuels and Harold Samuels, *The Illustrated Biographical Encyclopedia of Artists of the American West,* 192–93; Estill Curtis Pennington and James C. Kelly, *The South on Paper: Line, Color and Light,* 41. According to Taft, Graham began his career "as a topographer with a surveying party for the Northern Pacific railroad in the early 1870s." Taft also quotes a description of him from an account in the *Minneapolis Journal,* 11 January 1906, of a reunion of early workers on the Northern Pacific line: "A young man, very short of stature and inclined to corpulency, who waddled along with a surveying party in Montana and Idaho, making their topographical maps" (p. 348, n. 4).

7. *Harper's Weekly,* 4 June 1888, supp., 421.
8. L. D. Luke, *A Journey from the Atlantic to the Pacific Coast by way of Salt Lake City Returning by Way of the Southern Route . . . ,* 71.
9. Twain, *Life on the Mississippi,* 157. Twain admired the "fine new homes" on the outskirts of town, calling them "noble and beautiful and modern." He also liked Forest Park, found the public buildings "stately and noble," and declared that changes in the city provided evidence of "progress, energy, [and] prosperity" (158–59).

Looking North

ST. LOUIS, FROM THE MISSISSIPPI RIVER.—Drawn by Charles Graham.

View of the levee, from the bridge

Figure 8–4. Views of St. Louis in 1888, drawn by Charles Graham and published in New York by *Harper's Weekly*. (Collection of A. G. Edwards and Sons, Inc., St. Louis, Missouri.)

A writer in *Harper's New Monthly Magazine,* the sister publication of that for which Graham produced his sketches, provided more detail and engaged in harsher criticism. Looking at St. Louis from Eads Bridge, he claimed, "The city itself is barely visible." He caught a glimpse of "a dome or two, or the outlines of a shot-tower or an elevator" looming vaguely out of the clouds of smoke. He felt that climbing to the dome of the Courthouse for a panoramic view of the city would be useless:

> The photographers take their pictures on Sundays when the chimneys have stopped streaming for the time being, and then some partial prospects are to be had; but, as a rule, St. Louis is as invisible as London. When it is old and as large it is likely to be at least as sooty. These Western cities exhale a tainted breath, stifle themselves in the fumes of their own prosperity.[10]

This writer noted the movement of business beyond Fourth Street, the principal shopping thoroughfare of St. Louis since the fire in 1849. At the corner of Olive and Sixth he "found close together Barr's, one of those mammoth emporiums of general merchandise," now relocated from its former site between Third and Fourth streets, and "a great handsome building, like a Renaissance palace," occupied by the St. Louis Life Insurance Company and located immediately north of the Barr department store. He saw this shift in the center of the business district as part of a much larger movement away from the river and toward higher land beyond:

> Westward, in this metropolis . . . the course of empire takes its way. The tendency of residences . . . of the fashionable sort, is to the west, and business follows them up. The rise of all the west-bound streets between Washington Avenue on the north and Pine Street on the south is lined with comfortable dwellings, improving in display toward the crest. Certain transverse avenues, as Garrison Avenue and Grand Avenue, assemble choice collections of these.[11]

Charles Dudley Warner, who visited the city at this time and wrote about

it at length, looked at westward expansion with different eyes. He saw the vast extension of the city limits in 1875 as a mistake, "for it threw upon the city the care of enormous street extensions" and caused "a sporadic movement" to new developments west of Grand Avenue. This, he believed, "created a sort of furor of fashion," causing people to move from residences in what he found to be the most attractive parts of the city, west of Fourteenth Street where it was crossed by Lucas Place and other east-west streets. Warner concluded his discussion on this point with these words:

> In this quarter, and east of Grand Avenue, are fine high streets, with detached houses and grounds, many of them both elegant and comfortable, and this is the region of the Washington University, some of the finest club-houses, and handsomest churches. The movements of city populations, however, are not to be accounted for. One of the finest parts of the town, and one of the oldest of the better residence parts, that south of the railways, containing broad, well-planted avenues and very stately old homes, and the exquisite Lafayette Park, is almost wholly occupied now by Germans, who make up so large a proportion of the population.[12]

Frank Leslie's Illustrated Newspaper published the other view of St. Louis in 1888 featured in a national periodical, an illustration reproduced in Figure 8-5. Frank Adams, an artist employed by *Leslie's,* a great rival of *Harper's* in pictorial journalism, drew the city as it would have appeared if viewed from the northeast above the waterfront of East St. Louis. Adams must have sketched the city on a clear day, for his city seems not to be troubled by smoke. Elsewhere on the double-page print Adams showed the interior of the convention building, delegates arriving by boat and seeking lodging, and illuminated arches on Olive Street.

Of course, neither this view nor that drawn by Graham shows any aspects of the growth of the city to the west that visitors regarded with amazement and residents looked on with pride. In the absence of bird's-eye views from the 1880s we must use an image of St. Louis that appeared in another type of publication that proved extremely popular in America during the last two or three decades of the nineteenth century. These were souvenir view booklets, consisting typically of one or two dozen views of important public buildings, churches, major private structures, and often including one or more general city views.[13]

10. *Harper's New Monthly Magazine* 68 (March 1884): 497–98. The author apparently visited several other cities along the Mississippi River and found similar conditions. The article included this statement about smoke in these places: "They burn a soft and inferior coal, yielded them by the region round about, and all are more or less enveloped in smoke. While the sun is shining on the Eastern sea-board . . . these cities of the plain, artificers in iron and brass and every useful work, are pouring forth vapors as if they were but the mouthpieces of some fiery subterranean activity."

11. This passage continues: "A drive should be taken along Grand Avenue, which is to sweep around a considerable portion of the city, somewhat after the manner of the exterior boulevards at Paris. It is still in a transition state. Handsome churches of the charming gray limestone are going up along it. At one point Vandeventer Place, an inclosure with a grass-plot in the centre . . . opens from it, and gives a view of the pleasant country beyond" (ibid., 509–10).

12. Warner's perceptive observations on the city can be found in a chapter dealing with St. Louis and Kansas City in Charles Dudley Warner, *Studies in the South and West with Comments on Canada,* 319–47.

13. David Brodherson, "Souvenir Books in Stone: Lithographic Miniatures for the Masses," is the first scholarly examination of this source for pictorial records of the American scene.

1. VIEW OF THE CITY OF ST. LOUIS. 2. DELEGATES ARRIVING BY BOAT. 3. SEEKING LODGINGS. 4. INTERIOR OF CONVENTION HALL. 5. ILLUMINATION OF ARCHES ON OLIVE STREET.

MISSOURI.—THE DEMOCRATIC NATIONAL CONVENTION AT ST. LOUIS—VIEWS OF THE CITY AND OF THE INTERIOR OF THE CONVENTION HALL, WITH SCENES AND INCIDENTS.

FROM SKETCHES BY FRANK ADAMS—SEE PAGE 263.

Figure 8–5. View of St. Louis in 1888, drawn by Frank Adams and published in New York by *Frank Leslie's Illustrated Newspaper.* (John W. Reps.)

Several publishing houses specialized in issuing these souvenirs, one of the most important being Adolph Wittemann of New York. In 1886 Wittemann issued his *St. Louis Album*, which included the double panel reproduced in Figure 8–6. Four major buildings occupy segments along the upper part of the illustration, while the lower portion shows a "View West from Court House." Although Wittemann's original is much smaller than the J. C. Wild view reproduced on the left half of the left-hand portion of Figure 3–7, both look in the same direction: Wittemann's from the Courthouse and Wild's from the Planters Hotel in the next block to the north. Together, the two images provide a useful and instructive record of how this part of the city changed in the period from 1842 to 1886.

The almost photographic quality of the Wittemann view is no accident, for the artist drew in India ink over an image taken by a camera, after which he bleached away all traces of the underlying photograph. Wittemann printed this view using the collotype process in which photographic negatives were used to transfer the image to a glass plate coated with photosensitive gelatin. The resulting image could then be inked and printed in a lithographic press.[14]

Elsewhere in Wittemann's album many other illustrations of imposing buildings, gardens, and parks provided ample visual evidence of substantial growth and change in St. Louis. About that same time an annual publication recording, among other topics, urban development in the nation summarized some of the accomplishments that had been realized in the city during the decade and a half prior to 1886:

> Since 1870 the business portion has spread over many blocks to the west, crowding out the dwellings; and all the churches there, except the cathedral, have followed the movement and built new edifices. In 1885, 1,991 new brick and 504 frame buildings were erected. . . . Important buildings recently erected are a custom-house and post-office . . . , the Exposition and Music Hall Building . . . , the Art Museum . . . , the Chamber of Commerce . . . , and Armory Hall. . . . The number of steam railroads entering the city is 34, and of street-railways 14. . . . The number of churches has increased from 150 to 216.[15]

All the public buildings this source mentions and many more appear on the view of St. Louis in 1893 drawn by Frederick Graf that is reproduced in Figure 8–7. Although no work of art and in places no more than diagrammatic in its imagery, Graf's lithograph provides a splendid guide to the principal public and office buildings of St. Louis and to many industries, churches, and railroad facilities as well. Before examining some of the new features of the city shown on this very large print, we need to consider the artist who drew both this and two other later views of St. Louis.

Born in Paris in 1861, Graf was in St. Louis by 1879, when the city directory listed his occupation as "tinner." Subsequent city directories identify him in 1884 as an engraver, in 1885 as a designer, and 1887 as a "draughtsman," working for Alphonso Whipple, a printer. The 1889 directory lists him once again as an engraver, and then he is listed as a lithographer in 1890, possibly the year he began his own business. He produced his first view of St. Louis three years later and in 1896 drew and published an even larger portrait of the city. In 1907 Graf issued a detailed perspective of the business district. We will consider these two additional views later in this chapter.[16]

Graf eventually terminated his business and went to work for the St. Louis City Planning Board preparing perspective drawings of proposed projects. Then, for twelve years beginning in 1921, he drew similar sketches of planning proposals in other places for a large city-planning consulting firm with its main office in St. Louis. Shortly before his death in 1933 he was at work on a pictorial guide to St. Louis. Newspapers in that city and elsewhere published many of Graf's drawings to illustrate what proposed buildings or other improvements would look like. Near the end of his life Graf summarized his work for Harland Bartholomew, the planning consultant: "I suppose we have handled proposed city betterment plans for at least eighteen or twenty places since I've been attached to this office. And I've been given all the picturization to do. After the

14. I am indebted to Helena Zinkham, Division of Prints and Photographs, Library of Congress, for information on how images were produced by drawing over photographs. She discovered this when doing research on the work of the New York artist and publisher Charles Magnus, who used this technique to obtain images for his lettersheets. Zinkham presented preliminary findings of her research in a still unpublished paper given before the North American Print Conference in 1986. For a summary of how the collotype process came to the United States and its use before 1900, see Helena E. Wright, "Partners in the Business of Art: Producing, Packaging, and Publishing Images of the American Landscape 1850–1900."

15. *Appletons' Annual Cyclopaedia and Register of Important Events of the Year 1886*, 183.

16. I have relied on two newspaper obituaries in addition to city directory listings and two newspaper stories in the 1930s about Graf's current work as an illustrator of city planning proposals. The obituaries appeared in the *St. Louis Post-Dispatch*, 13 August 1933, and the *St. Louis Globe-Democrat*, 14 August 1933. The news stories were published in the *Globe-Democrat Sunday Magazine*, 29 May 1932, and the *Post-Dispatch*, 23 May 1933. Both obituaries state that his father was "a craftsman in metals." In reality, his father was doubtless the Henry Graf, tinner, who had the same address in 1879 as Frederick and with whom Frederick was boarding at 1448 Chambers Street in 1884. In 1986 I asked Frederick's grandson, a prominent St. Louis architect, if he could help me find any of Graf's original drawings or could tell me anything more about his career. After consulting with his relatives, he assured me that no such material or information existed.

EXPOSITION BUILDING.

NEW POST OFFICE AND CUSTOM HOUSE.

THE FOUR COURTS.

LINDELL HOTEL.

VIEW WEST FROM COURT HOUSE.

Figure 8–6. Views of St. Louis in 1886, drawn by Louis Glaser, printed in New York by Adolph Wittemann, and published in St. Louis by James Overton. (Division of Prints and Photographs, Library of Congress.)

Figure 8-7. View of St. Louis in 1893, drawn, lithographed, and printed in St. Louis by Frederick Graf. (Division of Geography and Maps, Library of Congress.)

plan is completed by the engineers, I make the sketch to show how it will look."[17]

Graf's view of St. Louis in 1893 has an almost posterlike quality, with its strong colors and bold title. Except for the major buildings identified in the body of the view with obtrusive numbers, the artist provided little architectural detail. Graf's print surely must have had limited appeal as a wall decoration, and it is not clear to whom he expected to sell this view. Only two impressions have been recorded, both in the Library of Congress. Almost certainly these were the copies deposited for copyright in 1892, the date lettered below the title.[18]

In considering earlier views of St. Louis we have found several others that exist in only one or two known impressions. In this respect, St. Louis view-makers seem to have encountered an extraordinary run of bad luck. In the case of Graf's view, the Panic of 1893 may have interfered with his plans, and it is possible that copies never reached the market. However, it is equally likely that customers regarded it so lightly that after its novelty wore off they simply discarded it as they would an old newspaper.

However residents of St. Louis may have looked on this urban portrait, it provides us today with a useful key to the central city as it neared the end of a century of remarkable growth and change. The census of 1890 established St. Louis as the nation's fourth largest city, with a population of 451,770. Brooklyn ranked third, but after its consolidation with New York City in 1898 St. Louis became the third most populous city in the country, at least until the census of 1900 revealed that its population of 575,238 placed it behind New York City, Chicago, and Philadelphia

Many features stand out clearly on Graf's view. It reveals, for example, how inappropriate the grotesque tower of the McLean Building (number 14) must have been as a close companion of the Courthouse.[19] The view also shows

17. *St. Louis Globe-Democrat Sunday Magazine,* 29 May 1932. That article lists some of the cities for which Graf prepared drawings: Springfield and Jefferson City, Missouri; Louisville, Kentucky; Knoxville, Tennessee; San Antonio, Texas; San Jose and Sacramento, California; Vancouver, British Columbia; Lansing and Jackson, Michigan; Des Moines, Iowa; Binghamton, New York; Peoria, Illinois; New Orleans, Louisiana; and Toledo and Hamilton, Ohio.

18. The two impressions of the Graf view are shared by the divisions of Geography and Maps and of Prints and Photographs of the Library of Congress. Each lacks an identical irregular portion of the lower left corner. This does not interfere with the image of the city, but some of the decorative border and part of a box with population statistics are lost.

19. Because the numbers in the legend are small and were printed in colored ink that is not easily read, they are not legible in the reduced reproduction in this book. The following transcription will help readers locate places not identified in the text: 1. Meyer Bros. Drug Co.;

better than any other similar image what a dramatic change in scale had occurred within the St. Louis central district. The brick and stone warehouses along and near the levee that earlier visitors found so impressive in their size and bulk seem dwarfed in Graf's view by much larger buildings then lining the streets of the greatly expanded and nearly transformed business district.

Several enormous structures, like the Southern Hotel (number 2), Barr's (number 40), and the Famous Building (number 53), occupied entire blocks. Others, located on more restricted sites, such as the Wainwright Building (number 23) and the Union Trust Building (number 42)—both designed by Louis Sullivan—piled story on story to reach heights that a few years earlier would have been regarded as either physically impossible or economically unjustifiable.

The concentration of tall buildings in the blocks stretching westward between Olive and Locust and between Chestnut and Pine marked the new axis of the late nineteenth-century city. It replaced the one defined first by warehouse and mercantile structures following a north-south orientation along the river and later by the emergence of Fourth Street as the center of downtown activity. With admirable clarity Graf's view demonstrates that at the beginning of the last decade of the century St. Louis had turned a right angle in moving to the west.

This new vector of urban growth led toward the city's newest major struc-

2. Southern Hotel; 3. St. L. and S.F.R.R Freight Depot; 4. Mer. Br. & Terminal Co. Fr. Depot; 5. Cupples Block; 6. Wainwright Brewery; 7. French Cathedral; 8. Elevator; 9. Four Courts and Jail; 10. Collier White Lead Co.; 11. Olympic Theatre; 12. Grand Opera House; 13. Court House; 14. McLean's Block; 15. Insane Asylum; 16. Lafayette Park; 17. "The Republic" Building; 18. Merchants Exchange; 19. Planters House; 20. Houser Building; 21. Roe Building; 22. "Globe-Democrat" Building; 23. Wainwright Building; 24. City Hall; 25. Union Depot; 26. Grand Avenue Bridge; 27. Gay Building; 28. U.S. Appraiser's Building; 29. Rialto Building; 30. Laclede Building; 31. Commercial Building; 32. Fagin Building; 33. Odd Fellows Building; 34. Hagan Theatre; 35. Security Building; 36. Third National Bank; 37. Bank of Commerce; 38. Mercantile Library; 39. "Post-Dispatch" Building; 40. Barr's; 41. Mercantile Club; 42. Union Trust Building; 43. Columbia Building; 44. Custom House and Post Office; 45. Bd. of Education & Public Lib'ry; 46. Exposition; 47. Ventilator, Eads Bridge Tunnel; 48. Equitable Building; 49. American Central Building; 50. Lindell Hotel; 51. Boatmen's Bank; 52. Union Market; 53. Famous Building; 54. St. Joseph's Church; 55. Stifel's Brewery; 56. Columbia Brewery; 57. St. Patrick's Church; 58. Mer. Br. & Terminal RR Depot; 59. C.B.& O. RR Depot; 60. Wabash RR Depot; 61. Belcher's Sugar Refinery; 62. St. Louis Elevator; 63. Eads Bridge; 64. Shot Tower; 65. Excelsior Stove Works; 66. Merchants Elevator; 67. Farmers Elevator; 68. Merchants Bridge; 69. Water Tower No. 2; 70. Water Tower No. 1; 71. Water Works, Bissel's Point; 72. Water Works, Chain of Rocks; 73. Madison and Car Works; 74. Venice, Glucose Works & Elevator.

ture—the great Union Station on Market Street between Eighteenth and Twentieth streets. On Graf's view, number 25 shows the location of the station on a site strongly opposed by older downtown interests because of its distance from the former business center. Graf also clearly shows the corridor of railroad tracks, yards, and freight stations leading through the old Mill Creek valley. In the foreground he also provides details of the elevated rail tracks paralleling the river that offered connections between lines entering the city from the north and south and the passenger and freight facilities of the east-west railroads.

Graf followed the tradition of some earlier viewmakers in anticipating the completion of Union Station, which did not open until two years after the copyright date of the print. He also turned ahead the hands of the clock by including another highly important building, one on which work started in 1892 but which was not opened for another four years and was not fully completed until 1904. This was the chateau-like City Hall (number 24 on the view) that occupied what was once Washington Park on the block bounded by Market, Twelfth, Thirteenth, and Walnut streets.

North of Eads Bridge, Graf's view shows a profusion of railroad depots, factories, and grain elevators stretching along the river from the western approach to the bridge and extending several blocks inland. The shot tower (number 64) and the lofty chimney stack of the sugar refinery (number 61) mark the approximate center of this dense industrial district of which the Excelsior Stove Works (number 65) was one component.

Just above the western river pier of the bridge the view shows the Wabash Railway depot. Above and to the right is a twin-towered facade at the south end of a large building. This was the depot of the Merchants Bridge and Terminal Railroad, constructed when a second bridge company completed in 1889 another railroad bridge across the Mississippi three miles north of Eads Bridge near the waterworks at Bissell's Point. The Merchants Bridge (number 68) can be seen just before the second bend in the river. Well beyond that, identified by Graf as number 72, lay the new Chain of Rocks water plant, a project that finally made it possible for residents of the city to enjoy water free from traces of Mississippi mud and silt.[20]

In each of the next three years another St. Louis artist and printer issued views of the city. They were, in fact, slightly different versions of the same image. They came from the hands of Charles Juehne, who came to St. Louis from Albany, New York, in 1874. In the latter city, the directories for 1872 and 1873 list him as a lithographer. As was discussed in the previous chapter, the 1874 St. Louis directory identified him as an engraver, employed by Robert A. Campbell, who was a publisher with offices at room 38 of the Insurance Exchange Building.[21]

Juehne changed employment in 1875, for the directory lists him as a lithographer with an office in room 42 of the building at 414 Olive, the street address for the Insurance Exchange, which occupied the southeast corner of Olive and Fifth streets. Similar listings appear in directories through the end of the century, but in 1900 and thereafter until 1911, his last such appearance, he is identified as an artist, with an office or studio after 1903 at 810 Olive Street.

These directory listings disclose two fascinating and tantalizing connections. The information supplied in 1882 reveals that Juehne lived at 2718 Gamble Avenue, an address next door to the residence of Theodor Schrader, the lithographic printer who bought the business of Eduard Robyn and then printed and published several fine city views of towns in Missouri and Illinois before the Civil War. It seems possible that Schrader discussed his experience as a viewmaker with his neighbor and fellow lithographer, Juehne, and showed him examples of his works.

Far more important, as the previous chapter suggested, city directory listings provide firm evidence that Juehne had every opportunity to know Camille N. Dry. This, in turn, offers a reasonable basis for believing that Juehne took part in the preparation of Compton and Dry's heroic-size view of St. Louis, a project so large that it would have required many draftsmen and lithographers.[22] If Juehne did participate in preparing the Dry view of St. Louis and also had the benefit of Schrader's advice about urban viewmaking, it helps to explain the generally high quality of his own delineations of the city, especially the two that followed his initial effort.

Figure 8–8 reproduces the high-level, bird's-eye view that Juehne drew and published in 1894. It measured 18 x 24 inches, a size that may have inhib-

20. A second railroad crossing of the Mississippi had been discussed for years. The Eads Bridge tunnel proved inadequate to handle all the rail traffic, and it was choked with smoke. Several visitors remarked about the need for another bridge. See Warner, *Studies in the South and West*, 319.

21. The 1872 and 1873 Albany directories are the only ones listing Juehne around this time. His name does not appear in those for 1868, 1869, 1870, 1871, or for 1874, 1875, 1876, etc.

22. Richard Compton's business office for the project was located at the northwest corner of Locust and Sixth streets in the St. Louis Life Insurance Company Building and only two blocks from the addresses of Dry and Juehne in the Insurance Exchange Building. In 1873 and 1874 Compton had his office on the northeast corner of Pine and Fourth, even closer to the Insurance Exchange Building.

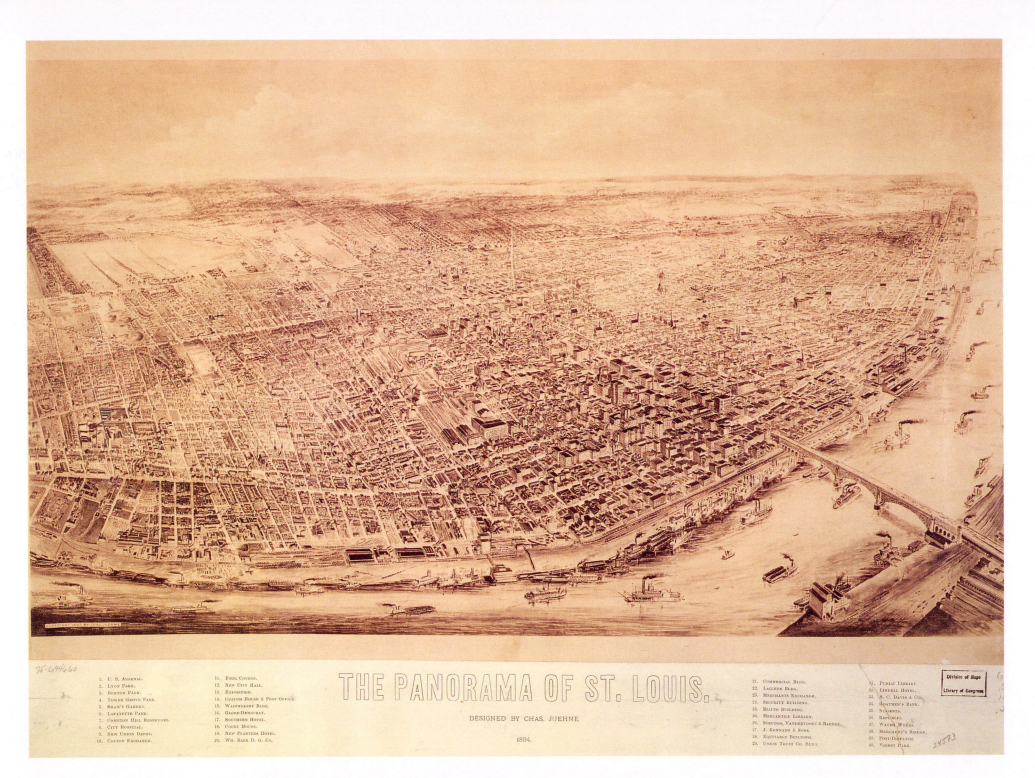

THE PANORAMA OF ST. LOUIS.

DESIGNED BY CHAS. JUEHNE

1894.

1. U. S. ARSENAL.
2. LYON PARK.
3. BENTON PARK.
4. TOWER GROVE PARK.
5. SHAW'S GARDEN.
6. LAFAYETTE PARK.
7. COMPTON HILL RESERVOIR.
8. CITY HOSPITAL.
9. NEW UNION DEPOT.
10. COTTON EXCHANGE.

11. FOUR COURTS.
12. NEW CITY HALL.
13. EXPOSITION.
14. CUSTOM HOUSE & POST OFFICE.
15. WAINWRIGHT BLDG.
16. GLOBE-DEMOCRAT.
17. SOUTHERN HOTEL.
18. COURT HOUSE.
19. NEW PLANTERS HOTEL.
20. WM. BARR D. G. CO.

21. COMMERCIAL BLDG.
22. LACLEDE BLDG.
23. MERCHANTS EXCHANGE.
24. SECURITY BUILDING.
25. RIALTO BUILDING.
26. MERCANTILE LIBRARY.
27. SCRUGGS, VANDERVOORT & BARNEY.
28. J. KENNARD & SONS.
29. EQUITABLE BUILDING.
30. UNION TRUST CO. BLDG.

31. PUBLIC LIBRARY.
32. LINDELL HOTEL.
33. S. C. DAVIS & CO.
34. BOATMEN'S BANK.
35. NUGENTS.
36. REPUBLIC.
37. WATER WORKS.
38. MERCHANT'S BRIDGE.
39. POST-DISPATCH.
40. FOREST PARK.

Figure 8–8. View of St. Louis in 1894, drawn and published in St. Louis by Charles Juehne. (Division of Geography and Maps, Library of Congress.)

ited the artist's efforts to record the appearance of the city in great detail. Like Parsons and Atwater, Juehne resorted to the use of stereotyped building images in the background portions of the print while rendering the structures in the foreground with considerable fidelity. However, the drawing lacks crispness and precision, and the sepia ink Juehne used makes the view look drab and dull.

In 1895 and 1896 the artist revised his view in several ways. He used the identical perspective but extended the scope to include much more of the southern part of the city. He redrew the entire view in a sharper and more authoritative style, added many more buildings rendered in realistic fashion, and enlarged the size of his lithograph to 23 x 40 inches. He also expanded the numbered legend at the bottom of the view, used red ink to number the corresponding buildings and street names, and added a buff-colored tone to provide cloud and shadow effects.[23]

These two views are so nearly identical, differing only in the date shown in large numbers as part of the title and by the addition in 1896 of two additional items to the legend, that a single reproduction represents them both. This appears in Figure 8–9, the last and best of Juehne's three efforts to represent the city on stone and paper. His views have not been well known in St. Louis, for until 1987 no collection in the city included any examples of these prints.[24]

The elevated perspective Juehne used allowed him to present many features of the city that Graf could not include or show clearly in his lithograph

published a few years earlier. One of these was the bridge over the railroad tracks at Jefferson Avenue. Juehne's view makes obvious the importance of that major north-south thoroughfare and shows how the bridge both eliminated a safety hazard and speeded vehicular traffic. The view also shows Union Station with its enormous area of enclosed tracks and boarding platforms stretching south from the terminal building with its soaring tower. Above the image of the station and to the left of center are the new buildings of St. Louis University, occupying a site on the west side of Grand Avenue. This new site replaced the old and cramped location of the university at Washington Avenue and Ninth Street. Beyond the university and nearby Vandeventer Place, whole new neighborhoods extend to Kingshighway and even farther west and spread northward almost to the Fairgrounds.

A journalist for *The Review of Reviews,* writing in 1896 as St. Louis played host to the Republican National Convention, provides a commentary on the city that Juehne portrayed. The writer described recent changes in the city as a "transformation" of "the past five or six years." He identified the instrument of change as "the electric trolley system of local transit." He noted that until recently "St. Louis was . . . an exceptionally compact city" with "most of its homes, as well as its factories and business houses," located within three miles of the new Union Station. Conversion of the old horse-car lines into electric trolley routes changed this pattern. By 1896, with almost three hundred miles of electric-powered street railways,

> the consequence has been an almost magical development of a great residential zone, three or four miles wide, the outer edge of which lies upon the average about six miles from the centre of the city. Within this belt are thousands of attractive new homes, the typical St. Louis residence being a square, detached, red brick house, standing within a small plot of well-kept ground.[25]

Because Juehne's view embraces so much territory, only Vandeventer Place can be seen clearly among the many other private streets and places that by this time provided elegant and protected sites for larger estates. The anony-

23. The legend on the 1896 version of Juehne's view identifies these places: 1. U. S. Marine Hospital; 2. Concordia College; 3. Convent of the Good Shepherd; 4. U. S. Arsenal; 5. Park; 6. Anheuser-Busch Brewery; 7. Benton Park; 8. Tower Grove Park; 9. Shaw's Botanical Garden; 10. Forest Park; 11. Compton Hill Reservoir and Park; 12. City Hospital; 13. Lafayette Park; 14. Cupples Station Blocks; 15. Four Courts; 16. New City Hall; 17. Union Station; 18. Cotton Exchange; 19. Court House; 20. Globe-Democrat Building; 21. Wainwright Building; 22. Holland Building; 23. Planters Hotel; 24. Merchants Exchange; 25. Laclede Building; 26. Commercial Building; 27. Barr's; 28. Rialto Building; 29. Security Building; 30. Mercantile Library; 31. Equitable Building; 32. Union Trust Building; 33. Chemical Building; 34. Custom house & Postoffice; 35. Public Library; 36. Columbia Building; 37. Mercantile Club; 38. Odd-Fellows' Building; 39. Century Building; 40. Exposition Building; 41. Masonic Temple; 42. Washington University; 43. Nugent's; 44. St. Louis University; 45. St. Louis High School; 46. Fair Grounds; 47. Water Tower; 48. Water Works; 49. Merchants Bridge; 50. Eads Bridge.

24. All three of the Juehne lithographs in the Division of Geography and Maps of the Library of Congress bear copyright acquisition stamps in the years in their titles. Recently a corporate collection in St. Louis acquired the library's duplicates of the 1895 and 1896 Juehne views of the city.

25. "St. Louis: This Year's Convention City," 674. The first electric trolleys ran in St. Louis in 1887. Three main companies operated the lines until 1899, when they consolidated operations. One cable-car line running from Sixth and Locust to Vandeventer Avenue via Franklin Avenue began service in 1886, and the following year another line connected the central city with the Fairgrounds.

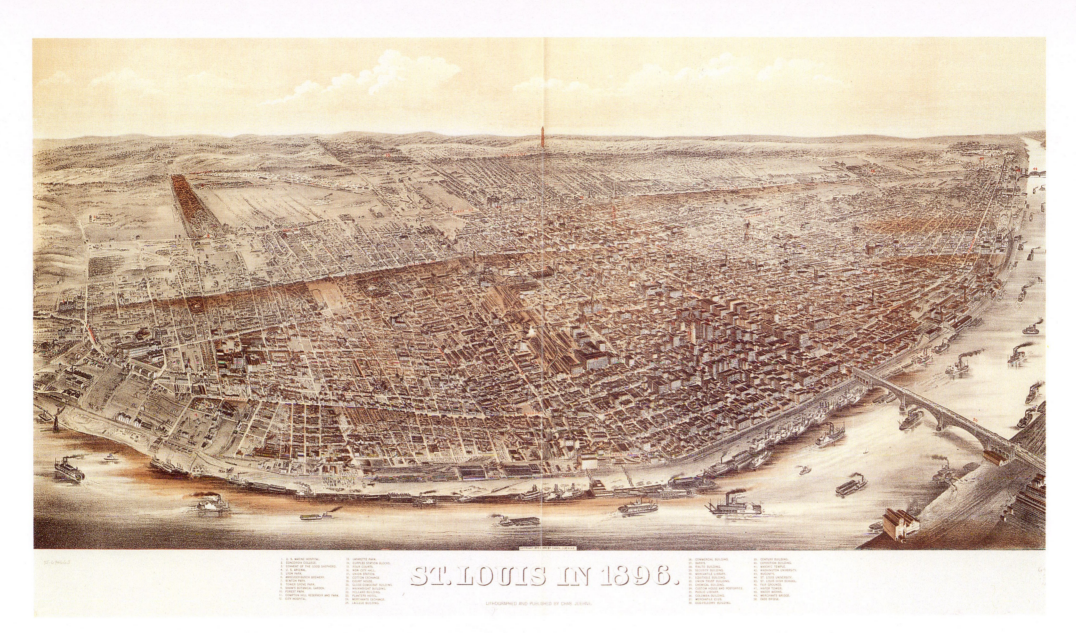

ST. LOUIS IN 1896.

LITHOGRAPHED AND PUBLISHED BY CHAS. JUEHNE.

Figure 8–9. View of St. Louis in 1896, drawn, printed, and published in St. Louis by Charles Juehne. (Division of Geography and Maps, Library of Congress.)

mous journalist informed his readers about these distinctive and admirable features of the St. Louis townscape:

> The wealthier element is domiciled in mansions of the most comfortable and attractive appearance; and it is quite local fashion to build these mansions in so-called "places," or "terraces,"—which are, in effect, private streets or parkways, with perhaps a half dozen houses on either side of the street or parkway and with an ornamental entrance at each end. The finer residence districts of St. Louis have a great number of these "places," which constitute one of the most distinctive features of the town.[26]

Two other artists recorded their impressions of St. Louis in 1896. Figure 8–10 reproduces one of these, a large halftone illustration of a painting by G. W. Peters that he probably executed in watercolor. *Harper's Weekly* used this in its June issue to illustrate a story on a disaster that struck the city on 27 May 1896 when a tornado caused massive damage to portions of the waterfront.[27] Peters looked north from the industrial district at the river or eastern end of the Mill Creek valley, but since there is no sign of devastation in his scene he must have painted it before the storm. The caption to the illustration provides some essential information about both the view and the effects of the violent tornado:

> This Picture shows the Territory which felt the full Force of the Storm. In the immediate Foreground is the lower End of Mill Creek Valley, indicated by the curving Line of the Elevated [rail] Road, which comes down the Valley from the Union Station and goes north to the Merchants Bridge, passing under the west End of the Eads Bridge. The Levee Front on the Missouri Side was swept clean of Steamboats and Wharves. The east End of the Bridge was wrecked, and the Elevators and Mills near it were destroyed by the Storm and by Fire.[28]

Unlike Juehne, who showed only a few of the city's factories producing smoke, Peters displays the full, murky magnitude of the industrial pollution that almost choked St. Louis most of the time. His view seems almost a celebration of the industry and the railroads that had brought St. Louis to its enviable position as one of the major urban centers of the nation. Clearly, Peters regarded smoke as a sign of the renewed prosperity that lay ahead as the city emerged from the economic depression of 1893.

This print foreshadowed the end of the era of hand-drawn city views. Ten years before *Harper's Weekly* published its reproduction of Peters's painting, a practical method of reproducing continuous tones had been perfected. This process used a fine screen to break up a photographic image of a drawing or painting (or anything that could be photographed) into a myriad of uniformly spaced tiny dots. The size of each dot depended on the shade of gray needed to reproduce a convincing duplicate on paper of the original object. Groups of large dots registered on the human eye as dark gray; groups of small dots were perceived as light gray.[29]

Harper's and many other publications began to use this process almost immediately because it was both faster and cheaper than wood engraving. It also permitted these journals and other illustrated publications to include for the first time printed versions of photographs among their illustrations. Previously a wood engraver had to simulate the continuous tones of a photograph being copied by hatching and crosshatching on the wood blocks used for printing. Photography had already been used for some years to produce line illustra-

26. Ibid., 678. This writer added his views on the city's smoke problem: "The attractiveness and comfort of the city would be vastly enhanced if the smoke nuisance could be completely abated. Most of the factories are in the central districts, and these use an Illinois soft coal, which makes the city almost as black as Pittsburgh was before the era of natural gas. Inasmuch as the coal fields are very near, it has been suggested that nothing could be more simple and practicable than the electrical transmission of power and heat from great plants erected a few miles from St. Louis on the Illinois side, thus saving the transportation of the coal and completely ridding the city of its pall of smoke."

27. The storm and its effect on St. Louis are described in Judith Ciampoli, "The St. Louis Tornado of 1896: Mad Pranks of the Storm King."

28. The illustration accompanies George Grantham Bain, "The St. Louis Disaster," 570. In addition to a long and detailed description of the damage wrought by the tornado, Bain's article includes this passage on that portion of St. Louis seen in the view: "St. Louis is divided on an east and west line by the Mill Creek Valley. The creek for which the valley was named now lies far below the surface, and is an adjunct to the city's sewer system. In this valley lie most of the railroad tracks which enter the city. Twenty years ago, when ferries brought passengers and

freight from Eastern roads across the Mississippi River, only the west-bound railroads used the valley. When the great Eads Bridge was planned and the Union Depot was constructed, the meeting-place of east and west bound roads was fixed in this valley, and the tunnel from the bridge was brought under the city's streets and houses in a sweeping curve from Main Street and Washington Avenue to Tenth and Poplar streets. When, only a year ago, the new Union Station was completed, the Mill Creek Valley remained the highway for practically all the city's railroad traffic.

"It has not been many years since the Mill Creek Valley was bridged, so as to make communication between the northern and southern sections of the city safe. But for the little garden spot around Lafayette Park and the limited residence section to the west known as Compton Hill, the improvement of that part of the city has been for many years chiefly in the direction of small, cheap dwellings and factories. Between Lafayette Park and the river, a little more than a mile away, the few homes once occupied by some of the old French families of St. Louis have been abandoned of recent years as tenements, and the factories thickened about them."

29. For a good, illustrated explanation of halftone reproduction, see Jerry Demoney and Susan E. Meyer, *Pasteups & Mechanicals: A Step-by-Step Guide to Preparing Art for Reproduction,* chap. 4, pp. 38–48.

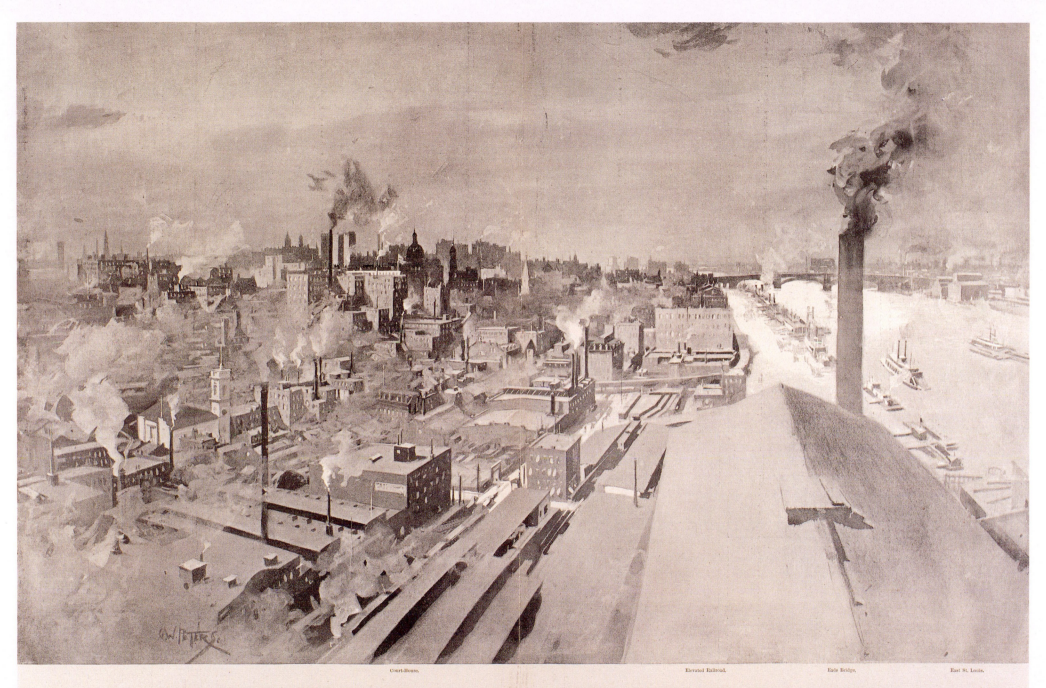

THE CITY OF ST. LOUIS—LOOKING TOWARD THE EADS BRIDGE, AND SHOWING THE REGION DEVASTATED BY THE TORNADO OF MAY 27, 1896.—DRAWN BY G. W. PETERS.—[SEE PAGE 570.]

This Picture shows the Territory which felt the full Force of the Storm. In the immediate Foreground is the lower End of Mill Creek Valley, indicated by the curving Line of the Elevated Road, which comes down the Valley from the Union Station and goes north to the Merchants Bridge, passing under the west End of the Eads Bridge. The Levee Front on the Missouri Side was swept clean of Steamboats and Wharves. The east End of the Bridge was wrecked, and the Elevators and Mills near it were destroyed by the Storm and by Fire.

Figure 8–10. View of St. Louis in 1896 Showing the Part of the City Damaged by a Tornado, drawn by G. W. Peters and published in New York by *Harper's Weekly.* (John W. Reps.)

tions, and the perfection of the halftone screen for the creation of continuous-tone illustrations seemed a major advance.[30]

This new method of reproducing illustrations had drawbacks: it reduced both contrast and sharpness. The general drabness of Figure 8–10 comes as much from the method of printing as it does from Peters's fondness for picturing smoke. Except in the highlight of the river in the distance (probably created by hand retouching of the negative or plate), some intensity of gray appears in every portion of the print. This simply reflects the presence everywhere of the halftone screen. Modern techniques go some way in moderating or eliminating this problem, but for decades after their development most halftones resembled the dark, low-contrast appearance of Peters's portrait of St. Louis.[31]

Lack of sharpness comes partly from reduced contrast but is mainly an inherent shortcoming of the halftone process. Dots on paper simply cannot be made to duplicate exactly a line or hard edge. The finer the screen, the better is the illusion of sharpness. Nevertheless, even when the spacing of the dots is reduced to the minimum feasible distance and the human eye can no longer distinguish individual dots, a "line" reproduced by the halftone method will not appear as sharp and precise as a true line not made up of discrete elements.[32]

30. For early photography in America and its first applications in printing, see William F. Robinson, *A Certain Slant of Light: The First Hundred Years of New England Photography.* Other useful sources of information on this subject include Taft, *Photography and the American Scene: A Social History, 1839–1889,* chap. 21, pp. 419–50; Geoffrey Wakeman, *Aspects of Victorian Lithography: Anastatic Printing and Photozincography,* 43–51; and J. Luther Ringwalt, ed., *American Encyclopaedia of Printing,* 285. Additional sources are cited in Reps, *Views and Viewmakers,* 35–38, with my own brief treatment of the use of some photographic methods in the creation of city views.

31. I write this paragraph without knowing how the illustration will appear as a book illustration. Serious problems arise when a halftone is made from a halftone, thus superimposing two sets of dots. One technique is to photograph the original halftone in line, thus preserving the original screen and not adding another. However, when the original must be substantially reduced, as in this case, the resulting screen value may be so fine that it cannot be successfully printed. What occurs is that the spaces between adjoining dots are so small that dots become joined. This "plugging" of what are intended to be medium or dark gray areas on a reproduction makes them black.

32. Many of the black-and-white illustrations in this book and all of the color ones are printed from necessity as halftones. It is virtually the only way that color can be reproduced commercially because each of the three primary colors plus black requires a separate screen. To print without creating a distracting moiré pattern, each screen is given a different angle. Some of the black-and-white illustrations are reproduced in line, but not all that were originally printed as line engravings or lithographs can be reproduced in this way. Severe reductions in size can make some line engravings subject to plugging because adjoining lines of hatching or crosshatching become too close together. In other cases, reproductions had to be made from photographs

In the final view of St. Louis published in the nineteenth century, Fred Graf combined a line drawing of the entire city with twenty halftone border vignettes made from photographic images of individual buildings, street scenes, and statues. This large lithograph, which Graf drew and published in 1896, appears in Figure 8–11. This print was not represented in any St. Louis collections until 1987, when a city corporation acquired an impression. Like several others in this book, its image is being reproduced here for the first time.[33]

Graf lettered the title of this view on a shield held aloft by two winged young women seated on a carved bench or altar inscribed "Population 615,000." Boosters of most cities wildly exaggerated local populations almost as a matter of routine and almost automatically also complained about undercounting when the next census revealed that reality had fallen short of expectations or projections. Graf proved as guilty as the rest in this respect, for as noted earlier, the census of 1900 put the St. Louis population at 575,238.

Although Graf's view is not as convincing in its handling of perspective as is Juehne's, its sharpness and clarity of detail, especially in the western reaches of the city, provide a quality that his rival's lacked. Further, Graf seems to have handled color better than Juehne, and this makes many features of his view stand out with greater precision and definition. For example, Graf presents with some accuracy the design of Forest Park with its winding drives and bodies of water, while Juehne shows only a wooded rectangle and an identification number corresponding to the park's name in the legend.

Graf used some old devices often employed by urban viewmakers confronted with an enormous city and having limited time to draw its portrait. Aside from the parks, beyond Grand Avenue he simply depicted a vast grid of streets and hundreds of stereotyped houses occupying the scores of city blocks the streets defined. East of Grand Avenue he concentrated on those elements with high recognition value: churches, parks, public structures, large factories, railroad lines and terminals, and the large and well-known offices and stores in

that were either not critically sharp in focus or were made on low- or medium-contrast film or paper. Halftones of these at least preserve the image, although they fail to convey the character of the original. Many publishers, including those who should know better, simply use halftones for all illustrations because they are generally easier to obtain than first-quality line negatives. What they fail to realize is that a halftone reproduction of an original line drawing or print does as much violence to its character as printing the book or the journal in a typeface composed of small dots instead of sharp lines with clearly defined edges.

33. The Library of Congress acquired its two impressions in 1896, undoubtedly the two copies required for a copyright submission. It is one of those that has since been disposed of by the library in exchange for a city view not in its collection.

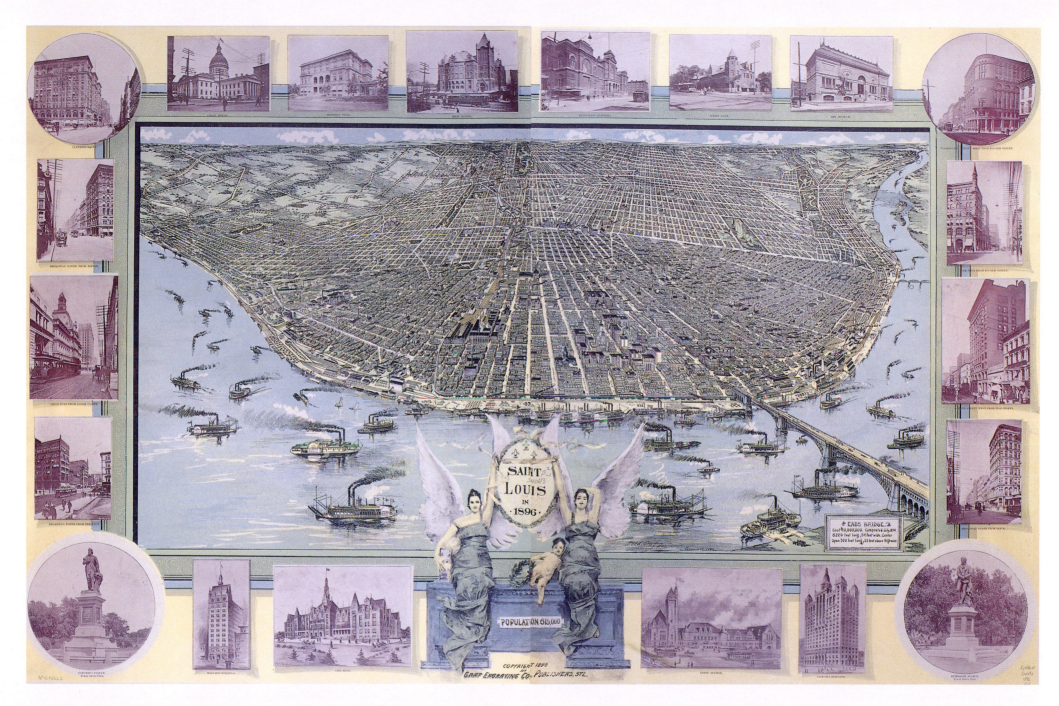

Figure 8–11. View of St. Louis in 1896, drawn by Fred Graf and published in St. Louis by Graf Engraving Co. (Division of Geography and Maps, Library of Congress.)

the central business district. Graf then filled the spaces in between with images of buildings that generally indicated the type and scale of those in each neighborhood.

Just visible on Graf's view is a well-known part of the city that was beginning to change in character. This is the Cheltenham district south of Forest Park and west of Kingshighway. Deposits of clay ideally suited for firebricks led industrialists to build several brick and tile factories in this area beginning about 1855. Here a number of Italians found work in the early 1880s, nearly all of them from the same part of Lombardy. At the time Graf published his view several hundred of them lived in this western neighborhood, by that time known as "Dago Hill." A few immigrants from Sicily also made their home here. In the years before World War I many thousands of other Italians came to St. Louis, and a large proportion of them settled where they found a familiar language, food stores that stocked accustomed items, and neighborhoods that perpetuated customs from Italy. Thus was born and developed The Hill, still a St. Louis neighborhood that retains a distinctive ethnic character, although one less pronounced as time passes.[34]

Graf selected photographic views of buildings and streets for his vignettes that best displayed the city's most urban atmosphere. Three views of Broadway and others of Olive, Fourth, Washington, and Pine show many of the major commercial buildings in the business district. Sharing places of prominence to the left and right of the title, drawn images of the City Hall and of Union Station demonstrate that St. Louis could boast of elaborate civic structures as well.

A plan of the city published by the U.S. Geological Survey in 1904 and based on surveys completed a year earlier shows the extent of this Mississippi River metropolis just a few years after Graf issued his second view. Figure 8–12 reproduces a part of this topographic map, issued by the government as a special publication in honor of the Louisiana Purchase Exposition, a world's fair that St. Louis proudly opened to visitors in 1904. Forest Park provided a spacious site for the Fair's buildings, whose outlines stand out clearly near the western limits of the city.[35]

The St. Louis Fair of 1904 left the city bathing in a glow of praise from abroad and self-congratulations from its residents. It also gave the city a permanent art museum and a new campus for Washington University. The text on the back of the special map explained that Washington University "boasts a handsome group of new administration buildings, situated upon an eminence overlooking Forest Park. These building, only just completed, are within the World's Fair grounds, and are at present occupied by the Exposition officials." This brief essay on the history and present characteristics of St. Louis called attention to one feature of the metropolis that time drastically changed: "Unlike most large cities, it has few suburbs. Kirkwood, Webster Groves, and Clayton, to the west, are the only ones of note, and the population of Kirkwood, the largest of these, is only about 3,000."[36]

Shortly before the Federal Government published this map, William Reedy, a St. Louis editor, summed up the accomplishments of the city in an essay he wrote for a book on towns and cities of the American West. He declared that with the opening in 1874 of Eads Bridge, "the city was put in touch with the East." Reedy cited as evidence of a love of beauty the acquisition of Forest Park, "the greatest natural public city park in the country, after Fairmount in Philadelphia," and O'Fallon Park, "but little less magnificent." He recognized the generosity of Henry Shaw in making possible the creation of Tower Grove Park, "perhaps the finest specimen of the park artificial to be found anywhere." Reedy continued his catalog of civic achievements:

> The city paved all its downtown streets with granite, and later its outlying streets with asphalt, erected a new customhouse, a Four Courts Building, stupendous water-works, and constructed a gigantic extension of the sewer system. The development of the system of street-railway transportation in St. Louis was more rapid and more perfect that in any other city in the world. A new mercantile library was built. . . . Churches increased in great numbers. Schools multiplied.[37]

34. Dry depicted this portion of the city when it was still sparsely developed and the main activities centered around the brick and tile factories. For a detailed study of The Hill, see Gary Ross Mormino, *Immigrants on the Hill: Italian-Americans in St. Louis, 1881–1982.* For a treatment of the immigration process, see Mormino, "Lombard Roots: From Steerage to the Hill."

35. Edward Hungerford, in *The Personality of American Cities,* wrote of the Louisiana Purchase Exposition, "It was a really great fair and it has left a permanent impress upon the town in the form of a fine Art Gallery and the splendid group of buildings at the west edge of the city which are being devoted to the uses of Washington University" (234).

36. U.S. Geological Survey, "The Louisiana Purchase and the City of St. Louis."

37. William Marion Reedy, "St. Louis 'The Future Great,'" 368–70. Reedy took a different view on the importance of suburbanization from that held by the author of the text on the 1904 map of St. Louis. He noted, "The city has to-day a population of 575,000. In the suburban territory there are over 700,000 more people in close relationship daily and almost hourly with the business and social life of the city." This claim appears to be based on the wildest kind of boosterism. Even in 1920 when the city's population stood at 772,897, the county population numbered only 100,737. Reedy published a literary magazine, *The Mirror,* and for many years was active in various civic improvement activities in St. Louis. His portrait, and a description of some of his ideas and projects, can be found in James Neal Primm, *Lion of the Valley: St. Louis, Missouri,* 374ff.

Figure 8–12. Map of St. Louis and Vicinity in 1903, published in Washington by the U.S. Geological Survey in 1904. Detail. (Map Room, Olin Library, Cornell University.)

Citizens of St. Louis regarded these acts of civic and municipal enterprise with pride, and at the time of the Louisiana Purchase Exposition they confidently looked ahead to a continuing succession of additional public improvements. Yet this was a fair held to commemorate an event that took place a century earlier, so the city was also in a mood to consider its past.

An anonymous publisher, probably about 1902, decided to capitalize on this nostalgic atmosphere by issuing his version of George Catlin's view of St. Louis in 1832. Earlier, as was discussed in Chapter II, a publisher in the late 1860s issued printed versions of Catlin's painting, then in the collection of the Mercantile Library. Another version appeared as an inset on a large map of the United States.[38] Figure 8–13 reproduces the early-twentieth-century issue of this appealing view, a wood engraving that may have been published as a separate sheet or, possibly, was used to illustrate a book, journal, report, or other publication with accompanying text.[39]

The last view of St. Louis in the tradition of those we have considered in this book came from the hands of Fred Graf. For his third and final separately issued print, Graf concentrated on the city's business section. This lithograph of 1907 showing the downtown area from a point above and slightly north of Eads Bridge is reproduced in Figure 8–14. Graf excelled in views such as this where he did not have to include the entire city. In addition to depicting the St. Louis central district as it existed, the artist presented his conception of a proposed civic center. One can see this near the top center of the print. It consisted of lines of monumental buildings on the east and west side of a formal mall following the axis of Thirteenth Street. The existing City Hall was to form part

38. We have already considered one version of the Catlin view, reproduced in Figure 2–6. The other measures ca. 5 ½ x 14 inches. An impression of the lithographic map of the United States on which it appears is in the Map Division of the New York Public Library and is titled *St. Louis in 1832. From an Original Painting by Geo Catlin in Possession of the Mercantile Library.* It is an inset on *Historical Map of the United States ,* published in Chicago in 1876 and edited by Rufus Blanchard. The copyright entry is in the name of Blanchard, who undoubtedly published it. A map with the same title and date and issued by the same publisher in the Library of Congress lacks the inset showing St. Louis.

39. The only impression of this view I have found is in a corporate collection in St. Louis, where it has been dated ca. 1902. The evidence for this is uncertain. It passed through the hands of The Old Print Gallery in New York City in 1978.

of the southeast corner of this great composition. In the end, St. Louis produced a less coherent civic center that followed the east-west axis of Market Street.

When the census of 1910 reported the city's population to be 687,029 and that the city was still in fourth position among the largest urban centers, few could have predicted what lay ahead. During the next decade Cleveland and Detroit passed St. Louis in total population; in 1930 the city dropped to seventh largest; in the following ten years it actually lost population; and, although it regained that and a bit more by 1950, it then reached its highest population of 856,796. Since then there has been nothing but decline. These decreases have been drastic: 12.5 percent from 1950 to 1960, a further 17 percent between 1960 and 1970, and a shattering 47 percent during the decade ending in 1980. The census then counted only 453,000 inhabitants—almost exactly the population of St. Louis in 1890.

The printed urban views that we have considered, therefore, depict the city in its golden years of the nineteenth century. Then St. Louis faced only the issue of how best to manage growth—not the far more difficult problems of arresting decline, renewing and rehabilitating a deteriorating housing stock, coping with poverty, crime, and disease, and patching up with crumbling public utilities, streets, and public buildings.

Yet in the past few years St. Louis has achieved significant victories in reclaiming itself—not as one of the largest among America's now swollen ranks of metropolitan centers, but as a place with its own distinctive character and offering diverse choices for ways of living in an urban environment. The aerial photograph of St. Louis reproduced in Figure 8–15, closely resembling in its viewpoint such nineteenth-century printed views as those by J. W. Hill, James T. Palmatary, and Parsons and Atwater, reveals the city's appearance today.

Once more optimism and confidence stir within the hearts and minds of civic leaders and residents alike, and visitors again find the city a deeply satisfying and richly rewarding place to visit and explore. Both visitors and those who live in St. Louis may find it instructive to contemplate what the city was like in the past and how it grew. For that purpose, they can find no better guides than the viewmakers of St. Louis who recorded the city of their time and left an unrivaled graphic record for us to use in exploring and understanding the city where they worked.

ST. LOUIS IN 1832.

From an Original Painting by **Geo. Catlin** *in possession of the Mercantile Library Association.*

Figure 8–13. View of St. Louis in 1832 from a Painting by George Catlin, published ca. 1902, probably in St. Louis. (Collection of A. G. Edwards and Sons, Inc., St. Louis, Missouri.)

THE HEART OF ST. LOUIS

Figure 8–14. View of the Central Part of St. Louis in 1907, drawn by Fred Graf and published in
St. Louis by Fred Graf Engraving Co. (Division of Geography and Maps, Library of Congress.)

Figure 8–15. St. Louis from the air looking west, photographed by Alex MacLean in October 1987.

ACKNOWLEDGMENTS

During the several years needed for research, photography, and writing to complete this book it was my good fortune to have the help of many persons in St. Louis, at Cornell University, and elsewhere. Without their aid my task would have been much more difficult. It should go without saying (but I will state it nonetheless) that responsibilities for errors and omissions are mine alone.

In the Missouri Historical Society I continually relied for information and other assistance on Duane Sneddeker, Curator of Prints and Photographs. His help proved invaluable in locating and recording many of the illustrations used in this book, and he offered constructive suggestions from time to time leading to material I might otherwise have overlooked.

I also wish to thank a former Curator of Prints and Photographs, Judith Ciampoli, who first provided me access to the pictorial collections of the Society when I was engaged on another project. Stephanie A. Klein, Curator of Library Collections, also assisted me in my studies of St. Louis history.

Janice K. Broderick, Curator of Collections for A. G. Edwards and Sons, Inc., not only introduced me to the rich assemblage of St. Louis pictorial material over which she presides but also on many occasions directed me to additional sources of similar prints and put me in touch with other persons who could answer questions or otherwise facilitate my research. She also arranged for me to photograph many of the items in the Edwards collection and has constantly assisted me in many other ways.

In the St. Louis Mercantile Library Association I found John Neal Hoover, Assistant Director and Special Collections Librarian, always informed, enthusiastic, understanding, and efficient. He guided me to illustrations in several publications that would not otherwise have come to my attention. I was also helped and encouraged in that unique institution by its Director, Charles Bryan, and by Mark J. Cedeck, Curator of the John W. Barriger Railroad Collection.

For three busy days in Edwardsville, Illinois, with the cheerful, energetic, and knowledgeable assistance of Louisa Bowen, Archivist of the Elijah P. Lovejoy Library at Southern Illinois University, I located and photographed several St. Louis city views. There, also, Ms. Bowen provided access to the copious research files of Professor John Francis McDermott. His notes on John Caspar Wild yielded valuable fragments of information on this most elusive of American view-makers, and other files contained much other worthwhile material.

On two occasions during my visits and at other times by correspondence or telephone my studies were facilitated through the efforts of Holly Hall, Head, Department of Special Collections, Olin Library, Washington University. There, as elsewhere, I was permitted to photograph several of the illustrations used herein, including a great many sheets of the Compton-Dry view of 1875 and an apparently unique impression of a lettersheet with a St. Louis view.

Martha Hilligoss, Supervisor, Art Department, St. Louis Public Library, introduced me to the biographical files of artists in her department of the library and guided me in using them in my search for information about the view-makers who created the images of nineteenth-century St. Louis. I was similarly assisted in his branch of the library collections by Noel C. Holobeck, Librarian, History and Genealogy Room, when I combed city directories and other sources of local history for names, addresses, and occupations of those associated with St. Louis urban prints.

Early in my research for this book and a related study of views of cities on the Mississippi River, I received valuable assistance from Carley Robison, Archivist of the Henry W. Seymour Library at Knox College in Galesburg, Illinois. There I found, recorded, and photographed several rare views in a remarkable collection that deserves to be better known.

Staff members of several other St. Louis institutions also extended aid and

provided information, although in some cases my search of these collections proved unproductive. They include Catherine Weidle, Librarian, St. Louis Room, St. Louis University; Stephanie Sigala, Librarian, St. Louis Art Museum; Imre Meszaros, Librarian, Art and Architecture Library, Washington University; and Miss Lois Waninger, Co-ordinator, Carondelet Historical Society.

It is a pleasure also to acknowledge my appreciation for the assistance extended me by Phyllis Y. Brown and Eric P. Newman, who generously shared their encyclopedic knowledge of St. Louis prints with me. Mr. Newman also allowed me to photograph for this book several items in his collection, including two lithographs of St. Louis that are not represented in any of the city's institutional collections.

Others who helped in various ways include Laurel Meinig, Kenneth M. Newman, Professor Howard S. Miller, and Jonathan Flaccus. Norbury L. Wayman's studies of St. Louis neighborhoods provided useful insights or confirmed my own conclusions. Thomas Stewart of The Silver Image deserves my thanks for the high quality of his photographic prints from my negatives and his willingness to tolerate my exacting demands. Robert Little of Allied Photo Color photographed an important image in the Missouri Historical Society beyond the capacity of my own camera and lighting equipment.

As they have so often in the past on similar projects of mine, the staff of the Division of Geography and Maps of the Library of Congress offered skilled assistance on a number of occasions, either in person or through correspondence. Patrick Dempsey replied to most of my queries, but I am also grateful to Richard Stephenson, Gary Fitzpatrick, and Andrew Modelski among the several staff members of that division who were unfailingly cooperative. Bernard Reilly and Helena Zinkham, among others in the Library's Division of Prints and Photographs, also went out of their way to respond to my queries and requests.

I wish to record my appreciation for similar assistance extended in institutions elsewhere by Robert Karrow, Curator of Maps at the Newberry Library; Wendy Shadwell, Curator of Prints at the New-York Historical Society; Larry Viskochil, Curator of Prints and Photographs at the Chicago Historical Society; Denise McHugh, Associate Curator of the DAR Museum in Washington, D.C.; and Alice C. Hudson, Chief of the Map Division, and Roberta Waddell, Curator of Prints, at the New York Public Library.

At Cornell a host of skilled and dedicated librarians in Olin Library and the Fine Arts Library have helped me on numerous occasions. They include Judith Holiday, Barbara Berthelsen, Marie Gast, Caroline Spicer, Robert Kibbee, Martha Hsu, and Susan Szasz. I thank them and others whose names may have slipped my memory.

Several graduate students in the Department of City and Regional Planning at Cornell scanned microfilm copies of St. Louis newspapers to search for news accounts appearing when artists and publishers issued views of the city. In this dull, time-consuming, and (alas) usually unproductive task I was fortunate to have the assistance of Gil Hanse, Robert McCollough, and Rebecca Sample.

I asked three persons to read and comment on this work when in manuscript form, individuals who had already helped in other ways and whose names appear above. They are Janice Broderick, Phyllis Brown, and Duane Sneddeker. Their notes, suggestions, comments, questions, and other reactions prevented me from making any more errors than may already appear and led me to revisions in the text that improved both its accuracy and its style.

To David Mesker, Senior Vice-President, Finance, of A. G. Edwards and Sons, I owe a special debt for his constant encouragement, expressions of support for my studies in many ways, and his unflagging interest in the progress of my work. The collection of St. Louis graphics he has been instrumental in assembling for his company reflects both his good taste and the love he has for his city.

A grant from the American Philosophical Society in Philadelphia to photograph old views of towns and cities in museums and libraries along the Mississippi took me to print and archival collections in several other places on the river. There I was able to study the work of such artists as J. C. Wild and Augustus Hageboeck who were also responsible for images of St. Louis.

The Graham Foundation of Chicago awarded a grant to have these same cities photographed from the air. The view of St. Louis from above the Illinois shore with which this book ends is one result of this larger project. I am indebted to both of these sources for their generosity in funding a study that is yet to be completed.

Finally, I lovingly acknowledge the continued support of my wife, Constance Peck Reps, who for forty years has never failed to cheer my efforts, ease my way, or hearten me in times of worry.

J.W.R.
July 1988
Ithaca, N.Y.

NOTES ON THE ILLUSTRATIONS

This list provides bibliographic information about the illustrations reproduced in this work. Keys to the abbreviations identifying locations of original impressions and to those designating other catalogs or similar works citing views or plans will be found below.

For the views in Chapter I, locations of impressions are shown only for the illustrations used in this book. For views in all other chapters these notes list the holdings of major St. Louis institutional and private collections and several important public collections elsewhere.

CODES FOR LOCATIONS OF ORIGINAL IMPRESSION

A — Author's collection
ACMW-FW — Amon Carter Museum of Western Art, Fort Worth, Texas
AGE-SL — A. G. Edwards & Sons, Inc., St. Louis, Missouri
CHS-C — Chicago Historical Society, Chicago, Illinois
CUO-I — Olin Library, Cornell University, Ithaca, New York
CUFA-I — Fine Arts Library, Cornell University, Ithaca, New York
EEN-SL — Eric and Evelyn Newman Collection, St. Louis, Missouri
HNOC-NO — Historic New Orleans Collection, New Orleans, Louisiana
KC-G — Preston Player Collection, Knox College, Galesburg, Illinois
LC-M — Division of Geography and Maps, Library of Congress, Washington, D.C.
LC-P — Division of Prints and Photographs, Library of Congress, Washington, D.C.
MAC-M — Muscatine Art Center, Muscatine, Iowa
MHS-SL — Missouri Historical Society, St. Louis, Missouri
ML-SL — The St. Louis Mercantile Library Association, St. Louis, Missouri
MM-NN — The Mariners Museum of Newport News, Newport News, Virginia
NL-C — The Newberry Library, Chicago, Illinois
NYH-NY — The New-York Historical Society, New York, New York
NYP-NY — The New York Public Library, New York, New York
SAM-SL — St. Louis Art Museum, St. Louis, Missouri
SHSM-C — State Historical Society of Missouri, Columbia, Missouri

SIU-E — Research Collections, Lovejoy Library, Southern Illinois University, Edwardsville, Illinois
SLPL-SL — St. Louis Public Library, St. Louis, Missouri
WU-SL — Special Collections, Olin Library, Washington University, St. Louis, Missouri

CODES FOR REFERENCES RECORDING VIEWS OR PLANS

ACMW-FW — Amon Carter Museum of Western Art. *Catalogue of the Collection, 1972.* Fort Worth: Amon Carter Museum of Western Art, 1973.
LC-M — U.S. Library of Congress. *Panoramic Maps of Cities in the United States and Canada: A Checklist of Maps in the Collections of the Library of Congress, Geography and Map Division.* John R. Hébert and Patrick E. Dempsey, comps. Washington, D.C.: Library of Congress, 1983.
Marsch — Marsch, Angelika. *Meyer's Universum.* Lüneburg, DDR: Nordostdeutsches Kulturwerk, 1972.
MM-NN — Mariners' Museum. *Catalog of Marine Prints and Paintings, Mariners' Museum Library, Newport News, Virginia.* 3 vols. Boston: G. K. Hall & Co., 1964.
Pyne — *Illustrated Catalogue of the Notable Collection of Views of New York and Other American Cities . . . Formed by Mr. Percy R. Pyne 2d.* Catalogue Descriptions written by Mr. Robert Fridenberg. New York: The American Art Association, 1917.
Rathbone — Rathbone, Perry T., ed. *Westward the Way.* St. Louis: City Art Museum of St. Louis, 1954.
Reps — Reps, John W. *Views and Viewmakers of Urban America: Lithographs of Towns and Cities in the United States and Canada, Notes on the Artists and Publishers, and a Union Catalog of their Work, 1825–1925.* Columbia: University of Missouri Press, 1984.
Stokes — Stokes, I. N. Phelps, and Haskell, Daniel C. *American Historical Prints: Early Views of American Cities, etc. From the Phelps Stokes and Other Collections.* New York: New York Public Library, 1932.
Wolf — Wolf, Edwin, II. *American Song Sheets, Slip Ballads, and Poetical Broadsides, 1850–1870: A Catalogue of the Collection of The Library Company of Philadelphia.* Philadelphia: The Library Company of Philadelphia, 1963.

ILLUSTRATIONS

Figure 1–1. *Venetie M.D. MCCCCC.* Detail of unsigned view of Venice in 1500 [drawn by Jacopo de' Barbari and published in Venice by Anton Kolb]. Woodcut in six sheets, 53 x 110 5/8 in. (134.5 x 281.8 cm). NL-C (later state).

Figure 1–2. Plate 43 of *Pictorial St. Louis The Great Metropolis of the Mississippi Valley: A Topographical Survey Drawn in Perspective A.D. 1875.* View of a portion of St. Louis northwest of Washington Avenue and Tenth Street, drawn by Camille N. Dry, printed by St. Louis Globe-Democrat Job Printing Co., [and published in 1875 by Richard J. Compton & Co., St. Louis]. Lithograph, 13 x 18 1/2 in. (33 x 47 cm). AGE-SL.

Figure 1–3. *Civitas Veneciaru{m}.* Detail of a view of Venice in 1486 drawn, cut, and published by Erhard Reuwich. From Bernard von Breydenbach, *Peregrinationes in Terram Sanctam* (Mainz: E. Reuwich, 1486). Woodcut, entire print, 10 3/8 x 63 3/8 in. (26.3 x 160.9 cm); detail, 10 3/8 x 14 1/4 in. (26.3 x 36.2 cm). CUO-I (facsimile).

Figure 1–4. *Roma.* Unsigned view of Rome in 1493. From Hartman Schedel, *Liber Cronicarum* (Nuremberg: Anton Koberger, 12 July 1493). Woodcut, 9 1/16 x 21 1/8 in. (23 x 53.6 cm). A.

Figure 1–5. *Die Stat Florentz.* Unsigned view of Florence probably based on a woodcut by Francesco Rosselli, ca. 1490. From Sebastian Münster, *Cosmographei Universalis* (Basel: Heinrich Petri, 1550). Woodcut with letters in metal type. 8 13/16 x 14 3/16 in. (22.4 x 36 cm). A.

Figure 1–6. *Alcmaer. . . .* Plan-view of Alkmaar, Netherlands, in 1597, drawn and engraved by Cornelis Drebbel in Alkmaar from a survey by Adriaen Anthonisz or Jacob Metius. Engraving, 17 5/8 x 23 11/16 in. (44.7 x 60.1 cm). A.

Figure 1–7. *Amstelredamvm.* Unsigned view of Amsterdam, Netherlands, in 1544, after a multi-sheet view by Cornelis Anthoniszoon. From Georg Braun and Franz Hogenberg, *Civitates Orbis Terrarum* (Antwerp: Philippum Gallaeum, and Cologne: [Georgius Bruin, Simon Novellanus, and Franciscus Hogenbergius], 1572). Engraving, 13 7/16 x 19 3/16 in. (34.1 x 48.7 cm). A.

Figure 1–8. *Delfi Batavorum Vernacule Delft.*

Undated plan-view of Delft, Netherlands, in 1649 or before, engraved by Frederick de Wit. From de Wit, *Theatrum Ichnographicum Omnium Urbium et Praecipuarum Belgicarum XVII Provinciarum . . .* (Amsterdam: Frederick de Wit, 1698). A.

Figure 1–9. *Constantinopolitana . . . 1635.* Unsigned skyline panorama view of Constantinople [now Istanbul] in 1635, engraved by Mathew Merian. From Pierre d'Avity, *Neuve Archontologia* (Frankfurt: M. Merian, ca. 1649). Engraving, 8 7/8 x 27 3/8 in. (22.5 x 69.5 cm). LC-M.

Figure 1–10. *Arcis Carolinae delineatio.* Unsigned plan-view of Fort Caroline, Florida, from a watercolor by Jacques Le Moyne in 1564. Engraved and published by Theodore de Bry. From Jacques Le Moyne, *Brevis Narratio Eorum Quae in Florida Americae Provincia Gallis Acciderunt* (Frankfurt, 1591). Engraving, 6 3/4 x 8 1/8 in. (17 x 20.5 cm). A.

Figure 1–11. *New Jorck sive Neu Amsterdam.* Unsigned view of New York ca. 1673 as published then by Hugo Allard in Amsterdam, copied and published in 1730 by Matthew Suetter in Augsburg, and reissued after 1757 by Tobias Conrad Lotter. Inset view on a map titled *Recens Edita Totius Novi Belgii in America Septentrionali.* Engraving, map, 19 1/2 x 22 3/4 in. (49.8 x 57.7 cm); view, 3 3/8 x 14 3/4 in. (18.7 x 37.5 cm). A.

Figure 1–12. *An Exact Prospect of Charlestown, the Metropolis of the Province of South Carolina.* Unsigned skyline panorama of Charleston, South Carolina [drawn by Bishop Roberts ca. 1739], published by the *London Magazine,* 1762. Engraving, 7 x 20 1/4 in. (17.8 x 51.4 cm). The Old Print Gallery, Washington, D.C.

Figure 1–13. *The Town of Boston in New England.* Plan-view of Boston in 1722, drawn by John Bonner, engraved and printed in Boston by Fra[ncis] Dewing. Engraving, 17 x 23 in. (43.1 x 58.4 cm). NYP-S.

Figure 1–14. *An East View of Montreal, in Canada. Vue Orientale de Montreal, en Canada.* Undated skyline panorama of Montreal drawn by Thomas Patten, printed for John Bowles, Robert Sayer, Thos. Jefferys, Carrington Bowles, and Henry Parker, London [1768]. Engraving, 13 5/8 x 19 15/16 in. (34.6 x 49 cm). LC-R.

Figure 1–15. *A View of Savannah as it Stood the 29th of March, 1734.* Bird's-eye view of Savannah, Georgia, in 1733, drawn by Peter Gordon,

engraved by P.[ierre] Fourdrinier, and published in London by the Trustees for Establishing the Colony of Georgia. Engraving, 15 3/4 x 21 3/4 in. (40 x 55.2 cm). LC-P.

Figure 1–16 *New-York vu de L'Ouest.* View drawn [in 1817] and lithographed [in 1821] by Ed.[ouard] de Montulé. From his *Recueil des Cartes et des Vues du Voyage en Amérique ,* accompanying his *Voyage en Amérique, en Italie, en Sicile et en Egypte, Pendant les Anneés 1816, 1817, 1818 et 1819.* Printed by Dalaunay and published in Paris in 1821. Lithograph, 7 x 9 1/2 in. (17.6 x 24 cm). A.

Figure 1–17. *Lockport from Prospect Hill.* View drawn by [George] Catlin ca. 1825. From Cadwallader Colden, *Memoir Prepared at the Request of the committee of the Common Council of the City of New York, and Presented to the Mayor of the City, at the Celebration of the completion of the New York Canals* (New York: by Anthony Imbert by order of the Corporation of New York, 1825 [1826]). Lithograph, 4 9/16 x 7 5/16 in. (11.6 x 18.7 cm). A.

Figure 1–18. *View of the Upper Village of Lockport, Niagara co. N.Y. From Above the Race, showing the Ten combined Locks on the Erie Canal 1836.* View drawn and copyrighted by W.[illiam] Wilson and printed in 1836 by [John Henry] Bufford's Lith, 144 Nassau St. N.Y. Lithograph, 15 1/8 x 20 in. (38.5 x 50.9 cm). LC-P.

Figure 2–1. *Saint Louis des Illinois Fortifié par Mr. Dom. Frs. de Cruzat en 1780 . . .* Manuscript copy made in 1846 and certified by Leon Spencer of a manuscript plan of St. Louis in 1780 drawn by Auguste Chouteau. 26 1/2 x 37 3/4 in. (67.3 x 95.8 cm). MHS-SL.

Figure 2–2. *Plan of St. Lewis with the Project of an intrenched Camp French.* From George H. Victor Collot, *Voyages dans l'Amérique Septentrionale; ou, Description des Pays Arrosés par le Mississippi, l'Ohio, le Missouri, et autres Rivièrs Affluentes . . .* (Paris: A. Berttrand, 1826), atlas volume. Engraving, 7 1/2 x 10 5/8 in. (19 x 27 cm). Impressions: LC-M.

Figure 2–3. *Partial View of St. Louis.* Unsigned view of a portion of St. Louis engraved by [William L.] Leney and [William] Rollison in New York City, published by the Bank of St. Louis in 1817. Line engraving on $10.00 bank note, 2 11/16 x 6 11/16 in. (6.9 x 17 cm). View only, 1 3/8 x 2 5/8 in. (3.4 x 6.6 cm). Impressions: EEN-SL.

Figure 2–4. Unsigned and untitled key to bank-note view of St. Louis in 1817 [prepared by Eric Newman]. From Stella M. Drumm and Isaac H. Lionberger, "Earliest Picture of St. Louis," *Glimpses of the Past* 8 (1941): 71–98, illus. p. 74.

Figure 2–5. *Plan of St. Louis, Including the late Additions.* Unsigned plan of St. Louis in 1822. From Lewis C[aleb] Beck, *A Gazetteer of the States of Illinois and Missouri* (Albany: Charles R. and George Webster, 1823). Engraving, 6 1/4 x 15 3/8 in. (15.9 x 39 cm). Impressions: EEN-SL; LC-M; ML-SL.

Figure 2–6. *St. Louis in 1832. From an original Painting by Geo Catlin in Possession of the Mercantile Library Association.* Undated view of St. Louis as painted in 1832 by George Catlin, [1865–1869]. Lithograph, 12 1/2 x 19 1/4 in. (31.8 x 48.9 cm). Impressions: AGE-SL; CHS-C; MM-NN. Recorded: MM-NN, LP 2809; Reps 2070 [N.D.].

Figure 2–7. *Saint Louis, 1832. From a Painting by L. D. Pomarade* [Pomarede]. View of St. Louis as painted by Leon. D. Pomarade in 1832. From Camille N. Dry and Rich.[ard] J. Compton, *Pictorial St. Louis: The Great Metropolis of the Mississippi Valley* (St. Louis: [Compton & Company], 1876). Lithograph, 12 3/4 x 18 7/8 in. (32.3 x 48.1 cm). Impressions: AGE-SL; EEN-SL; LC-M; MHS-SL; ML-SL; SLPL-SL; WU-SL. Recorded: MM-NN, LP 1166; Reps, 2058.

Figure 2–8. Unsigned and untitled view of St. Louis on map recorded in Figure 2–11. Lithograph, ca. 3 3/4 x 6 1/8 in. (9.5 x 15.5 cm). Impressions: EEN-SL; LC-M.

Figure 2–9. Unsigned and undated advertising card view for Steamboat *Peoria,* active 1832 until 1834. Lithograph, view only, 5 3/8 x 19 5/8 in. (13.2 x 49.8 cm). Impressions: MHS-SL.

Figure 2–10. *Front View of St. Louis.* Unsigned view, printed and published by E.[ugene Charles] Dupré [St. Louis] in *Atlas of the City and County of St. Louis, by Congressional Townships . . . up to the 1st Day of January, 1838* (St. Louis, 1838). Lithograph, 7 3/4 x 10 1/4 in. (19.7 x 26 cm). Impressions: EEN-SL; SLPL-SL; WU-SL.

Figure 2–11. *City of St. Louis.* Plan of St. Louis surveyed & designed by R.[ene] Paul, City Surveyor & Commissioner. Survey ordered 10 July 1823; completed December 1823; adopted March 1824; revised and corrected, June 1835. Drawn by

G. Kramin, printed by [George] Lehman & [Peter S.] Duval, Philadelphia. Lithograph, 18 1/2 x 32 5/16 in. (47 x 82.1 cm). Impressions: EEN-SL; LC-M.

Figure 2-12. *View of St. Louis, Mo.* Undated view of St. Louis from the Illinois shore drawn by E. W. Playter and printed by T.[homas] Moore in Boston, [1836?]. Lithograph, 13 x 19 1/4 in. (33.1 x 49 cm). Impressions: LC-P; MHS-SL. Recorded: Reps, 2040.

Figure 3-1. *View of St. Louis Taken from Illinois.* Undated view of St. Louis drawn, lithographed, [and published in 1839] by J.[ohn] C.[aspar] Wild and printed by E. Dupré of St. Louis. Lithograph, 20 1/2 x 27 5/8 in. (52.2 x 70.3 cm). Impressions: CHS-C; NYH-NY; NYP-S. Recorded: Rathbone, 188; Reps, 2025; Stokes C. 1840—E-37.

Figure 3-2. *View of Front St. Looking North from Walnut.* Undated view of Front Street in St. Louis drawn, [lithographed], printed, and published [in 1840] by J. C. Wild in St. Louis. Lithograph, 9 3/4 x 15 in. (24.8 x 38.1 cm). Impressions: MHS-SL; NYH-NY; SLPL-SL; WU-SL. Recorded: Reps, 2026.

Figure 3-3. *North East View of St. Louis. From the Illinois Shore.* Undated view of St. Louis from the northeast drawn, lithographed, [and published in 1840] by J. C. Wild, and printed at the *Missouri Republican* Office, St. Louis. Lithograph, 11 1/16 x 15 5/16 in. (28.1 x 39 cm). Impressions: MHS-SL; NYH-NY; WU-SL. Recorded: Reps, 2028.

Figure 3-4. *South East View of St. Louis from the Illinois Shore.* Undated view of St. Louis from the southeast, drawn, [lithographed, printed, and published in 1840] by J. C. Wild in St. Louis. Lithograph, 11 15/16 x 15 3/16 in. (30.4 x 38.7 cm). Impressions: MHS-SL; NYH-NY. Recorded: Reps, 2029.

Figure 3-5. *View of St. Louis from South of Chouteaus Lake.* View of St. Louis from the southwest, [drawn, lithographed], printed and published [in 1840] by J. C. Wild in St. Louis. Lithograph, 10 7/8 x 15 3/16 in. (27.7 x 38.7 cm). Impressions: KC-G; MHS-SL; NYH-NY; WU-SL. Recorded: Pyne, 494; Reps, 2027.

Figure 3-6. *View of St. Louis. From the Illinois Shore.* View of St. Louis drawn, lithographed, and published in St. Louis by J. C. Wild, and printed in St. Louis by Chambers and Knapp.

Lithograph, 6 1/4 x 8 1/4 in. (15.9 x 21 cm). From J. C. Wild, *The Valley of the Mississippi Illustrated,* unnumbered first part (St. Louis: J. C. Wild, 1841). Impressions: CHS-C; MHS-SL; ML-SL; SHSM-C; SIU-E; SLPL-SL. Recorded: Reps, 2030.

Figure 3-7. *Panorama of St. Louis and Vicinity.* View of St. Louis from the Planters Hotel as seen looking west, north, east, and south. Drawn, lithographed, and published by J. C. Wild in St. Louis, and printed in St. Louis by Chamber and Knapp. Lithograph in four sheets, 10 3/4 x 70 1/2 in. (27.3 x 179.3 cm). Numbered legend on each sheet. From J. C. Wild, *The Valley of the Mississippi Illustrated,* no. 8 (St. Louis, 1842). Impressions: CHS-C; MHS-SL; ML-SL; SHSM-C; SIU-E; SLPL-SL. Recorded: Reps, 2031.

Figure 3-8. Untitled watercolor view of Carondelet, Missouri, painted by J. C. Wild in 1841. ML-SL.

Figure 3-9. *View of Carondelet. (Vuide Poche.)* View of Carondelet, Missouri (now part of St. Louis), drawn, lithographed, and published by J. C. Wild in St. Louis. Lithograph, 6 1/2 x 8 1/2 in. (16.5 x 21.6 cm). From J. C. Wild, *The Valley of the Mississippi Illustrated,* no. 2 (St. Louis: J. C. Wild, 1841). Impressions: CHS-C; MHS-SL; ML-SL; SHSM-C; SIU-E; SLPL-SL. Recorded: Reps, 1986.

Figure 3-10. *South View of S. Louis. From the Mouth of the Cahokia, Illinois.* Undated view of St. Louis from the south with the steamboats *Meteor* and *General Pratte.* Drawn and published by J. C. Wild in St. Louis ca. 1841. Lithograph, size unknown. Impressions: none located. Known from photograph in the collection of The Old Print Shop, New York. Recorded: Reps, 2033.

Figure 3-11. *Front Street.* View of Front Street in St. Louis [drawn by J. C. Wild] and published by G[eorge] Wool[l], 32 Market Street, St. Louis, [1842 or earlier]. Lithograph, 2 5/8 x 6 7/16 in. (6.3 x 16.5 cm). Impressions: MHS-SL.

Figure 3-12. *North East View of St. Louis From the Illinois Shore.* View of St. Louis from the northeast [drawn by J. C. Wild] and published by George Wooll, No 71, Market, St. Louis. Mo. [1842-44]. Lithograph, 11 1/2 x 15 5/8 in. (29.2 x 39.7 cm). Impressions: KC-G. Recorded: Reps, 2034.

Figure 3-13. *Vue de St. Louis du Missouri.* Unsigned view of St. Louis [drawn by J. C. Wild], lithographed by Vandenbossche à Alost

[Aaist in East Flanders], from Pierre de Smet, *Voyages aux Montagnes Rocheuses . . .* (Malines: P. J. Hanico, 1844), frontispiece. Lithograph, 3 11/16 x 6 1/16 in. (9.3 x 15.4 cm). Impressions: CUO-I; ML-SL.

Figure 3-14. *View of St. Louis (Missouri).* View of St. Louis from the east drawn by J. C. Wild and engraved by J. T. Hammond. From *The Ladies Repository,* January 1845. Engraving, 5 x 7 3/4 in. (12.7 x 19.7 cm). Impressions: AGE-SL; ML-SL.

Figure 3-15. *San Louis (Mississippi).* Unsigned and undated view from Charles A. Dana, ed., *The United States Illustrated: The West* (New York: Herrmann J. Meyer, [1853]). Steel engraving, 4 7/8 x 6 5/16 in. (12.3 x 16 cm). Impressions: AGE-SL; EEN-SL; KC-G; MHS-SL; ML-SL; SLPL-SL; WU-SL.

Figure 4-1. *St. Louis, Mo. {Feb. 13} 184{2}* [material in brackets in manuscript]. Unsigned view of St. Louis from the east printed by St. Louis Lith S. Second St, No. 140, [1842 or earlier]. Lithograph, 1 3/8 x 7 1/16 in. (4.7 x 18 cm). Billhead, letterhead, or lettersheet illustration. Impressions: MHS-SL.

Figure 4-2. *Map and View of St. Louis Mo.* Undated plan and view of St. Louis drawn and printed by J.[ames] M. Kershaw, 34 Second St., St. Louis. From J. H. Sloss, *The St. Louis Directory for 1848 . . .* (St. Louis: Charles and Hammond, 1848). Lithograph, 8 1/2 x 10 1/2 in. (21.6 x 26.7 cm). 22 vignettes. Impressions: EEN-SL; LC-M; MHS-SL; SLPL-SL; WU-SL. Recorded: LC-M, 438; Reps, 2037.

Figure 4-3. *St. Louis Mo.* Unsigned and undated view of St. Louis ca. 1848, based on drawing by James M. Kershaw, engraved by H.[enry?] Fisher, St. Louis. Engraving, 5 7/8 x 12 7/8 in. (14.7 x 32.6 cm). Lettersheet illustration. Impressions: MHS-SL.

Figure 4-4. *View of St. Louis.* Unsigned and undated view of St. Louis printed by J.[ulius] Hutawa [St. Louis.], [1846-47?]. Lithograph, 20 5/16 x 23 1/2 in. (51.6 x 59.7 cm). 6 vignettes. Impressions: CHS-C; EEN-SL. Recorded: Reps, 2036.

Figure 4-5. *St. Louis.* Undated view of St. Louis drawn by Henry Lewis ca. 1846-1848. [Printed by C. H. Müller, Aachen] and published by Arnz & Co., Düsseldorf, 1854-1857.

Lithograph, 5 7/8 x 7 13/16 in. (15 x 19.9 cm). From Lewis, *Das Illustrirte Mississippithal.* Impressions: EEN-SL; HNOC-NO; LC-R; MHS-SL; ML-SL; NL-C; NYH-NY; SAM-SL; SIU-E; SLPL-SL. Recorded: Reps, 2046.

Figure 4-6. *Carondelet or Vide-Poche, Missouri. Carondelet oder Vide-Poche. (Die leere Tasche) Missouri.* Undated view of Carondelet, Missouri, drawn by Henry Lewis ca. 1846-1848. [Printed by C. H. Müller, Aachen] and published by Arnz & Co., Düsseldorf, 1854-1857. Lithograph, 6 1/8 x 7 11/16 in. (15.6 x 19.6 cm). From Lewis, *Das Illustrirte Mississippithal.* Impressions: EEN-SL; HNOC-NO; LC-R; MHS-SL; ML-SL; NL-C; NYH-NY; SAM-SL; SIU-E; SLPL-SL. Recorded: Reps, 1987.

Figure 4-7. *View of St. Louis, Mo.* Undated and unsigned view of St. Louis from the east printed by Juls. [Julius] Hutawa, Lithr. Second St. No. 45, St. Louis, Mo., [1849?]. Lithograph 22 5/8 x 34 1/16 in. (57.6 x 86.7 cm). Impressions: AGE-SL; EEN-SL; MHS-SL. Recorded: Reps, 2043 [dated 1854].

Figure 4-8. *View of the City of St. Louis The Great Fire of the City on the 17th & 18 May, 1849.* View of the St. Louis fire in 1849 drawn by L[eopold] Gast, and an unsigned map of the burned district. Printed and published by Juls. [Julius] Hutawa Lithr. Chestnut St. 62 St. Louis, Mo., 1849. Engraving, 15 1/2 x 20 1/2 in. (39.3 x 52 cm). Impressions: AGE-SL; EEN-SL.

Figure 4-9. *Great Fire at St. Louis, Mo. Thursday Night May 17, 1849.* Unsigned view of the St. Louis fire in 1849, printed and published by N.[athaniel] Currier 252 Nassau St. cor of Spruce N.Y. Lithograph, 8 13/16 x 12 3/4 in. (22.4 x 32.5 cm). Impressions: AGE-SL; EEN-SL; NYH-NY. Recorded: Reps, 2039.

Figure 4-10. *The Great Fire in St. Louis May 17th 1849. Der Grosse Brand in St. Louis am 17. Mai 1849.* View of the St. Louis Fire in 1849 drawn by Henry Lewis. [Printed by C. H. Müller, Aachen] and published by Arnz & Co., Düsseldorf, 1854-1857. Lithograph, ca. 6 x 7 3/4 in. (15.2 x 19.7 cm). From Lewis, *Das Illustrirte Mississippithal.* Impressions: AGE-SL; EEN-SL; HNOC-NO; LC-R; MHS-SL; MHS-SP; ML-SL; NL-C; NYH-NY; SAM-SL; SLPL-SL; SIU-E.

Figure 4-11. [Untitled view of St. Louis] at top of *Plan of the City of St. Louis, Mo,* second 1850 edition. Plan drawn by Julius Hutawa and pub-

lished by Juls. [Julius] Hutawa and L.[eopold] Gast, Lithrs. N. Second St. 45 near Pine St., 1850. Lithograph, map, 25 x 34 7/8 in. (63.5 x 88.6 cm); view, 5 1/2 x 20 in. (14 x 50.8 cm). Impressions: ML-SL.

Figure 4-12. *St. Louis Mo. 1853.* View of St. Louis drawn and lithographed by E.[duard] Robyn and printed and published by E. [duard] and C.[harles] Robyn Lithogrs. No. 44 n. 2nd St. [St. Louis], 1853. Lithograph, 13 7/8 x 26 in. (35.2 x 65.8 cm). Impressions: ACMW-FW; MHS-SL. Recorded: Reps, 2042.

Figure 4-13. *St. Louis Mo.* View of St. Louis [drawn by Eduard Robyn], printed by E.[duard] and C.[harles] Robyn in St. Louis, and sold by C. Witter, 38 Walnut Str. [St. Louis], [1853?]. Lithograph, 4 x 8 5/16 in. (10.1 x 21.1 cm). Impressions: WU-SL.

Figure 4-14. *Saint Louis, Mo. in 1855.* Unsigned view of St. Louis printed and published by Leopold Gast & Brother [St. Louis], 1855. From [John Hogan], *Thoughts About the City of St. Louis, her Commerce and Manufactures, Railroads, &c* (St. Louis, 1854). Engraving on stone, 7 3/4 x 51 3/8 in. (19.7 x 130.5 cm). Impressions: AGE-SL; EEN-SL; KC-G; LC-P; MHS-SL; NL-C. Recorded: Reps, 2044.

Figure 4-15. *View of St. Louis.* Unsigned view of St. Louis from [Robert Sears], *A New and Popular Pictorial Description of the United States* (New York, 1848). Wood engraving, 4 1/8 x 6 in. (10.5 x 15.2 cm). Impressions: AGE-SL (from *Sears Pictorial Description of the U.S.* [New York, 1854]); EEN-SL.

Figure 4-16. *View of the City of St. Louis, Missouri.* View of St. Louis drawn by Wade, engraved by Pierson, printed and published in *Gleason's Pictorial*, 15 April 1854. Wood engraving, 5 3/4 x 9 3/8 in. (14.6 x 23.8 cm). Impressions: AGE-SL; CUO-I; EEN-SL; ML-SL.

Figure 4-17. *St. Louis.* View of St. Louis drawn [in 1853] by F.[rederick] Piercy, engraved by C.[harles] Fenn, and published in *Route from Liverpool to Great Salt Lake Valley* (London, 1855). Steel engraving, 9 x 11 3/4 in. (22.8 x 29.8 cm). Impressions: AGE-SL; MHS-SL; ML-SL.

Figure 4-18. *St. Louis, Missouri.* Unsigned view of St. Louis, published in *Harper's Weekly*, 4 July 1857. Wood engraving, 3 x 9 3/16 in. (7.6 x 23.3

cm). Impressions: AGE-SL; EEN-SL; MHS-SL; ML-SL.

Figure 4-19. *View of St. Louis.* View of St. Louis drawn by R. Telfer, engraved by D. Scattergood, published in James T. Lloyd, *Lloyd's Steamboat Directory* (Cincinnati, 1856). Wood engraving, 3 3/8 x 6 1/16 in. (8.6 x 15.4 cm). Impressions: ML-SL.

Figure 4-20. [Title obliterated]. View of St. Louis drawn by Devereux [Devraux] [in 1854], published in *St. Louis Pictorial Advertiser*, St. Louis, [1858?]. Wood engraving, ca. 5 3/4 x 9 1/16 (14.6 x 23 cm). Impressions: ML-SL.

Figure 5-1. *St. Louis, 1852.* View of St. Louis drawn by J.[ohn] W.[illiam] Hill and [Benjamin Franklin?] Smith, printed by F[rancis]. Michelin 225 Fulton St, N.Y., and published by Smith Brothers & Co., New York, 1852. Lithograph, 26 x 41 7/8 in. (66.2 x 106.5 cm). Impressions: AGE-SL (cropped); EEN-SL; KC-G; MHS-SL; MM-NN. Recorded: MM-NN, LP 1864; Reps, 2041.

Figure 5-2. *St. Louis.* View of St. Louis drawn by J. W. Hill [and (Benjamin Franklin?) Smith], engraved by Wellstood & Peters, printed by Middleton Wallace [Cincinnati], and published in the *Ladies Repository*, January 1855. Steel engraving, 4 3/4 x 7 3/4 in. (12.1 x 19.7 cm). Impressions: AGE-SL; EEN-SL; MHS-SL.

Figure 5-3. *View of St. Louis, Missouri.* View of St. Louis drawn by G.[eorge] Hofmann, based in part on a daguerreotype by [Thomas M.] Aesterly [Easterly], engraved by E.[mille] B. Krausse, printed in New York by W. Pate, and published by C.[harles] A. Cuno, Krausse & Hofmann 31 South Main St St. Louis, Mo, [1854]. Line engraving, 25 x 36 in. (63.5 x 91.4 cm). Impressions: AGE-SL; EEN-SL; MHS-SL.

Figure 5-4. *St. Louis.* Unsigned view of St. Louis [by G. Hofmann], published by Charles Magnus, 12 Frankfort St NY. [ca. 1854]. Line engraving, 4 1/2 x 7 1/4 in. (11.4 x 18.4 cm). Impressions: AGE-SL; MHS-SL.

Figure 5-5. *Bird's Eye View of the City of St. Louis.* Unsigned view of St. Louis [by G. Hofmann], from Richard Edwards and M. Hopewell, *Edwards' Great West* (St. Louis, 1860). Wood engraving, 4 3/4 x 7 1/2 in. (12.1 x 19 cm). CUO-I; EEN-SL; MHS-SL; ML-SL.

Figure 5-6. *Our City (St. Louis, Mo.).* Unsigned view of St. Louis [based in part on view by G.

Hofmann], printed by A. Janicke & Co. 3d st opp the Post Office St Louis, published by Hagen & Pfau at the *Anzeiger des Westens*, 1859. Lithograph, 16 15/16 x 22 in. (43 x 55.8 cm). Impressions: AGE-SL; LC-P; MHS-SL. Recorded: LC-M, 438.1; Reps, 2049.

Figure 5-7. *Kennedy's Sectional Map of St. Louis. with Street Directory.* Unsigned plan of St. Louis, printed by Alex. McLean 15 Chestnut St, [St. Louis], published by R. V. Kennedy, 1859. Lithograph, 16 x 19 in. (40.6 x 48.2 cm). Impressions: MHS-SL; ML-SL.

Figure 5-8. *Bird's Eye view of St. Louis Mo.* View of St. Louis drawn [and published?] by J.[ames] T. Palmatary in 1858, and printed by Middleton Strobridge & Co., Cin.[cinnati] O.[hio]. Lithograph, 54 x 93 in. (137.5 x 236.7 cm). Impressions: MHS-SL. Recorded: Reps, 2048.

Figure 5-9. Detail of Figure 5-8 showing central and northern portions of St. Louis.

Figure 5-10. Detail of Figure 5-8 showing west-central portions of St. Louis.

Figure 6-1. *St. Louis.* View of St. Louis in 1854 by Professor Devraux of Philadelphia, from Richard Edwards and M. Hopewell, M.D., *Edwards' Great West* (St. Louis, 1860). Wood engraving, ca. 5 1/8 x 7 9/16 in. (13 x 19.2 cm). Impressions: EEN-SL; MHS-SL; ML-SL.

Figure 6-2. Untitled and unsigned headpiece view of St. Louis from *Edwards' Descriptive Gazetteer and Commercial Directory of the Mississippi River from St. Cloud to New Orleans* (St. Louis, 1866). Wood engraving, 7/8 x 4 1/4 in. (2.3 x 10.4 cm). Impressions: ML-SL.

Figure 6-3. *St. Louis.* Unsigned and undated view published by Charles Magnus 12 Franklin St. N.Y. Part of illustration on patriotic envelope. Engraving, view with figure, 2 3/4 x 4 9/16 in. (7 x 11.5 cm). EEN-SL; LC-P.

Figure 6-4. *St. Louis Mo.* Undated and unsigned view, published by C.[onrad] Witter 27 Cor of Walnut & 2nd Sts. St. Louis Mo [1852–1862]. Engraving, entire sheet, 11 1/8 x 9 1/4 in. (28.2 x 23.5 cm); view only, 2 1/2 x 7 in. (6.4 x 17.8 cm). Lettersheet illustration. Impressions: LC-P.

Figure 6-5. *St. Louis Mo.* Undated and unsigned view of St. Louis published by Eli Adams, agent, No. 267 1/2 Broadway, under

Keevil's Big Hat. St. Louis. Lettersheet illustration. Lithograph, 4 1/4 x 7 1/8 in. (10.8 x 18.1 cm). Impressions: MHS-SL.

Figure 6-6. Untitled, undated, and unsigned view of St. Louis published ca. 1867 by the Western Transit Insurance Company, St. Louis. On broadside advertising policies and services of the company. Wood engraving, 6 x 9 15/16 in. (15.2 x 25.2 cm). Impressions: MHS-SL.

Figure 6-7. *St. Louis.* View of St. Louis drawn and engraved by Boullemier and printed ca. 1867 by Gilquin et Dupain, r. de la Calandre, 19 Paris. Steel engraving, 4 9/16 x 5 3/4 in. (11.6 x 14.6 cm). Impressions: AGE-SL; Art Gallery, Washington University, St. Louis; MHS-SL.

Figure 6-8. *Carondelet, Mo.* Undated and unsigned view of Carondelet, Missouri (now part of St. Louis), published ca. 1860 by Th.[eodor] Schrader, Lithr. No. 42 North 2nd Street St. Louis. Lithograph, 21 1/2 x 26 5/8 in. (54.8 x 67.8 cm). 12 vignettes. Impressions: Carondelet Historical Society; MHS-SL. Recorded: Reps, 1988.

Figure 6-9. *View of St. Louis from Lucas Place.* Undated and unsigned view of St. Louis from the west, printed by E. Sachse & Co., Baltimore and published ca. 1865 by Edw. Buehler, 15 S. 4th Str. St. Louis. Lithograph, 18 1/2 x 30 7/8 in. (47.1 x 78.5 cm). Impressions: CHS-C; MHS-SL; MM-NN. Recorded: MM-NN, LP 490; Rathbone, 194; Reps, 2050.

Figure 6-10. *Saint Louis, Mo. in 1868.* Unsigned view of St. Louis engraved, printed, and published by Gast, Moeller & Co. Lithographers, 225 Olive St., St. Louis, 1868. Lithograph, 6 1/4 x 53 1/4 in. (15.8 x 135.2 cm). Impressions: AGE-SL; MHS-SL.

Figure 6-11. *St. Louis,—A General View of the City from East St. Louis.* View of St. Louis from the northeast by A.[lfred] R. Waud, engraved by Kilburn, from *Every Saturday*, 14 October 1871. Wood engraving, 9 x 18 1/2 in. (22.8 x 47 cm). Impressions: AGE-SL; EEN-SL; MHS-SL; ML-SL.

Figure 6-12. *The City of St. Louis.* View of St. Louis from the southeast drawn by A. C. Warren, and [engraved by R. Hinshelwood], from William Cullen Bryant, ed., *Picturesque America; or, The Land We Live In* (New York, [1872]), II. Steel engraving, 6 1/2 x 9 1/4 in. (16.5 x 23.5 cm). Impressions: AGE-SL; EEN-SL; ML-SL.

Figure 6-13. *St. Louis, Missouri.* View of St.

Louis from the southeast drawn by C.[harles] A. Vanderhoof, engraved by Schell and Hogan, from *Harper's Weekly*, 8 July 1876. Wood engraving, 9 3/8 x 13 5/8 in. (23.8 x 34.5 cm). Impressions: AGE-SL; EEN-SL; MHS-SL.

Figure 6–14. *Saint Louis, Mo.* View of St. Louis engraved, printed, and published by A.[ugustus] Hageboeck, St. Louis, Mo, [Davenport, Iowa] 1874. Line engraving, probably on stone, 8 7/8 x 24 7/8 in. (22.5 x 63.2 cm). Impressions: EEN-SL; LC-P. Recorded: Reps, 2054.

Figure 6–15. *St. Louis Times' Picture of The Bridge, River & City.* Undated and unsigned view of St. Louis from the northeast published by the *St. Louis Times*, ca. 1874. Lithograph and stone engraving, 14 1/2 x 37 1/2 in. (36.8 x 95.2 cm). Impressions: AGE-SL.

Figure 6–16. *The City.—As Seen from the roof of Advance Elevator, East St. Louis.* View of St. Louis based on the *St. Louis Times* view of ca. 1874. From *Saint Louis Illustrated . . .* (St. Louis: Will Conklin, 1876). Wood engraving, 7 3/16 x 15 1/2 in. (18.2 x 39.3 cm). Impressions: ML-SL; SIU-E; WU-SL.

Figure 6–17. *The Bridge at St. Louis.* View of St. Louis from the south, drawn or lithographed by F.[erdinand?] Welcker and published by Compton & Co., St. Louis, 1874. Lithograph, 27 3/4 x 38 1/2 in. (70.6 x 98 cm). 8 vignettes, 1 portrait. Impressions: AGE-SL; LC-P; The Old Cathedral Museum, St. Louis. Recorded: Rathbone, 206; Reps, 2055.

Figure 6–18. *Birds Eye View of St. Louis Showing the New Line of the St. Louis, Kansas City & Northern Ry. Running into the Union Depot.* Unsigned view of St. Louis from the south copyrighted by C.[harles] K. Lord, 1876. Lithograph, 12 x 23 3/4 in. (30.5 x 60.5 cm). 15 references, 2 vignettes. Impressions: LC-M; MHS-SL. Recorded: Reps, 2059; LC-M, 439.1.

Figure 7–1. *St. Louis.* Unsigned view of St. Louis published by Geo.[rge] Degan, New York, 1873. Lithograph, 15 1/16 x 22 13/16 in. (38.3 x 58.2 cm). Impressions: KC-G; LC-P. Recorded: LC-M, 438.2; Reps, 2052.

Figure 7–2. *The City of St. Louis.* View of St. Louis drawn by [Charles R.] Parsons and [Lyman] Atwater, and published by [Nathaniel] Currier & [James] Ives, New York, 1874. Lithograph, 21 1/4 x 32 5/8 in. (55.3 x 83 cm). 32

unnumbered references below places identified. Impressions: ACMW-FW; AGE-SL; CHS-C; EEN-SL; KC-G; MHS-SL; ML-SL; MM-NN; SAM-SL; SHSM-C. Recorded: ACMW-FW, 1578; LC-M, 438.3; MM-NN, LP 45; Reps, 2056.

Figure 7–3. *Pictorial St. Louis The Great Metropolis of The Mississippi Valley: A Topographical Survey Drawn in Perspective A.D. 1875.* Title page from book by Camille N. Dry and Rich.[ard] J. Compton. [St. Louis: Richard J. Compton & Co.], 1875. Printed by St. Louis Globe-Democrat Job Printing Co. Lithograph, 11 3/4 x 18 in. (30 x 46 cm). Impressions: ACMW-FW; AGE-SL; EEN-SL; LC-M; MHS-SL; ML-SL; WU-SL. Recorded: LC-M, 439; Reps, 2057.

Figure 7–4. *Specimen Page, From Manufacturing Portion of the City.* Undated and unsigned view of a portion of St. Louis [drawn by Camille N. Dry] and published by Compton & Company, No. 3, St. Louis Life Insurance Building, Cor. Sixth and Locust, St. Louis, [1874?]. Lithograph, 13 x 18 1/2 in. (33 x 47 cm). Advertising text below image. Impressions: MHS-SL.

Figure 7–5. *The Perspective. Key to the Perspective Locating the Plates. Map of the Territory in the Above Perspective.* Unsigned plan and perspective diagram of St. Louis [drawn by Camille N. Dry], copyright in 1874, from Camille N. Dry and Rich.[ard] J. Compton, *Pictorial St. Louis. . . .* Lithograph, 13 x 18 1/2 in. (33 x 47 cm). See entry for Figure 7–3 for additional details.

Figure 7–6. Plate 42 of *Pictorial St. Louis* showing Lucas Place and vicinity. See entry for Figure 7–3 for additional details.

Figure 7–7. Plate 85 of *Pictorial St. Louis* showing Vandeventer Place and vicinity. See entry for Figure 7–3 for additional details.

Figure 7–8. Plates 74, 75, 52, and 49 of *Pictorial St. Louis* showing St. Louis Place and vicinity. See entry for Figure 7–3 for additional details.

Figure 7–9. Plates 77, 78, 47, and 48 of *Pictorial St. Louis* showing the St. Louis Water Works and vicinity. See entry for Figure 7–3 for additional details.

Figure 7–10. Plates 7, 8, 15, and 16 of *Pictorial St. Louis* showing the eastern end of Victor Street and vicinity. See entry for Figure 7–3 for additional details.

Figure 7–11. Plates 23, 24, 3, and 4 of *Pictorial*

St. Louis showing the railroad depots west of Seventh Street and vicinity. See entry for Figure 7–3 for additional details.

Figure 7–12. Plates 21, 22, 1, and 2 of *Pictorial St. Louis* showing the central business district. See entry for Figure 7–3 for additional details.

Figure 7–13. Plates 58, 55, 38, and 39 of *Pictorial St. Louis* showing Lafayette Park and vicinity. See entry for Figure 7–3 for additional details.

Figure 7–14. Plates 91, 92, 65, and 66 of *Pictorial St. Louis* showing Tower Grove Park and vicinity. See entry for Figure 7–3 for additional details.

Figure 7–15. Plates 99, 100, 89, and 90 of *Pictorial St. Louis* showing Forest Park and vicinity. See entry for Figure 7–3 for additional details.

Figure 8–1. *The Levee and Great Bridge at St. Louis.* Undated and unsigned view of St. Louis from the north, from Willard Glazier, *Peculiarities of American Cities* (Philadelphia: Hubbard Brothers, 1883). Wood engraving, 3 1/4 x 6 in. (8.2 x 15.2 cm). Impressions: EEN-SL; ML-SL.

Figure 8–2. *Views in Saint Louis.* Undated views of St. Louis drawn by Thompson, from Willard Glazier, *Down the Great River; Embracing an Account of the Discovery of the True Source of the Mississippi . . .* (Philadelphia: Hubbard Brothers, 1888). Wood engraving, 3 3/8 x 6 1/8 in. (8.5 x 15.5 cm). CUO-I; ML-SL.

Figure 8–3. *A Pen Picture of the Progress of the City of Saint Louis, Mo.* Views of buildings in St. Louis drawn and published in 1884 by Henry M. Vogel and, printed in St. Louis by J. E. Lawton Printing Co. Lithograph, 18 1/2 x 26 in. (47 x 66.1 cm). 37 vignettes. Impressions: CHS-C; LC-M. Recorded: LC-M, 440; Reps, 2060.

Figure 8–4. *St. Louis, From the Mississippi River.* Views of St. Louis looking north and of the levee from the Eads Bridge looking southwest drawn by Charles Graham. From *Harper's Weekly*, supplement, 4 June 1888. Wood engraving, 9 1/2 x 13 3/4 in. (24.1 x 34.8 cm). Impressions: AGE-SL; EEN-SL; MHS-SL; ML-SL.

Figure 8–5. *View of the City of St. Louis.* View of St. Louis from the northeast drawn by Frank Adams, from *Frank Leslie's Illustrated Newspaper*, 9 June 1888. Wood engraving, 4 7/16 x 19 3/4 in. (11.2 x 51 cm). On sectioned sheet with interior

and exterior scenes of the city, Impressions: EEN-SL.

Figure 8–6. *View West From Court House.* View of St. Louis looking west from the Courthouse from *St. Louis Album*, drawn by Louis Glaser, copyrighted in 1886 by Adolph Wittemann, 25 Park Place, New York, and published by Jas Overton, Southern Hotel, St. Louis, Mo. Collotype, 5 5/8 x 18 1/2 in. (14.3 x 47 cm). On sectioned double panel with views of four buildings and with references numbered 1–18. Impressions: LC-P.

Figure 8–7. *St. Louis in '93.* View of St. Louis drawn and lithographed by Fred. Graf, and printed by Fred. Graf Litho. S. E. cor. 3d & Locust. StL., 1893. Lithograph, 25 x 39 1/8 in. (63.5 x 96.8 cm). Numbered references 1–74 below image. Impressions: LC-M; LC-P. Recorded: LC-M, 441; Reps, 2061.

Figure 8–8. *The Panorama of St. Louis.* Bird's-eye view of St. Louis from the southeast drawn and published in St. Louis by Chas. Juehne, 1894. 40 numbered references below image. Lithograph, 18 x 24 in. (45.8 x 61 cm). Impressions: LC-M. Recorded: LC-M, 442; Reps, 2062.

Figure 8–9. *St. Louis in 1896.* Bird's-eye view of St. Louis from the southeast drawn, printed, and published in St. Louis by Chas. Juehne, 1896. Lithograph, 23 1/2 x 40 in. (59.7 x 101.7 cm). 50 numbered references below image. Impressions: AGE-SL; LC-M. Recorded: LC-M, 445; Reps, 2065.

Figure 8–10. *The City of St. Louis—Looking Toward the Eads Bridge, and Showing the Region Devastated by the Tornado of May 27, 1896.* Elevated view of St. Louis from the south drawn by G. W. Peters. From *Harper's Weekly*, 6 June 1896. Halftone reproduction of drawing or watercolor, 13 3/8 x 19 5/16 in. (34 x 49 cm). Impressions: AGE-SL; EEN-SL; MHS-SL; ML-SL.

Figure 8–11. *Saint Louis in 1896.* Bird's-eye view of St. Louis from the east drawn by Fred Graf and published by Graf Eng. Co., St. Louis, 1896. Lithograph, 26 x 40 1/2 in. (66.1 x 103 cm). Impressions: AGE-SL; LC-M. Recorded: LC-M, 444; Reps, 2064.

Figure 8–12. *Saint Louis Special Map.* Topographical map of St. Louis and vicinity surveyed in 1903 and published by the U.S. Geological Survey, [Washington], 1904. Lithograph, 17 1/4 x

19 1/8 in. (43.8 x 48.5 cm). Impressions: CUO-I.

Figure 8–13. *St. Louis in 1832. From an Original Painting by Geo. Catlin in Possession of the Mercantile Library Association.* Undated view of St. Louis in 1832 by George Catlin, published ca. 1902. Wood engraving, 6 1/2 x 10 1/2 in. (16.5 x 26.6 cm). Impressions: AGE-SL; ML-SL.

Figure 8–14. *The Heart of St. Louis.* Elevated view of downtown St. Louis from the northeast drawn by Fred Graf and published by Fred Graf Engraving Co., St. Louis, 1907. Lithograph, 19 1/2 x 24 1/2 in. (49.6 x 62.3 cm). Impressions: AGE-SL; LC-M. Recorded: LC-M, 448; Reps, 2068.

Figure 8–15. Aerial photograph of St. Louis from the east taken by Alex MacLean, Landslides, September 30, 1987, 8:15 A.M., altitude 1,200 feet.

OTHER VIEWS OF ST. LOUIS NOT ILLUSTRATED IN THIS BOOK

The views listed below are those located and examined but which have not been reproduced in this work. They are arranged in chronological order of publication. Insofar as possible, each entry conforms to the style used for the illustrations, and the same abbreviations used in that section apply here as well.

1841–1844

South East View of St. Louis. From the Illinois Shore. Unsigned and undated view of St. Louis [drawn by J. C. Wild], printed 1841–1844 by George Wooll, No 71 Market Street [St. Louis]. Lithograph, 11 15/16 x 15 5/15 in. (30.4 x 38.7 cm) Impressions: MHS-SL. Recorded: Pyne, 493; Reps, 2035.

1848?

St. Louis & New Orleans Packet Steamer Grand Turk, N. Robirds, Master. . . . Undated view of portions of St. Louis in background of portrait of steamship, drawn by H. S. Blood, printed by Fishbourne, Lithog. 46 Canal Street, New Orleans [1848?]. Lithograph, 18 x 26 1/2 in. (45.8 x 67.5 cm). Impressions: MHS-SL. Recorded: Reps, 2038.

1847–1851

Untitled and undated view of St. Louis within irregular oval inset on *Map of the City of St. Louis,*

Mo., published by Julius Hutawa Lithographer North Second Street No 45 St Louis Mo.

[1847–51]

Lithograph, size unknown. Impressions: none located. Information from glass-plate negative in MHS-SL.

1847–1851?

St. Louis Mo. Undated and unsigned view printed by Juls. Hutawa's Lith. Estl. [St. Louis]. Lithograph, 3 3/4 x 7 3/8 in. 9.5 x 18.7 cm). Frontispiece to *A Guide to Pomarede's Original Panorama of the Mississippi River.* Impressions: Ohio Philosophical and Historical Society, Cincinnati.

1854

Untitled view of St. Louis on twenty-year, $1,000 bond issued by the City of St. Louis for the Saint Louis & Iron Mountain Railroad Company 1 January 1854 [date in manuscript]. Engraving, 1 5/8 x 15 3/4 in. (3.8 x 40 cm). Impressions: MHS-SL.

1854

St. Louis. Unsigned view of St. Louis in *Die Gartenlaube,* January 1854, p. 10. Wood engraving, 5 1/2 x 7 3/8 in. (14 x 18.7 cm). Impressions: MM-NN.

1855

St Louis. Inset view of St. Louis on J. M. Atwood, *Map of the Western States* in *Ensign & Thayer's Travellers' Guide Through the States of Ohio, Michigan, Indiana, Illinois, Missouri, Iowa, and Wisconsin . .* (New York: Ensign, Bridgman & Fanning, 1855). Lithograph, entire map, 22 1/2 x 27 1/2 in. (57.1 x 69.8 cm); view only, 2 3/4 x 4 in. (7 x 9.9 cm). Impressions: Jonathan Flaccus, Putney, Vermont.

1855?

Untitled and unsigned inset view of St. Louis on a plan of the city titled *City of St Louis from February 15, 1841 to Decr. 5, 1855,* published by Julius Hutawa Lithographer North Second St No. 45 St. Louis, Mo. Lithograph, entire map, 10 1/2 x 26 in. (265.6 x 66 cm); view only, 3 3/16 x 7 1/2 in. (8.1 x 19 cm). Impressions: MHS-SL.

1855?

⌐Saint Louis, Mo. in 1855?⌐ View of St. Louis printed and published by Leopold Gast & Brother, St. Louis, 1855?. Engraving on Stone, 7 3/4 x 51 3/8 in. (19.7 x 130.5 cm)[?]. Presumed second state of view in Figure 4–14 and differing only in the addition of 75 numbered references in body of view. Impressions: none located. Publication assumed from evidence summarized in Chapter VI.

1856

View of St. Louis (Missouri). View of St. Louis from the east drawn by J. C. Wild and engraved by J. T. Hammond. From *The American Encyclopedia of History, Biography and Travel . . .* (Columbus: J. & H. Miller, 1856 [and subsequent editions]). Engraving, 5 x 7 3/4 in. (12.7 x 19.7 cm). Apparently identical to Figure 3–14. Impressions: CUO-I.

1856

St. Louis - The Great Commercial Metropolis of the West. Unsigned and undated view of St. Louis similar to Figure 3–15. From J.[oseph] C.[amp] G.[riffith] Kennedy, *The Progress of the Republic, Embracing a Full and Comprehensive Review of the Progress, Present Condition . . . and Industrial Resources of the American Confederacy . . .* (Washington, W. M. Morrison & Co., [1856]). Wood engraving, 5 1/2 x 9 in. (14 x 22.8 cm). Impressions: AGE-SL.

1857

San Louis am Mississippi. View published in *Meyer's Universum,* XIX, Hildburghausen, Germany, 1857. Roman numerals DCCCLXXXII at upper right above image. Steel engraving , 4 7/8 x 6 5/16 in. (12.3 x 16 cm). Image of city identical to Figure 3–15. Same plate also published in *Conversations-Lexikon,* Hildburghausen, J. Meyer, 1857–1860. Impressions: AGE-SL; KC-G; MHS-SL; Recorded: Marsch, p. 80.

1860–1861?

St. Louis. Unsigned view of St. Louis based on the engraved view by G. Hofmann published in 1854. From *Souvenir Album of the Visit to America in 1860 of Albert Edward, Prince of Wales* [1860–1861?]. Wood engraving (?), ca. 5 x 8 in. (12.7 x 20.2 cm). Impressions: none located. Information from photograph in file of The Old Print Shop, New York, N.Y.

1861

Central Part of the Levee, at St. Louis. Unsigned view of a portion of the St. Louis waterfront, from John Warner Barber and Henry Howe, *Our Whole Country. A Panorama and Encyclopedia of the United States,* 2 vols. (Cincinnati: Charles Tuttle, 1861), 2:1271. Wood engraving, 3 x 4 in. (7.6 x 10.2 cm). Impressions: CUO-I.

1863?

Untitled and undated view of St. Louis placed near the city's location on a map, *Panorama of the Mississippi Valley and its Fortifications,* engraved by

F. W. Boell and published by C.[harles] Magnus, 12 Frankfort Street New York. Engraving, entire map, 23 1/8 x 25 1/8 in. (58.7 x 63.8 cm); view only, 2 x 2 1/2 in. (5.1 x 6 cm). View apparently identical to Figure 6–3. Impressions: LC-M.

1860–65?

St. Louis. Unsigned and undated view of St. Louis, published by Charles Magnus, 12 Franklin St. N.Y. Engraving, 2 1/8 x 2 7/16 in. (5.4 x 6.2 cm). Song sheet headpiece on "There's a Good Time Coming." Apparently identical to Figure 6–3. Impressions: Library Company of Philadelphia. Recorded: Wolf, *Song Sheets,* 2316.

1865

St. Louis. Unsigned view of St. Louis on accident insurance certificate issued by the Western Transit Insurance Co. 15 November 1865. Lithograph, ca. 1 3/4 x 6 1/2 in. (4.5 x 16.5 cm). Impressions: Library, MHS-SL.

1871

View of the Bridge Now Building Across the Mississippi at St. Louis. View of the Eads Bridge and City of St. Louis from the Shot Tower, drawn by Robert P. Mallory, from *Every Saturday,* 14 January 1871, 44–45. Wood engraving, 11 3/4 x 18 1/4 in. (29.8 x 46.4 cm). Impressions: ML-SL.

Ca. 1871

St. Louis, Mo. Unsigned and undated view copyright by G. Hofmann. Wood engraving (?), size unknown. Information from photograph in MHS-SL. Impressions: none located.

1872

Vista de S. Louis, Missouri. Unsigned view looking south to the Eads Bridge engraved by Kilburn, from *O Novo Mundo,* 23 March 1872. Wood engraving, ca. 14 x 20 in. (35.5 x 50.8 cm). Impressions: NYH-NY.

1874

Untitled and unsigned view of the Eads Bridge and St. Louis copyright by Compton and Co. [St. Louis] and printed by the St. Louis Democrat Lithography & Print. Company, [1874]. On invitation to dedication of the bridge. Lithograph, view only, 3 1/8 x 7 3/8 in. (7.9 x 18.7 cm). Impressions: MAC-M.

Ca. 1874

View of St. Louis, Missouri. Unsigned and undated view based on the steel engraving of 1872 recorded as Figure 6–12. Probably an illustration from an unidentified book. Wood engraving, 5

1/2 x 4 1/2 in. (14 x 11.4 cm). Impressions: AGE-SL.

1876
St. Louis in 1832. From an Original Painting by Geo Catlin in Possession of the Mercantile Library. Insert view of St. Louis in 1832 on *Historical Map of the United States* . . . (Chicago: edited by Rufus Blanchard, 1876). Copyright by Rufus Blanchard. Lithograph, ca. 5 1/2 x 14 in. (14 x 35.5 cm). Impressions: Map Division, New York Public Library.

1876
Saint Louis in 1851. View based on lithograph by Smith and Hill in 1852, drawn by F. Merk, from *Saint Louis Illustrated* . . . (St. Louis: Will Conklin, 1876), 12. Wood engraving, 4 7/8 x 7 7/8 in. (12.4 x 20 cm). Impressions: WU-SL.

1878
View of the City of St. Louis and the Mississippi River, Looking Down Stream. View of St. Louis from the northeast, drawn by Wm. T. Keller, engraved by Telfer (?). From the *London Daily Graphic*, 6 January 1878. Wood engraving, 8 1/16 x 18 1/4 in. (20.5 x 46.3 cm). Impressions: MHS-SL.

1878?
St. Louis. Unsigned and undated view similar or identical to *London Daily Graphic* view of 6 January 1878 noted above. Wood engraving, 7 1/4 x 15 1/2 in. (18.4 x 39.3 cm). Impressions: MHS-SL.

1879
Untitled and unsigned view of the Eads Bridge and St. Louis from the south, on certificate of Second Preferred Stock issued by the St. Louis Bridge Company in 1879 and printed in New York by the American Bank Note Company. Line engraving, 8 x 11 in. (20.3 x 27.9 cm); view only, 2 3/8 in. x 5 11/16 in. (6 x 14.5 cm). Impressions: EEN-SL.

1886?
View West From Court House. View of St. Louis looking west from the Courthouse. From an undated souvenir view book, *Album of St. Louis*, published in St. Louis by E. P. Gray Book House. Collotype, 5 5/8 x 18 1/2 in. (14.3 x 47 cm). On sectioned double panel with views of two buildings and two street scenes. 19 unnumbered references above view. Apparently identical to Figure 8-6 except for lack of numbered refer-

ences. Impressions: A.

1886
Bridge Seen From the South. View of St. Louis looking north to the Eads Bridge. From an undated souvenir view book, *Album of St. Louis*, published in St. Louis by E. P. Gray Book House. Collotype, 2 1/2 x 8 1/2 in. (6.4 x 21.6 cm). 3 unnumbered references below view. Impressions: A.

1893
St. Louis (Mo.) View of St. Louis on a playing card, part of "American Cities. A Game," published by Parker Brothers, Salem, Mass., 1893. Lithograph, ca. 1 x 1 1/2 in. (2.5 x 3.8 cm) on card ca. 3 x 4 1/2 in. (7.6 x 11.4 cm). Impressions: Collection of Mrs. Arthur Liman, New York City.

1895
St. Louis in 1895. Bird's-eye view of St. Louis from the southeast, drawn and published by Chas. Juehne [St. Louis], 1895. Lithograph, 23 x 40 in. (58.5 x 101.7 cm). 48 numbered references below the image. Impressions: AGE-SL; LC-M. Recorded: LC-M, 443; Reps, 2063.

1897?
Undated and untitled view of St. Louis [1897?].

Lithograph?, size unknown. Impressions: none located. Photograph in LC-M. Recorded: LC-M, 446; Reps, 2066.

1904
Panoramic View of the Wholesale and Office District of St. Louis. Looking South from Lucas Ave. and Seventh Street. View drawn and copyright by Charles Juehne [St. Louis], 1904. Lithograph, 5 x 10 1/2 in. (12.7 x 26.7 cm). Impressions: LC-M. Recorded: LC-M, 447; Reps, 2067.

Date Unknown
St. Louis [title in manuscript]. Unsigned and undated view. Lithograph, 15 1/2 x 25 1/8 in. (39.4 x 64 cm). Impressions: none located. Information from auction sales catalog. Recorded: Pyne, 493; Reps, 2071.

Date Unknown
Les États-Unis.—Vue de Saint-Louis (Missouri). Undated view drawn by Ch. Benoist, engraved by Gerard. Wood engraving, 7 x 6 1/8 in. (17.8 x 15.5 cm). Probably from a French book, possibly titled *Géographie Pittoresque.* Impressions: A.

BIBLIOGRAPHY

Alfred R. Waud, Special Artist on Assignment: Profiles of American Towns and Cities, 1850–1880. New Orleans: The Historic New Orleans Collection, 1979.

Appletons' Annual Cyclopaedia and Register of Important Events of the Year 1886. N.s. vol. 9 (whole series, vol. 26). New York: D. Appleton, 1888.

Appletons' Illustrated Hand-Book of American Cities; Comprising the Principal Cities in the United States and Canada. New York: D. Appleton, 1877.

Bachmann, Friedrich, comp. *Die Alte Deutsche Stadt* 6 vols. Leipzig and Stuttgart: Karl W. Hiersemann and Anton Hiersemann, 1942–1961.

Bain, George Grantham. "The St. Louis Disaster." *Harper's Weekly* 40 (6 June 1896): 570.

Baltimore Museum of Art. *The World Encompassed.* Baltimore: Walters Art Gallery, 1952.

Barber, John Warner, and Henry Howe. *Our Whole Country: A Panorama and Encyclopedia of the United States.* 2 vols. Cincinnati: Charles Tuttle, 1861.

Beck, Lewis Caleb. *A Gazetteer of the States of Illinois and Missouri.* Albany: Charles R. and George Webster, 1823. Reprint. New York: Arno Press, 1975.

Bellier de la Chavignerie, Emile. *Dictionnaire Général des Artistes de l'Ecole Française depuis l'Origine des Arts du Dessin jusqu'à nos Jours.* 2 vols. Paris: Renouard, 1882–1885.

Bénézit, Emmanuel. *Dictionnaire Critique et Documentaire des Peintres. Sculpteurs. Dessinateurs et Graveurs. . . .* 3 vols. Paris: R. Roger and F. Chernoviz, 1911–[1923].

Bernhard, Karl, Duke of Saxe-Weimar-Eisenach. *Travels Through North America During the Years 1825 and 1826.* Philadelphia: Carey, Lea & Carey, 1828.

Birch's Views of Philadelphia: A Reduced Facsimile of the City of Philadelphia . . . as it Appeared in the Year 1800; With Photographs of the Sites in 1960 & 1982 by S. Robert Teitelman. Philadelphia: Free Library of Philadelphia, 1982.

Blaeu, Joan. *Toonneel der Steden van de Vereenighde Nederlanden, met Hare Beschrijvingen.* 2 vols. Amsterdam: Joan Blaeu, 1648.

Bordone, Benedetto. *Libro di Benedetto Bordone Nel qual si Ragiona de Tutte l'Isole del Mondo. . . .* Venice: Nicolo d' Aristotile, detto Zoppino, 1528.

Boston Museum of Fine Arts. *M. & M. Karolik Collection of American Water Colors & Drawings, 1800–1875.* 2 vols. Boston: Museum of Fine Arts, 1962.

Boutros, David. "The West Illustrated: Meyer's Views of Missouri River Towns." *Missouri Historical Review* 80 (April 1986): 304–20.

Brackenridge, Henry M. *Views of Louisiana Together with a Journal of a Voyage up the Missouri River, in 1811.* Pittsburgh: Cramer, Spear & Eichbaum, 1814. Reprint. Chicago: Quadrangle Books, [1962].

Braun, Georg, and Franz Hogenberg. *Civitates Orbis Terrarum.* 6 vols. [separately titled]. Cologne and Antwerp, 1572–1617.

Breydenbach, Bernhard von. *Die Reise ims Heilige Land: ein Reisebericht aus dem Jahre 1483.* Wiesbaden: G. Pressler, 1977. (Facsimile of German translation of Breydenbach, *Peregrinationes in Terram Sanctam.* Mainz: E. Reuwich, 1486.)

The British Library. *Sir Francis Drake: An Exhibition to Commemorate Francis Drake's Voyage around the World, 1577–1580.* London: British Museum Publications, 1977.

Brodherson, David. "Souvenir Books in Stone: Lithographic Miniatures for the Masses." *Imprint* 12 (Autumn 1987): 21–28.

Brumfield, Theo. V. "A Study in Philanthropy: Tower Grove Park." Part 1. *Bulletin of the Missouri Historical Society* 21 (July 1965): 315–22.

Brun, Carl. *Schweizerisches Künstler-Lexikon.* 3 vols. Frauenfeld: Verlag von Hüber & Co., 1913.

Bryan, John Albury. *Lafayette Square: The Most Significant Old Neighborhood in Saint Louis.* St. Louis: John Albury Bryan, 1962.

Bryant, William Cullen, ed. *Picturesque America; or, The Land We Live In.* 2 vols. New York: D. Appleton, 1872.

Buckingham, J[ames] S[ilk]. *The Eastern and Western States of America.* 3 vols. London: Fisher, Son & Co., 1842.

Campbell, Tony. *New Light on the Jansson-Visscher Maps of New England.* Map Collectors Series, no. 24. London: The Map Collectors' Circle, 1965.

Cazden, Robert E. *A Social History of the German Book Trade in America to the Civil War.* Columbia, S.C.: Camden House, 1984.

Ciampoli, Judith. "The St. Louis Tornado of 1896: Mad Pranks of the Storm King." *Gateway Heritage* 2 (Spring 1982): 25–31.

"The City of St. Louis. *Atlantic Monthly* 19 (June 1867): 655–72.

Colden, Cadwallader. *Memoir Prepared at the Request of the Committee of the Common council of the City of New York, and Presented to the Mayor of the City, at the Celebration of the Completion of the New York Canal.* [New York]: Printed by Order of the Corporation of New York, 1825.

Collot, George H. Victor. *Voyage dans l'Amèrique Septentrionale; ou, Description des Pays Arrosés par le Mississippi, l'Ohio, le Missouri, et autres Rivières Affluentes. . . .* Paris, 1826.

Conley, Timothy G. *Lafayette Square: An Urban Renaissance.* St. Louis: Lafayette Square Press, 1974.

Conningham, Frederic A. *Currier & Ives Prints: An Illustrated Check List.* Rev. ed. New York: Crown Publishers, 1970.

"The Cover." *Missouri Historical Society Bulletin* 3 (October 1946): 3–6.

"The Cover: E. Dupré, Lithographs." *Missouri Historical Society Bulletin* 12 (October 1955): 5–7.

"The Creole Sketchbook of A. R. Waud." *American Heritage* 15 (December 1963): 33–48.

Cunningham, John T. "Barber and Howe: History's Camp Followers." *New Jersey History* 102 (Spring/Summer 1984): 65–72.

Dana, Charles A., ed. *The United States Illustrated: In Views of City and Country. with Descriptive and Historical Texts.* Vol. 2, *The West: or the States of the Mississippi Valley and the Pacific.* New York: Hermann J. Meyer, [1853–1854].

Davidson, Marshall B. *Life in America.* 2 vols. Boston: Houghton Mifflin, 1951.

Davies, Hugh William. *Bernhard von Breydenbach and His Journey to the Holy Land, 1483–4: A Bibliography.* 1911. Reprint. Utrecht: Haentjens Dekker & Gumbert, 1968.

Deák, Gloria-Gilda. *American Views: Prospects and Vistas.* New York: The Viking Press and the New York Public Library, 1976.

Demoney, Jerry, and Susan E. Meyer. *Pasteups & Mechanicals: A Step-by-Step Guide to Preparing Art for Reproduction.* New York: Watson-Guptill Publications, 1982.

de Smet, Pierre. *Voyages aux Montagnes Rocheuses. . . .* Malines: P. J. Hanico, 1844.

Dicey, Edward. *Six Months in the Federal States.* 2 vols. London and Cambridge: Macmillan and Co., 1863.

Dickens, Charles. *American Notes for General Circulation.* London: Chapman and Hall, 1842.

Drumm, Stella M., and Isaac H. Lionberger. "Earliest Picture of St. Louis." *Glimpses of the Past* 8 (1941): 71–98.

Dry, Camille N., and Richard J. Compton. *Pictorial St. Louis: The Great Metropolis of the Mississippi Valley.* St. Louis: Compton & Co., 1875.

Ebert, John, and Katherine Ebert. *Old American Prints for Collectors.* New York: Charles Scribner's Sons, 1974.

Edmonds, John H. "The Burgis Views of New York and Boston." *Proceedings of the Bostonian Society* 34 (1915): 29–33.

Edwards, Richard, and M. Hopewell. *Edwards' Great West and her Commercial Metropolis, Embracing a General View of the West, and a Complete History of St. Louis. . . .* St. Louis: Published at the Office of "Edwards' Monthly," a Journal of Progress, 1860.

Edwards' Descriptive Gazetteer and Commercial Directory of the Mississippi River From St. Cloud to New Orleans. . . . St. Louis: Edwards, Greenough & Deved, 1866.

Elliot, James. *The City in Maps: Urban Mapping to 1900.* London: The British Library Board, 1987.

Faherty, William Barnaby, S.J. *Henry Shaw: His Life and Legacies.* Columbia: University of Missouri Press, 1987.

Fairbanks, Jonathan. "The Great Platte River Trail in 1853: The Drawings and Sketches of Frederick Piercy." In *Prints of the American West,* edited by Ron Tyler, 67–86. Fort Worth: Amon Carter Museum, 1983.

Falk, Alfred. *Trans-Pacific Sketches: A Tour Through the United States and Canada.* Melbourne, Sydney, and Adelaide: George Robertson, 1877.

Fauser, Alois. *Repertorium Alterer Topographia: Druckegraphik von 1486 bis 1750.* Wiesbaden: Dr. Ludwig Reichert Verlag, 1978.

Field, Ruth K. "Some Misconceptions About Lucas Place." *Missouri Historical Society Bulletin* 20 (January 1964): 119–23.

Flagg, Edmund. *The Far West: or, A Tour Beyond the Mountains.* New York: Harper & Brothers, 1838.

Foley, William E. "The Laclede-Chouteau Puzzle: John Francis McDermott Supplies Some Missing Pieces." *Gateway Heritage* 4 (Fall 1983): 18–25.

Foley, William E., and C. David Rice. *The First Chouteaus: River Barons of Early St. Louis.* Urbana and Chicago: University of Illinois Press, 1983.

Flint, Timothy. *Recollections of the Last Ten Years.* Boston, 1826. Reprint. Edited with an Introduction by George R. Brooks and a Foreword by John Francis McDermott. Carbondale and Edwardsville: Southern Illinois University Press, 1968.

"Fragment of Col. Auguste Chouteau's Narrative of the Settlement of St. Louis. Journal." *Collections of the Missouri Historical Society* 4 (1911): 349–66.

G., B. "An East Prospect of the City of Philadelphia." In *Philadelphia: Three Centuries of American Art,* pp. 56–59. Philadelphia: Philadelphia Museum of Art, 1976

Gabet, Charles Henri Joseph. *Dictionnaire des Artistes de l'Ecole Française au XIX Siècle. Peinture. Sculpture. Architecture. Gravure. Dessin. Lithographie et Composition Musicale.* Paris: Madame Vergne, 1831.

Gaylor, Charles. *Lewis' Panorama. A Description of Lewis' Mammoth Panorama of the Mississippi River, from the Falls of St. Anthony to the City of St. Louis. . . .* Cincinnati: printed at the Dispatch Office, 1849.

Giuseppi, M. S. "The Work of Theodore de Bry and His Sons, Engravers." *Proceedings of The Huguenot Society of London* 11 (1915–1917): 204–26.

Glaser, Lynn. *Engraved America: Iconography of America Through 1800.* Philadelphia: Ancient Orb Press, 1970.

Glazier, Willard. *Down the Great River; Embracing an Account of the Discovery of the True Source of the Mississippi. . . .* Philadelphia: Hubbard Brothers, 1887.

———. *Peculiarities of American Cities.* Philadelphia: Hubbard Brothers, 1883.

Groce, George C., and David H. Wallace. *The New-York Historical Society's Dictionary of Artists in America, 1564–1860.* New Haven: Yale University Press, 1957.

Haberly, Loyd. *Pursuit of the Horizon, A Life of George Catlin, Painter & Recorder of the American Indian.* New York: Macmillan Co., 1948.

Hagen, Harry M. *This Is Our Saint Louis.* St. Louis: Knight Publishing Co., 1970.

Hannon, Robert E., ed. and comp. *St. Louis: Its Neighborhoods and Neighbors, Landmarks and Milestones.* St. Louis: Regional Commerce and Growth Association, 1986.

———. "St. Louis in 1871 as Seen by a Noted Artist." *Pictures—St. Louis Post-Dispatch,* 31 March 1963, 10–13.

Heilbron, Bertha L., ed. Introduction to *The Valley of the Mississippi Illustrated by Henry Lewis,* by Henry Lewis. St. Paul: Minnesota Historical Society, 1967.

———. *Making a Motion Picture in 1848: Henry Lewis' Journal of a Canoe Voyage from the Falls of St. Anthony to St. Louis.* St. Paul: Minnesota Historical Society, 1936.

Heller, Otto. "Charles Sealsfield, a Forgotten Discoverer of the Valley of the Mississippi." *Missouri Historical Review* 31 (July 1937): 382–401.

Hibbert, Arthur, and Ruthardt Oehme. *Old European Cities.* London: Thames & Hudson, n.d.

Hill, J. Henry. *John William Hill, An Artist's Memorial.* New York, 1888.

Hind, Arthur M. *A History of Engraving and Etching from the 15th Century to the Year 1914.* Boston: Houghton Mifflin Co., 1923. Reprint. New York: Dover Publications, 1963.

———. *An Introduction to a History of Woodcut, with a Detailed Survey of Work Done in the Fifteenth Century.* Boston: Houghton Mifflin Co., 1935. Reprint. New York: Dover Publications, 1963.

History of Southeast Missouri. Chicago: Godspeed Publishing Co., 1888.

[Hoffman, Charles F.]. *A Winter in the West.* 2 vols. New York: Harper & Brothers, 1835.

[Hogan, John.] *Thoughts about The City of St. Louis, Her Commerce and Manufactures, Railroads, &c.* St. Louis: Republican Steam Press Print, 1854.

Holloway, Marcella M., CSJ. "The Sisters of St. Joseph of Carondelet: 150 Years of Good Works in America." *Gateway Heritage* 7 (Fall 1986): 24–31.

Holt, Glen E. "St. Louis Observed 'from Two Different Worlds': An Exploration of the City through French and English Travelers' Accounts, 1874–1889." *Missouri Historical Society Bulletin* 29 (January 1973): 63–87.

Horton, Loren N. "Through the eyes of Artists: Iowa Towns in the 19th Century." *Palimpsest* 59 (September–October 1978): 133–47.

Hullmandel, C[harles]. *The Art of Drawing on Stone, Giving a Full Explanation of the Various Styles. . . .* London: C. Hullmandel, 1824. Reprint. New York and London: Garland Publishing, 1982.

Hungerford, Edward. *The Personality of American Cities.* New York: McBride, Nast & Co., 1913.

Hyde, Ralph. *Gilded Scenes and Shining Prospects: Panoramic Views of British Towns 1575–1900.* New Haven: Yale Center for British Art, 1985.

Hyde, William. "The Great Balloon Experiment: Details and Incidents of the Trip." *Glimpses of the Past* 10 (1941): 93–111.

Hyde, William, and Howard L. Conard, eds. *Encyclopedia of the History of St. Louis.* 4 vols. New York, Louisville, and St. Louis: The Southern History Co., 1899.

Ingalls, Sheffield. *History of Atchison County Kansas.* Lawrence, Kans.: Standard Publishing Co., 1916.

Jane, Cecil, trans. *The Journal of Christopher Columbus.* New York: Clarkson N. Potter, 1960.

"Jenny Lind in America. *Glimpses of the Past* 4 (1937): 47–51.

Johnson, Lila M. "Found (and Purchased): Seth Eastman Water Colors." *Minnesota History* 42 (Fall 1971): 258–67.

Johnston, Norman J. "St. Louis and Her Private Residential Streets." *Journal of the American Institute of Planners* 28 (August 1962): 187–93.

Kaser, David. *A Directory of the St. Louis Book and Printing Trade to 1850.* New York: The New York Public Library, 1961.

Keeler, Ralph, and A. R. Waud. "St. Louis. I. A General View of the City." *Every Saturday,* 14 October 1871, 377, 380–82. "St. Louis. II. The Great Fair." *Every Saturday,* 14 October 1871, 382. "St. Louis. III. Rambling About the City." *Every Saturday,* 28 October 1871, 412–15. "St. Louis. A Visit to the Wine-Cellars and President Grant's Farm." *Every Saturday,* 25 November 1871, 525–26.

Kellner, George H. "The German Element on the Urban Frontier: St. Louis, 1830–1860." Ph.D. diss., University of Missouri–Columbia, 1973.

Kennedy's Saint Louis City Directory for the Years 1857. St. Louis: R. V. Kennedy, 1857.

Keuning, Johannes. "The 'Civitates' of Braun and Hogenberg." *Imago Mundi* 17 (1963): 41–44.

Kingsford, William. *Impressions of the West and South, During a Six Weeks' Holiday.* Toronto: A. H. Armour & Co., 1858.

Klein, Benjamin F. *Lithography in Cincinnati.* Cincinnati: Young & Klein, 1956.

Koke, Richard J. *A Checklist of the American Engravings of John Hill (1770–1850).* New York: New-York Historical Society, 1961.

———. "John Hill, Master of Aquatint 1770–1850." *New-York Historical Society Quarterly* 433 (January 1959): 51–117.

Kouwenhoven, John A. "Downtown St. Louis As James B. Eads Knew It When The Bridge Was Opened A Century Ago." *Bulletin of the Missouri Historical Society* 30 (April 1974): 181–95.

Krohn, Ernst C., ed. "The Autobiography of William Robyn." Parts 1, 2. *Missouri Historical Society Bulletin* 9 (January, April 1935): 141–54, 230–54.

Lammert, Susan R. "The Origin and Development of Landscape Parks in 19th Century St. Louis." M.A. Thesis, Washington University, 1968.

Langstroth, T. A. *The History of Lithography Mainly in Cincinnati (March, 1958).* Scrapbook with typed text. Art and Music Division, Cincinnati, Ohio, Public Library.

Lass, William E. "Tourists' Impressions of St. Louis, 1766–1859." Parts 1, 2. *The Missouri Historical Review* 52, 53 (July, October 1958): 325–38, 11–21.

Latrobe, Charles Joseph. *The Rambler in North America.* 2 vols. London: R. B. Seeley & W. Burnside, 1835.

LeCheminant, Wilford Hill. "'Entitled to be an Artist': Landscape and Portrait Painter Frederick Piercy." *Utah Historical Quarterly* 48 (Winter 1980): 49–65.

Lewis, Henry. *The Valley of the Mississippi Illustrated by Henry Lewis.* Edited by Bertha L. Heilbron. Translated by A. Hermina Poatgieter. St. Paul: Minnesota Historical Society, 1967.

Lionberger, Isaac H., and Stella M. Drumm "Thoughts About the City of St. Louis." (Text of [Hogan, John]. *Thoughts about The City of St. Louis, her Commerce and Manufactures, Railroads, &c.* St. Louis: Republican Steam Press Print, 1854). *Glimpses of the Past* 3 (1936): 151–71.

"Lithography." *United States Literary Gazette* 4 (15 June 1826): 224–27.

Lloyd, James T. *Lloyd's Steamboat Directory. . . .* Cincinnati: Jas. T. Lloyd & Co., 1856.

Löher, Franz von. *Land und Leute in der Alten und Neuen Welt: Reiseskizzen.* 2 vols. Göttingen and New York: George H. Wigand and L. W. Schmidt, 1855–1858.

Loughlin, Caroline, and Catherine Anderson. *Forest Park.* Columbia: Junior League of St. Louis and the University of Missouri Press, 1986.

Lowic, Lawrence. *The Architectural Heritage of St. Louis, 1803–1891.* St. Louis: Washington University Gallery of Art, 1982.

Luke, L. D. *A Journey from the Atlantic to the Pacific Coast by Way of Salt Lake City Returning by Way of the Southern Route. . . .* Utica: Ellis H. Roberts & Co., 1884.

Lytle, William M., comp. *Merchant Steam Vessels of the United States, 1807–1868.* Mystic, Conn.: The Steamship Historical Society of America, 1952.

McCauley, Lois B. *Maryland Historical Prints, 1752 to 1889.* Baltimore: Maryland Historical Society, 1975.

McDermott, John Francis. *The Lost Panoramas of the Mississippi.* Chicago: University of Chicago Press, 1958.

———. *Seth Eastman's Mississippi: A Lost Portfolio Recovered.* Urbana: University of Illinois Press, 1973.

———. "Captain Stoddard Discovers St. Louis." *Missouri Historical Society Bulletin* 10 (April 1954): 328–35.

———. "J. C. Wild, Western Painter and Lithographer." *Ohio State Archaeological and Historical Quarterly* 60 (April 1951): 111–25.

———. "John Caspar Wild: Some New Facts and a Query." *Pennsylvania Magazine of History and Biography* 83 (October 1959): 452–55.

———. "Henry Lewis's *Das Illustrirte Mississippithal.*" *Papers of the Bibliographical Society of America* 45 (Second Quarter 1951): 1–4.

———. "Leon Pomarede, 'Our Parisian Knight of the Easel.'" *Bulletin of the City Art Museum of St. Louis* 34 (Winter 1949): 8–18.

———. "Portrait of the Father of Waters: Leon Pomarede's Panorama of the Mississippi." *Bulletin de l'Institut Français de Washington,* n.s. 2 (December 1952): 46–58.

———. "Some Rare Western Prints by J. C. Wild." *Antiques* 72 (November 1957): 452–53.

Mackay, Charles. *Life and Liberty in America: or, Sketches of a Tour in the United States and Canada in 1857–58.* New York: Harper & Brothers, 1859.

McMaster, S. W. *60 Years on the Upper Mississippi. My Life and Experiences.* Rock Island, Ill., 1893.

Marsch, Angelika. *Meyer's Universum: Ein Beitgrag zur Geschichte des Stahlstiches und des Verlagswesens im 19. Jahrhundert.* Lüneburg: Nordostdeutsches Kulturwerk, 1972.

Marshall, Thomas Maitland, ed. "The Journal of Henry B. Miller." *Collections of the Missouri Historical Society* 6 (1931): 213–87.

Marzio, Peter. *The Democratic Art: Pictures for a 19th-Century America.* Boston: David R. Godine, in association with the Amon Carter Museum of Western Art, Fort Worth, Tex., 1979.

Mayor, A. Hyatt. "Aquatint Views of Our Infant Cities." *Antiques* 88 (September 1965): 314–18.

Merten, John W. "Stone by Stone Along a Hundred Years with the House of Strobridge." *Bulletin of the Historical and Philosophical Society of Ohio* 8 (January 1950): 3–48.

Michel, Peter. "The St. Louis Fur Trade: Fur Company Ledgers and Account Books in the Archives of the Missouri Historical Society." *Gateway Heritage* 6 (Fall 1985): 10–17.

Miller, Alexander. *The Hand-Book of Transfer Lithography.* Liverpool: Evans, Chegwin & Hall, 1840.

Millichap, Joseph R. *George Catlin.* Boise, Idaho: Boise State University, [1977].

Montague, William L. *The Saint Louis Business Directory for 1853–54.* St. Louis: E. A. Lewis, 1853.

Mormino, Gary Ross. *Immigrants on the Hill: Italian-Americans in St. Louis, 1881–1982.* Urbana and Chicago: University of Illinois Press, 1986.

———. "Lombard Roots: From Steerage to the Hill." *Gateway Heritage* 1 (Winter 1980): 3–13.

Nagler, Georg Kaspar. *Neues Allgemeines Künstler-Lexicon. . . .* 22 vols. Munich: E. A. Fleischmann, 1835–1852.

Nordenskiold, A. E. *Facsimile-Atlas to the Early History of Cartography.* Stockholm, 1889.

Norton, Bettina A. *Edwin Whitefield: Nineteenth-Century North American Scenery.* Barre, Mass.: Barre Publishing, 1977.

Oehme, Ruthardt. Introduction to *Cosmographei* by Sebastian Münster. Facs. ed. Amsterdam: Theatrum Orbis Terrarum, 1968.

Paxton, John A. *The St. Louis Directory and Register Containing the Names, Professions, and Residence of all the Heads of Families and Persons in Business. . . .* St. Louis: Printed for the Publisher, 1821.

Pennington, Estill Curtis, and James C. Kelly. *The South on Paper: Line, Color and Light.* Spartanburg, S.C.: Robert M. Hicklin, Jr., 1985.

Peters, Harry T. *Currier & Ives: Printmakers to the American People.* 2 vols. Garden City, N.Y.: Doubleday, Doran & Co., 1929–1931.

Petersen, William J. *Mississippi River Panorama: The Henry Lewis Great National Work.* Iowa City: Clio Press, 1979.

Peterson, Charles E. "Colonial Saint Louis." *Missouri Historical Society Bulletin* 3 (April 1947): 94–111.

Philadelphia Museum of Art. *Philadelphia: Three Centuries of American Art.* Philadelphia: Philadelphia Museum of Art, 1976.

Piercy, Frederick Hawkins. *Route from Liverpool to Great Salt Lake Valley.* Edited by Fawn M. Brodie. Cambridge: The Belknap Press of Harvard University Press, 1962.

Pittman, Philip. *The Present State of the European Settlements on the Mississippi.* London: J. Nourse, 1770.

Popham, A. E. "Georg Hoefnagle and the *Civitates Orbis Terrarum.*" *Maso Finiguera* 1 (1936): 183–201.

Portfolio of the Old Print Shop 20 (January 1961): 111.

Primm, James Neal. *Lion of the Valley: St. Louis, Missouri.* Boulder, Colo.: Pruett Publishing Co., 1981.

———. "Henry Shaw, Merchant-Capitalist." *Gateway Heritage* 5 (Summer 1984): 2–9.

Raiche, Stephen J. "Lafayette Square: A Bit of Old St. Louis." *Bulletin of Missouri Historical Society* 29 (January 1973): 88–95.

Ray, Frederic E. *Alfred R. Waud: Civil War Artist.* New York: The Viking Press, 1974.

Reedy, William Marion. "St. Louis 'The Future Great.'" In *Historic Towns of the Western States,* edited by Lyman P. Powell. New York & London: G. P. Putnam's Sons, 1901.

Reps, John W. *Cities of the American West: A History of Frontier Urban Planning.* Princeton: Princeton University Press, 1979.

———. *Cities on Stone: Nineteenth Century Lithograph Images of the Urban West.* Fort Worth, Tex.: Amon Carter Museum of Western Art, 1976.

———. *The Making of Urban America: A History of City Planning in the United States.* Princeton: Princeton University Press, 1965.

———. *Views and Viewmakers of Urban America. . . .* Columbia: University of Missouri Press, 1984.

———. "Cities by Sachse: The Urban Views of a Baltimore Lithographer." To be published in the proceedings of the North American Print Conference.

Ringwalt, J. Luther, ed. *American Encyclopaedia of Printing.* Philadelphia: Menamin & Ringwalt and J. B. Lippincott & Co., 1871.

Robinson, William F. *A Certain Slant of Light: The First Hundred Years of New England Photography.* Boston: New York Graphic Society, 1980.

Rodgers, Thomas L. "Recollections of St. Louis—1857–1860." *Glimpses of the Past* 9 (1941): 111–21.

Rolevinck, Werner. *Fasiculus Temporum.* Cologne: Arnold Ther Hoernen, 1474.

Rosenberg, C. G. *Jenny Lind in America.* New York: Stringer & Townsend, 1851.

Roylance, Dale, and Nancy Finlay. *Pride of Place: Early American Views from the Collection of Leonard L. Milberg '53.* Princeton: Princeton University Library, 1983.

Rücker, Elisabeth. *Die Schedelsche Weltchronik.* Munich: Prestel-Verlag, 1973.

Rutledge, Anna Wells. "Charleston's First Artistic Couple." *Antiques* 52 (August 1947): 100–102.

St. Louis City Plan Commission. *History: Physical Growth of the City of Saint Louis.* St. Louis: St. Louis City Plan Commission, 1969.

The St. Louis Directory, For the Years 1854–5. St. Louis: Chambers & Knapp, 1854.

Saint Louis Illustrated. . . . St. Louis: Will Conklin, 1876.

"St. Louis in 1844." *Glimpses of the Past* 4 (1937), 46–47.

"St. Louis in 1849." *Missouri Historical Society Bulletin* 6 (April 1950): 368–73.

St. Louis Mercantile Library Association. *Annual Report of the Saint Louis Mercantile Library.* St. Louis: St. Louis Mercantile Library Association, 1865.

"St. Louis, Missouri." *Ballou's Pictorial Drawing-Room Companion* 11 (September 1856): 152–53.

St. Louis Pictorial Advertiser. St. Louis: L. Bushnell, [1858?].

"St. Louis: This Year's Convention City." *The Review of Reviews* 13 (June 1896): 672–78.

Samuels, Peggy, and Harold Samuels. *The Illustrated Biographical Encyclopedia of Artists of the American West.* Garden City, N.Y.: Doubleday & Co., 1976.

Sarkowski, Heinz. *Das Bibliographische Institut: Verlagsgeschichte und Bibliographie. 1826–1976.* Mannheim, Vienna, and Zurich: Bibliographisches Institut, 1976.

Savage, Charles C. *Architecture of the Private Streets of St. Louis: The Architects and the Houses They Designed.* Columbia: University of Missouri Press, 1987.

Sayer and Bennett's Enlarged Catalogue of New and Valuable Prints, in Sets, or Single . . . For 1775. Reprint. London: The Holland Press, 1970.

Scharf, John Thomas. *History of St. Louis City and County. . . .* 2 vols. Philadelphia: Louis H. Everts & Co., 1883.

Schedel, Hartmann. *Liber Cronicarum.* Nuremberg: Anton Koberger, 1493.

Schmitz, Marie L. "Henry Lewis: Panorama Maker." *Gateway Heritage* 3 (Winter 1982–1983): 37–48.

Schultz, Christian. *Travels on an Inland Voyage, Performed in the Years 1807 and 1808, Including a Tour of Nearly Six Thousand Miles.* New York: Isaac Riley, 1810.

Schulz, Juergen. "Jacopo de' Barbari's View of Venice: Map Making, City Views, and Moralized Geography Before the Year 1500." *The Art Bulletin* 60 (September 1978): 425–74.

Schurre, Jacques. *Currier & Ives Prints: A Checklist of Unrecorded Prints Produced by Currier & Ives, N. Currier and C. Currier.* [New York]: Jacques Schurre, 1970.

Sealsfield, Charles. *The Americans as They Are; Described in a Tour through the Valley of the Mississippi.* London: Hurst, Chance & Co., 1828.

Sears, Robert. *A New and Popular Pictorial Description of the United States.* New York: Robert Sears, 1848.

Senefelder, Alois. *A Complete Course of Lithography: Containing Clear and Explicit Instructions in all the Different Branches and Manners of that Art . . . to which is Prefixed a History of Lithography, from Its Origin to the Present Time.* London: R. Ackermann, 1819. Reprint. New York: Da Capo Press, 1977.

Shelley, Donald A. "William Guy Wall and His Watercolors for the Historic *Hudson River Portfolio.*" *New-York Historical Society Quarterly* 31 (January 1947): 25–45.

Sherer, S. L. "The 'Places' of St. Louis." *House and Garden* 5 (April 1904): 187–91.

Skelton, R. A. Introduction to *Civitates Orbis Terrarum.* Facs. ed. Amsterdam: Theatrum Orbis Terrarum, 1966.

———. "Tudor Town Plans in John Speed's *Theatre.*" *Archaeological Journal* 108 (1952): 109–20.

Snyder, Martin P. *City of Independence: Views of Philadelphia Before 1800.* New York: Praeger, 1975.

———. "Birch's Philadelphia Views: New Discoveries." *Pennsylvania Magazine of History and Biography* 88 (April 1964): 164–73.

———. "J. C. Wild and His Philadelphia Views." *Pennsylvania Magazine of History and Biography* 77 (January 1953): 32–75.

———. "William Birch: His 'Country Seats of the United States.'" *Pennsylvania Magazine of History and Biography* 81 (July 1957): 225–54.

———. "William Birch: His Philadelphia Views." *Pennsylvania Magazine of History and Biography* 73 (July 1949): 271–315.

Stevens, Walter B. *The Building of St. Louis.* St. Louis: Lesan-Gould Co., 1908.

Stokes, I. N. Phelps, and Daniel C. Haskell. *American Historical Prints: Early Views of American Cities.* New York: New York Public Library, 1932.

Stone, Carole. "New 'Perspective' Map Gives Better than a Bird's-eye View." *Cornell Chronicle* 19 (12 November 1987): 5.

The Story of the St. Louis Artists' Guild 1886–1936. St. Louis, n.p., n.d.

Strauss, Gerald. *Nuremberg in the Sixteenth Century.* New York: John Wiley & Sons,

Stumpf, Johannes. *Die Gemeiner Loblicher Eydgnoschafft Stetten Landen und Vlckeren Chronik Wirdiger Thaaten Beschreybung . . .* [*"Schweizer Chronik"*]. Zurich: Christoph Froschauer, 1548.

Sullivan, Margaret Lo Piccolo. "St. Louis Ethnic Neighborhoods, 1850–1930: An Introduction." *Missouri Historical Society Bulletin* 33 (January 1977): 64–76.

Taft, Robert. *Artists and Illustrators of the Old West, 1850–1900.* New York: Charles Scribner's Sons, 1953.

———. *Photography and the American Scene: A Social History, 1839–1889.* New York: Dover Publications, 1964.

Tatham, David. "John Henry Bufford, American Lithographer." Part 1. *Proceedings of the American Antiquarian Society* 86 (April 1976): 47–73.

———. "The Pendleton-Moore Shop—Lithographic Artists in Boston, 1825–1840." *Old Time New England: The Bulletin of The Society for the Preservation of New England Antiquities* 62 (Fall 1971): 29–46.

Terrell, John Upton. *Black Robe: The Life of Pierre-Jean De Smet Missionary, Explorer & Pioneer.* Garden City, N.Y.: Doubleday & Co., 1964.

"Theodor Schrader, St. Louis Lithographer." *Missouri Historical Society Bulletin* 4 (January 1948): 103.

Thieme, Ulrich, and Felix Becker. *Allgemeines Lexikon der Bildenden Künstler.* 37 vols. Leipzig: Verlag von Wilhelm Engelmann & E. A. Seemann, 1907–1950.

Tooley, R. V. "'Lafreri' Atlases." *The Map Collector* 14 (March 1981): 26–29.

———. "Maps in Italian Atlases of the Sixteenth Century." *Imago Mundi* 3 (1939): 12–47.

Trautmann, Frederic. "Missouri Through a German's Eyes: Franz von Lher on St. Louis and Hermann." *Missouri Historical Review* 77 (July 1983): 367–81.

Trollope, Anthony. *North America.* Edited by Donald Smalley and Bradford Allen Booth. New York: Alfred A. Knopf, 1951.

Twain, Mark [Samuel Clemens]. *Life on the Mississippi.* 1883. Reprint. London: Oxford University Press, 1962.

"Two Years in St. Louis—1834–1836." *Glimpses of the Past* 4 (1937): 39.

Twyman, Michael. *Lithography 1800–1850, the Techniques of Drawing on Stone in England and France and Their Application in Works of Topography.* London: Oxford University Press, 1970.

Tyler, Ron. *Visions of America: Pioneer Artists in a New Land.* New York: Thames and Hudson, 1983.

U.S. Census Office. "Part II, The Southern and Western States." In *Report on the Social Statistics of Cities.* Washington: Government Printing Office, 1887.

U.S. Geological Survey. "The Louisiana Purchase and the City of St. Louis." In *Saint Louis Special Map.* [Washington], 1904.

van Ravenswaay, Charles. *The Arts and Architecture of German Settlements in Missouri.* Columbia: University of Missouri Press, 1977.

———. "The Pioneer Photographers of St. Louis." Missouri Historical Society Bulletin 10 (October 1953): 56–57.

———. "Years of Turmoil, Years of Growth: St. Louis in the 1850s." Missouri Historical Society Bulletin 23 (July 1967): 303–24.

Verner, Coolie. "Copperplate Printing." In Five Centuries of Map Printing, edited by David Woodward, 51–75. Chicago: The University of Chicago Press, 1975.

Vickery, Robert. "The Private Places of St. Louis." Landmarks of St. Louis 4 (June 1964): 7–18.

Wainwright, Nicholas B. Philadelphia in the Romantic Age of Lithography: An Illustrated History of Early Lithography in Philadelphia. Philadelphia: Historical Society of Pennsylvania, 1958.

Wakeman, Geoffrey. Aspects of Victorian Lithography: Anastatic Printing and Photozincography. Wymondham, Eng.: Brewhouse Press, 1970.

"A Walk in the Streets of St. Louis in 1845." Missouri Historical Society Collections 6 (October 1928): 33–40.

Warner, Charles Dudley. Studies in the South and West with Comments on Canada. New York: Harper & Brothers, 1889.

Wayman, Norbury. Central West End. St. Louis: St. Louis Community Development Agency, [1978].

———. Old North St. Louis and Yeatman. St. Louis: St. Louis Community Development Agency, [1978].

———. Shaw. St. Louis: St. Louis Community Development Agency, [1978].

Weitenkampf, Frank. "John Hill and American Landscapes in Aquatint." American Collector 17 (July 1948): 6–8.

The Western Metropolis; or St. Louis in 1846. St. Louis: W. D. Skillman, 1846.

White, James Haley. "Early Days in St. Louis." Glimpses of the Past 6 (1939): 5–13.

Whitehall, Walter, and Sinclair Hitchings, eds. Boston Prints and Printmakers, 1670–1775. Boston: The Colonial Society of Massachusetts, 1973.

Wild, J[ohn] C[aspar]. The Valley of the Mississippi Illustrated in a Series of Views. Edited by Lewis Foulk Thomas. St. Louis: Chambers and Knapp, 1841. Facs. ed. St. Louis: Hawthorn Publishing Co., 1948.

Wilhelm, Paul, Duke of Württemberg. Travels in North America 1822–1824. Stuttgart & Tübingen, 1835. Rev. ed. Edited by Savoie Lottinville and translated by W. Robert Nitske. Norman: University of Oklahoma Press, 1973.

Wilkie, Franc B. Davenport Past and Present. Davenport, Iowa: Luse, Lane & Co., 1858.

Wilson, Adrian. The Making of the Nuremberg Chronicle. Amsterdam: Nico Israel, 1976.

Wright, Helena E. "Partners in the Business of Art: Producing, Packaging, and Publishing Images of the American Landscape 1850–1900." In Pioneers of Photography: Their Achievements in Science and Technology, chap. 26. Springfield, Va.: SPSE—The Society for Imaging Science and Technology, 1987.

Wolf, Edwin, II. American Song Sheets, Slip Ballads, and Political Broadsides, 1850–1870: A Catalogue of the Collection of The Library Company of Philadelphia. Philadelphia: The Library Company of Philadelphia, 1963.

Woodward, David, ed. Five Centuries of Map Printing. Chicago: The University of Chicago Press, 1975.

———. Note to catalog entry 27 in "La Geografia Moderna." Maphline spec. number 4 (May 1979).

Wordey, Emmeline Stuart. Travels in the United States, etc. During 1849 and 1850. New York: Harper & Brothers, 1851.

Wudrich, Lucas Heinrich. Das Druckgraphische Werk von Matthaeus Merian d. Ae. 2 vols. Basel: Bärenreiter-Verlag, 1966–1972.

INDEX

Note: Page numbers in italics refer to illustrations.

Adams, Eli, 104; view of St. Louis, *106*
Adams, Frank, 161; view of St. Louis, *160*
Adams, Otis, 59n
Alkmaar, 7; plan-view of, *5*
Allard, Hugo, 9; view of New Amsterdam, *9*
Amsterdam, plan-view of, *6, 7*
Andy Johnson, steamboat, 120
Anna Street, 88n
Anthoniszoon, Cornelis, 6n; view of
 Amsterdam, *7*
Aquatint etching, 11, 29n
Arch, the, 87
Armory Hall, 162
Arnhold, Ralph, 138n
Arsenal Island, 134
Arsenal Road, 134
Art Gallery, 174n
Art Museum, 162
Ashley, General, 19
Atlantic Monthly, 101, 111
Atwater, Lyman W., 128, 129, 168, 176; view of St.
 Louis, *129*
Avity, Pierre d', 7

Bachman, John, 89n
Bailey, O. H., 128n
Bain, George Grantham, 170n
Bank of St. Louis, *17, 20*
Baptist Church, 19, 23, 54
Barbari, Jacopo de, 1, 3; view of Venice, *1, 2, 5*
Barber, John Warren, 101n
Barnett, George I., 41n, 98n

Barr's Department Store, 160, 165
Bartholomew, Harland, 162
Beck, Lewis Caleb, 20n; plan of St. Louis, *18*
Becker, August H., 136
Bellefontaine Cemetery, 125, 134
Bellefontaine Road, 88n
Bellenger, Sylvain, 29n
Bennett, William James, 11
Benton Place, 148
Bernhard, Karl, duke of Saxe-Weimar-
 Eisenach, 20
Bethlehem, Pennsylvania, view of, *10*
Biddle Market, 89
Biddle Street, 93n, 148
Birch, William, 11
Biscoe, Rev. Thomas Curtis, 59n
Bissell's Point, 166
Blaeu, Joan, *6, 7*
Blair, Montgomery, 150
Board of City Common, 93
Board of Land Commissioners, 93n
Bois St. Lys, George de, 15; view of St Louis, *16*
Bonhomme Street, 17n
Bonner, John, view of Boston, *10*
Boston, view of, 9n, *10*, 49, 59
Bottger, A., 71n
Boullemier, 104; view of St. Louis, *107*
Bowen, J. T., 31, 46
Brackenridge, Judge Henry M., 17n
Braun, Georg, *6, 7*
Breydenbach, Bernhard von, 3
Broadway, 19, 20, 25, 28, 33, 41, 42, 53n, 59, 89,
 93n, 98, 111, 156n, 174
Buchanan Street, 53n, 88n
Buckingham, James Silk, 52

Buehler, Edward, 108, 110
Bufford, John Henry, 13
Bullard, Doctor, 23
Burgis, William, 9
Burnhum's Hotel, 98n

Cahokia, Illinois, 42; view of St. Louis from, *45*
Campbell, Robert A., 136
Campbell House, 98
Cape Girardeau, view of, 71n
Carondelet, Missouri, 59, 61, 108, 114; nunnery,
 44n, 61; views of, 42, *43, 44, 62, 109*
Carondelet Park, 125, 150
Carr Street, 148
Cathedral, 19, 21, 23, 24, 26, 33, 38, 42, 47n, 54,
 61, 64, 111
Catholic Church, 19, 20
Catlin, George, 20, 21, 23; view of Lockport, *13;*
 views of St Louis, *21, 176, 177*
Cedar Street, 143
Centenary Methodist Church, 41
Cerré Street, 18
Chain of Rocks water plant, 166
Chamber of Commerce, the, 125, 148, 162
Charleston, South Carolina, 80; view of, 9n, *10*
Cheltenham district, 174
Chestnut Street, 19, 23, 25, 26, 28, 33, 42, 88, 125,
 126, 156n, 165
Chevalier, J. B., 30, 31, 45n
Chicago, 1, 89n, 96, 102, 104, 111
Chouteau, Auguste, 14, 15, 18, 20, 93; plan of St.
 Louis, *15*
Chouteau, Marie, 14n
Chouteau Avenue, 88n, 155
Chouteau's Pond, 26, 33, 61, 68n, 88, 92, 100, 125

Christ Church, 21, 28, 42, 54, 98
Christy, William, 54n, 93n
Cincinnati, 1, 28, 30, 39, 47, 52, 57, 80, 89, 102;
 view of, 126n
Cincinnati Daily Gazette, 30n, 39n
Cincinnati Historical Society, 30n, 39n
Circuit Court Room, 19
City Building, 64, 70, 112
City Council, 93
City Hall, 21, 23, 28, 33n, 47n, 98, 166, 174, 176
City Hospital, 100
City Hotel, 26, 59
City Market, 21, 54. *See also* Market, the
Civic Center, 143
Civil War, 31, 49, 73, 75, 79, 96, 100, 101, 104, 111,
 114, 116, 166
Civitates Orbis Terrarum, ed. Braun and Hogen-
 berg, 6
Clark Avenue, 93, 98, 125
Clayton, Missouri, 174
Collier, Mrs. Sarah A., 111
Collier Building, 148
Collins, John, 30
Collot, Gen. George Henri Victor, 16
Collotype process, 162
Cologne, views of, 4n, 5n
Columbus, Mississippi, 131, 137
Compton, Richard J., 122n, 128, 131, *132,* 134, 136,
 137, 138, 143, 148, 153, 154, 166n
Compton-Dry, lithographers, 166; *Pictorial St.
 Louis,* 131, *132, 133, 134, 135;* view of Eads
 Bridge, *123;* views of St. Louis, *2, 22, 23n, 133,*
 135, 140, 141, 142, 144, 145, 146, 147, 149, 151, 152
Compton Hill, 170n
Conant, Alban Jasper, 136, 137

Concert Hall, 42

Conklin, Will, 120; view of St. Louis, 122

Constantinople, views of, 6, 7, 8

Cooke, George, 111

Cosmographei, ed. Sebastian Münster, 4–5

Cotton Exchange, 156

Courtenay, T. E., 21n

Courthouse, 1, 19, 20, 28, 33, 34, 38, 42, 47n, 52, 54, 57, 59, 61, 75n, 83, 87, 88n, 101n, 104, 111, 114, 125, 126, 143, 148, 155, 160, 162, 165

Cuno, Charles A., 85

Currier, Nathaniel, 128; view of St. Louis, 129

Custom House, 98, 101n, 125, 148, 162

Daily Missouri Democrat, 57, 85

Daily Union, 64

Dana, Charles A., 48–49

Davenport, Iowa, view of, 46n

De Bry, Theodore, 7n, 8, 9

Degan, George, 126–28; view of St. Louis, 127

Delft, plan-view of, 7

Delmar Street, 14

Devraux, Professor, 79n, 102; views of St. Louis, 79, 103

Dicey, Edward, 102

Dickens, Charles, 52

Doan, Thomas C., 130n

Dock Street, 88n

Drebbel, Cornelis, 5, 7

Dry, Camille N., 23, 126–153, 160n, 174n. *See also* Compton-Dry, lithographers

Duborg, Bishop Louis Guillaume Valentin, 19

Dupré, Eugene Charles, 24, 25, 31; view of St. Louis, 24, 32

Duval. *See* Lehman and Duval, printers

Eads, James Buchanan, 115, 122, 131, 148n

Eads Bridge, 112, 114, 115, 116, 120, 122, 126, 131, 137, 143, 154, 160, 166, 170, 174, 176; view of, 123

Easterly, Thomas M., 85, 87; view of St. Louis, 86

Eastman, Seth, 61

East St. Louis, 120; Illinoistown, 42, 70, 111; waterfront, 160

Edwards, Richard, 89, 102, 103

Edwards' St. Louis Directory, 101, 108

Eichbaum, George, 136n

Eighteenth Street, 88n, 94, 166

Eighth Street, 20, 125, 143

Eleventh Street, 93n, 111

Elliot, Richard, 93, 134

Elm Street, 25, 26, 98

Endres, Jacob, 130

Engraving, 5–13 passim, 85–87; copper, 6; steel, 6, 11n, 104, stone, 111n, 112n. *See also* Wood engraving

Episcopal Cemetery, 93n

Episcopal Church, 19, 33, 61

Episcopal Sisterhood of the Good Shepherd, 111

Erie Canal, 13

Every Saturday, 114, 150n; view of St. Louis, 115

Excelsior Stove Works, 166

Exposition and Music Hall Building, 162

Fairgrounds, 116n, 125, 168

Famous Building, 165

Federal Courts building, 98

Ferguson, Missouri, 158

Fetre, Henry G., 24n

Field, Ruth K., 111

Fifteenth Street, 89, 100, 111

Fifth Street. *See* Broadway

Fire station, 42

First Street, 26, 28, 64; North First, 47n

Fisher, Henry, 54, 57; view of St. Louis, 56

Flagg, Edmund, 26n

Flint, Rev. Timothy, 18

Florence, views of, 2n, 4, 4n, 5

Florissant, Missouri, 158

Forest Park, 125, 134, 150, 158, 172, 174; view of, 152

Fort Caroline, Florida, 8; view of, 9

"Four Courts." *See* Municipal Courts building

Fourdrinier, Pierre, 11

Fourteenth Street, 93n, 94, 111, 160

Fourth Street, 18, 19, 23, 25, 26, 28, 33, 42, 47n, 59, 83, 87–88, 93, 98, 111, 143, 148, 154, 156n, 160, 165, 174; North Fourth, 47n

Frank Leslie's Illustrated Newspaper, 160

Franklin Avenue, 54n, 93n, 168n

Front Street, 14, 33, 46, 47, 57, 154; views of, 34, 47. *See also* Levee

Garrison, Nicholas, 10

Garrison Avenue, 160

Gast, August, 71, 72n

Gast, Leopold, 57, 64, 68, 71

Gast, Moeller & Co, 111, 112–13, 113–114n

Gast & Brother, panorama of St. Louis, 108; views of St. Louis, 72–73, 65

Gast-Welcker panorama, 71, 72, 73

Gaylor, Charles, 64

General Pratte, steamboat, 45

Geyer Street, 93n

Gilbert, Cass, 94n

Glaser, Louis, view of St. Louis, 163

Glasgow Row, 88

Glazier, Capt. Willard, 154

Gleason's Pictorial, view of St. Louis, 75, 76

Globe-Democrat. See St. Louis Globe-Democrat

Gordon, Peter, 11

Government House, 20

Graf, Frederick, 162, 165, 166, 172, 174, 176; views of St. Louis, 164, 165n, 173, 178

Graf, Henry, tinner, 162n

Graham, Charles, 158, 160; view of St. Louis, 159

Grand Avenue, 88n, 93, 94, 125, 139, 150, 156n, 158, 160n, 168, 172

Hagebeck, Augustus, 116, 120; view of St. Louis, 119

Hagebeck, John, 120

Hagen, Harry M., 41n, 92

Halftone, process, 172; reproduction, 170; screen, 172

Harper's New Monthly Magazine, 160n

Harper's Weekly, 75, 114, 116, 158, 170; views of St. Louis, 78, 118, 171

Harrison, General, 33n

Hickory Street, 150

High School, 88n, 111

Hill, John William, 11n, 80n, 83, 120n, 128n, 176; views of St. Louis, 81, 82, 84

Hill, The, 19, 174n

Hinshelwood, R., view of St. Louis, 117

Hofmann, Charles F., 19, 24

Hofmann, George, 85, 87, 94, 96, 98, 101, 102, 126; views of St. Louis, 86, 89, 90

Hogan, John, 71, 72, 87, 111, 112n; view of St. Louis, 118

Hogenberg, Franz, 6, 7

Holden, Ezra, 30

Holloway, Sister Marcella M., 61n

Hoover, John, 102n

Hopewell, M., 89

Hospital, 42

Howe, Henry, 101n

Humboll, steamboat, 75n

Hungerford, Edward, 174

Hunt, Carol, 120n

Hutawa, Edward, 57

Hutawa, Julius, 54n, 57, 61, 64, 65, 70, 71n, 72n, 75n; views of St. Louis, 58, 63, 65, 68

Hyde, Ralph, 7

Hyde, William, 96

Illinois, steamboat, 61n, 63

Illinois shore, view from, 14, 16, 31, 33, 47, 54, 57, 70, 82, 101n, 102, 104, 116, 120, 134, 170

Illinoistown. *See* East St. Louis

Indians, 14, 21, 57n; prehistoric constructions, 19

Insane Asylum, 134

Insurance Exchange Building, 166n

Istanbul. *See* Constantinople

Ives, Halsey C., 130, 136

Ives, James, 128; view of St. Louis, 129

J. H. Lucas, steamboat, 102n, 103

Janicke, A., & Co, 92; view of St. Louis, 91

Janson, Jan, 6, 7

Jefferson Avenue, 93n, 168; bridge, 156

Jefferson City, Missouri, 89n

Jesuit College, 61

John Simonds, steamboat, 104n, 105

Juehne, Charles, 108, 136, 166, 168, 172; views of St. Louis (1894) 167, 168n (1896) 169

Kansas, steamboat, 102n, 103

Keller, Ralph, 114, 150n

Keller, William T., 120

Keokuk Street, 88n

Keppler, Joseph, 114

Kern, Maximilian G., 150n

Kershaw, James M., 54, 57; plan of St. Louis, 55

Kingsford, William, 72n, 83

Kingshighway, 134, 150, 156n, 168, 174

Kirkwood, Missouri, 158, 174

Kouwenhoven, John A., 148n

Kramin, G., plan of St. Louis, 25

Krausse, Emille B., 85; view of St. Louis, 86

Laclède Liguest, Pierre, 14, 15, 20, 23

Laclède's Landing, 120

Ladies Repository, The, 47, 81, 83, 84, 85, 120n

Lafayette Avenue, 93

Lafayette Park, 93, 94, 100, 125, 148, 150, 155, 160, 170n; view of, 149

Lafayette Square, 94n

Lafferri, Antonio, 5

Lamasson, 64

La Navidad, woodcut of, 8

Lane, Fitz Hugh, 137n

Latrobe, Charles Joseph, 24

Laurel Street, 28

Leffingwell, Hiram, 93, 125n, 134
Lehman and Duval, printers, view of St. Louis, 23
Le Moyne, Jacques, 8n
Leney, William L., view of St Louis, 17
Levee, 17, 57, 64, 70, 87, 92, 96, 101n, 102, 104, 116n, 120, 154, 155, 156n, 158, 165, 170
Lewis, Henry, 21n, 59, 61, 64, 108; view of Caron-delet, 62; views of St. Louis, 60, 67;
Liberty Hall and Cincinnati Gazette, 39n
Lind, Jenny, 83
Lindell Hotel, 98, 104
Lithography, 12, 112n; color, 70
Lockport, New York, views of, 13
Locust Street, 25, 42, 57, 88, 89, 96, 98, 155, 165, 168n. See also Lucas Place
Löher, Franz von, 53
London Daily Graphic, 120
Longworth, Nicholas, 30n
Lord, C. K., 122, 125; view of St. Louis, 124
Lotter, Tobias Conrad, 9n
Louisiana Purchase, 17, 54, 93
Louisiana Purchase Exposition, 174, 176
Lowic, Lawrence, 14n, 41n, 52n, 54, 88n, 89n, 98n, 125n
Lucas, Judge J. B. C., 18, 25, 54n, 93n, 94
Lucas Market, 139
Lucas Place, 94, 98, 100, 108, 111, 139, 155, 160; view of, 110, 140. See also Locust
Lucas Street, 93n
Lucrode, Fr. Berchem, 71n
Lutheran Church, 54

McCune, Joseph, 139
McDermott, John Francis, 14n, 16n, 21n, 23n, 29n, 30n, 31n, 33n, 38n, 44n, 45n, 46n, 47n, 59n
McDowell's Medical College, 88, 89
McIlvain's Lumber Yard, 139
Mackay, Charles, 72, 87
McLean, Alex, plan of St. Louis, 92
MacLean, Alex, aerial photograph of St. Louis, 179
McLean, James, 148
McLean Building, 148, 165
Magnus, Charles, 89, 104; view of St. Louis, 105
Main Street, 25, 57, 88n, 143, 154, 156n, 170n. See also First
Market, the, 23, 28, 33n, 64, 112
Market House, 61
Market Street, 14, 17, 19, 20, 21, 25, 26, 28, 33, 46, 53n, 57, 61, 64, 88, 93n, 96, 98, 120, 139, 148,

156n, 166, 176
Meramec Street, 93
Mercantile Library Association. See St. Louis Mer-cantile Library Association
Merchants Bridge, 166, 170
Merchants Exchange, 115, 125, 148
Merian, Matthew, 7; view of Constantinople, 8
Merk, F., 120n
Meteor, steamboat, 45
Methodist Church, 42, 61
Mexico City, plan-view of, 8n
Meyer, Hermann, 49n
Meyer, Joseph, 49n
Mill Creek, 92, 100, 143, 166, 170
Miller, Henry B., 25, 26
Miller's Exchange, 114
Minnesota Historical Society, 44n, 59n
Mississippi Avenue, 93
Mississippi River, 1, 7, 14, 17, 18, 19, 21, 26, 28, 31, 33, 38, 40, 47n, 49, 53, 54, 57, 59, 61, 70, 71, 72, 75n, 87, 100, 101n, 102, 104, 108, 111, 112, 114, 115, 120, 122, 134, 143, 148, 154, 155, 158, 160n, 166, 170n, 174
Missouri, steamboat, 57n
Missouri Avenue, 93
Missouri Botanical Garden, 125
Missouri Historical Society, 15n, 21n, 33, 44n, 47n, 59, 61, 68n, 70n, 71n, 72, 75n, 83, 92, 94, 108, 111n, 114, 120n, 132n
Missouri Hotel, 26, 28
Missouri Park, 94, 98, 111, 139
Missouri Republican. See St. Louis Missouri Republican
M'Makin, Andrew, 29, 31, 32
Moeller, Charles F., 111
Mogul, steamboat, 26
Montesano House, 61
Montreal, view of, 11
Montulé, Edouard de, view of New York City, 12
Moore, Thomas, 26, 32
Mormino, Gary Ross, 174
Mound Church, 61
Mounds. See Indians
Mueller, Gottlieb, 136
Mullikin, Napoleon, 139
Municipal Courts building, 125, 143, 155, 174
Münster, Sebastian, 4, 5; woodcuts, 6
Myrtle Street, 25

N.O. Standard, steamboat, 120
National Hotel, 26, 53
Natural Bridge Road, 93

New Amsterdam. See New York City
New Bremen, 53
Newman, Eric, 104n, 120n; Eric and Evelyn, col-lection, 112n
Newman, Harry Shaw, 45n
Newman, Kenneth, 45n
New Orleans, 54n
New Orleans Daily Delta, 82n
New Orleans Times Picayune, 82n
New York City, 10n; views of, 9, 12, 126n
Ninth Street, 25, 41, 42, 54n, 88, 93n, 125, 148, 168
North Baptist Church, 59
North St. Louis, Village of, 143
Nuremberg Chronicle, ed. Hartmann Schedel, 3–4

Oak Street, 25, 26
Odd Fellows Hall, 61, 68
O'Fallon, Col. John, 54n, 93n, 139n; addition, 93n
O'Fallon Park, 125, 150, 174
Ohio, steamboat, 6n, 63
Olive Street, 25, 42, 57, 88, 94, 98, 100, 111, 125, 155, 160, 165, 174
Overall, Charles, 41n
Oxford, 5n, 6n

Pacific (then Franklin), Missouri, 89
Palmatary, James T., 89n, 94–100, 104, 108, 128n, 176; views of St. Louis, 95, 97, 99
Park Avenue, 93, 150
Park Place, 150
Parsons, Charles R., 128, 168, 176; view of St. Louis, 129
Pate, William, 85
Patten, Thomas, view of Montreal, 11
Paul, R., 23; plan of St. Louis, 25
Paxton, 20n
Peck, Charles, 139
Pendleton, William, 26
Peoria, steamboat, 23
Peregrinationes in Terram Sanctam ed. Bernhard von Breydenbach, 3
Perspective, 4, 5, 6, 10, 31, 134, 172; aerial "maps," 138n; axonometric projection, 131; bird's-eye view, 10, 49, 57, 82n, 94, 108, 125, 126, 156, 160, 166; Dry's, 137n; elevated, 82, 168; ground-level, 7, 10, 49, 57, 82; high-level, 1; plan-views, 5, 6, 10; Wild's, 30; with single vanishing point, 87, 96; with two vanishing points, 131n

Peters, G. W., 170, 172; view of St. Louis, 171
Philadelphia, 28, 29, 30, 31, 39, 45, 47, 68, 70, 80; panorama of, 31; views of, 9n, 11,
Phoenix Brewery, 150
Photography, 170, 172, 176
Piazza San Marco. See Venice
Pictorial St. Louis. See Compton-Dry, lithographers
Piercy, Frederick, 75, 77
Pierson, view of St. Louis, 75, 76
Pine Street, 17, 25, 26, 28, 41, 42, 57, 111, 125, 155, 160, 165, 174
Pitman, Philip, 15
Pitzman, Julius, 139, 150
Planters Hotel, 26, 33, 39, 40, 41, 52, 54, 57, 59, 61, 130, 148, 156, 162; view of St. Louis from, 40–41
Playter, E. W., 26, 28, 31; view of St. Louis, 27
Plum Street, 143
Pomarede, Leon D., 21, 23; view of St. Louis, 22
Poplar Street, 92, 125, 170n
Post Office, 98, 125, 148, 162
Postl, Karl, 20
Powers, Hiram, 30n
Presbyterian Church, 28, 61; Associate Reformed, 59; First United, 42, 54, 98, 111; Reformed, 41; Second, 33, 42, 54, 64, 98; Third, 54
Preston Place, 150
Pride of the West, steamboat, 57n
Primm, James Neal, 53n
Prune Street, 26, 28
Public Library, 94

Railroad: Depot, 101n; Elevated [rail] Road, 170; Iron Mountain Rail Road, 143; North Missouri Railroad, 92; St. Louis, Kansas City and Northern Railroad, 125; Pacific Railroad, 88, 89, 92, 100, 143, 156; Terminal Railroad, 166; Wabash Railway depot, 166
Real Estate Exchange, 156
Reedy, William Marion, 174n
Reuwich, Erhard, 3
Roberts, Bishop, view of Charleston, 10
Robyn, Charles, 68, 71, 130n
Robyn, Eduard, 68, 71, 122, 137, 166; Robyn-Welck-er panorama, 71; views of St. Louis, 69, 70
Robyn, Gustav A., 68
Robyn, William, 68
Rodgers, Thomas L., 83n, 87
Rogers, Charles, 59
Rollison, William, view of St. Louis, 17
Rome, 3, 5; view of, 4

Rosati, Right Rev. Joseph, 25n
Rosenberg, C. G., 83
Rosselli, Francesco, 2n, 4n
Ruger, Albert, 131
Russell, Prof. John, 26n

Sachse, Edward, 89n, 96, 108; shop, 111; view of
 Lucas Place, *110*
Sachse, Julius, 108n
Sachse, Theodore, 108n
St. Charles Street, 18, 25, 28, 42, 93n, 94, 111
St. George's Church, 61
St. Louis, steamboat, *63, 74*
St. Louis Daily Democrat, 57n
St. Louis Daily Evening Gazette, 31, 33n, 38n, 44
St. Louis Daily Pennant, 33n
St. Louis Globe-Democrat, 131n, *132,* 148n, 162n, 165n
St. Louis Hotel, 38
St. Louis Life Insurance Company Building,
 160, 166n
St. Louis Mercantile Library Association, 1, 14,
 20, 21n, 23, 42, 64n, 75n, 79, 88n, 98, 102n,
 174, 176
St. Louis Missouri Republican, 23n, 24n, 33, 35, 38n,
 40, 42, 45n, 46, 47, 59n, 71, 88n, 96n
St. Louis Place, 139n, 143; view of, *142*
St. Louis Post-Dispatch, 71n, 162
St. Louis Presbyterian, 70
St. Louis Times, view of St. Louis, *120*
St. Louis University, 23, 38, 41, 42, 89, 148,
 156n, 168
St. Louis Weekly Reveille, 46n, 59n
St. Patrick's Catholic Church, 54, 148
St. Paul's Episcopal Church, 54
St. Vincent's cemetery, 93n
St. Xavier's Church, 54, 61, 148
Salathée, Friedrich, 29n
Salisbury Street, 53n
Sandusky, Ohio, 94n
Santo Domingo, 9
Saturday Courier, Philadelphia, 29
Savage, Charles C., 98n, 139n
Savannah, Georgia, view of, 10, *11*
Saxe-Weimar, duke of, 20
Scattergood, D., view of St. Louis, 79
Scharf, J. Thomas, 136n
Schedel, Hartmann, 3, 4
Schell, view of St. Louis, *118*
Schmitz, Marie L., 59n, 61

Schrader, Andreas August Theodor, 71n, 108,
 166; view of Carondelet, *109*
Schultz, Christian, 16n
Sealsfield, Charles (alias). *See* Postl, Karl
Sears, Robert, 73; view of St. Louis, *74*
Second Street, 17, 19, 25, 52, 57, 98, 154, 156n
Second Carondelet. *See* Eighteenth Street
Selma, Missouri, 42, 44n
Senefelder, Alois, 12
Seutter, Mathew, 9n
Seventeenth Street, 100
Seventh Street, 18, 25, 26, 42, 89, 92, 93n, 98,
 100, 148, 156; view of, *146*
Shaw, Henry, 125, 150, 174
Shaw's Garden, 116n, 125, 150, 155
Singleton, Henry, 33
Sisters of St. Joseph, 61
Sixteenth Street, 111
Sixth Street, 25, 26, 42, 98, 148, 160, 168n
Skinker Boulevard, 150
Smet, Father Pierre-Jean de, 47
Smith, Benjamin Franklin, Jr., 80, 82; views of
 St. Louis, *81, 84*
Smith, Charles J., 154n
Smith, David, 80
Smith, Francis, 80
Smith, George, 80
Smith Brothers, 47n, 80, 82n, 83, 85n, 94,
 120n, 128n
Snyder, Martin P., 11n, 29n, 30n, 31n, 45n
Soulard, Julia (Cerré), addition, 93n; neigh-
 borhood, 54n, 143
South Side, view of, *145*
Southern Hotel, 98, 143, 165; rebuilt, 156
Spruce Street, 26, 42
Stevens, Walter B., 156n
Stockholm, view of, 6n
Stoddard, Capt. Amos, 16
Stoddard Addition, 93
Stoner, J. J., 131
Stumpf, Johannes, 5n
Sullivan, Louis, 165

Taft, Robert, 158n, 172n
Telfer, R., 75; view of St. Louis, 79
"Ten Buildings", 88
Tenth Street, 2, 93, 170n
Thayer, Benjamin W., 26
Theatre, the, 20, 38, 42, 52, 57, 61, 98,

Third Street, 19, 23, 24, 25, 26, 42, 57, 59, 98, 111,
 125, 143, 154, 160
Thirteenth Street, 94, 98, 100, 166, 176
Thomas, J. E., 38
Thomas, Lewis F., 38, 39n, 42n, 44
Thomas Jefferson National Expansion Memorial
 Park, 87
Tower Grove Park, 125, 150, 174; view of, *151*
Trollope, Anthony, 104n
Tucker Boulevard, 93n, 98, 125, 166
Twain, Mark, 155n, 158
Twelfth Street. *See* Tucker
Twentieth Street, 166
Twenty-seventh Street, 155

Union Addition, 139
Union Depot, 125, 156, 170n
Union Hotel, 26, 28
Union Methodist Church, 111
Union Station, 143, 166, 168, 170n, 174
Union Stockyards, 143
Union Trust Building, 165
Unitarian Church of the Messiah, 61, 88
U.S. Arsenal, 38, 143
U.S. Geological Survey, 174, *175*
U.S. Powder Magazine, 42
Upham, Warren, 59n

Vanderhoof, Charles A., 116; view of St.
 Louis, *118*
Vandeventer Avenue, 168n
Vandeventer Place, 139, 160n, 168; view of, *141*
van Ravenswaay, Charles, 57n, 71n, 87n
Venice, views of, *2, 4n,* 29
Verandah Row, 88
Victor Street, 143; view of, *145*
Vine Street, 26, 88
Visscher, Nicholas, 9n
Vogel, Henry M., 156; view of St. Louis, *157*

Wade, view of St Louis, 75, *76*
Wainwright Building, 165
Wall, Louis J. W., 72n
Wall, William Guy, 11
Walnut Street, 17, 19, 23, 25, 26, 28, 33, 42,
 98, 166
Walsh, Thomas, 98
Walter, Valentine, 130
Warner, Charles Dudley, 160

Warren, A. C., 116; view of St. Louis, *117*
Washington Avenue, *2,* 23, 26, 41, 54n, 59, 88, 98,
 111, 116, 120, 143, 148, 155, 156n, 160, 168,
 170n, 174
Washington Park, 98, 166
Washington University, 139, 174
Water Street. *See* Front Street
Waterworks, 134, 143; view of, *144*
Waud, Alfred R., 114, 116, 158; view of St.
 Louis, *115*
Wayman, Norbury L., 143n, 150n, 153n
Webster Groves, Missouri, 174
Welcker, Ferdinand, 71, 122, 137
Wellge, Henry, 154n
Western Transit Insurance Company, 104; view
 of St. Louis, *106*
Wheeler, John P., 137n
White, James Haley, 18n
White Cloud, steamboat, *64*
Whitefield, Edwin, 80, 94
Wild, John Caspar, 28–51, 54, 57, 61, 70, 85, 148;
 panorama from Planters Hotel (1842), *40–41,*
 111; Public Landing, (Cincinnati), 30, 33; *Valley
 of the Mississippi Illustrated,* 38, 39, 40n, 42, 47;
 views of Carondelet (1841), *43, 44;* views of
 Front Street, *34, 47; Views of St. Louis,* 33, 38n
—views of St. Louis: 1839, *32;* from the
 northeast (1840), *35;* from the southeast (1840),
 36; from the southwest (1840), *37;* from the
 east (1841), *39;* from the south (1841), *45;* 1845,
 50; 1853, *51*
Wilhelm, Friedrich Paul, duke of
 Württemberg, 19
Wilson, William, view of Lockport, *13*
Wimar, Charles, 21n
Wit, Frederik de, view of Delft, *7*
Wittemann, Adolph, 162, *163*
Witter, Conrad, 49n, 104; view of St. Louis, *105*
Wittler, Edward E., 72n
Wm. McKee, steamboat, 102n, *103*
Wolgemut, Michel, 3
Woodcuts, 5, 6, *7, 8*
Wood engraving, 73, 75n, 79, 88, 170. *See also*
 Engraving
Wooll, George, 46, 47n; view of Front Street, *47;*
 view of St. Louis, *48*
Wortley, Lady Emmeline Stuart, 52–53, 64
Wyoming Street, 88n

Zinkham, Helena, 104n, 162n